Art in the Eurasian Iron Age

Art in the Eurasian Iron Age

Context, connections and scale

edited by

Courtney Nimura, Helen Chittock, Peter Hommel
and Chris Gosden

OXBOW | books
Oxford & Philadelphia

Published in the United Kingdom in 2020 by
OXBOW BOOKS
The Old Music Hall, 106–108 Cowley Road, Oxford OX4 1JE

and in the United States by
OXBOW BOOKS
1950 Lawrence Road, Havertown, PA 19083

Hardback Edition: ISBN 978-1-78925-394-8
Digital Edition: ISBN 978-1-78925-395-5 (ePub)

A CIP record for this book is available from the British Library

Library of Congress Control Number: 2019951276

Printed in the United Kingdom by Short Run Press

Typeset in India for Casemate Publishing Services. www.casematepublishingservices.com

For a complete list of Oxbow titles, please contact:

UNITED KINGDOM
Oxbow Books
Telephone (01865) 241249
Email: oxbow@oxbowbooks.com
www.oxbowbooks.com

UNITED STATES OF AMERICA
Oxbow Books
Telephone (610) 853-9131, Fax (610) 853-9146
Email: queries@casemateacademic.com
www.casemateacademic.com/oxbow

Oxbow Books is part of the Casemate Group

Front cover: A Late Iron Age (100 BC–AD 43) harness plate from Santon, Suffolk. Reproduced by permission of University of Cambridge Museum of Archaeology & Anthropology (1897.225A).

MARC FITCH FUND

Contents

List of figures and tables

List of contributors

TIM CHAMPION
Faculty of Arts and Humanities, University
of Southampton, Avenue Campus, Highfield,
Southampton, SO17 1BF, United Kingdom

HELEN CHITTOCK
AOC Archaeology (South), Unit 7, St Margarets
Business Centre, Moor Mead Road, Twickenham,
TW1 1JS, United Kingdom

SALLY CRAWFORD
School of Archaeology, University of Oxford,
34–36 Beaumont Street, Oxford, OX1 2PG,
United Kingdom

NATHALIE GINOUX
Sorbonne Université/Centre André Chastel,
Institut national d'histoire de l'art,
2 rue Vivienne, 75002 Paris, France

CHRIS GOSDEN
School of Archaeology, University of Oxford,
34–36 Beaumont Street, Oxford, OX1 2PG,
United Kingdom

PETER HOMMEL
School of Archaeology, University of Oxford, 1
South Parks Road, Oxford, OX1 3TG,
United Kingdom

JODY JOY
The Museum of Archaeology and Anthropology,
University of Cambridge, Downing St,
Cambridge, CB2 3DZ, United Kingdom

DIRK KRAUSSE
Landesamt für Denkmalpflege, Berliner Straße
12, 73728, Esslingen, Germany

TESS MACHLING
tess.machling@gmail.com

RENA MAGUIRE
Queen's University Belfast, Department of
Archaeology and Palaeoecology, School of
Natural and Built Environment, Belfast, BT7
1NN, Northern Ireland. Rena.Maguire@qub.ac.uk

COURTNEY NIMURA
School of Archaeology, University of Oxford,
34–36 Beaumont Street, Oxford, OX1 2PG,
United Kingdom

LAURENT OLIVIER
Musée d'Archéologie nationale de
Saint-Germain-en-Laye, Domaine National de
Saint-Germain-en-Laye, Château-Place Charles
de Gaulle, 78100 Saint-Germain-en-Laye, France

REBECCA O'SULLIVAN
School of Archaeology, Jilin University, No. 2699
Qianjin Street, Changchun, 130012, China

KATHARINA ULMSCHNEIDER
Worcester College, University of Oxford,
OX1 2HB, United Kingdom

PETER S. WELLS
Department of Anthropology, University of
Minnesota, 395 HHH Center, 301 19th Avenue S,
Minneapolis, MN 55455, USA

ROLAND WILLIAMSON
bodgitandbendit1@gmail.com

Introduction: Context, connections and scale

Chris Gosden, Helen Chittock, Peter Hommel and Courtney Nimura

Around 500 BC a new mode of visual expression emerged in Europe. To the north of the Alps, craftspeople began to decorate objects in ways that were strikingly different from the long-standing traditions of the preceding millennia (*e.g.* Garrow & Gosden 2012, 40–41; Jacobsthal 1944, 155–58; Wells 2008; 2012; Chapter 3, this volume). Whereas the artistic styles of the Bronze Age had been built around repetitive arrangements of geometric motifs, this new style was founded on swirling patterns and imagery where the boundaries between individuals (both human and animal) and objects are blurred. It also presented an increasingly sharp contrast with Mediterranean art of the same period, which generally emphasised narrative, symmetry and what might be thought of as 'realistic' representations of the world (Gosden *et al.* 2016). This new style, though sometimes referred to as *La Tène*, after its type-site in Switzerland, is more commonly known as Celtic Art.

We use the term 'Celtic Art' here (and in our chapters throughout this volume) with caution, emphasising its combined identity as an academic construct by capitalising both 'Celtic' and 'Art' and acknowledging that, as a label, it has meant many things to many people over the past 200 years (see Farley & Hunter 2015). Arguably, it is defined by a classic series of objects picked out by 19th century scholars (*e.g.* Kemble *et al.* 1863; Westwood 1856 – as discussed by Collis 2003; 2014; Morse 2005) and consolidated as an archaeological category over the course of the 20th century (*e.g.* Allen 1904; Dechelette 1908; Hawkes 1931; 1959; Jacobsthal 1944; Leeds 1933; Megaw 1970; Megaw & Megaw 1989; Stead 1985a; 1985b). However, in recent decades, the idea that this diverse group of objects can be seen as evidence for a single 'Celtic' community in prehistory have been thoroughly contested (*e.g.* Collis 2003; Garrow & Gosden 2012; Garrow *et al.* 2008). Indeed, there has been a positive drive towards the deconstruction of Celtic Art, on the premise that the large group of objects it

encompasses are neither 'Celtic', nor 'Art' in the modern sense of the word (Gosden & Hill 2008).

This was a goal of the Technologies of Enchantment project, which set out to investigate the ways in which Celtic Art was deployed (through its production, use and deposition) on different contexts to bring together images, objects, people and spaces (Garrow & Gosden 2012). The European Celtic Art in Context (ECAIC) project (2015–2018) expanded this approach to continental Europe to consider what Celtic Art has to say about the way Iron Age Europeans understood the world and their place within it (see Gosden *et al.* 2016). The project explored two deliberately controversial ideas: that there are good reasons to directly compare the traditions of art that had emerged to the north and south of the Alps by the mid-1st millennium BC, and that, to a greater or lesser extent, both art forms derive from two wider streams of interaction at a continental scale.

Art can be seen as a proxy for broader changes in society. In the Classical world, we can see changes in the modes of representation as a reflection of an increasingly mechanistic view of the universe. Celtic Art, by contrast, could be seen as animistic: one in which spirits inhabit the material world. The contrast between an animistic Celtic Art and a naturalistic Classical tradition is obviously contentious. Scholars from Jacobsthal onwards have often looked for the origins of Celtic Art in the Mediterranean world, so that the northern forms become an unsophisticated, barbarian version of the arts of the civilised south, no doubt a reflection of the Classical training of early art historians in the study of Celtic Art. While it is undoubtedly true that some borrowing of motifs occurs from the Mediterranean into temperate Europe, this is relatively limited, and the idiom within which borrowed motifs, such as lotuses, are placed shows a contrasting sensibility and overall approach to the world.

Olivier (2014) has described Celtic Art as 'intellectually realistic', arguing that it is true to a set of ideas stressing transformation, transparency and repositioning, rather than to a desire to represent the world as it appears to us. Processes such as *rabatment*, where both halves of an animal or object may be seen at once, or *transparency*, where one part of a scene can be looked through to perceive another, allow the depiction of a world in the process of transformation – in its geometric elements, which play with shape and form, but also in the relationship between people, plants and animals, which morph into one another or where time is brought into play in a manner reminiscent of Cubism. This is not a primitive art unable to accurately reproduce the world, but a sophisticated series of plays on the essential qualities of living and non-living beings. Celtic Art is a true representation of the cosmological ideas of cause, effect and temporality. Coincidental with the start of Celtic Art, just after 500 BC, Greek artists developed new modes of naturalistic painting and statuary, which became a key strand of later Roman art and is linked to the rise of novel forms of individualism (see Elsner 2007 for an analysis of Roman art).

Using a contrast between intellectually realistic and naturalistic representation, we can identify two streams of art and sensibility in the ancient world. A northerly

stream runs from the steppe to the Atlantic starting at least in the middle of the 1st millennium BC and concerns ambiguity, play and transformation, with a changing balance between geometric and figurative forms. A southerly stream runs from the Persian world to Italy over the same time period and is partly concerned with a more conventionally realistic portrayal of people and sacred beings in painting, statuary and on metal or pottery vessels. Both were in contact, but where motifs or forms were shared, they were incorporated into a style with a different logic of construction and appreciation. We are attempting to analyse Celtic Art as an element of the northerly stream, looking at the recurrence of the logic of construction after the decline of the Roman empire.

If Celtic Art is looked at as part of a broader Eurasian universe of form and decoration, we want to know what this universe looked like and how resemblances of form and decoration manifest themselves from central Asia to the Persian world to Europe. The largest scale of question is what was the effect of these styles in helping to create local groups and an international milieu? We are developing ideas current in art history, anthropology and archaeology to look at how aesthetic effects derived from and fed into notions of cosmology, political power and identity. Although techniques (*e.g.* filigree and granulation) and specific motifs (such as lyres and palmettes) undoubtedly derive from the Mediterranean world, they are accepted into an ontology in which the boundaries between people, animals, plants and objects were not fixed and stable, a world we can broadly call animistic. Such animistic art is found with variations widely across Eurasia: 'At a time when the new style developed in Europe, during the 5th century BC, S-curves, spirals, formlines, and stylized, sometimes hybrid animals – can be found across much of temperate Eurasia' (Wells 2012, 204). At the level of material, torcs from the Glauberg in Germany have been found to be made from Achaemenid gold (Megaw & Megaw 1989). Comparative work has started, but needs to be pursued in a more systematic manner. Within Europe connections have also been pursued, and here a prime example of relatedness and differentiation is supplied by coins. Some of the key contexts of burial, such as tumuli, are found in very similar form right across Eurasia in the early and middle 1st millennium BC (Gosden *et al.* 2018).

More local questions need also be asked: what were the regional variations of Celtic Art in a series of crucial areas of Europe in which Celtic Art is common, including Ireland, Britain, the Aisne/Marne region of France, the Mosel-Rhine area, Switzerland, Austria, the Czech and Slovak Republics and the Carpathian Basin? Is it now possible to chart the differential distribution of key motifs (s-curves, spirals, circles and animal ornament), forms (animal forms, cauldrons/situlae, fibulae, helmets, horse gear, mirrors, torcs and swords), materials (gold, silver, bronze and iron) and contexts (graves, settlements, hoards, watery locations, religious sites)? Secondly, what were the longer distance connections of Celtic Art, both within Europe and beyond? There are specific sets of links, such as swords with dragon pairs found in eastern France and Pannonia, which might indicate gift partnerships or other links.

A crucial element is the link between style and contexts. Discussions of Celtic Art are full of discussions of style, but these rarely break free from issues of chronology. Jacobsthal defined the Early, Waldalgesheim, Sword and Plastic Styles as successive modes of art through the Early and Middle Iron Age (a scheme modified for Britain by Stead [1985a] and discussed by Garrow and Gosden [2012]). Worries about chronology have focused attention away from what styles are composed of and, especially, what they might do in terms of sensory perceptions or emotional responses. We are attempting to characterise styles in terms of what they were composed of and what they did. Celtic Art has often been seen as a series of parts (forms and motifs), with fewer attempts to specify the rules of combination and transformation (Megaw & Megaw 1989).

The subtitle of this volume is *context, connections and scale*: three interlinked themes that connected the main interests of the ECAIC project. Each of the papers in the volume deals with these themes in different ways. The ECAIC project has pursued an expanded notion of context by examining it not only in its archaeological sense, but also considering the contexts of Iron Age patterns and images on single impressive objects and within much wider assemblages. The authors focus on different temporal and spatial scales, with some examining huge assemblages at continental scales or considering long term change, and others conducting far more detailed enquiries into individual objects to access particular moments in time. They highlight that connections between people and objects lie at the core of what Iron Age art did, and which allowed for the movement of ideas and practices across large distances.

This volume originates from ongoing conversations with members of the ECAIC project's Advisory Board as well as a workshop hosted in September 2017 at Oxford, entitled *Art in the Eurasian Iron Age*. This volume presents 11 of the papers given at the conference, a historic publication by Paul Jacobsthal (up to now unpublished) and an introduction of this work by Sally Crawford and Katharina Ulmschneider, as well as a discussion paper by Tim Champion.

Chapters 1, 2 and 3 comprise broad-scale introductions to the material this volume deals with, providing perspectives on the role of art in Iron Age society, long-distance connections across Eurasia during the 1st millennium BC and the usefulness of the ECAIC database in pursuing the study of these broad themes. The volume opens with a characterisation of the Iron Age and its art by Chris Gosden (Chapter 1), who considers the networks, assemblages and events involved in material lives during this volatile period of later prehistory. Gosden highlights the new questions being asked of so-called Celtic Art in recent work, and the ways in which they may lead to new understandings of the group dynamics and performance that were crucial to Iron Age life. Chapter 2 comprises an introduction to the ECAIC database by Courtney Nimura, Helen Chittock, Chris Gosden and Peter Hommel of the ECAIC project, who provide details of the construction and analysis of the database and the challenges and new questions this process brought. They also begin to demonstrate the types of questions this database will be used to answer in the

project's forthcoming monograph. In Chapter 3, Peter Wells provides a comprehensive overview of design elements and practices that were shared across stretches of Eurasia during the 1st millennium BC and the spheres of interaction through which long-distance connections may have occurred at a time where profound cultural changes were occurring across this part of the globe. Wells identifies motifs, for example s-spirals and palmettes, which comprise the basis of Celtic Art but also appear across Eurasia.

Chapters 4 and 5 encompass studies of differing aspects of Iron Age imagery, both zoomorphic and anthropomorphic. Both chapters tackle the issues of realism and representation in prehistoric art to question the deeper ideas, worldviews and sensibilities displayed in art across different parts of Iron Age Eurasia. Rebecca O'Sullivan and Peter Hommel look eastwards in Chapter 4, where they consider the tradition of depicting fantastical composite animals, which formed an important aspect of Iron Age art across the Eurasian steppe and beyond. They use the distinctive ways these images were constructed to examine northern Eurasian cosmologies and contrast the structuring of imagery with that of the Mediterranean world. Helen Chittock focuses on a different aspect of Iron Age imagery in Chapter 5, examining anthropomorphic images from across Europe at multiple scales. She focuses on the tactile nature of the images and demonstrates similarity and difference in the ways they functioned in time and space, also emphasising the contrast with Mediterranean traditions of depicting people.

Chapters 6, 7 and 8 all deal with the fundamental principles of art in Iron Age Europe and the mechanisms through which it operated, with a focus on time and memory. Following on from Chapters 4 and 5, in Chapter 6, Laurent Olivier advances the idea that Celtic Art is not 'aniconic' as has sometimes been suggested, rather the depictions it encompasses do not conform to modern, Western ideas of realism. Olivier examines the intellectual realism that lies behind Celtic Art, arguing that the imagery is not deliberately hidden, as is often argued, but that it represents an ontological perception of reality different from our own, and that of those inhabiting Mediterranean societies during the late 1st millennium BC. Chapter 7 comprises a reconsideration of the roles of motifs in Celtic Art by Jody Joy. Whilst the study of the motif has been somewhat shunned in recent decades, Joy demonstrates their capacity to act and re-contexutalises them as parts of objects. Drawing on the work of Alfred Gell, he argues that motifs can create relations between people and objects in the past, present and future, presenting a case study from Snettisham in Norfolk, East Anglia. In Chapter 8, Nathalie Ginoux also considers some of the underlying processes involved in the design and perception of European Celtic Art and the capacities of its makers to inscribe time and memory into the objects they create. Ginoux argues that its ambiguous designs formed important mnemonic devices, much like the work of poets and bards described in early medieval and Classical literature. Through a process of 'iconographic concentration', Celtic Art objects produced powerful sensory experiences.

Chapters 9, 10 and 11 deal with the potential long-distance connections between craftspeople and the ways in which designs travel in time and space. In Chapter 9, Dirk Krausse presents new findings from the Heuneburg plateau in south-west Germany. He argues that a proto-La Tène style was developing here as early as the 6th century BC, driven by a group of innovative craftspeople, who were influenced by Mediterranean style and technique. This local group of *avant garde* artists formed one aspect of the complex series of influences and connections that led to the emergence of La Tène art in Europe. Rena Maguire's contribution in Chapter 10 focuses on Iron Age equestrian equipment, or 'tack'. Maguire seeks to explain the appearance of similar motifs in distant parts of Europe at different times during the Iron Age, suggesting that particular, well-known motifs were chosen to appear on items of horse gear in Late Iron Age Ireland to invoke stability and security at a time of stress and volatility. Machling and Williamson's detailed study of the crafting of gold torus torcs from Iron Age Britain comprises Chapter 11. They draw on the insights of modern-day goldsmiths and jewellers as valuable sources of evidence on the intricate techniques required to create torcs, and this approach has allowed for the identification of individual makers and for new perspectives on the sharing of skill and knowledge amongst Iron Age goldworkers.

Chapters 12 and 13 form a pair. Chapter 13 presents a previously unpublished paper written by Paul Jacobsthal and presented to the Oxford Philological Society in 1938, having arrived at the University of Oxford in 1936 as a refugee from Nazi Germany. In the paper, Jacobsthal traces a particular motif, a 'monster' across Eurasia, discussing long-distance connections in time and space, but notably downplaying his primary specialism in Early Celtic Art. Sally Crawford and Katharina Ulmschneider's contribution, Chapter 12, precedes Jacobsthal's paper and forms an introduction to his ideas and an examination of the emergence of this work at a pivotal moment in his career, which would also influence his personal future. By examining the political and personal context of this piece of work, Crawford and Ulmsneider demonstrate the importance of considering the environment in which scholarship is produced.

In the final chapter, Tim Champion gives an overview of the ideas presented in this volume. In an extremely useful critique of many approaches to Celtic Art, Champion argues partly for holism, saying that we should set the analysis of decorated metalwork within a broader range of material culture within the Iron Age, including also the general history of metallurgy. He further stresses the importance of the wider cultural milieu of the Iron Age, in particular the importance of poetry and song.

Celtic Art is an old body of material being substantially added to by new finds. At least as importantly, the decorated materials from the later Iron Age continuously show sets of possibilities for new thought and analyses at a series of scales from a single object to connections across Eurasia. The papers in this volume demonstrate many of the possibilities inherent in Celtic Art, while also indicating many novel directions.

Acknowledgements

The editors would like to thank all the authors for their valuable contributions to the volume and to those workshop participants not represented here who contributed presentations and points for discussion. Many of the authors were members of the ECAIC project's Advisory Board, who we thank for guiding the project throughout its duration. The ECAIC project was funded by the Leverhulme Trust (reference number RPG-2014-384, 2015–18), and the Marc Fitch Fund generously provided a publication grant to help support the production cost of this volume. We also thank Oxbow's Publisher, Julie Gardiner, and Editor, Jessica Scott, for their guidance and Thibaut Deviese for translation help. And finally, we thank our team of anonymous peer reviewers who have been instrumental in helping to shape each chapter.

References

Allen, J.R. 1904. *Celtic Art in Pagan and Christian Times*. London, Methuen & Co.

Collis, J. 2003. *The Celts: Origins, myths, interventions*. Stroud, Tempus.

Collis, J. 2014. The Sheffield origins of Celtic art. In C. Gosden, S. Crawford & K. Ulmschneider (eds), *Celtic Art in Europe: Making connections*, 19–27. Oxford, Oxbow Books.

Dechelette, J. 1908. *Manuel d'archéologie préhistorique celtique et gallo-romaine: Archéologie préhistorique*. Paris, Alphonse Picard et fils.

Elsner, J. 2007. *Roman Eyes: Visuality and subjectivity in art & text*. Princeton, NJ, Princeton University Press.

Farley, J. & Hunter, F. (eds). 2015. *Celts: Art and identity*. London, British Museum Press.

Garrow, D. & Gosden, C. 2012. *Technologies of Enchantment? Exploring Celtic Art: 400 BC to AD 100*. Oxford, Oxford University Press.

Garrow, D., Gosden, C. & Hill, J.D. (eds). 2008. *Rethinking Celtic Art*. Oxford, Oxbow Books.

Gosden, C. & Hill, J.D. 2008. Introduction: Re-integrating Celtic art. In Garrow *et al.* 2008, 1–14.

Gosden, C., Hommel, P. & Nimura, C. 2016. European Celtic art and its eastern connections. *Antiquity Project Gallery* 90(349), https://www.antiquity.ac.uk/projgall/gosden349.

Gosden, C., Hommel, P. & Nimura, C. 2018. Making Mounds: Monuments in Eurasian prehistory. In T. Romanciewicz, M. Fernández-Götz, G. Lock & O. Büchsenschütz (eds), *Enclosing Space, Opening New Ground*, 141–52. Oxford, Oxbow Books.

Hawkes, C.F.C. 1931. Hillforts. *Antiquity* 5(17), 60–97.

Hawkes, C.F.C. 1959. The ABC of the British Iron Age. *Antiquity* 33/131, 170–82.

Jacobsthal, P. 1944. *Early Celtic Art*. Oxford, Clarendon.

Kemble, J., Latham, R.G. & Franks, A.W. 1863. *Horæ Ferales. Or, Studies in the Archæology of the Northern Nations*. London, Lovell Reave & Co.

Leeds, E.T. 1933. *Celtic Ornament in the British Isles Down to AD 700*. Oxford, Clarendon Press.

Megaw, J.V.S. 1970. *Art of the European Iron Age: A study of the elusive image*. New York, Harper & Row.

Megaw, M.R. & Megaw, J.V.S. 1989. *Celtic Art: From its beginning to the Book of Kells*. London, Thames and Hudson.

Morse, M. 2005. *How the Celts Came to Britain: Druids, skulls and the birth of archaeology*. Stroud, Tempus.

Olivier, L. 2014. Les codes de représentation visuelle dans l'Art celtique ancien [Visual representation codes in Early Celtic Art]. In C. Gosden, S. Crawford & K. Ulmschneider (eds), *Celtic Art in Europe: Making connections*, 39–55. Oxford, Oxbow Books.

Stead, I. 1985a. *Celtic Art in Britain before the Roman Conquest*. London, British Museum Press.

Stead, I. 1985b. *The Battersea Shield*. London, British Museum Press.

Wells, P.S. 2008. *Image and Response in Early Europe*. London, Duckworth.
Wells, P.S. 2012. *How Ancient Europeans Saw the World: Vision, patterns, and the shaping of the mind in prehistoric times*. Princeton, NJ, Princeton University Press.
Westwood, J.O. 1856. Celtic ornament. In O. Jones (ed.), *The Grammar of Ornament*, 89–97. London, Bernard Quaritch.

Chapter 1

Art, ambiguity and transformation

Chris Gosden

Abstract

Iron Age cultures were large, connected, volatile, varied and contested. After 150 years or more of concerted study we are only just getting a sense of what life in the 1st millennium BC was like. This chapter concerns the role of art in such societies, looking at how it might have been used performatively and as a means of coming to grips with an unstable cultural situation. I will start with a brief characterisation of the Iron Age, provide a theoretical model for thinking about general Iron Age relations using three terms (network, assemblage and event), before focusing on art in particular. The art of the Iron Age, or more especially the later Iron Age after around 450 BC, was the mirror image of the more realistic arts of the Greek and Roman worlds that grew up at the same time. Rather than a commitment to realism (a contested term, I know), so-called Celtic Art played with form and material, combining plants, animals and people, playing with the four dimensions of space and time, while contradicting any notion that the world was static. The most interesting pieces were many things at once, containing visual allusions, illusions and puns. Assemblages of objects enhanced this notion of motility and change. I will assess the assemblage from Waldalgesheim to look at combinations of form and ornament. The chapter ends with some thoughts on the role of art in the volatile world of the mid-1st millennium BC.

We are gaining an ever-richer sense of what European Iron Age cultural forms were like at an empirical level, but this new richness has not, so far, led to a very profound shake up of our overall pictures of the Iron Age. I will concentrate on art here, but in order to position the changes in material culture happening in the later Iron Age, it is necessary to provide some broader context of the cultural matrix within which so-called Celtic Art grew up and helped shape people's worlds. These ideas will be developed at greater length in the monograph publication of the European Celtic Art in Context project (see Gosden *et al.* 2016).

Two broad assumptions underlie my thoughts, which need stating so that the reader can see their influence, even if they cannot be fully discussed now. First, I see material culture as an active quality in people's lives. People do not first have social

and cultural aims and then develop material forms to realise these aims. Rather the world is made intelligible in the process of making and using things, so that a world that makes sense is co-produced by people and their material means (such ideas derive from the approach known as Material Engagement Theory – see Malafouris 2013). Here I will argue that style is a technology for allowing us to understand the world in a particular way. Secondly, it is important to stress the importance of process, highlighting becoming rather than being (Gosden & Malafouris 2015). Such a stress takes us beyond divisions into simple archaeological periods and allows us to look at time in a more complex manner, encompassing links to the past as well as movements into the future. Change and process should be seen as non-directional and non-teleological. Human history, or any part of it, such as the Iron Age, does not have a set direction, much less a progressive tendency from the more simple to the more complex.

Moving from these very broad assumptions to something a little more concrete, I would like to briefly introduce three crucial terms: network, assemblage and event.

Networks

A network is composed of the totality of connections in which a group is enmeshed. Networks are made up of people and things in combination. The lure of things helps shape connections as much as links between people. Networks are dense and complicated, involving plants and animals, hills and streams, as well as artefacts of all kinds. All elements of these networks have their own shape and purposes, so that people were one element among many, never in charge of relations, although striving to shape them. Networks can be seen as local, encountered by people every day in the ongoing process of living their lives. Other networks were between groups and areas. Such broader connections are not just, or indeed mainly, constructed through trade. Groups exchange partners in marriage, people move for many reasons, as do ideas and materials. These forms of movement take place through the important, but vaguely defined processes of diffusion, to which we need to give more thought. Networks are nested, with the densest links being local and gradually rippling out across Eurasia in the Iron Age. Archaeological indicators of such networks are given by the distribution of artefacts of particular styles and materials, as well as, where available, information on human movement from isotopes and genetics.

In more concrete terms, Iron Age networks are made up of those within temperate Europe itself, but they also bring in materials from Etruria, Greece and later Rome, from the Pontic area, the Persian world and the steppe groups to the east. Steppe connections have been of particular interest to our project (Gosden *et al.* 2018). Networks are varied and discontinuous across space – Martin Guggisberg (2018) has made the point that there are a number of contemporary forms of art in Europe from La Tène A including Celtic and Scythian Art. Each of these has concentrations of finds in some areas and many fewer in others, a variability that is only partly due

to burial practices. Imports of Mediterranean items vary also in intensity, and some of this variation, but not all, is because of the geography of connections along rivers and over mountain passes. Scythian artefacts are found in eastern Europe, with Celtic Art to the west. There are considerable numbers of La Tène style artefacts within the area of Scythian distribution with fewer Scythian artefacts coming west (Wells 2012), an imbalance that needs further investigation.

Assemblages

Constellations of artefacts, which we call assemblages, have two dimensions. First, they are situated within and help form local patterns of practice. The world is made intelligible through the items we make and use. A world that makes sense is also a world that works in a more practical sense, providing food, shelter and technical means. Across Iron Age Europe there are both similarities in material things, but also many variations on the broader themes, with uptakes of some items and not others. The history and distribution of wheel-turned pottery in the earlier Iron Age is a prime example, with some groups making pots on the wheel around 500 BC and others sticking to hand-forming techniques for centuries after that (Fitzpatrick *et al.* 2008). Second, assemblages are partly put together through the position of a group or region with networks. The streams of connections across Eurasia help shape what is available to people and what is not. From the things that are available, people will pick and choose those they want, rejecting things that do not fit in with current means of shaping the world. Broader trends in material engagement are also influential. In Britain after 800 BC, the use and deposition of bronze declines markedly, but the uptake of iron is slow. From around 800 to 400 BC, there is relatively little metal in use compared to earlier and later periods. When iron starts to become more common, after around 400 BC, so too does bronze (and indeed gold and silver). The start of the Iron Age sees not so much a replacement of bronze by iron, but a relative lack of interest in both metals (which cannot be due either to a technological lack or difficulties of supply), which is reversed relatively rapidly around the Middle Iron Age (Garrow & Gosden 2012, chapter 3). Whether such trends are seen elsewhere in Europe needs further research. The values attached to materials fluctuate, often for reasons that are not straightforwardly functional.

Events

An event is an individual set of actions that punctuates broader trends. It occurs relatively rapidly, judged by the timescales to which archaeologists are accustomed. An obvious example of an event is the construction of a large mound and the burial of one or more people within it. Large and spectacular burials might in reality occur in smaller stages, which can be picked apart by careful excavation. Nevertheless, their duration is relatively short and punctuates the flow of cultural action, perhaps

re-directing it in some way. A further example of an event would be the construction of the gate at the Heuneburg (Fernández-Götz & Krausse 2016, 322), which significantly changed the approach to, and entry into, the settlement. Where networks and assemblages are shaped by broader and longer lasting trends, events may derive from local contingency, or from the direction of action by an individual or small group. The Iron Age of Europe appears very eventful, punctuated by many dramatic forms of social action, designed to create heightened emotion or draw bodily attention to particular sets of relationships. No two events are the same, so that burials under mounds during Hallstatt D and La Tène A are never identical, either in the construction of the mound and its landscape setting or the exact set of materials placed within the grave. Variability in burial is only partly due to change through time. Power in the Iron Age derived in considerable part from performance, whether this was a military victory, a large feast, the founding of a new settlement, or the burial of an important individual. For performances to be powerful, they had to both fit within accepted tropes of action, but also bring some originality and difference to the event. Compared with later forms of power in Europe, social standing in the earlier Iron Age had a somewhat insecure base, deriving not from the ownership of land and its produce, but from a manipulation of the theatre of cultural life, due in turn to the individual's position within a network, their command of assemblages, and their ability to stage a compelling event.

A number of features stand out of the period of interest here, that is from Hallstatt D, when the cultural setting in which Celtic Art grew up first formed, and La Tène C (rather later in Britain). The societies of Hallstatt D and La Tène A were volatile, changing rapidly. This is most obviously seen in the growth of *Fürstensitze* (princely seats) in the few areas where they were found. People aggregated together in some thousands, constructing impressive buildings and engaging in craft production and an intense social life, before dispersing again two or three generations later. Elsewhere, for instance in lowland Britain, large aggregation sites of a similar period, but very different type, were found, for instance as evidenced by the large midden deposits at Potterne and All Cannings Cross (Barrett & McComish 2009; Lawson 2000). Here no emphasis on architecture or permanent settlement was found, but the mass of animal bones, evidence of craft production and of the human dead has some parallels across the channel in the so-called *Fürstensitze*. Much has and should be said about this period of change and creativity, but the one point to raise here is that it was intense connections between people that were important through the medium of material culture, both large (architectural forms) and small (portable artefacts).

In the terms used above, networks were worked hard to bring in raw materials and finished things from near and far, through a great range of social connections. Many things were fashioned to be striking, appealing to the senses and moving the emotions. Similar items were found across large areas of Europe, but each more local assemblage had its own special characteristics. Lastly, such a seething mass of material and social action occasionally crystallised out in spectacular events, in which

the most stunning artefacts were used in pieces of social theatre, such as burial or the creation of a new architectural form. As an aside, the volatility of Hallstatt D and La Tène A cultural forms has made it difficult to construct a chronology that works over larger regions. More discussion and disagreement have occurred over dating of sites and assemblages from 650 to 400 BC than any other period of the Iron Age (*e.g.* Garrow *et al.* 2009). Chronological complexity contains an important indication of the nature of life in these centuries, in that various areas had their own sequences, reshaped around important events, in which material forms were crucial. Finally, the nature of life in Hallstatt D and La Tène A is thrown into relief by the succeeding La Tène B period, when, in many areas, people settle into smaller farmsteads with their own territories and often neighbouring flat cemeteries, with many fewer spectacular burials. Large settlements are also absent in most areas. Imports from various external regions are still found, but at much lower levels than before. Celtic Art continues, but in a new cultural context.

Celtic Art, as a series of more-or-less spectacular objects, emerged within a performative cultural setting, helping also to shape it. Before considering Celtic Art more directly, some more general remarks are necessary on what art is and what its social position can be.

The role of art

There have been long debates as to what constitutes art (see Garrow & Gosden 2012, chapter 2) and whether as a concept it is too bound up with western preconceptions of high culture, galleries and patrons to be useful cross-culturally. My main intention here is to argue that objects act to channel, reinforce or refract human actions. It is not what objects mean that counts, but what they do. I have come to define art as things that need skill to make, but also that require skill to appreciate. Art is skilled practice for the makers and those engaging with it. Art is not representation – it is not a mirror that reflects reality back at us by creating images that re-create the world in different media. Rather art helps shape our perception of the world, highlighting certain aspects of the relationships and processes of the world. Art is an active engagement with the world, which brings together the capacities of the human body with objects that shape perceptions and reactions. Art engages perception and action so that compelling art objects are ones with which we enter an active relationship. In this sense, art is a technology that helps us create and understand the world; complexities of form and decoration attract attention not just of sight, but also through touch, heft and even sound.

In such a view, art becomes a technology for producing the world in particular ways, in ways that make certain sorts of sense. Such a statement is misleading if it makes us think that art as technology settles and fixes a view of the world. The most interesting forms of art are those that engage intellectually, raising questions about the constitution of the world, partly through playing with the primary elements of

our experience of the world: the three dimensions of space and that of time. If we accept that our experience of space and time are not hard-wired into us, but culturally and individually variable due to the education of our senses while young, then the world around us is crucial in creating such basic channeling of experience and sense. The artefacts we interact with, the landscapes we live in, and the forms of people, animals and plants we encounter all slowly structure our perceptions of shape, size and duration. The artefactual domain in any culture has its own tropes and rules of production and use, its own preferred range of materials, and a sense of how long objects should last or when they become redundant. Objects which more consciously play with such elements are those we might call art.

We have divided art forms into styles. Gell (1998) has described *style* as 'relations between relations'. The material from which an object is made, its size and broad shape, the use of line to create spaces and shapes, the infilling of those shapes through lines, cells or dots, the use of colour – all these and many more elements form a set of relations together constituting a style. Style teaches us to see and appreciate the world in particular ways, shaping our perceptions. When art works powerfully it imposes its rules upon us, encouraging or forcing us to live through the style to some extent. A further important aspect that Gell brings out is the longevity of style, which to some mysterious degree evolves independently of humans. In discussing the inter-artefactual domain using the example of carved Maori houses from Aetearoa/ New Zealand (drawing on the work of Roger Neich), Gell looks at how one house influences another in its form and carving, so that houses evolve over many human generations in a manner which is not straightforwardly to do with human choice and decisions, but rather through carvers working within a strong tradition. It is almost as though the houses were using human muscles and capabilities to reproduce themselves. Styles are obviously not totally outside human control, but in choosing to work in a style people are following rules transmitted from older human generations, which are given form and effect through the medium of objects.

People do not exist independently of objects, but with and through them. Celtic Art created an important corpus of articles through which to live, variable over space and across time, but with some overall integrity.

What is Celtic Art?

I will argue that Celtic Art was philosophical and performative. It reworked space and time, as well as the links between people, plants and animals in ways that were recognisable from daily life, but also profoundly altered. Celtic Art posed puzzles about the nature of reality, so that people thought into and through the art, which posed as many questions as it presented answers.

The questions asked of Celtic Art have often been inherited from Jacobsthal; they include the origins of the art, the chronology of various styles, the possible meaning of decorations, the organisation of craftwork that created these objects, the connections

between regions (especially with the Mediterranean), and the hierarchical nature of so-called Celtic society. These are all valid and important questions, but it must be said that many are not much closer to being answered than they were in the earlier part of the last century. It is time to complement this set of questions with new enquiries. These might include: setting the objects we call Celtic Art in the fullest context of their connections with human and animal bodies during use, as well as their various contexts of deposition; using evidence from this first enquiry to tell us more about the sensory and emotional impacts of Celtic Art and its broader material connections; exploring further the eastern connections of Celtic Art, particularly those with the so-called Scythian world; looking more at the variability in the intensity of use of Celtic Art and the types of objects in use across Europe, taking into account the effects of the existence of different contexts of deposition, mainly where graves are found and where not.

I am not inclined to search for the meanings of Celtic Art, partly because ambiguity is crucial to many decorations, making the question 'what is it?' one of the least productive we can ask. Celtic Art did not aspire to realism, unlike its classical cousin, which started in Greece at much the same time. Its different aspirations did not make Celtic Art bad art, and in fact for many of us, it is fascinating because of the play that is central to so many artefacts. Celtic Art derived out of, and contributed to, the dynamic world of the Iron Age, where relationships were changeable and power unstable, as was the nature of the world more broadly. Laurent Olivier (Chapter 6, this volume) has been an inspiration in exploring the play with dimensions and intellectual reality of Celtic Art motifs, which are different to Classical art's realism.

The Waldalgesheim assemblage

To give us a glimpse of the complexity of the assemblages and actions of Celtic Art, let us look at one of the most famous assemblages, found near the present-day village of Waldalgesheim. Waldalgesheim is both an assemblage, in the form of grave goods, but also gave its name, through the work of Jacobsthal (1944) to a phase of Celtic Art. Celtic Art is famously said to have no genesis, but this is starting to change through new finds at the Heuneburg (Krausse, Chapter 9, this volume), although the full range of art came together very quickly, perhaps because some aspects of it existed in media (clothing, the human skin) which are rarely preserved archaeologically. It is also hard to see how the shift from Jacobsthal's Early Style to the Waldgesheim Style happened, although possible evidence of early changes is present in both eastern France and Italy. Duncan Garrow and I put forward the idea for Britain that although styles were to some degree successive (the Early Style was followed by Waldalgesheim and then the Plastic Style), older motifs and modes of decoration did not simply die out but accumulated over time, so that later objects could have a combination of styles and motifs (Garrow & Gosden 2012). We were also keen to situate the metallic aspects of Celtic Art in Britain within the broader use of metals, so that it seems that at the

end of the Bronze Age around 800 BC the production and use of metalwork of all kinds declined, only picking up again around 400 BC. Iron does not replace bronze, but the early use of iron tracked that of bronze, so that when iron started to become common, bronze also made a comeback (as did gold and silver). Celtic Art in Britain emerges at a time when metalwork becomes more important overall, so that bronze, iron, gold and silver were all newly valued, a value which made them ideal media for complex decorations.

A brief look at the difficult burial of Waldalgesheim will hint at how newer questions might be explored (these will be developed further in a book now in preparation on Celtic Art by the ECAIC team). The fragmentary evidence of the burial at Waldalgesheim creates a provocative set of evidence and material iconic of one of the most striking aspects of Celtic Art.

The Waldalgesheim grave was discovered by a farm worker, Peter Heckert, in October 1869 near the village of Waldalgesheim, in the Landkreis of Mainz-Bingen in the middle Rhine valley. Investigations and recoveries of material took place over the next two years in ways that are now hard to reconstruct in detail. Over the years, the Waldalgesheim material has become one of the most discussed sets of material included in the corpus of Celtic Art, not least because Jacobsthal used elements of the material to define his Waldalgesheim Style, dating to La Tène B and fitting between the Early and Plastic Styles. Studies of the Waldalgesheim Style, like those of Celtic Art more generally, have focused on origins of the style, its chronology, the nature and meaning of the style, the organisation of craft production that created it, and how far it provides evidence of contacts between regions, especially with the Mediterranean. At the heart of new enquiries would be an attempt to embed our analyses within the broader sets of material relations set up between Celtic Art and other aspects of the world in both life and death, exploring in the process more of the connections between people, plants, animals and skilled artefactual production. Looking at how Celtic Art linked to the sensory and emotional aspects of peoples' lives, eastern connections, as well as connections across Europe would add extra dimensions, as well as puzzles.

Various assumptions have been made on the basis of the fragmentary nature of the evidence from Waldalgesheim (the fullest single account of Waldalgesheim is Joachim 1995, from which my thoughts here have stemmed). It has been thought that the burial was under a barrow, which is reasonable, but without any clear evidence. Such a barrow would be one of the latest in the middle Rhine, constructed at a time when most burials were simple and without mounds. We do know that the grave pit was surrounded by rough stones at the top and that there was a layer of stones part way down the grave fill, above which were found the gold items, with the bronze ones below. Broadly speaking, three sets of material were found (see Figs 1.1 & 1.2 for a selection of material from Waldalgesheim): an extensive set in bronze and iron deriving from a chariot and horse gear, including a yoke and its fittings and decorations, rein rings, wheel rims and fasteners (the latter sets in iron have been lost); secondly, a set of personal forms of decoration including a neckring, arm, bracelet

GRABHÜGELFUND bei WALDALGESHEIM

Band III. Heft I. Taf. 1.

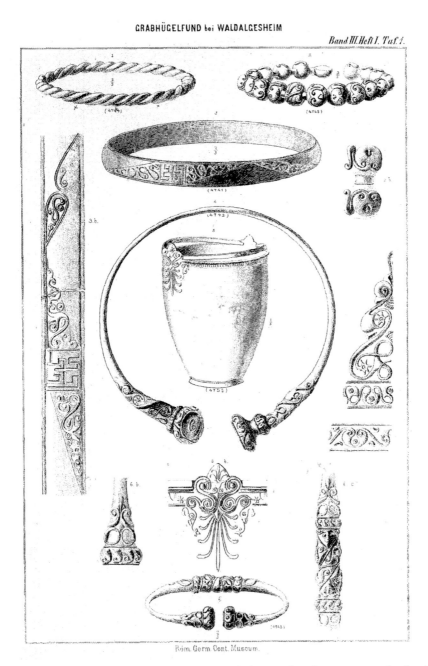

Röm. Germ. Cent. Museum.

Fig. 1.1. Some of the material from Waldalgesheim, including neck and arm rings and a detail of the decoration below the bucket handle (after Lindenschmit 1881, taf. 1. Reproduced from Joachim 1995, 12, abb. 4).

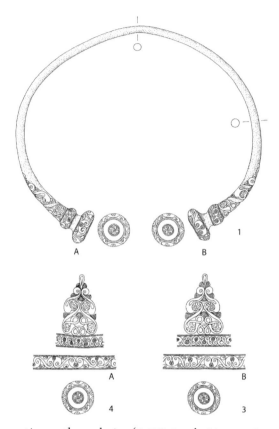

Fig. 1.2. Detail of the decoration on the neck ring (© LVR-LandesMuseum Bonn, Sigrun Wischhusen. Reproduced from Joachim 1995, 61, abb. 37).

and leg rings, beads and the metal decorations of clothing (fascinating and hard to reconstruct); thirdly, a flagon and a bucket presumably used originally to hold liquids (wine?), maybe linked to a ceramic pot (a full set of finds is given in Joachim 1995, 241–42, Tabelle 1). Two assumptions have been made – that these were the personal possessions of the deceased and that the absence of weapons makes this a female grave. No bones are reported in the grave, probably due to their destruction by the soil. Further deductions have followed. The gap in time between the beautifully decorated spouted flagon, probably dating to late La Tène A and belonging to the Early Style, and that of the bronze situla, dating to the boundary between La Tène B1 and B2, may be 60 years. This has led to the slightly surprising conclusion that the deceased woman was around 60 years old when buried (Joachim 1995, 211).

We would love to know more about the nature of the grave, but the layer of stones between the upper and lower finds does indicate some division, and not the sort we might expect if the connection of the finds to the deceased was being emphasised. Also, the spouted flagon was filled with 'Aschenerde', some sort of ashy earth, possibly

indicating a cremation, demonstrating that it had had a complex history, a thought reinforced by the wear on the outside of it, presumably due to long handling. In its final use, the spouted flagon was not used as a wine container. It is not clear whether the chariot was buried whole; its apparently partial state might have been due to poor recovery, or it could be that a part represented the whole in the original burial. We do not know whether any bones of the horses used to draw the chariot went into the grave, nor is it clear what was the layout of all the items in the grave. If this was a woman and these were her objects, she presumably drove a chariot, which would have a martial or at least performative aspect, even in the absence of personal weapons. Certainly other graves where neck, arm and leg rings are found have contained female bodies, but whether this was always a straightforward association, and whether the absence of weapons (if the chariot does not count as one) always makes a person female, we must be wary. Had one person worn all the ornaments in the grave, this would have amounted to considerable weight on arms, legs and body. This leaves out the dress ornaments in metal, which depending on their full number, would have constituted a lot to carry and a form of dress not encouraging of easy bodily movement.

We could imagine alternative scenarios for the Waldalgesheim grave in which the complex process of digging a grave pit, possibly lining it with wood, surrounding it with stones, and then putting a mound over the top would have involved the coordinated labour of many. As well as the complexity of construction, people may have come and gone with objects of various types, some contemporary and others older, perhaps with the burnt body of another person, animal or object in the spouted flagon. The origins of objects linked to a number of areas, in Italy for snail shells and the bronze bucket and perhaps the Champagne region for the spouted flagon; there was also much locally made material, employing a great range of crafts (the lignite ring needs mentioning here) including textiles. If these were the personal belongings of the deceased, a strict selection had been made – there is little of the everyday in this grave, as far as we know. The grave might be seen as the working through of relations and connections at a moment of personal drama for the kin group, rather than an attempt to represent the whole life of a person – male or female. The use of an old-fashioned mode of burial, if this was a barrow, suggests links to a past that was then fading.

The most discussed aspect of the Waldalgesheim assemblage is the decoration. I am not going to add much here, except to stress that as well as the famous wave-tendrils and whorls (the German *wirbeln* is much more evocative of the shape), there was the older more geometrical decoration of the flagon, as well as depictions of human forms (on the presumed yoke mounts), and some more elusive faces within the tendrils of the gold rings. The Waldalgesheim decoration is complex and multiple, only partly structured around the material that gave the name to the broader style. Much of the ornament on Celtic Art, and here the so-called Waldalgesheim Style, is exemplary, complex, ambiguous and entrancing. The wave-tendrils, which define the Waldalgesheim Style, are found on the bronze plaques and the gold rings. These

are complex items, made of several parts each and are decorated through hammer-ing, stamping, notching, engraving and polishing (Joachim 1995, 64). Sometimes the resulting motifs look a bit like faces, at other times the wave-tendrils resemble trailing vines with leaves – the latter is especially true on the bracelets, echoed also in belt and ornamental plaques. The overall impression is one of ambiguity and movement. Such ornaments are here connected with the human body, although an exception are the reconstructed wavy lines found on the end of the yoke. Overall, the closer one is to a human person, the more common the ambiguous ornament of the Waldalsgesheim Style becomes.

The wave-tendrils and whirls are only part of a very complex story of ornament on the Waldalgesheim assemblage. The spouted flagon, of probably earlier date, has an incredible variety of leaf-shaped (based on lotus leaves?) ornaments combined around circles all drawn with compasses, showing mathematical understanding and technical skill. These vary across the surface of the vessel, rotated through different angles, looking similar, but subtly different to other registers of ornament. Even on this object, these are combined with the figure of a horse with a rather human-looking eye, a handle with a ram at one end, and a hirsute human face at the other. Here we have a combination of ambiguous and complex ornament with more figural motifs. It is the interaction of all these styles that is important to peoples' senses and emotions, rather than the stress on just one. If the Waldalgesheim material is linked to other assemblages, as has been the case in many publications, even more dimensions, links and effects can be seen. Future analysis might show whether there is an emphasis on ambiguous ornament on items such as neck, arm and leg rings.

Final thoughts

The 1st millennium BC in central and northern Europe is unlike any other thousand-year period before or after it, so it is difficult to understand through lack of analogies. Compared to earlier periods, populations were relatively high, and a mosaic of pastoral and arable systems had been established across large areas. Such a set-up of subsistence and social arrangements was not stable, however. There were times when groups were intensely attached to their landscapes, never more so than when engaged in large-scale group projects such as laying out land divisions, building and maintaining hillforts, or constructing funerary landscapes. At other times, people became unmoored from their local area, moving *en masse* by migration or forming novel clustered arrangements in the new and relatively brief towns of the Early Iron Age. We do not properly understand either the attachment to land or why landscapes were abandoned and people moved. Compared with later periods, such as that of the Roman period or the early middle ages, it is quite possible that positions of power and status were not fixed and named. This is not to say that Iron Age societies were egalitarian, but rather that power was attained rather than inherited, making it unstable. Individual charisma and the performances of women and men would have

been part of the picture, whether through war, philosophy or construction projects. It was only a group that allowed the charisma of the individual to flourish, and Iron Age groups had sets of dynamics of alternating stability and motility, extreme openness at times and boundedness at others. In understanding the nature of the group lies the nub of the problem in understanding Iron Age societies.

The study of Celtic Art is potentially helpful in pursuing this understanding. Aspects of Celtic material culture were of crucial importance in the performances of Iron Age life, which lay at the root of power and status. Iron Age artefacts, including especially the pieces we now call art, were often constructed to be striking to the senses and emotions. Much has been lost, so that clothing, hair styles and tattoos are little represented in the archaeological record. But the aspects of self-presentation of the woman at Waldalgesheim (if indeed it was a woman) in death give us some sense of the drama of aspects of life. Even in its fragmentary state, the Waldalgesheim assemblage has many dimensions. The breeding of horses and the skill of making and riding chariots, the drinking of wine (if indeed the bronze containers were used for wine), the range of personal ornament, but then also the construction of a burial chamber and mound, which might have been archaic at the time they were built, all indicate complex theatres of life of which we now glimpse only a part.

Some individual objects had long and complicated life histories, which may or may not have been linked to the life of the human individual buried. Other objects may have been made to be buried. The event of the burial involved a range of people and materials. These included not just the metalwork, usually the focus of attention, but also the layer of stones dividing some artefacts from others, as well as extra elements of the burial now lost to us. Much of our evidence for Celtic Art comes from a series of events of this type, which constitute assemblages of materials, although we must be aware that materials assembled after death may not have been objects owned by the deceased during their life.

Artefacts are assembled through networks. In the Waldalgesheim case, some of these connections were local, but still complex, requiring a combination of craftspeople, with various types of metalworkers and those skilled in wood, leather, lignite, textiles, pottery and tomb construction, amongst other things. The situla and shells may come from Italy, the spouted flagon possibly from France, and the gold maybe from coins of unknown provenance. Skilled analysis in the present allows us to work from events to networks, through assemblages of various kinds. Multiple forms of decoration were found in this assemblage, and we should not be beguiled only by the wave-tendrils of the Waldalgesheim Style. A broader focus on materials allows us to set the fine-grained analysis of motifs and their combinations, long the foundation for an analysis of Celtic Art, in wider archaeological and cultural contexts.

In all, this is an exciting time in the study of Celtic Art, with large amounts of well-excavated and well-contexted material from across Europe. The sets of material relations are large and compelling, especially if we look more broadly at the materiality of the burials and the bodies. In the pages that follow, we will see some of the latest

thought on Celtic Art, and we hope in our own project to pursue in more detail some of the avenues hinted at here.

References

Barrett, J. & McOmish, D. 2009. The Early Iron Age in southern Britain: Recent work at All Cannings Cross, Stanton St Bernard and East Chisenbury, Wiltshire. In M.-J. Roulière-Lambert (ed.), *De l'âge du Bronze a l'âge du Fer en France et en Europe occidentale XeViie siècle avant J.C. La Moyenne vallée du Rhône aux âges du Fer*, 565–72. Revue Archéologique de l'Est Supplément 27. Saint-Romain-en-Gal, Musée Gallo-Romain.

Fernández-Götz, M. & Krausse, D. 2016. Urbanization processes and cultural change in the early Iron Age of central Europe. In M. Fernández-Götz & D. Krausse (eds), *Eurasia at the Dawn of History: Urbanization and social change*, 319–35. Cambridge, Cambridge University Press.

Fitzpatrick, A. with Powell, A.B. & Allen, M.J. 2008. *Archaeological Excavations on the Route of the A27 Westhampnett Bypass, West Sussex, 1992. Volume 1: The Late Upper Palaeolithic - Saxon.* Salisbury, Wessex Archaeology Report 21.

Garrow, D. & Gosden, C. 2012. *Technologies of Enchantment? Exploring Celtic Art: 400 BC to AD 100.* Oxford, Oxford University Press.

Garrow, D., Gosden, C., Hill, J.D. & Bronk Ramsey, C. 2009. Dating Celtic art: A major radiocarbon dating programme of Iron Age and Early Roman metalwork in Britain. *Archaeological Journal* 166, 79–123.

Gell, A. 1998. *Art and Agency: An anthropological theory.* Oxford, Oxford University Press.

Gosden, C., Hommel, P. & Nimura, C. 2016. European Celtic art and its eastern connections. *Antiquity Project Gallery* 90(349), https://www.antiquity.ac.uk/projgall/gosden349.

Gosden, C., Hommel, P. & Nimura, C. 2018. Making Mounds: Monuments in Eurasian prehistory. In T. Romanciewicz, M. Fernández-Götz, G. Lock & O. Büchsenschütz (eds), *Enclosing Space, Opening New Ground*, 141–52. Oxford, Oxbow Books.

Gosden, C. & Malafouris, L. 2015. Process archaeology (P-Arch). *World Archaeology* 47, 701–17.

Guggisberg, M. 2018. Art on the northern edge of the Mediterranean world. In C. Haselgrove, K. Rebay-Salisbury & P.S. Wells (eds), *The Oxford Handbook of the European Iron Age*. Oxford, Oxford University Press. DOI: 10.1093/oxfordhb/9780199696826.013.19.

Jacobsthal, P. 1944. *Early Celtic Art.* 2 vols. Oxford, Clarendon Press.

Joachim, H-E. 1995. *Waldalgesheim. Das Grab einer keltischen Fürstin.* Köln, Rheinisches Landesmuseum Bonn, Rheinland-Verlag GmbH.

Lawson, A.J. 2000. *Potterne 1982-5: Animal husbandry in later prehistoric Wiltshire.* Salisbury, Wessex Archaeological Report 17.

Lindenschmit, L. 1881. Grabfund bei Waldalgesheim. In L. Lindenschmit, *Die Alterthümer unserer heidnischen Vorzeit III, Tafel 1.* Mainz, von Zabern.

Malafouris, L. 2013. *How Things Shape the Mind.* Boston, MA, MIT Press.

Wells, P.S. 2012. *How Ancient Europeans Saw the World: Vision, patterns, and the shaping of the mind in prehistoric times.* Princeton, NJ, Princeton University Press.

Chapter 2

Collecting Iron Age art

Courtney Nimura, Peter Hommel, Helen Chittock
and Chris Gosden

Abstract

This paper introduces the process of creating the database of objects for the European Celtic Art in Context project. It gives the details of the data included, highlighting their benefits and weaknesses. Through a series of distribution maps and tables, we provide an introduction to some of the general patterns seen in the data and suggest directions for future research.

Creating a database of Celtic Art

The European Celtic Art in Context (ECAIC) project had a general aim of considering the different forms and ornamentation of Celtic Art within a wider archaeological context across Europe and further east into Eurasia. As we explained in the Introduction of this volume, the origins of Celtic Art have generally been associated with the Mediterranean world, yet alternative observations about the eastern influence on the origins of Celtic Art have also been theorised (see list of research in Pare 2012, 153–54). Although our primary focus was on Europe (in its broadest geographical sense), this project also considered what non-Mediterranean influences might have been exerted as part of widespread east–west connections, ultimately linking Europe with the Eurasian steppe and Central Asia.

As a first step to understanding these connections, we set out to build a database of ornamented or ornamental objects from across Europe. It aimed to combine information on the form and decoration of objects on the one hand, with information about their archaeological context on the other, and eventually grew to include 38,383 objects from 47 countries.

Origins and issues

The ECAIC database grew mainly out of two previous databases on Celtic Art, the Technologies of Enchantment project database (2005–2008; see Garrow 2008; Garrow

& Gosden 2012), and a database of objects collected by Vincent Megaw (forthcoming) as part of his book *Early Celtic Art: A supplement*. Because of their different origins, and the subsequent datasets that were incorporated, the ECAIC database is decidedly uneven. This unevenness of geographical, chronological and typological representation points to a number of greater issues that arise not only from the study of Celtic Art, but also in any attempt to quantify the qualitative.

The first issue one faces when creating such a database is what should be considered Celtic Art, and therefore included or excluded from such a database. The definition of Celtic Art (what is Celtic? what is art?) has been amply debated, and we will not replicate that debate here (see Garrow & Gosden 2012, chapter 1). But how then can one create a database of something undefined? Garrow (2008, 17–18) summarised the issue encountered when creating the Technologies of Enchantment database and came to a single important conclusion: that the database should err on the side of inclusivity rather than exclusivity. Therefore, anything that had ever been classified as 'Celtic Art' previously would be included in their dataset. This explains the presence of a number of objects that are undecorated and plain, but are of an object class that is typically considered Celtic Art. We have taken a similar approach, as a continuation of the Technologies of Enchantment project, which is explained below.

The second issue is when the tradition of Celtic Art 'begins' and 'ends'. Numerous theoretical debates have occurred about the dating of these objects, and although we are sensitive to these discussions, we have used fairly conservative date parameters. Again, this is largely because of the existing date parameters included in the foundational and subsequent datasets that comprise the ECAIC database.

The third issue is how you can categorise a style of art that seems to confound categories. Celtic Art by definition is entangled, swirly, and not easily broken up into discreet and definable motifs – the apparent intention of this decoration is to defy exactly this type of categorisation. Although some have attempted to do so (*e.g.* Fox 1958; Jacobsthal 1944), this was not our aim. Instead, we wanted to think about the overall impression that an object gives. Without wanting to be overly constrained by the established styles of Celtic Art (see Joy 2015; Chapter 7, this volume, Fig. 7.2), or be hindered by trying to break up designs into composite pieces, we devised a set of broad descriptive terms with which we could 'tag' each object (*e.g.* 'geometric', mirror symmetry, rotational symmetry, narrative). Although entirely subjective, this allowed our database to be more flexible about how we stored information on the ornamentation of these objects.

Certain steps were taken to mitigate these issues. We have been inclusive as opposed to exclusive, widening our parameters to encompass an array of objects. The earliest adorned metalwork that formed the basis of the Celtic Art corpus are the La Tène style objects dated to *c.* 475 BC found on the continent (*e.g.* Megaw & Megaw 1989; but see Krausse, Chapter 9, this volume), and the latest are found in Britain even after the primary Roman occupation (*e.g.* Hunter 2008). We therefore chose to include objects that fall within the period 500 BC to the 1st century AD

(these include objects whose beginning/end dates fall within this period, *e.g.* from 550–450 BC). The geographical parameters were equally wide, with the primary list including: the Republic of Ireland, Northern Ireland, Scotland, Wales, England, France, Belgium, Luxembourg, Netherlands, Germany, Switzerland, Italy (northern), Austria and the Czech Republic. Other countries are represented in the database, including Spain and Portugal to the west and the Balkan States to the east, but the data from these regions was decidedly patchier. Based on previous databases, catalogues and definitions of Celtic Art, we also included any metal or stone object that has a decorative form (where the ornamentation is integral to the form of the object, such as torcs, bracelets etc., but which may not have surface ornamentation); and any object that has surface ornamentation. Although we would have preferred to include glass, ceramic, bone and other materials, these would have made our (already very large) dataset untenable. We did, however, include all object types that are worn on the body (including weaponry and tools), on animals (*e.g.* horses) or are parts of chariots. These include, for example: brooches, pins, anklets, bracelets, arm rings, torcs, pendants, plaques, toggles and horse gear. Just as with the Technologies of Enchantment database, not all of these objects are ornamented, but they have still been included. Miscellaneous fixtures and fittings that may have been attachments for weaponry, personal ornament or chariots are also included.

As this database is a collection of datasets pieced together from a number of sources, each object record in the ECAIC database has a provenance that states from where the data were originally derived. We explore these further in the following section.

The data

As described, the ECAIC database was first built from two disparate databases; because of this, it inherited some idiosyncrasies. The Technologies of Enchantment database (Garrow & Gosden 2010) includes Iron Age/Romano-British Celtic Art, from *c.* 400 BC–AD 100. The database brought together in digital form basic information on 2582 objects from five main corpora (Jope 2000; MacGregor 1976; Palk 1984; 1992; Spratling 1972; Stead 2006) and the Portable Antiquities Scheme (a digital database of finds from England; PAS nd). It included only metalwork from England, Scotland and Wales, and did not include certain object types, such as brooches, pins or coins (this database is fully explained in Garrow 2008). The second database, Vincent Megaw's Early Celtic Art Supplement (ECAS), includes objects from across Europe, though not comprehensively, from around the 6th/7th century BC–1st century AD. This dataset highlights the more 'special' Celtic Art objects, mainly derived from Jacobsthal's (1944) catalogue and updated to reflect the objects found since the publication of that magnum opus. As with most catalogues of Celtic Art, it also excludes coins, but does include a wider variety of materials, including glass and ceramic.

After the ECAIC database was created on the basis of these two datasets, data were collected from other museums and select publications and some objects were removed from the database based on our own parameters. As explained above, we decided that the database would house only metal and stone objects. Overall, the ECAIC database includes object records from 11 different datasets, obtained by the project from various sources, but broadly categorised as: (1) records obtained directly from museums, (2) records from other databases and (3) records from museums included in obtained databases. Object records generously given directly from museums (1) included the following institutions: British Museum (6829 objects), Musée d'Archéologie nationale, St-Germain-en-Laye/National Archaeological Museum, France (11,172 objects), Bergmuseum Salzburg/Salzburg Museum (3 objects), Armagh County Museum (32 objects), Rijksmuseum van Oudheden/National Museum of Antiquities, the Netherlands (143 objects), Pánstwowe Muzeum Archeologiczne, Warsaw/State Archaeological Museum, Poland (24 objects) and Neues Museum Biel/Nouveau Musée Bienne (775 objects). Although many of these were national museums, their datasets included objects from outside their own countries. Despite this, we were unable to obtain a broad enough geographical spread by obtaining records only from museums. We were lucky, therefore, to have access to other existing Celtic Art/artefact datasets (category 2). These included the two described above: the *Technologies of Enchantment* database and ECAS database (2086 objects), as well as: the *Portable Antiquities Scheme* (PAS) database: a database created through a government-led scheme in England and Wales, that encourages metal detectorists to record and report their finds, which are logged in the database (6302 objects); and *Artefacts: Collaborative online encyclopaedia of small finds*: a database of small finds from a wide range of sources to which many researchers have contributed, which aims to provide a high-level 'wiki' based platform for archaeological finds across Europe (9535 objects; Artefacts 2008–19).

As we pointed out at the start of this chapter, collating a wide variety of datasets means inheriting some of their idiosyncrasies and making space for difference. These datasets were created for different reasons, are of varying quality, quantity and level of detail, and were created in different languages. However, there is also significant crossover between them (which we attempted to cull by searching for museum numbers or other unique identifiers included in both datasets). This is particularly true of the Artefacts database, which draws on a wide range of sources, including the PAS and individual researcher and museum contributions. Similarly, the Technologies of Enchantment database contains objects from the PAS database, as well as objects from the British Museum. The Early Celtic Art Supplement draws on many European museums, but most of them are not museums from which our project directly received data. Despite the data collection difficulties, a vast array of information is contained in the fields included in the ECAIC database, which we look at in more detail below.

The objects

Each record in the ECAIC database equates to an object or a group of objects when applicable, such as the beads of a necklace. A number of data fields were defined, which will not be discussed in detail, but are given in Table 2.1. In short, each object may contain the following information: type of object, date, the place it was found, the materials of which it is made, dimensions, condition, visual characteristics, images, archaeological context, recovery method, a list of references in which it was published, a home institution (or database provenance) and the archaeological site on which it was found (if any). So, what can the ECAIC database tell us? We can begin by looking at some basic information, such as the frequency and spatial distribution of objects of different types and then at objects from particular contexts and datasets.

The what and where of Celtic Art

One of the key benefits of bringing together these datasets into one database is the ability to look at a wider picture of, for example, the distribution of the material, their collective dates, or the contexts in which they were found. Figure 2.1 shows the spatial distribution of the findspots of all objects in the ECAIC database across Europe (where findspots are known). In total, 47 countries are represented in the database (Fig. 2.2). The main biases are towards certain parts of Europe, namely England and France, resulting from the data the project was able to obtain (as described above). The concentration of objects in south-eastern Britain, for example, is partly a result of the success of the Portable Antiquities Scheme in England and Wales, but may also reflect particular depositional practices during the Iron Age, or differences in the types of objects in circulation in different areas. This map also shows a picture of Celtic Art over an extended period of time, from the Middle Iron Age to Early Roman period (*c.* 600 BC–AD 100), which can also be pared down to specific time periods where dating resolution allows.

Each dataset within the ECAIC database used a different set of object categories, which we subsequently placed into one of the following broad categories: Animal Equipment, Armour & Weaponry, Container, Dress Component, Musical Instrument, Other, Personal Accessory, Personal Ornament, Sculpture, Tools & Equipment, Vehicle Component, Vehicle Component/Animal Equipment.

Figure 2.3 shows the frequency of each of the 12 object categories in the database. Personal Ornament is, by far, the largest category, containing 45.34% of the total and encompassing object types such as torcs, brooches and pins. Of the objects in this category, 44.64% are brooches or brooch components. The commonness of personal ornament, particularly brooches, within the ECAIC database suggests that these types of objects were frequent in Iron Age Europe, but may also say something about the ways these objects were deposited and recovered archaeologically.

The Personal Accessory and Dress Component object categories, like Personal Ornament, are also related to personal appearance (see Chittock, Chapter 5, this

Table 2.1. ECAIC database fields.

Object data	
ECAIC UID	Object UID
Object	Smallest category of object type
Object subcategory	Middle category of object type
Object category	Broadest category of object type
Object description	Description
Dimensions	Dimensions of the object
Condition	Condition of the object
Visual characteristics	Series of checkboxes for the visual characteristics of an object
Number of objects	If the object is in more than one piece (fragments) or if it was originally recorded as a group of objects
Site ID	A UID related to the *Site* table
Context	Broadest level of context
Context details	More specific level of context
Context comments	Free text description of context
Recovery method	Method of recovery, *e.g.* metal detector, excavation etc.
Sex, Age, Burial info	More specific details of burial
Probable import	Yes/No and sometimes production place, if known
Place found	
Name	The name of the place found, town, country etc.
Admin area	The type of administrative area, *e.g.* City, Country, County etc.
Place found	Description
Site	
Site name	The name of the site, which may differ from the place it is found
Site type	Categorised using a list of types determined by the ECAIC team
Site	Description
X, Y	Lat/Long
Location provenance	The source of the x/y coordinates
Date	
Start / End date	Numerical start / end date
Type	Type of date: either Context, Estimated, Period (where a chronological division was given but no numerical dates) or Typology
Chronological division	An archaeological 'period' *e.g.* La Tène A
C^{14}	C^{14} BP date, C^{14} standard deviation, Lab code for the radiocarbon date, Material dated, delta C13 value
Dating notes	Any notes for information not captured by the other fields
Date reference	Reference where date was found

(Continued)

Table 2.1. (Continued)

Data/accession information	
Institution	Name of the institution where object is currently held
Collection	The name of the collection within a museum, *e.g.* The Morel Collection within the British Museum
Number	Accession number or related database number where known
Link	A web link to a collection or object, usually on a museum's website, or a web link to an object in another database, *e.g.* PAS website
Date	Name and date data were entered and modified

References	
Reference	Short version of references, including page numbers. Full versions of references are held in separate table *Bibliography*

Materials and production techniques	
Category	Material, Production technique, Surface treatment, Ornamentation technique
Type	The type of the category: *e.g.* Cu alloy for Material, chasing for Surface treatment etc.
Colour	Colour of the material entered
Location on object	Location on object of the material, treatment or technique

Imagery	
Imagery	Specific type of human or animal, where known, and how many present, if countable
Location on object	Where the specific motif is found on the object

volume). Objects related to grooming, such as combs and mirrors are contained within the Personal Accessory category, and the Dress Component category contains components of clothing and accessories, such as belt buckles and footwear components. These two categories make up far smaller proportions of the objects in the database than Personal Ornament: just 1.78% and 2.82% respectively. The Other category, which contains miscellaneous tools, fittings and ornaments makes up a fairly large proportion of the database (19.28%), as does Armour and Weaponry (11.60%). The remaining categories (Animal Equipment, Container, Musical Instrument, Sculpture, Tools & Equipment, Vehicle Component, Vehicle Component/Animal Equipment) each constitute less than 10% of the database.

Mapping particular categories of objects shows that not all object types reflect the overall spatial distribution seen in Figure 2.1. For example, torcs are clustered in parts of eastern and southern Britain and in the area to the north-west of the Alps (Fig. 2.4), with a sparser distribution centring on modern Hungary. Brooches, conversely, are concentrated in England and along parts of the Mediterranean and Adriatic coastlines, in clusters across the Alps, and more sparsely scattered across

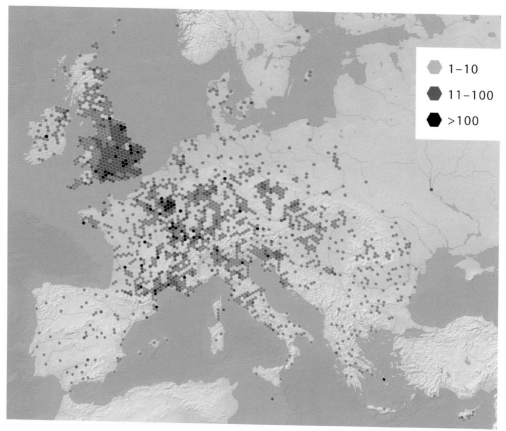

Fig. 2.1. The distribution of all object findspots in the ECAIC database.

central Europe and Spain (Fig. 2.5). Again, these trends can be attributed to a complex combination of Iron Age activity, archaeological activity and the construction of the ECAIC database. We can also look at these patterns in their archaeological contexts.

The context of Celtic Art

Celtic Art objects are commonly found in graves, hoards, wet places and settlement contexts, to name a few. The range of sites and contexts from which the objects in the ECAIC database have been recovered is wide and complex. Sites can be divided fairly simply into categories such as Funerary and Settlement, for example, but the diversity within these types is great, and the ranges of context types within each site can be wide. This is an issue that is compounded when multiple countries are represented in one database – naming traditions are national and archaeological phenomena are varied.

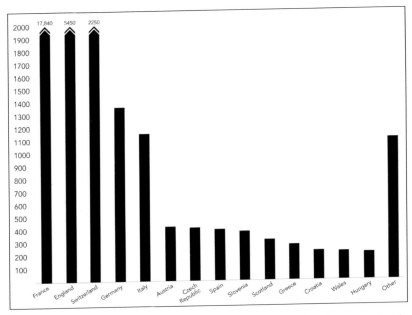

Fig. 2.2. *Quantities of objects from the 47 countries represented in the ECAIC database.*

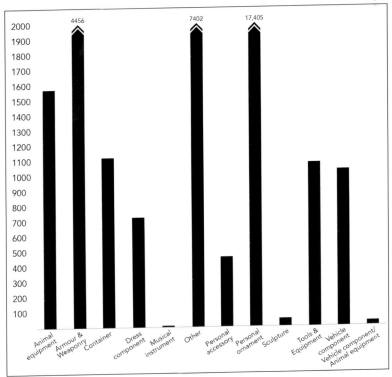

Fig. 2.3. *The overall frequencies of different object categories in the ECAIC database.*

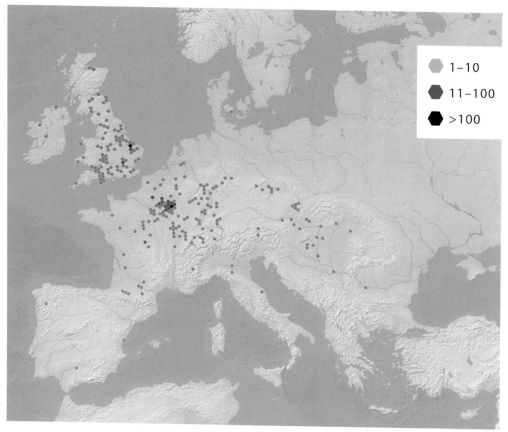

Fig. 2.4. The distribution of torc findspots from the ECAIC database.

We can look at the example of 'Funerary' sites (sites with, for example, grave, burial, inhumation etc. in their description), which make up 21.7% of the objects in the ECAIC database (Fig. 2.6). The contexts within these sites include those from within many types of graves: flat graves, graves under mounds, cremation burials, chariot burials, single burials, graves as part of cemeteries and mass burials. They also include objects from probable or possible burials: contexts that 'look like' burials, but where no human remains survive, and those that have been disturbed, but contain burial-like assemblages. Many of the objects from funerary sites within the ECAIC database are classified simply as coming from burial contexts, but others are classified more specifically. For example, around 8.64% of the objects from funerary sites are classified as coming from tumuli, barrows or mounds, whilst 17.71% come from wagon, cart or chariot burials.

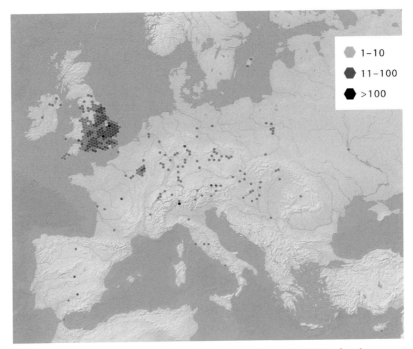

Fig. 2.5. The distribution of brooch findspots from the ECAIC database.

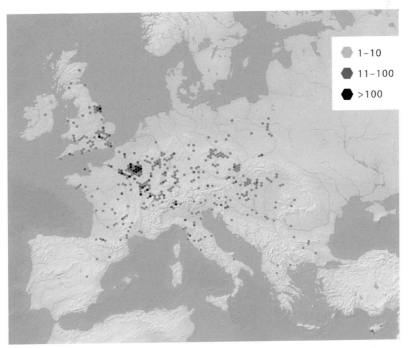

Fig. 2.6. The distribution of objects from funerary sites in the ECAIC database.

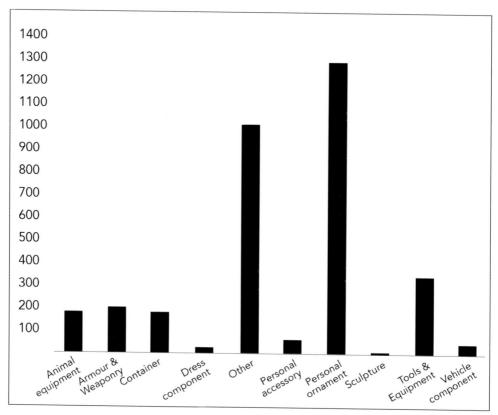

Fig. 2.7. Frequencies of different objects from settlement sites in the ECAIC database.

The densest concentration is in north-east France, with smaller clusters in eastern France and across the north of the Alps, stretching into central Europe. Despite the overall concentration of objects from the ECAIC database in England, the density of objects from funerary sites here is comparatively low, with small clusters in East Yorkshire and south-east England, reflecting a dearth of contexts traditionally defined as 'funerary' in Iron Age Britain.

We can also look more specifically at the relationship of object types and contexts, for example, from settlement sites. In the ECAIC database, a number of contexts were included in the site type Settlement. These included not only pits, post holes and ditches, for example, but also graves and hoards in some cases. They were determined based on: previous categorisations (such as in the Technologies of Enchantment database), by information included in the object descriptions or by the nature of the context (a villa context was automatically included in the Settlement site type, but not hillfort). Interrogating the database shows that 8.69% of objects come from Settlement site types. Breaking down the category of settlement sites, of the 3336 objects classified as coming from settlement sites, 58.63% are categorised as coming

from oppidum contexts; and the remainder are from settlement features or structures, such as ditches, houses, pits and floors. Other contexts from settlements that appear in very small numbers are villa features and Late Iron Age/Romano British settlement features.

We can then look at the frequencies of different object categories from settlement sites (Fig. 2.7). Personal Ornament is the most frequent find on these sites, making up 38.60% of the objects in this graph, but other categories are also unusually frequent: Other (30.30%) and Tools & Equipment (10.19%). The frequency of Personal Ornament is expected, given its overall domination of the ECAIC database. Tools & Equipment and miscellaneous objects from the Other category would also be expected to be frequent on settlement sites, seeing as these are sites where the use and storage of tools and equipment occurred most often.

Concluding thoughts

This chapter has introduced the ECAIC database and described some of its strengths and weaknesses, and the opportunities for analysis it affords. We have introduced some very broad stroke trends, such as the dominance of personal ornaments, especially brooches (see Chittock, Chapter 5, this volume), and some basic patterns of deposition. It is clear that there are distinctions between Britain and the continent, which are only partially attributable to discrepancies in the database (see Garrow 2008; Garrow & Gosden 2012). It is also clear that there are major and many influences from varied site taphonomies and biases in the database, but we would argue that genuine Iron Age patterns can be discerned and, most importantly, tested on smaller scales – the ECAIC database provides a springboard for future enquiries.

Acknowledgements

The European Celtic Art in Context project (2015–2018) was funded by the Leverhulme Trust (reference number RPG-2014-384; PI: Chris Gosden; Co-Is: J.D. Hill, British Museum; Ian Leins, English Heritage; Jody Joy, Museum of Archaeology and Anthropology, University of Cambridge). The database would not have existed without the generosity of the following contributors (alphabetically): Luc Amkreutz (Rijksmuseum van Oudheden), Sean Barden (Armagh County Museum), Julia Farley (British Museum), Michel Feugère (Artefacts), Duncan Garrow (University of Reading), Jonas Kissling (Neues Museum Biel), Wilfried K. Kovacsovics (Bergmuseum Salzburg), Katarzyna Kowalska (Pánstwowe Muzeum Archeologiczne, Warsaw), Vincent Megaw (Flinders University), Laurent Olivier (Musée d'Archéologie Nationale, St-Germain-en-Laye), Dan Pett (Fitzwilliam Museum, University of Cambridge) and Alison Roberts (Ashmolean Museum of Art and Archaeology, University of Oxford). Many thanks to Chris Green for producing the maps that accompany this paper. We also thank the two referees for their insightful comments; all errors remain our own.

References

Artefacts. 2008–19. *Artefacts© Online Encyclopedia of Archaeological Small Finds.* Available at: http:// artefacts.mom.fr/en/home.php (Accessed 14 April 2017).

Fox, C. 1958. *Pattern and Purpose: A survey of Early Celtic Art in Britain.* Cardiff, The National Museum of Wales.

Garrow, D. 2008. The space and time of Celtic Art: Interrogating the 'Technologies of Enchantment' database. In D. Garrow, C. Gosden & J.D. Hill (eds), *Rethinking Celtic Art,* 15–39. Oxford, Oxbow Books.

Garrow, D. & Gosden, C. 2010. *Technologies of Enchantment Database.* Available at: https://www. britishmuseum.org/research/research_projects/complete_projects/technologies_of_ enchantment/the_celtic_art_database.aspx (Accessed 6 January 2017).

Garrow, D. & Gosden, C. 2012. *Technologies of Enchantment? Exploring Celtic Art: 400 BC to AD 100.* Oxford, Oxford University Press.

Hunter, F. 2008. Celtic art in Roman Britain. In D. Garrow, C. Gosden & J.D. Hill (eds), *Rethinking Celtic Art,* 129–45. Oxford, Oxbow Books.

Jacobsthal, P. 1944. *Early Celtic Art.* 2 vols. Oxford, Clarendon Press.

Jope, E.M. 2000. *Early Celtic Art in the British Isles.* 2 vols. Oxford, Clarendon Press.

Joy, J. 2015. Stylistic variation in early Celtic art. In J. Farley & F. Hunter (eds), *Celts: Art and identity,* 57–58. London, The British Museum Press.

MacGregor, M. 1976. *Early Celtic Art in North Britain.* Leicester, Leicester University Press.

Megaw, M.R. & Megaw, J.V.S. 1989. *Celtic Art: From its beginning to the Book of Kells.* London, Thames and Hudson.

Megaw, J.V.S. forthcoming. *Early Celtic Art: A supplement.* Oxford, Oxford University Press.

Palk, N. 1984. *Iron Age Bridle Bits from Britain.* Edinburgh, Department of Archaeology.

Palk, N. 1992. Metal Horse Harness of the British and Irish Iron Ages. Unpublished PhD thesis, University of Oxford.

Pare, C. 2012. Eastern relations of early Celtic art. In C. Pare (ed.), *Kunst und Kommunikation. Zentralisierungsprozesse in Gesellschaften des europäischen Barbarikums im 1. Jahrtausend v. Chr.,* 153–78. RGZM-Tagungen 15. Mainz, Verlag des Römisch-Germanischen Zentralmuseums.

PAS. nd. *Portable Antiquities Scheme Database.* Available at: https://finds.org.uk/database (Accessed 5 August 2016).

Spratling, M.G. 1972. Southern British Decorated Bronzes of the Late Pre-Roman Iron Age. Unpublished PhD thesis, University of London.

Stead, I.M. 2006. *British Iron Age Swords and Scabbards.* London, British Museum Press.

Chapter 3

Eurasian Iron Age interactions:
A perspective on the sources and purposes of
La Tène style ('Celtic') art

Peter S. Wells

Abstract

With ongoing fieldwork and new discoveries in Central Asia, together with recent publications of richly outfitted Iron Age graves in east Asia, our perspectives on the origins of the particular features that comprise the La Tène style in temperate Europe are widening. While earlier investigators sought the origins of the La Tène style in the arts of Greece and Etruscan Italy, it is becoming increasingly apparent that the creation and widespread adoption of the new style needs to be understood in the context of Eurasia-wide processes of change around the middle of the final millennium BC. This broader perspective leads us to better understanding of the purposes to which this new style was put, with regard to the kinds of objects that were designed employing the style, and the ways in which those objects were crafted, used, perceived and deposited. Comparisons with changes in other contexts provide useful models to enrich our understanding of the stylistic changes throughout Eurasia during the Iron Age.

The art tradition known as 'Celtic Art' originated in continental Europe around the 5th century BC. Its earliest expressions are known as 'Early La Tène' style, after the lakeshore site in western Switzerland. The style was developed by craftworkers and artists throughout the Late Iron Age (known as the 'La Tène period'), into the Middle Ages, and on into modern times. The style has long served to express the identity of specific groups, from the elites of Late Iron Age Europe to peoples of the western British Isles today (Farley & Hunter 2015; Müller 2009), thus it has retained its social and cultural importance for two and a half millennia.

The sources of the Early La Tène style has been a topic of considerable interest for well over a century (for recent discussions, see Frey 2016; Hunter *et al.* 2015, 30–31; Kruta 2015; Müller 2014). In his then comprehensive work, Paul Jacobsthal traced the origins of the new style to the Mediterranean world, mainly the arts of Greece

and Etruria, while allowing for some influence from the Near East (1944, 160–62 and *passim*). Subsequent researchers have for the most part accepted Jacobsthal's judgment, though scholars have noted features of many Early La Tène objects that suggest the arts of Thrace, Persia and the Scythian world. Christopher Pare (2012, 153–54) provides an instructive list of objects and links with traditions to the east suggested for them by different researchers. Identifying and sorting out these different 'influences' and connections has always been complex and problematic.

New discoveries and new approaches even further afield – in Central Asia and as far east as China, suggest that we need to look at material cultures of societies throughout Eurasia as a whole to get a broader picture of the circumstances in which the new style was created.

The Early La Tène style represents a radical departure from the strictly geometric ornament of the preceding Early Iron Age. The new style is characterised by curvilinear shapes derived from plant forms, including palmettes or 'tear drops', spirals and formlines, and by highly stylised, often hybridised, representations of animals and of humans (Frey 2002a). Initially, the style appeared almost exclusively on finely crafted bronze and gold objects associated with richly outfitted burials. It is striking that similar new elements appeared at about the same time in elite contexts in China (Bunker 1995; von Falkenhausen 2006), a subject about which more will be said below.

This paper focuses on three questions:

1) Where did the elements that comprise the new Early La Tène style come from?
2) For what purposes was the new style adopted at this particular time?
3) How did the elements that comprised the new style get to temperate Europe?

Where did the elements that comprise the Early La Tène style come from?

The broadening of the database

Two major catalysts have contributed to the development of new perspectives on the question. One has been the presentation since the mid-1970s of major international exhibitions of materials attributed to the peoples we know as the 'Scythians', whose material culture is found from central Europe to China, and comparable exhibitions of archaeological materials from China.

A second has been the design and execution of new international fieldwork projects conducted in different parts of Eurasia, and of synthetic studies of materials recovered through these efforts. Much archaeological data from China has been published recently in media readily accessible to western scholars. Researchers have begun to conduct major field research projects in the central regions of Eurasia, in particular focusing on the nomadic groups that linked the peoples across Eurasia (*e.g.* Cugunov *et al.* 2010; Frachetti 2012; Hanks 2010; Honeychurch & Makarewicz 2016).

Imports into Europe from the Scythian regions, the Near East, and beyond (Fig. 3.1)

Since the 1960s, a number of significant discoveries have been made in Europe that suggest connections to the Scythian lands and the Near East during the 6th and 5th centuries BC. The neckring from the Vix burial has generated much discussion about possible Greco-Scythian origins (*e.g.* Megaw & Megaw 1989, 46). Numerous ivory objects from the central grave at Grafenbühl (Herrmann 1970), drinking horns in the Hochdorf (Krausse 1996) and Kleinaspergle (Kimmig 1988) burials, the little bronze situla from an Early La Tène deposit at Straubing in Bavaria (Tappert & Mielke 1998), and the glass bowl in the grave at Ihringen on the upper Rhine (Kistler 2010) are among objects that indicate connections with Near Eastern societies around the time that the Early La Tène style appeared in temperate Europe. These join objects recovered earlier whose full significance may not have been appreciated, such as the bronze bowl from the *Panzergrab* at Stična in Slovenia (Gabrovec 1966, 11, fig. 5.4), a bronze ring from the Glauberg suggestive of Persian connections (Frey 1980), and the little glass bottle from the Römerhügel grave (Paret 1921, 69, fig. 13.5).

In much of eastern Europe the material culture associated with the Scythians is well represented by burial mounds, settlements and hillforts (Rolle 2011, 114, map 4.1), and in the Carpathian Basin Scythian objects are common (Párducz 1973). A striking example of Scythian material is the deposit from Witaszkowa, also known as Vettersfelde (Nebelsick 2006). The most familiar object is the 41 cm long electrum fish plaque in distinctively Scythian style. Associated objects include a sword, a quiver for a bow, a four-part gold phalera ornamented with figures, gold buttons and a neckring and a bracelet.

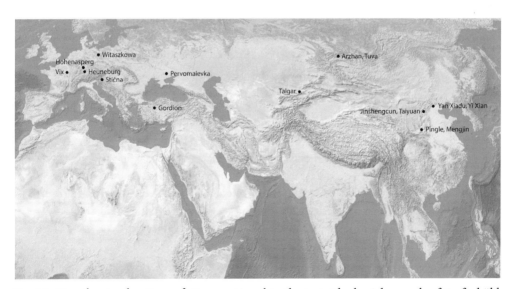

Fig. 3.1. Map showing locations of sites mentioned in the text. The burial mounds of Grafenbühl, Hirschlanden, Hochdorf, Kleinaspergle and Römerhügel are all associated with the hilltop site of Hohenasperg (base map: Ktrinko, Eckert4, Wikimedia).

Common design elements and themes across Eurasia

As I have argued (Wells 2012, 201–209), many of the elements that comprise the Early La Tène style can be identified in other parts of Eurasia, from south-western Asia to China, around the same time that the new style appeared in Europe. S-curves, spirals, palmettes and formlines characterise many objects from different parts of Eurasia (*e.g.* Chugunov 2017a; Reeder 1999, 109, no. 7). The so-called Animal Style, which includes elements that characterise the Early La Tène style of Europe (Chugunov 2017b), is believed to have developed by the 9th century BC in southern Siberia, perhaps even earlier (Di Cosmo 1999), and it was spread by the peoples known as Scythians both eastward and westward.

A common practice in the manufacture of many bronze and ceramic vessels at both the western and eastern ends of Eurasia in the middle of the final millennium BC was attaching small figures of animals, often hybrid creatures combining features of different real animals, to the sides and tops. Examples in temperate Europe include the jugs from grave 2 at the Glauberg (Herrmann 2002a, 257, fig. 251) and from the rich burial at Reinheim (Keller 1965, plate 19). In China, ceramic vessels from Yan Xiadu (von Falkenhausen 2006, 303, fig. 61) and bronze vessels from Pingle (von Falkenhausen 2006, 368, fig. 86, top) have such attached animals. In China, Xiaolong Wu (2017, 131) writes specifically of the appearance of 'fantastic' animals at this time (*e.g.* von Falkenhausen 2006, 355, fig. 80), introduced from regions to the west. We see fantastic creatures in Early La Tène Europe as well, for example on the Erstfeld gold neck rings (Müller 2009, 196–99). In both Europe and China, backward-facing animals is another characteristic motif, for example on the fibula from Glauberg grave 1 (Herrmann 2002b, 250, fig. 243) and on the Weiskirchen belt hook (Megaw & Megaw 1989, 66, fig. 65), and on ceramic vessels from Yan Xiadu and on bronze vessels from Jinshengcun in China (von Falkenhausen 2006, 303, fig. 61 and 355, fig. 80, bottom row).

In addition to the striking similarities between objects and design elements, burial practices are also similar in different parts of Eurasia. Svend Hansen (2016) and Alessandro Naso (2016) have recently noted the active construction of burial tumuli over a broad swathe of western Eurasia, from western Europe to Anatolia, from the 8th century BC. Hayashi (2013, 105), Gheyle *et al.* (2016) and Korolkova (2017) document this trend well eastward into the steppe regions of Eurasia. Some of the most spectacular tumulus graves date to the late 6th and 5th centuries BC, such as Vix in east-central France (Joffroy 1962), the Hohmichele (Riek 1962) and Hochdorf (Biel 1985) in south-west Germany, the tumuli at Stična (Gabrovec 1966) and other sites in Slovenia, Gordion in Anatolia (Liebhart *et al.* 2016), and the many kurgans north of the Black Sea (Alekseev 2006; Korolkova 2017; Tolochko & Polin 1999). Recent work by Russian and German archaeologists at Tuva in southern Siberia has revealed similar large tumuli containing richly outfitted burials (Cugunov *et al.* 2010).

Burial chambers constructed of logs and boards in temperate Europe and in the Scythian regions north of the Black Sea and further east in Tuva are fundamentally similar (*e.g.* Biel 1985 for temperate Europe; Korolkova 2017 for the Scythian regions).

In west-central Europe and in the Scythian regions north of the Black Sea, it was often the custom during the late 6th and 5th centuries BC to place stone sculptures on top of the large mounds that contained rich graves. Examples include those from Hirschlanden, Hochdorf and the Glauberg in Germany (Frey 2002b), and Pervomaievka in the central Dnipro area of central Ukraine (Bohush & Buzian 1999, 96; see also Rolle 2011, 116, fig. 4.3 and 118, fig. 4.5).

Between the 6th and 4th centuries BC, similar categories of objects were placed in the more richly equipped graves throughout Eurasia. These include vessels of bronze and ceramic, associated with the practice of feasting; in men's graves, weapons, often highly ornate; personal ornaments and mirrors in women's burials; and vehicles – wagons, carts or horses in both men's and women's burials (Thote 2000). Bronze mirrors were widely distributed across Eurasia now for the first time (Moyer 2012). Khazanov (2015, 32) notes that across the steppes, different nomadic peoples shared both material culture and practices (see also Chang 2018, 3). There is considerable local variation depending on regional traditions, but the overall pattern of similarity in the categories of objects is striking across the 10,000 km of Eurasia.

In considering the exotic imports in graves in temperate Europe, it is important to bear in mind that almost all of the richly outfitted burials in west-central Europe of the late 6th and early 5th centuries BC were looted in antiquity (Fischer 1983, 198–99). This is true of the central grave in the Hohmichele tumulus at the Heuneburg, of the Magdalenenberg, and of all of the richly outfitted graves around the Hohenasperg north of Stuttgart, except Hochdorf. The reason that this point is so important is that these are the graves that contain, or once contained, the most abundant evidence for interactions between central regions of temperate Europe and the east. Hochdorf preserves the evidence of the drinking horns and the related customs that may link the practice here with the Near East (Krausse 1996, 311–16). Even though the Grafenbühl central grave was looted, its contents of ivory carvings link it closely to that part of the world (Herrmann 1970). We can never argue from negative evidence, but we need to take account of the fact that we are probably missing a great deal of important material.

Many details of the chronology of objects and sites across Eurasia still need to be worked out. Many parts of this vast land area have not been substantially investigated archaeologically as yet. Once more sites, both settlement and cemetery, have been excavated and the materials from them analysed, and more C14 and dendochronological dates obtained, the chronology will become clearer. Then it will be possible to explore connections between peoples and the developments of styles and motifs in different regions with much greater precision. In order to move forward in our understanding of the interactions and the relationships between groups across Eurasia during the final millennium BC, we need to work with the evidence available to us now. In this way, we can raise the questions that will help to guide further fieldwork and analysis in order to begin to fill in the gaps in our understanding.

For what purposes was the new style developed and applied?

Many scholars have shown that elites (however defined) in widely different contexts tend to express their status through display of special objects – made of precious materials, created through intricate processes, and of foreign origin (Helms 1988, 111–30; Linduff 2006, 368; Thote 2016). In Early La Tène Europe, the earliest expressions of the new style are in exceptionally rich graves (Echt 2016, 364). The same association of the elements of the new style is also apparent in Central Asia, for example in the graves of the Tuva region (Cugunov *et al.* 2010), and in the east in China (von Falkenhausen 2006; Linduff 2006, 368; Thote 2016). The special elements of Early La Tène style – the spirals, S-curves, formlines, hybrid creatures – were all signs of what we might call cosmopolitanism – evidence that the individuals possessing these objects had contacts far afield and thus belonged to what we would today call an 'international elite'. It is important, however, to consider these objects not as passive items of display, but rather as objects that the owners actively used to compete for status and power (Hedeager 2011; Hunter & Joy 2015, 62).

Objects bearing the new style can be understood in terms of two categories of use – items worn on the person, and objects of special social importance, that is, objects that involve interacting with other people in special contexts. The worn items are all worn in places where they were especially visible to others – on the neck, on the chest and on the front of the belt (Wells 2008, 64–84). The other media bearing the new style include especially weapons, most notably swords; and bronze vessels associated with social feasting.

In Central Asia, the Animal Style was similarly applied to especially visible personal ornaments, such as the gold belt plaques (Marsadolov 2017), and in China especially to the ornate bronze vessels associated with feasting (von Falkenhausen 2006; Thote 2000).

For this study, it is especially significant that the same signs of expressing cosmopolitanism that we see in the Early La Tène goldwork and bronzework in temperate Europe were employed at the same time in China (Linduff 2006, 368; Thote 2016). The hybrid animals, the swirling curves, the highly textured surfaces of figurines throughout Eurasia were designed to capture and hold viewers' attention (Wells 2012, 31–32).

How did the design patterns and other cultural elements get to temperate Europe?

Texts and globalisation

Historians have much to say about the so-called Silk Road linking western and eastern Eurasia (Frankopan 2015; Lind 2007; Whitfield 2004). Since for most of Eurasia during the 5th century BC there are no sources of written information, the historical Silk Road began centuries later. While the historical sources tend to describe a single route, or at most two or three alternate routes, the archaeological evidence suggests not fixed routes but a great variety of possible routes and sub-routes.

As with most early textual sources, those that pertain to our topic are very limited in the amount of information they provide. Herodotus, writing in the middle of the 5th century BC, displays some familiarity with the peoples he calls Scythians, but his account is not of great use for the issues under consideration here (Ivantchik 2006). For east Asia, relevant written sources do not begin until the 3rd century BC (Jäger 2007). During the Roman Period, textual sources are much more abundant and attest to interactions across Eurasia from Europe to China (see *e.g.* Sidebotham 2011), but we need to be cautious in applying those accounts to the situation 500 years earlier.

In the field of archaeology, the concept of 'globalisation' is being pushed back into Roman and even prehistoric times (Jäger 2007). Hingley (2005) and Pitts and Versluys (2015) argue for its application to the Roman Period, Moyer (2012) uses the concept for the Iron Age, and Frank (Frank & Gills 1993) and more recently Vandkilde (2016) argue for 'world systems' or 'globalisation' in the Bronze Age. As Bunker (1995, 70) and Kuzima and Mair (2008) argue, there is good reason to think that what in historical times is known as the Silk Road goes back at least to the Bronze Age.

Fundamental change across Eurasia

Archaeological evidence

In the latter part of the Early Iron Age, from around 600 BC, in some parts of temperate Europe substantial centres of economic activity emerged, among the best studied of which are the Heuneburg in south-west Germany and Mont Lassois in east-central France. Among the striking aspects of these sites are the so-called southern imports, most notably Attic pottery from Greece, bronze vessels from both Greece and Etruria, and coral from the Mediterranean Sea. These southern imports were identified as indicating important relations with the Mediterranean societies from the early 1950s, when major excavations began at the Heuneburg and the Vix burial was discovered, with its Attic pottery, enormous Greek krater, Etruscan bowls, and gold neckring of unusual provenance. Also during the final decades of the 6th century BC and the first half of the 5th, quantities of ivory were imported into temperate Europe, sometimes in finished carved form (as at Grafenbühl), other times to be carved locally (as in the case of sword handles at Hallstatt and elsewhere). The importation and circulation of amber increased in scale.

During the early 5th century BC, at the same time that the new La Tène style was created, many substantial changes took place (Echt 2016, 354). The major centres such as the Heuneburg in south-west Germany (Krausse *et al.* 2016) and Mont Lassois in eastern France (Chaume & Mordant 2011) were abandoned by about the middle of the 5th century BC. Unusually large burial mounds containing multiple burials (as many as 127 graves in the Magdalenenberg [Spindler 1999]) and richly outfitted chambers in their centres gave way to much smaller tumuli with one or just a few graves. The richest graves of the Early La Tène period tend to be much less rich than the richest of the preceding period. A new attitude toward imports coming from the Mediterranean world is apparent, with the transforming of foreign objects, for example adding La

Tène style gold attachments to the Greek bowls at Kleinaspergle, and developing local variations on imported vessels, with the fashioning of local bronze and ceramic jugs, and imitating Attic pottery (Chytráček 2008).

Fundamental changes are evident at this time elsewhere in Eurasia as well. In Greece, Robin Osborne (2018) notes a change in the ways that figures were represented on Attic pottery, especially in the years 520–440 BC, suggesting major shifts in ways of seeing and perceiving. In the lands north of the Black Sea, Meyer (2013) describes the development of what he calls Greco-Scythian art during this time. In the region just east of the Urals, Koryakova (2006) notes the beginning of stronger expressions of social differences. For north-central Mongolia, Wright, Honeychurch and Amartuvshin (2009) identify major changes apparent in the archaeological material. In China, Thote (2016) notes what he calls a 'breakdown of traditions' and cites specifically major changes in the practices of making art and decoration (2008). Emma Bunker (1995, 17) notes the appearance in China of new styles of images used to decorate goods for elites, including belt ornaments, vessels and gear associated with horses. Wu (2017) describes the appearance of fantastic animals – hybrids – now. All of these observations by scholars working in Europe, in the Mediterranean region, in Ukraine, in Russia east of the Urals, and in China, suggest that widespread changes in the ways that people understood their world were underway.

Textual evidence

In the late 1940s, Karl Jaspers (1953) developed the concept of the Axial Age to characterise the middle of the final millennium BC as a time of profound cultural change throughout much of Eurasia (for a recent summary see Assmann 2016, 183–84). The argument is that the appearance of texts of fundamental importance to religious and political systems appeared at this time, in places as widely dispersed as Greece in the west and China in the east, and including the lands on the east coast of the Mediterranean and in India. Ehret (2002) and Harris (2007) argue that around the middle of the final millennium BC throughout much of the greater Mediterranean region (and probably further afield as well), the control of trade often shifted from rulers (kings) to merchants who engaged in commerce for their own benefit.

Modelling interactions across Eurasia

Recent field research in different parts of the Eurasian steppes is leading to a picture of the region as a corridor along which people, goods and ideas moved regularly. As Anthony (2007, 456–57) suggests, already during the 2nd millennium BC the steppes became regular passageways between parts of Eurasia. Frachetti (2012, 2) and Alexeyev *et al.* (2017) highlight the importance of contacts and interactions that the nomadic peoples of the steppes had with the more settled societies all around them. In her recent excavations at sites in the Talgar region in south-eastern Kazakhstan, Chang (2018) has documented sedentary villages occupied by agriculturalists and craft workers that were

involved in the networks that carried objects and ideas throughout Eurasia. Her work makes clear that we need to think in terms of the people in different regions practicing a wide range of different kinds of economy and playing different roles in the circulation systems of the time. A model based on the concept of the 'interaction sphere' provides a useful way of conceptualising these movements of people, objects and ideas.

Interaction spheres

The interaction sphere model was developed to apply to the phenomenon known as Hopewell in North America (Struever & Houart 1972). In this cultural context, dating between 100 BC and AD 500, circulation of goods is documented over a vast area, from Canada in the north to Florida in the south, and from Nebraska in the west to New York State in the east. A wide range of objects, including copper ornaments, forms cut from slabs of mica, stone pipes, sea shells, grizzly bear teeth, shark teeth, aligator teeth and pearls, circulated throughout this vast area of North America. These objects, originating in widely separated regions, are found associated together in burials throughout the area. This circulation of objects was not just an economic matter, but also a social one, in which a prime motivation was the maintaining of social relationships over great distances (see *e.g.* Case & Carr 2008). The interaction sphere model has been applied to other contexts, notably by K.-C. Chang (1986, 234–45) in his study of the development of complex societies in China.

As we grapple with the complex archaeological patterns throughout Eurasia in the 6th to 4th centuries BC, the concept of the interaction sphere provides a useful model for encompassing the whole situation. The model does not presuppose any specific mechanism of transmission of objects, whether through merchant exchange, diplomatic gift-giving, or social interaction. It simply provides a way of thinking about how objects, style elements and cultural practices can have spread so widely within a relatively short time. As represented in Figure 3.2, we can think of this model in terms of overlapping regional interaction spheres. This model is highly schematic and does not attempt to document the occurrence of every example of circulating material.

In Europe, there is abundant evidence for the circulation of coral from the shores of the Mediterranean northward to the Main River, with sites in eastern France, southern Germany, and Austria especially well represented by this imported material (Champion 1985). A wider network is represented by amber, mainly collected on the shores of the Baltic Sea and circulating throughout temperate and Mediterranean Europe (Stahl 2006). The little bronze situla from Straubing on the Danube River in Bavaria represents the northernmost point of a circulation system that includes the Near East and especially Egypt (Tappert & Mielke 1998). Another network is represented by ivory, an ornamental material occurring in much of temperate Europe (Mac Sweeney & Wells 2018) and originating in Africa, the Near East and south Asia.

Moving eastward, the distribution of lapis lazuli (Kuzima & Mair 2008), most of it from what is now Afghanistan, in Egypt and the Near East constitutes another circulation system overlapping with those of the situla and of ivory. Chugunov (2017b) notes

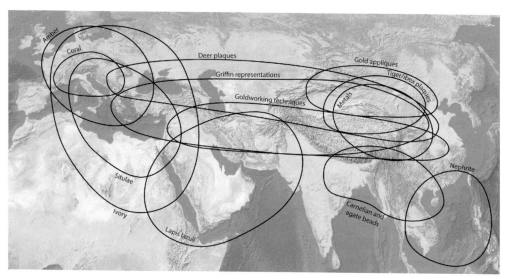

Fig. 3.2. Map of Eurasia showing with drawn ovals some of the interaction spheres evident in the distributions of the archaeological evidence. This map is highly simplified and could be greatly expanded by adding additional data. Many other categories of material could be shown, such as the distribution of Attic pottery and that of objects produced in the 'Greco-Scythian' style. This map is intended not as a final document, but as a suggestion for ways of thinking about the interactions throughout Eurasia. Important is the overlapping of the spheres, meant to suggest the complex pattern of intersecting systems along which people, objects and ideas circulated. For literature on each label, see pp. 45–46 (base map: Ktrinko, Eckert4, Wikimedia).

the distribution of similar deer plaques from the Black Sea to China. Liu (2017, 1589) documents evidence for the spread of goldworking techniques from the Near East to China. Hayashi (2012) identifies connections via representations of griffins from Greece and Persia to China. Beads made of carnelian and of agate show interaction between India and China (Bellina 2003; Mei 2006; Rawson 2010). Between south-east Kazakhstan and northern China, interactions are apparent in the distribution of plaques representing tigers and ibexes (Yang & Linduff 2013). In the eastern regions of Eurasia, Linduff (2006) documents the presence of bronze objects of ultimately Siberian origin in northern China, Hsu and colleagues (2016) illustrate the circulation of metals between western and central China, and Hung and colleagues (2007) illustrate a circulation system of nephrite jewellery in the coastal regions of south-east Asia. Korolkova (2006, 206, fig. 9) shows the distribution at this time of representations of camels, from the Black Sea to northern China, indicating common means of transporting goods across Eurasia.

These are just some of the systems of circulation, of objects, themes, motifs, designs and technologies, that researchers have identified. As research goes on, with new sites discovered, new analyses of materials recovered in different parts of Eurasia, new thinking about contacts and interactions, and new chronological fixed points, it will be possible to develop a much more precise model for these transactions.

For the question at hand – the origins of the Early La Tène style – three important points emerge. First, the design patterns, themes and motifs that characterise the Early La Tène style were in wide circulation in much of Eurasia at the same time that the style was developing during the 6th and 5th centuries BC. Second, the 5th century BC, and the centuries just before and just after it, were times of unusually profound changes in much of Eurasia, evident in both the textual and the archaeological sources of evidence. Third, the development and adoption of the new style had a purpose – it was actively used by emerging elites to distinguish themselves, to convey messages of eliteness and exclusion to their communities, and to demonstrate their outside connections – their sophistication, their worldliness. As indicated in the discussion above, very similar processes of change are evident at the same time in Europe in the west, in central regions of Asia and in parts of eastern Asia.

Conclusion

The middle of the final millennium BC appears to have been a time of unusually rapid and widespread change throughout much of Eurasia, from Europe in the west to China in the east. Major changes have been noted in the textual evidence by historians and philosophers and in the material evidence by archaeologists. As research progresses in central regions of Eurasia, filling in gaps in our knowledge of the archaeological geography between Europe and China, it is becoming ever clearer that a great deal of movement and interaction was taking place. In the archaeological evidence, these movements and interactions are especially clear in the circulation of objects and in the sharing, through borrowing, copying, adopting and adapting, of stylistic elements and motifs, as well as of technological processes.

Acknowledgements

I thank Chris Gosden, Helen Chittock, Lothar von Falkenhausen and Anthony Barbieri-Low for invitations to conferences at which I developed the argument presented here. And I thank Lothar von Falkenhausen for advice on the map in Figure 3.1, Ryan Mattke for providing the base map for Figures 3.1 and 3.2 and Courtney Nimura for greatly improving the quality of both maps.

References

Alekseev, A. 2006. Scythian kings and 'royal barrows' of the fifth and fourth centuries B.C.: Modern chronology and interpretation. In Aruz *et al.* 2006, 160–67.

Alexeyev, A.Y., Korolkova, E.F., Rjabkova, T.V. & Stepanova, E.V. 2017. The Scythians and their cultural contacts. In Simpson & Pankova 2017, 276–321.

Anthony, D.W. 2007. *The Horse, the Wheel, and Language: How Bronze-Age riders from the Eurasian steppes shaped the modern world.* Princeton, NJ, Princeton University Press.

Aruz, J., Farkas, A. & Fino, E.V. (eds). 2006. *The Golden Deer of Eurasia: Perspectives on the steppe nomads of the ancient world.* New York, NY, The Metropolitan Museum of Art.

Assmann, J. 2016. Egypt in the 'Axial Age'. In Fernández-Götz & Krausse 2016, 183–97.

Baitinger, H. & Pinsker, B. (eds). 2002. *Das Rätsel der Kelten vom Glauberg.* Stuttgart, Theiss.

Bellina, B. 2003. Beads, social change and interaction between India and South-east Asia. *Antiquity* 77(296), 285–97.

Biel, J. 1985. *Der Keltenfürst von Hochdorf.* Stuttgart, Konrad Theiss Verlag.

Bohush, T. & Buzian, H. 1999. Scythian culture in the central Dnipro area. In E.D. Reeder (ed.), *Scythian Gold: Treasures from ancient Ukraine,* 94–96. New York, NY, Harry N. Abrams.

Bunker, E.C. 1995. Chinese luxury goods enhanced: Fifth century B.C.-first century A.D. In J.F. So & E.C. Bunker (eds), *Traders and Raiders on China's Northern Frontier,* 69–75. Washington, DC, Smithsonian Institution.

Case, D.T. & Carr, C. 2008. *The Scioto Hopewell and Their Neighbors.* New York, NY, Springer.

Champion, S. 1985. Production and exchange in Early Iron Age central Europe. In T.C. Champion & J.V.S. Megaw (eds), *Settlement and Society: Aspects of West European prehistory in the first millennium B.C.* Leicester, Leicester University Press.

Chang, C. 2018. *Rethinking Prehistoric Central Asia: Shepherds, farmers, and nomads.* London/New York, Routledge.

Chang, K.-C. 1986. *The Archaeology of Ancient China.* 4th ed. New Haven, CT, Yale University Press.

Chaume, B. & Mordant, C. (eds). 2011. *Le complexe aristocratique de Vix.* Dijon, PU Dijon.

Chugunov, K.V. 2017a. Openwork belt holders. In Simpson & Pankova 2017, 214.

Chugunov, K.V. 2017b. Decorative plaques in the form of deer. In Simpson & Pankova 2017, 144.

Chytráček, M. 2008. Die Nachahmung einer rotfigurigen Trinkschale aus der frühlatènezeitlichen Flachlandsiedlung von Chržín (Mittelböhmen) und das überregionale Verkehrsnetz der Hallstatt- und Frühlatènezeit in Böhmen. *Germania* 86, 47–101.

Cugunov, K.V., Parzinger, H. & Nagler, A. 2010. *Der skythenzeitliche Fürstenkurgan Arzan 2 in Tuva.* Mainz, Verlag Philipp von Zabern.

Di Cosmo, N. 1999. The northern frontier in pre-imperial China. In M. Loewe & E.L. Shaughnessy (eds), *The Cambridge History of Ancient China: From the origins of civilization to 221 BC,* 885–966. Cambridge, Cambridge University Press.

Echt, R. 2016. Phase transition, axial age, and axis displacement: From the Hallstatt to the La Tène culture in the regions northwest of the Alps. In Fernández-Götz & Krausse 2016, 353–69.

Ehret, C. 2002. *The Civilizations of Africa: A history to 1800.* Charlottesville, VA, University of Virginia Press.

von Falkenhausen, L. 2006. *Chinese Society in the Age of Confucius (1000-250 BC).* Los Angeles, CA, Cotsen Institute of Archaeology.

Farley, J. & Hunter, F. (eds) 2015. *Celts: Art and identity.* London, British Museum Press.

Fernández-Götz, M. & Krausse, D. (eds) 2016. *Eurasia at the Dawn of History: Urbanization and social change.* Cambridge, Cambridge University Press.

Fischer, F. 1983. Thrakien als Vermittler iranischer Metallkunst an die frühen Kelten. In R.M. Boehmer & H. Hauptmann (eds), *Beiträge zur Altertumskunde Kleinasiens: Festschrift für Kurt Bittel,* 191–202. Mainz am Rhein, Verlag Philipp von Zabern.

Frachetti, M.D. 2012. Multiregional emergence of mobile pastoralism and nonuniform institutional complexity cross Eurasia. *Current Anthropology* 53, 2–38.

Frank, A.G. & Gills, B.K. 1993. *The World System: Five hundred years or five thousand?* London, Routledge.

Frankopan, P. 2015. *The Silk Roads: A new history of the world.* London, Bloomsbury.

Frey, O.-H. 1980. Zu einem keltischen Halsring vom Glauberg. *Fundberichte aus Hessen* 19/20, 609–15.

Frey, O.-H. 2002a. Frühe keltische Kunst: Dämonen und Götter. In Baitinger & Pinsker 2002, 186–205.

Frey, O.-H. 2002b. Menschen oder Heroen? Die Statuen vom Glauberg und die frühe keltische Grossplastik. In Baitinger & Pinsker 2002, 208–18.

Frey, O.-H. 2016. Early Celtic art in context. In Fernández-Götz & Krausse 2016, 370–79.

Gabrovec, S. 1966. Zur Hallstattzeit in Slowenien. *Germania* 44, 1–48.

Gheyle, W., De Wulf, A., Dvornikov, E.P., Ebel, A.V., Goossens, R. & Bourgeois, J. 2016. Early Iron Age burial mounds in the Altay Mountains: From survey to analysis. In Henry & Kelp 2016, 719–31.

Hanks, B. 2010. Archaeology of the Eurasian steppes and Mongolia. *Annual Review of Anthropology* 39, 469–86.

Hansen, S. 2016. Giant tumuli of the Iron Age: Tradition – monumentality – knowledge transfer. In Fernández-Götz & Krausse 2016, 225–42.

Harris, W.V. 2007. The late Republic. In W. Scheidel, I. Morris & R. Saller (eds), *The Cambridge Economic History of the Greco-Roman World*, 511–39. Cambridge, Cambridge University Press.

Hayashi, T. 2012. Griffin motif: From the west to east Asia via the Altai. *Parthica: Incontri di Culture nel Mondo Antico* 14, 49–64.

Hayashi, T. 2013. The beginning and the maturity of nomadic powers in the Eurasian steppes: Growing and downsizing of elite tumuli. *Ancient Civilizations from Scythia to Siberia* 19, 105–41.

Hedeager, L. 2011. *Iron Age Myth and Materiality: An archaeology of Scandinavia AD 400-1000.* New York, NY, Routledge.

Helms, M.W. 1988. *Ulysses' Sail: An ethnographic odyssey of power, knowledge, and geographical distance.* Princeton, NJ, Princeton University Press.

Henry, O. & Kelp, U. (eds). 2016. *Tumulus as Sema: Space, politics, culture and religion in the first millennium BC.* Berlin, De Gruyter.

Herrmann, F.-R. 2002a. Fürstengrab 2 aus Grabhügel 1. In Baitinger & Pinsker 2002, 257–61.

Herrmann, F.-R. 2002b. Fürstengrab 1 aus Grabhügel 1. In Baitinger & Pinsker 2002, 242–55.

Herrmann, H.-V. 1970. Die südländischen Importstücke. In H. Zürn, *Hallstattforschungen in Nordwürttemberg*, 25–34. Stuttgart, Verlag Müller & Gräff.

Hingley, R. 2005. *Globalizing Roman Culture: Unity, diversity and empire.* London, Routledge.

Honeychurch, W. & Makarewicz, C.A. 2016. The archaeology of pastoral nomadism. *Annual Review of Anthropology* 45, 341–59.

Hsu, Y.-K., Bray, P.J., Hommel, P., Pollard, A.M. & Rawson, J. 2016. Tracing the flows of copper and copper alloys in the early Iron Age societies of the eastern Eurasian steppe. *Antiquity* 90(350), 357–75.

Hung, H.-C., Iizuka, Y., Bellwood, P., Nguyen, K.D., Bellina, B., Silapanth, P., Dizon, E., Santiago, R., Datan, I. & Manton, J.H. 2007. Ancient jades map 3,000 years of prehistoric exchange in southeast Asia. *Proceedings of the National Academy of Science* 104(50), 19745–50.

Hunter, F., Goldberg, M., Farley, J. & Leins, I. 2015. In search of the Celts. In Farley & Hunter 2015, 18–35.

Hunter, F. & Joy, J. 2015. A connected Europe. In Farley & Hunter 2015, 52–79.

Ivantchik, A. 2006. Reconstructing Cimmerian and early Scythian history: The written sources. In Aruz *et al.* 2006, 146–53.

Jacobsthal, P. 1944. *Early Celtic Art.* 2 vols. Oxford, Clarendon Press.

Jäger, U. 2007. Wer lebte an der Seidenstrasse? Völker, Gruppen, Horden und die Schwierigkeit ihrer Bestimmung in historischer Zeit. In Wieczorek & Lind 2007, 49–61.

Jaspers, K. 1953. *The Origin and Goal of History.* New Haven, CT, Yale University Press.

Joffroy, R. 1962. *Le trésor de Vix.* Paris, Fayard.

Keller, J. 1965. *Das keltische Fürstengrab von Reinheim.* Mainz, Römisch-Germanisches Zentralmuseum.

Khazanov, A.M. 2015. The Scythians and their neighbors. In R. Amitai & M. Biran (eds), *Nomads as Agents of Cultural Change: The Mongols and their Eurasian predecessors,* 32–49. Honolulu, HI, University of Hawai'i Press.

Kimmig, W. 1988. *Das Kleinaspergle.* Stuttgart, Konrad Theiss Verlag.

Kistler, E. 2010. Grossköniglisches *symbolon* im Osten – exotisches Luxusgut im Westen: Zur Objektbiographie der archämenidischen Glasschale aus Ihringen. In R. Rollinger, B. Gufler, M. Lang, & I. Madreiter (eds), *Interkulturalität in der Alten Welt: Vorderasien, Hellas, Ägypten und die vielfältigen Ebenen des Kontakts,* 63–95. Wiesbaden, Harrassowitz Verlag.

Korolkova, E. 2006. Camel imagery in Animal Style art. In Aruz *et al.* 2006, 196–207.

Korolkova, E.F. 2017. Death and burial. In Simpson & Pankova 2017, 256–75.

Koryakova, L. 2006. On the northern periphery of the nomadic world: Research in the trans-Ural region. In Aruz *et al.* 2006, 102–13.

Krausse, D. 1996. *Hochdorf III: Das Trink- und Speiseservice aus dem späthallstattzeitlichen Fürstengrab von Eberdingen-Hochdorf (Kreis Ludwigsburg)*. Stuttgart, Konrad Theiss.

Krausse, D., Fernández-Götz, M., Lansen, L. & Kretschmer, I. 2016. *The Heuneburg and the Early Iron Age Princely Seats*. Budapest, Archaeolingua.

Kruta, V. 2015. *Celtic Art*. London, Phaidon Press.

Kuzima, E.E. & Mair, V.H. 2008. *The Prehistory of the Silk Road*. Philadelphia, PA, University of Pennsylvania Press.

Liebhart, R.F., Darbyshire, G., Erder, E. & Marsh, B. 2016. A fresh look at the *tumuli* of Gordion. In Henry & Kelp 2016, 627–63.

Lind, C. 2007. Ursprünge der Seidenstrasse. In Wieczorek & Lind 2007, 21–26.

Linduff, K.M. 2006. Why have Siberian artefacts been excavated within ancient Chinese dynastic borders? In D.L. Peterson, L.M. Popova & A.T. Smith (eds), *Beyond the Steppe and the Sown*, 358–70. Leiden, Brill.

Liu, Y. 2017. Exotica as prestige technology: The production of luxury gold in western Han society. *Antiquity* 91(360), 1588–602.

Mac Sweeney, N. & Wells, P.S. 2018. Edges and interactions beyond Europe. In C. Haselgrove, K. Rebay-Salisbury & P.S. Wells (eds), *The Oxford Handbook of the European Iron Age*. Oxford, Oxford University Press. DOI: 10.1093/oxfordhb/9780199696826.013.38.

Marsadolov, L.S. 2017. Two gold plaques representing deer. In Simpson & Pankova 2017, 145.

Megaw, M.R. & Megaw, J.V.S. 1989. *Celtic Art: From its beginning to the Book of Kells*. London, Thames and Hudson.

Mei, J. 2006. The material culture of the Iron Age peoples in Xinjiang, northwest China. In Aruz *et al.* 2006, 132–45.

Meyer, C. 2013. *Greco-Scythian Art and the Birth of Eurasia: From Classical antiquity to Russian modernity*. Oxford, Oxford University Press.

Moyer, A.C. 2012. Deep Reflection: An archaeological analysis of mirrors in Iron Age Eurasia. Unpublished PhD thesis, University of Minnesota.

Müller, F. 2009. *Art of the Celts 700 BC to AD 700*. Bern, Historisches Museum.

Müller, F. 2014. Theorie der keltischen Kunst. Ein Versuch. In C. Gosden, S. Crawford & K. Ulmschneider (eds), *Celtic Art in Europe: Making connections*, 28–38. Oxford, Oxbow Books.

Naso, A. 2016. Tumuli in the western Mediterranean, 800–500 BC. In Henry & Kelp 2016, 9–32.

Nebelsick, L. 2006. Vettersfelde. *Reallexikon der germanischen Altertumskunde* 32, 317–25.

Osborne, R. 2018. *The Transformation of Athens: Painted pottery and the creation of Classical Greece*. Princeton, NJ, Princeton University Press.

Párducz, M. 1973. Probleme der Skythenzeit im Karpatenbecken. *Acta Archaeologica Academiae Scientiarum Hungaricae* 25, 27–63.

Pare, C. 2012. Eastern relations of early Celtic art. In C. Pare (ed.), *Kunst und Kommunikation. Zentralisierungsprozesse in Gesellschaften des europäischen Barbarikums im 1. Jahrtausend v. Chr.*, 153–78. RGZM-Tagungen 15. Mainz, Verlag des Römisch-Germanischen Zentralmuseums.

Paret, O. 1921. *Urgeschichte Württembergs*. Stuttgart, Strecker und Schröder.

Pitts, M. & Versluys, M.J. (eds). 2015. *Globalisation and the Roman World: World history, connectivity and material culture*. New York, NY, Cambridge University Press.

Rawson, J. 2010. Carnelian beads, animal figures and exotic vessels: traces of contact between the Chinese states and Inner Asia, ca. 1000–650 BC. In M. Wagner & W. Wei (eds), *Bridging Eurasia*, 1–42. Mainz, Verlag Philipp von Zabern.

Reeder, E.D. (ed.) 1999. *Scythian Gold: Treasures from ancient Ukraine*. New York, NY, Harry N. Abrams.

Riek, G. 1962. *Der Hohmichele*. Berlin, De Gruyter.

Rolle, R. 2011. The Scythians: Between mobility, tomb architecture, and early urban structures. In L. Bonfante (ed.), *The Barbarians of Ancient Europe: Realities and interactions,* 107–31. New York, NY, Cambridge University Press.

Sidebotham, S.E. 2011. *Berenike and the Ancient Maritime Spice Route*. Berkeley, CA, University of California Press.

Simpson, S.J. & Pankova, S. (eds). 2017. *Scythians: Warriors of ancient Siberia*. London, British Museum Press.

Spindler, K. 1999. *Der Magdalenenberg bei Villingen. Ein Fürstengrabhügel des 7. vorchristlichen Jahrhunderts.* 2nd edition. Bonn, Habelt.

Stahl, C. 2006. *Mitteleuropäische Bernsteinfunde von der Frühbronze- bis zur Frühlatènezeit.* Dettelback, Verlag J.H. Röll.

Struever, S. & Houart, G.L. 1972. An analysis of the Hopewell Interaction Sphere. In E.M. Wilmsen (ed.), *Social Exchange and Interaction,* 47–147. Ann Arbor, MI, University of Michigan, Museum of Anthropology.

Tappert, C. & Mielke, D.P. 1998. Eine kleine syrische Bronzesitula aus frühkeltischer Zeit. *Jahresbericht des Historischen Vereins für Straubing und Umgebung* 99, 15–31.

Thote, A. 2000. Continuities and discontinuities: Chu burials during the Eastern Zhou period. In R. Whitfield & T. Wang (eds), *Exploring China's Past: New discoveries and studies in archaeology and art,* 189–204. London, Saffron Books.

Thote, A. 2008. Artists and craftsmen in the late Bronze Age of China (eighth to third centuries BC): Art in transition. *Proceedings of the British Academy* 154, 201–41.

Thote, A. 2016. Elite burials in first-millennium BC China: Towards individualization. In Fernández-Götz & Krausse 2016, 211–24.

Tolochko, P.P. & Polin, S.V. 1999. Burial mounds of the Scythian aristocracy in the northern Black Sea area. In Reeder 1999, 83–91.

Vandkilde, H. 2016. Bronzization: The Bronze Age as pre-modern globalization. *Praehistorische Zeitschrift* 91, 103–23.

Wells, P.S. 2008. *Image and Response in Early Europe*. London, Duckworth.

Wells, P.S. 2012. *How Ancient Europeans Saw the World: Vision, patterns, and the shaping of the mind in prehistoric times.* Princeton, NJ, Princeton University Press.

Whitfield, S. 2004. *The Silk Road: Trade, travel, war and faith*. London, The British Library.

Wieczorek, A. & Lind, C. (eds). 2007. *Ursprünge der Seidenstrasse: Sensationelle Neufunde aus Xinjiang, China.* Mannheim, Reiss-Engelhorn-Museum.

Wright, J.W., Honeychurch, W. & Amartuvshin, C. 2009. The Xiongnu settlements of Egiin Gol, Mongolia. *Antiquity* 83, 372–87.

Wu, X. 2017. *Material Culture, Power, and Identity in Ancient China*. Cambridge, Cambridge University Press.

Yang, J. & Linduff, K.M. 2013. A contextual explanation for 'foreign' or 'steppic' factors exhibited in burials at the Majiayuan cemetery and the opening of the Tianshan mountain corridor. *Asian Archaeology* 1, 73–84.

Chapter 4

Fantastic beasts and where to find them: Composite animals in the context of Eurasian Early Iron Age art

Rebecca O'Sullivan and Peter Hommel

Abstract

The Iron Age art of groups inhabiting the Eurasian steppe features many examples of composite creatures and animal transformations. While there is no shortage of research comparing Celtic Art to that of regions further east, the problems inherent to drawing links and detecting directions of influence using motifs remain salient. This chapter thus approaches composite creatures, prominent in both Celtic Art and that of wider north Eurasia, as a means to examine the underlying ideas that inform the creation of images. Examining creations such as the griffins of Early Iron Age Scythian art, the flying deer of the later Bronze Age in the eastern steppe, and the marvellous yet monstrous creatures of the Okunev culture in the Minusinsk Basin, this chapter pursues fantastic beasts as an idea, anchoring them firmly within the discourse of the social role of art, as well as northern Eurasian cosmologies. This chapter further outlines the utility of comparing distinctive art traditions, demonstrating that the presence of composites in both Celtic and Scythian art should not be viewed as a reflection of interaction with the 'civilisations' of the Mediterranean world, Western Asia or China, but instead represent active processes of adoption into a pre-existing conceptual space.

Introduction

Over the last century, the Iron Age art of northern Eurasia has been approached from a wide range of technical, typological and semiotic perspectives. Its varied characteristics have been treated as a rich source of evidence for both the reconstruction of pragmatic connections between communities and the study of ancient worldviews (*e.g.* Green 1999; Jacobson 1983; Kantorovich 2015a; Megaw & Megaw 1989; Melyukova 1989a; Perevodchikova 1994; Watt 2002). However, research has generally been partitioned along superficial stylistic boundaries according to the

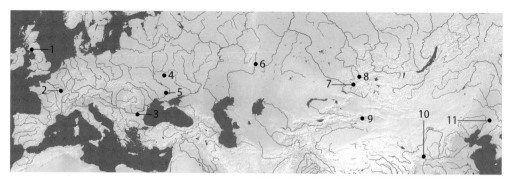

Fig. 4.1. Map of Eurasia with sites and locations mentioned in this chapter: Torrs Loch (1), Vix (2), Garchinovo (3), Aksyutintsy (4), Tolstaya Mogila (5), Obrucheski (6), Berel (7), Pazyryk (8), Jiaohegou (9), Majiayuan (10), Xichagou (11).

social nomenclature applied to the peoples of the continent in early textual sources. Of these, Celtic Art in the northern and western parts of the European peninsula and Scythian art in the steppe zone have been the most intensively developed as broad fields of study (Beisenov & Bazarbayeva 2013; Garrow *et al.* 2008; Korolkova 2006; Jacobson 1983; Jettmar 1967; Loehr 1955; Melyukova 1989b; Ol'khovskii 1997; Piotrovsky *et al.* 1986; Rostovtzeff 2000; Wells 2006). The relationship between these at times neighbouring traditions has of course been explored (*e.g.* Cunliffe 2017; Pare 2012; Sandars 1971), but we would argue that they may share a deeper connection that relates to cosmologies typical of northern Eurasia (Fig. 4.1).

There are pertinent similarities between the research approaches to and archaeological contexts of both Scythian – this term here includes the stylistic/regional/chronological subdivisions of the broadly mid- to late 1st millennium BCE Scytho-Sarmatian, Scytho-Siberian, Scythoid, Saka etc. – and Celtic groups. Both have been understood in opposition to the southern agricultural, predominantly sedentary, text-producing societies of the Mediterranean, Western and Central Asia, and dynastic China (Brentjes 2000; Guo Wu 2012; Khazanov 2015; Peake & Fleure 1928). In addition, the character of both Celtic and Scythian art reflects a clear interest in complex, enigmatic, often animal-themed ornament, whilst also being dominated by portable objects related to personal display and identity (Bunker 2002, 30). Both styles are distinctive in relation to their predecessors; they appear suddenly and spread rapidly within their specific milieu. Museum exhibitions devoted to these subjects in recent years have emphasised the significance of exotica in these societies as testament to extensive networks of exchange and external influence. However, in both Scythian and Celtic Art, the modes of representation permeate the full range of contemporary material culture and continue to resonate in the art of subsequent centuries. The character of finds from sites like Vix (*c.* 5th century BC) in southern France, Tolstaya Mogila (*c.* 4th century BC) in Ukraine, and Majiayuan (*c.* 4th–3rd century BC) in north-west China can perhaps be approached as the products of comparable processes

of interaction and engagement within the boundaries of very different forms of society. There is thus good reason to consider these streams of art in parallel, even if their specific characteristics defy any straightforward comparison and remain largely, if not entirely, distinct from each other.

This chapter focuses on issues concerning comparability between the two art streams, looking eastward from the Danube into the grasslands of the Eurasian steppe. Similar to Jacobsthal (Chapter 13, this volume), we choose a particular subset of the rich material record and set out in pursuit of monsters. Rather than hunting their genesis, however, we seek to understand why these fantastic beasts – defined here as creatures artificially created by the combination of parts from different animals – found such a comfortable home among the pastoralists of the steppe (Kantorovich 2015a; 2015b). Such creatures have long been noted within the bestiary of Celtic Art as well, where they have attracted much attention (see Frankfort 1955; Jacobsthal 1944; Megaw & Megaw 1989; Pare 2012, 163–64). Looking across the breadth of Eurasia, this chapter considers broad similarities and differences in the creation of fantastic beasts and examines the potential utility of comparing both the specific elements of composition and the broader processes behind these choices. This approach takes great inspiration from the recent work of David Wengrow (2011; 2013), and it is hoped that it will lead to further, more contextual examinations of the place of fantastic beasts in the corpus of northern Eurasian Iron Age art.

Modular monsters

Fantastic beasts, as defined here, are formed in two ways: by the composition of parts (limbs, torsos etc.) taken from two or more distinct animals that retain 'a certain basic coherence on the anatomical plan' (Wengrow 2013, 27) and by the transformation of elements of these animals (whether composite or not) into other forms. Theoretically, such creatures are widespread in human societies, and their power is suggested to stem from their dissonance with the perceived natural order of the world (Boyer 2001, 324; Sperber 1996). Grounded in concepts of the modular mind and the power of cognitive fluidity (cogently summarised in Mithen 2000), the universal monstrosity of early religious ideas seems appealing, as it provides a rich context in which more consistently defined hybrid deities common in later periods emerged. Yet, as Wengrow (2011, 132) points out, the argument for universality is based upon thoroughly casual use of examples separated both geographically and temporally by many thousands of years. The significant point comes as these monsters move from occasional reference to common practice within society, an event that occurs in the complex political economies of the urban world. Where they are found elsewhere, Wengrow argues they are the product of similar processes, and the popular survivors (*e.g.* lion's body + eagle's head = griffin or horse's body + eagle's torso = hippogriff) have persisted, attracting histories of their own (Frey 2004, 120; Scamander 2001, 21). Yet, these monsters of myth, each with their own characteristics, reflect only a part of a much broader bestiary that extends far beyond the urban world. The question facing us

in this chapter is whether the composites that decorate metal, bone, leather and other materials excavated from sites across Eurasia can be attributed to comparable processes as those identified by Wengrow.

Wengrow (2013) approached this question tangentially in his work on Western Asia and China through the works of Mikhail Rostovtzeff, whose extensive writings on the Eurasian animal style – considered one of the most diagnostic aspects of Scythian art – in the early 20th century presented the imagery of the Iron Age steppe based firmly on the character of the archaeological record. For Rostovtzeff (1922) the imagery of Scythian art spoke of a multiplicity of connections, cultural borrowings and local transformations. The Scythian world was one in which the control of trade routes across the steppe was the main source of power and influence and, as a result, access to exotic material, imagery (including composites) and craftsmanship became the primary mode of display for its increasingly cosmopolitan social elite.

The spread and persistence of distinctive modes of representation, such as the well-known curled predator motif (Fig. 4.2), certainly speak to the intensive interaction across the steppe at this time. The eagle-headed, winged lions on the pectoral from Tolstaya Mogila, which was mentioned above, show direct connections with the Hellenistic world and can be contextualised as both evidence of high-status 'international' gift exchange and local power politics (Brashinskiy 1979). The pectoral depicts many scenes clearly intended for a Scythian audience, and its craftspeople seem to have considered griffins to be an appropriate motif, as well as an understandable subject and signifier of a supernatural world (Künzl 2016). More broadly, the typological range and number of different instances of composites in Scythian art (Fig. 4.3) support the basic ideas of Rostovtzeff (1922) and Wengrow's

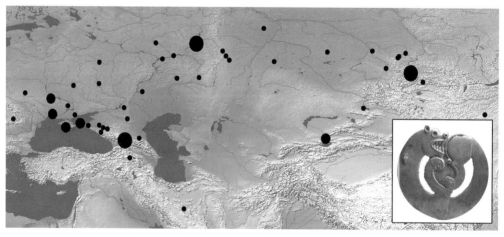

Fig. 4.2. Distribution and concentration of the motif known as the curled predator across Eurasia (data from Vasil'ev 2000). Inset: early example of the motif on a bronze harness fitting from Arzhan I, Republic of Tuva (Photo: P. Hommel).

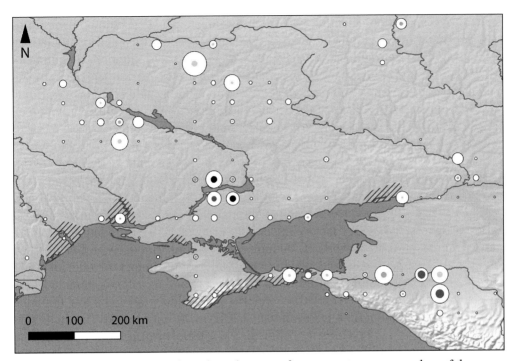

Fig. 4.3. *Distribution, number and typological variety of composite images as a subset of the corpus of animal art in Scythian burials across the northern Pontic steppe (data from Kantorovich 2015a; mapped using a 0.5° grid). The outer line indicates the total number of artistic representations within one grid square, and the inner dot represents the number of composite animals. The colour (from light to dark) represents the number of unique typological variants of composite images as classified by Kantorovich 2015a. Accepted areas of Greek colonial settlements are shown as hatched areas.*

(2013, 88–107) notions of both transformative and integrative transmission. The creatures appear to cluster just beyond the areas in which Greek colonial influence was most apparent. In such areas, the variety of composites also becomes more prolific, further supporting the idea that their creation was a phenomenon compelled by contact. In this context, the composites bolstered the position of elites through access to such imagery and merged traditions to mediate relations across 'tense cultural boundaries' (Wengrow 2013, 95). Not only griffins, but other combinations of animals, both predators and prey, suggest significant local uptake of the concept of composition – ram-birds, elk-goats and antlered fish join the more traditional fantastic menagerie. Both within and beyond the contact zone, other patterns of modularity develop, which only become explicit when examined in their contexts of use. For instance, numerous bridle ornaments depicting the dissociated limbs, ears, horns and antlers of a variety of recognisable beasts (see Kantorovich 2015a) join our discussion only when looked at in association with the animal they were intended to ornament and perhaps to augment.

That composites are secondary to other forms of naturalistic animal art seems equally clear (Fig. 4.3), a fact further emphasised by the relative absence of fantastic beasts in the early phases of animal style art in southern Siberia (*e.g.* Chugunov *et al.* 2010). In the eastern steppe, explicit hybrids appear somewhat later, though they are preceded by other forms of modularisation and certainly by the repetitive reproduction of images as a symbol of power (see Jacobsthal, Chapter 13, this volume). This eastern context is raised only as an isolated example by Wengrow (2013, 28–29), but it is one of the richest sources for understanding the ubiquity of such imagery in a society among whom perishable materials were among the most widely used.

Looking east

When composites first appear in southern Siberia is not quite clear, but signs of interest in monsters is apparent by the late 7th century BC. They are exemplified in the frozen tombs of the Pazyryk culture (6th–3rd century BC), spread throughout the Altai Mountains in Siberia, Mongolia, China and Kazakhstan. Thanks to remarkable preservation, fantastic creatures are found on every kind of surface from felt to tattooed human skin; there is little doubt that these creatures had been fully integrated into society. These eastern beasts include numerous bird-felines – similar in appearance to griffins – and their cousins the distinctive eared-eagles. Similar to the examples from the western steppe, the specific character of these depictions is often so precisely rendered that their connections in Western Asia are impossible to overlook, an association emphasised by other forms of exotic objects (Kantorovich 2012; 2015b).

These composites are joined by a much wider range of combinations: fantastic raptors complete with rams' horns or antlers and horses with raptor beaks (Fig. 4.4). Real animals are similarly placed at the centre of these transformations, though much more explicitly than in the western steppe. At Berel (*c.* 4th–3rd century BC) in eastern Kazakhstan, horses were adorned with wooden ibex horns, sacrificed and deposited in burial pits, such as in the dual burial of an older female and male (Kurgan 11, *c.* 3rd century BC) (Lepetz 2013). Similarly, at Pazyryk (*c.* 6th–3rd century BC) itself we find horses with antlers, wings and fang-like cheek-pieces. Though organic preservation is rarely comparable elsewhere, we find similar representations distributed widely from the Ural Mountains to the Ordos Plateau (Korolkova 2006; Melyukova 1989b; Moshkova 1992; Parzinger 2006; Wu'en Yuesitu 2008). Forming a living composite using

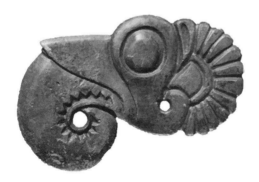

Fig. 4.4. Bronze raptor head with a ram's horns. Kurgan 2 Semibrat'ev, Taman Peninsula, 5th century BC (after Artamonov 1966, pl. 115).

one's horse may strike those familiar with Celtic Art in the form of the Torrs pony cap (*c.* 3rd century BC, Scotland) which has horns that morph into bird heads. Though it has been questioned whether the horns and cap were originally part of the same artefact (Hunter 2012), the transformation of horn tips into birds is nonetheless significant.

Perhaps similar phenomena were at play in both West and East; all these images appear in a period in which major social changes occurred. They follow evidence of increasing interaction in all directions and often coincide with new expressions of monumentality in the form of burials. Doubtless, the animal focus of such art made them particularly appealing for pastoralist societies whose animals represented both survival and wealth. However, it is possible that a deeper historical and ideological context existed that made the visual expression of composites particularly appealing to both Celtic and Scythian groups. This context could explain rare but remarkably similar forms that are found in assemblages far removed from this cultural milieu. To examine this, we must first question two of the tenets of Wengrow's thesis. Firstly, that earlier images of transformation were not relevant to the wider spread and uptake of these images and ideas. Secondly, that concepts of transformation – common in worldviews based around animistic and totemistic ontologies (sensu Descola 2013) – did not translate into physical images as a result of the perceived dangers associated with such imagery in these societies. We do this not to undermine the greater point that these images are closely related to social change, cultural interaction and display by the elite, but rather to add another dimension to the debate about monsters and the cosmology of the steppe.

Deer and birds

Our focal point for this discussion lies closer to the interface between images of natural and supernatural animals. It draws upon an early but persistent phenomenon of representing elk and deer, not as composites, but augmented with deliberately exaggerated antlers not paralleled in the natural world (Jacobson 1993, 54–56). This phenomenon draws us back into the Bronze Age (*c.* 1800–700 BC) of eastern Eurasia but reaches its zenith in an Iron Age world replete with more traditional monsters. A specific motif appears, more fantastic than monstrous but equally composited. From Inner Mongolia to the Pontic steppe,

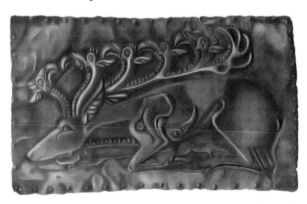

Fig. 4.5. Plaque of a deer with stylised antlers where the tines end in raptor heads. An inverted raptor head is also visible behind the shoulder. Mound 2, Aksyutintsy, Ukraine, 7th–6th century BC.

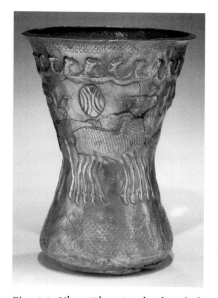

Fig. 4.6. Silver Thracian beaker (4th century BC) showing a design of a deer with eight legs and antlers that encircle the vessel's upper register. It appears to stand on land with waves present slightly below its hooves (courtesy of The Metropolitan Museum of Art, accession number: 47.100.88).

broadly naturalistic deer are depicted abstractly, as though they were in the very process of transformation, the tips of their antler tines erupting into the beaks and heads of birds (Fig. 4.5) (Windfuhr 2006). A complete history of this image is beyond the scope of this article, though it is worth noting some examples to emphasise their range and variety. They are regularly found in the material from Pazyryk cemeteries but are also clearly expressed as plaques at Garchinovo (*c.* 6th–5th century BC, Bulgaria) and Aksyutintsy (*c.* 7th–6th century BC, Ukraine) (Tchlenova 1963). Raptor-tipped antlers also appear as far east as Xichagou (3rd–1st century BC, Liaoning, China) but the main animal in the composite is a wolf rather than a deer (for a synthesis in English, see Kost 2014). Such images rarely transgress the boundaries of the steppe, but they inevitably attract attention when they do.

One such example is a Thracian silver beaker of the 4th century BC (Fig. 4.6), interpreted as the material representation of supernatural speed within a repertoire of locally and temporally specific iconographic elements focused on hunting and kingship (Taylor 1987). Such an interpretation is difficult to deny, given the deer's excess of legs and the author's thorough grounding in the local artistic context. Though influences from groups east and west of Thrace are evident in other archaeological remains (*e.g.* Kantorovich 2015a), we focus on this beaker as a possible example of shared cosmological ontologies rather than contact. Again, however, we wonder if there is further significance to the image that takes it into a wider Eurasian context. Unlike many of the Scythian and Siberian examples, the beaker explicitly depicts its subject in context. The ornament on the vessel is divided into three sections, which seem, perhaps simplistically, to denote water, land and sky. The deer stands on the land, while the bird heads at the top encircle the beaker, forming a closed area that is only connected to the lower land level via the deer. From this perspective, the composite deer acts as a bridge between earth and the sky above.

It is important to note that the image of a deer with bird heads morphing from its antlers is not exclusive to the western steppe. There are examples from Central Asia, such as one bone deer's head that has swirling antlers with a bird's beak from northern Jiaohegou cemetery in the central Tianshan (Shao Huiqiu 2012, 206). Metal plaques showing deer whose tines transform into bird heads are also found in central-northern Ningxia and central Inner Mongolia, whilst examples appear in dynastic

China from *c.* 475 BC (Kost 2014, 135). In discussions of this composite, there is little doubt that it is indicative of cosmologies local to the steppe rather than its southern neighbours. Additionally, the interpretation that birds were added to the antlers as an expression of its perceived ability to link different realms is strengthened by reference to more recent northern Eurasian cosmologies. Animal imagery across Eurasia has been variably interpreted through the lenses of magic and shamanism (Devlet & Jang 2014; Hančar 1952; Kubarev 1998; Zvelebil & Jordan 1999), and uncritical use of the latter term has led to some researchers becoming wary of attributing patterns in the archaeological record to shamanic activities or related animist ontologies (Demattè 2004). However, studies have identified several reoccurring features in northern Eurasian cosmologies that may be helpful to understanding why the concept of traversing multiple coexistent worlds is a feasible explanation for the creation of these images. Not only do many north Eurasian cosmologies – some described in the late 18th and early 19th centuries (Hoppál 1997) – consider the world to be populated by other non-human persons (Nandinbilig 2016, 211; Vasilevich 1972, 32), but the theme that the world is constructed of three parts – an upper world, middle world, and lower world – also appears. In particular, the middle world usually denotes the living world, while the upper and lower worlds are associated variously with the worlds of the dead and the realm of spirits (Hultkrantz 1996, 42). Water too is significant in many cosmologies but does not enter our discussion here (see Zvelebil & Jordan 1999). While the extent to which humans and non-human persons can move between the worlds varies between specific cosmologies (Vasilevich 1972, 35), both birds and deer appear regularly across northern Eurasia as agents in such transitions, and the images and bodies of both are found in suggestive contexts throughout later Eurasian prehistory (for examples and a more extensive discussion of such analogies see Lahelma 2005; Zvelebil & Jordan 1999).

The wider context of eastern Eurasian art provides a number of specific examples of such associations, not only representations of deer, which appear to show characteristics of flight, but also of fantastic beasts that appear to be entirely unconnected to the monsters of the South (*i.e.* in the urbanised centres that are the focus of Wengrow's hypothesis). These are perhaps particularly relevant to our discussion, since in eastern Siberia and Mongolia such images were frequently cut on rock faces and stele, remaining a persistent part of the landscape throughout the Iron Age. Later carvings similarly demonstrate the persistence of such places throughout the period under study.

Flying deer and monsters of rock

The association between deer and flight has long been made with reference to another tradition of monumental rock art in eastern Eurasia – the so-called deer stones (*c.* 1200–700 BC) which appear across central Mongolia and the Sayan-Altai range later in the Bronze Age (Jacobson 1993; Volkov 2002, 14–22; Whitaker 1981). Indeed, it has even been explicitly suggested that these deer with their beak-like snouts

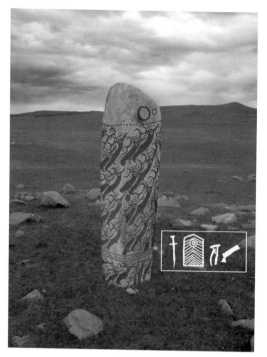

Fig. 4.7. A deer stone at Jargalantyn Am, Arkhangai aimag, Mongolia (c. 930–785 BC). Multiple deer encircle the stele, which is separated into three parts by a belt from which tools hang and a necklace-like ring at the top (Image and drawing: P. Hommel).

and extravagant antlers were in fact composite deer-bird creatures able to traverse boundaries between multiple worlds (Lymer *et al.* 2014, 168). Although the composite character of these depictions is markedly different from the later examples that inspired Wengrow's analysis, their context remains relevant for our discussion.

Deer stones, as has often been noted, have a consistent tripartite structure, that at least represents broad divisions of the human body, usually by representations of a belt in the lower part of the stone and a necklace in the upper part (*e.g.* Fig. 4.7). These three layers have been described as representing a similar cosmology to the one already described above with an upper, a middle and a lower world (for a concise overview of these ideas in English, see Fitzhugh 2009, 389–90). The deer, where they are present – for not all deer stones include deer – occupy the central part of the stone and are consistently oriented upwards, as if flying towards the upper register. Depictions of ear and temple rings at the head of the monuments are typical. These also appear to be sun-like, as in Figure 4.7, and are often described as solar symbols (Fitzhugh 2009, 388). The significance of deer in this context and in particular their antlers growing up into the sky indicates, at least in part, that the supernaturally endowed deer, marked out by its antlers and bird-like features, was a prominent concept, if not necessarily a formalised motif in early Eurasian art long before similar ideas were expressed in the form of explicit composites around the 5th century BC (Pan Ling 2008, 321).

From this perspective, the composite deer-bird was potentially considered an agent within socio-cultural frameworks or cosmologies. It is equally possible that its expression as a composite creature resulted from human understanding and description of it as a deer with a snout like a bird's beak. Thus, when people came to make a physical representation of the creature, the deer with bird features was the result. Indeed, it is significant that a tradition of fantastic beasts including parts of recognisable animals are evident in the Eurasian steppe even earlier in the Bronze Age. Known primarily from its monumental stele and complex burial architecture, the Okunev and Karakol (2700–1800 BC) cultures of the Minusinsk Basin – a major

focus of finds for early animal style artefacts in the Early Bronze and Late Iron Ages – Tuva, and the Altai in southern Siberia exhibit an interest in composites among earlier pastoralist societies.

It should be noted that, whilst arguments have been made to link the styles and features of these creatures with the formal artistic attributes of much later Iron Age animal figures (*e.g.* Sher 1988), we have no intention of proposing such a link. Unlike later art, the images frequently include anthropomorphic characteristics and their animal composites display a very distinctive style that does not obviously translate into later periods, with the exception of a few simple geometric signs (*e.g.* Vadetskaya *et al.* 1980). Nevertheless, they attest to a long tradition of highly original and thoroughly fantastic beast-making that occurred outside the confines of the urban world. Additionally, it is notable that they are located in the same region that would come to show a strong interest in breaking down boundaries between animal parts and emphasising the transitory capabilities of animal agents within northern Eurasian cosmologies.

The corpus of Okunev and Karakol art is replete with faces, from simple masks, divided into three parts, to painted images of human animal composites, or complex three-dimensional stele, combining multiple animal and anthropomorphic features, twisting vegetal motifs and geometric signs (Fig. 4.8) (Esin *et al.* 2014; Kyzlasov 1986; Vadetskaya *et al.* 1980). Purely zoomorphic images are equally striking, dominated by snakes and supernatural predators, described variously as felines or wolves (*cf.* Jacobson-Tepfer 2015) with monstrous jaws from which long forked tongues protrude (Fig. 4.9). Additionally, they can have animalistic ears and horns, with their skins covered in curved and/or straight lines that likely represent feathers or scales. Some are also given unnaturally extended legs in a style more characteristic of contemporary and earlier naturalistic depictions of elk.

The liminal nature of the anthropomorphic faces carved or painted on stele and rock panels has been noted by several researchers, the argument being that these are predominantly found at physical points of transition: on horizontal surfaces that connect the creator with the earth or near rivers and marshland environments (Jacobson-Tepfer 2015, 111–13; Rozwadowski 2017; Vadetskaya 1980, 72–74). Many of these faces had, and many more were later given, a close association with death, including – not always ceremoniously – in the burials of later periods (see Esin 2012, 16–18).

Other features, such as their lightning-shaped tongues, may suggest that people also understood these creatures in relation to real world phenomena. Anyone who has sat through an electrical storm in the open steppe does not easily forget the experience, and such phenomena may have been perceived as the actions of such beings on the world occupied by humans. The composite nature of the creatures, whether anthropomorphic or zoomorphic in their basic plan, reinforces their ability to cross boundaries or exist in liminal zones; potentially those between worlds that humans themselves could not contravene. Such creatures may be more syncretic than composite, simultaneously embodying all of the creatures they combine, whilst also

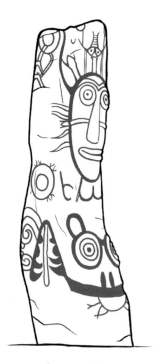

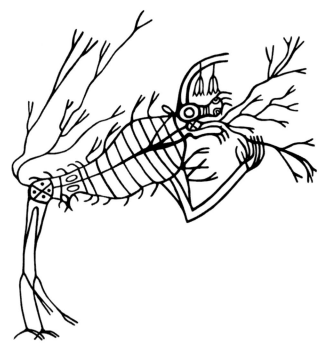

Fig. 4.8. *Okunev stele near Lake Beloye, Khakassia, c. 2700–1800 BC (Drawing: P. Hommel).*

Fig. 4.9. *Carved depiction of a fantastic creature with bovid horns and a tongue that looks like both a snake's tongue and lightning. Detail from panel at Kurgan 3, Byrkanov, Khakassia, c. 2700–1800 BC (Drawing: P. Hommel after Kurochkin 1995).*

being none of them. Again, the themes of transformation and a capacity to traverse inter-world boundaries are evident here. Such considerations demonstrate the varied roles of composites in prehistoric Eurasian societies.

Looking West: The griffin and the sphinx

Where then does this leave our comparison of similar themes and processes behind Scythian and Celtic Art? How are the patterns of composition seen to the west of the steppe comparable, if at all? This question demands a more comprehensive treatment than we can give in this paper, but certainly merits discussion. A cursory overview of motifs recorded in the remarkable survey by Kantorovich (2015a) and the main body of the European Celtic Art in Context (ECAIC) database highlights the overall dominance of human images in European assemblages and the reverse in the Eurasian steppe. If Bunker's (2009, 275) argument that the increased representation of animals in portable art in the eastern steppe was prompted by the emergence of mobile pastoralist strategies as opposed to agro-pastoralist ones is considered, this is perhaps less than totally surprising. However, the depiction of natural animals/ humans is not our primary concern here. What appears salient is that the interest in

human imagery in Celtic Art also seems to extend into their monsters. Though later horse-human images on coins do appear, anthro-zoomorphic hybrids seem far more common in northern Europe than the steppe zone. A comparable emphasis is seen only towards the beginning of the 1st millennium AD in the forest zone, developing from an earlier northern extension of animal style art through the basins of the Volga and Kama rivers (Oborin & Chagin 1988). Here we find far more explicit the imagery of human-animal and animal-animal transformation in the context of early shamanic practices. Such abundant depictions are at odds with Wengrow's (2013) supposition, based on a rather haphazard global ethnographic survey, that such images were rarely produced and remind us of the need for carefully considered historical analogies.

Despite the apparent differences between the focuses of the Celtic and Scythian art streams, two comparisons are worth making. The first is that in both cases, working from comparatively similar sources, we can see the adoption of specific forms of composites into contemporary art. In both cases, these were a small part of the broader corpus of imagery but reflected clear and deliberate local choices. In both cases, as Wengrow (2013) suggested, both seem to occur as phenomena of contact and are developed most intensively in conditions of significant social change – this indeed may explain the particularly common representation of composite beasts and human hybrids on early coinage in the later Iron Age (Oborin & Chagin 1988). It is, however, the now recognisable composites that have garnered most attention and become the focus of overarching theories of social change. For instance, whilst composites comprising parts from deer and raptors have formed the focus of this chapter, not all combinations are common enough to appear so striking as formalised representations of social change. For instance, a composite from the cemetery of Obruchevski (6th–4th century BC) in the southern Urals is formed of a feline that has a bird's head morphing out of its rear (Parzinger 2006, 545–55). Such a motif is not only less common, but the direction of transformation is different: the impression is more of two animals morphing from each other, rather than the examples highlighted in this chapter that are more suggestive of one animal from which many others transform. Indeed, the presence of such fantastic beasts that exist alongside the composites described here, as well as broader animal styles of art in the Celtic and Scythian worlds, attests to local and regional contexts prompting the appearance of such phenomena.

Conclusion

The search for fantastic beasts has here focused on creatures that are the explicit combination of multiple animals identifiable as having parallels in the modern world. Though representations of animals dominated the art of the Eurasian steppe during the Iron Age, composites have been found widely in contexts from northern China to the western steppe. We examined earlier interpretations, which have seen composites in the steppe as a simple function of contact, the evidence of interaction with the 'civilisations' of the south, or an active adoption in conditions of significant social change. Looking at the distributions of these patterns in the western and eastern

steppe, we conclude that these models seem broadly applicable. However, the way in which living animals were drawn into these ideas, together with a number of specific forms of composition, suggested that there were also other reasons why fantastic beasts were able to find a home in the steppe and develop into a persistent feature of Iron Age and later artistic styles.

Through analysis of a transformative motif in which the tips of deer antlers came to be represented as birds, we explored a possible interpretation of the deer as a liminal being, able to move within different spheres of the world. Drawing on established discussions of the tripartite world in Eurasian anthropology, we demonstrated deer-bird composites and other still more fantastic beasts from the Bronze Age may have provided a pre-existing niche into which monsters, composites and other syncretic animal hybrids could comfortably fit. Evidently, such ideas can hold currency over long periods of time, without necessarily meaning that the people holding that idea were in direct contact or 'evolved' from each other.

This has been but a brief introduction to 'the wealth of fantastic beasts' that inhabited Iron Age Eurasia (Scamander 2001, xxi), but the findings here have interesting significance for a much deeper parallel study of Celtic and Scythian art. Importantly, this chapter establishes that the idea behind formalised combinations of animal parts took hold in northern Eurasia as a result of established worldviews, rather than the artistic domestication of monstrous creatures. It is hoped therefore that any future studies of fantastic beasts in this region will approach them holistically as part of their regional context.

Acknowledgements

This research was completed as part of the Leverhulme Trust-funded ECAIC project. We would like to express our thanks to the anonymous reviewers for their many excellent comments on an earlier version of this chapter. We have tried to incorporate their suggestions, though any remaining mistakes are our own.

References

Artamonov, M.I. 1966. *Sokrovishcha skifskikh kurganov v sobranii Gosudarstvennogo Ermitazha*. Leningrad (Saint Petersburg), Artiya.
Beisenov, A.Z. & Bazarbayeva, G.A. 2013. Iskusstvo drevnikh kochevnikov tsentral'nogo Kazakhstana: obrazy, syuzhety, kompozitsii. *Vestnik Yuzhno-Ural'skogo Gosudarstvennogo Universiteta* 13(2), 12–17.
Boyer, P. 2001. *Religion Explained: The evolutionary origins of religious thought*. New York, NY, Basic Books.
Brashinskiy, I.V. 1979. *V poiskakh skifskikh cokrovisch*. Leningrad (Saint Petersburg), Nauka.
Brentjes, B. 2000. 'Animal style' and shamanism: Problems of pictorial tradition in northern in Central Asia. In J. Davis-Kimball, E.M. Murphy, L. Koryakova & L.T. Yablonsky (eds), *Kurgans, Ritual Sites, and Settlements: Eurasian Bronze and Iron Age*, 259–68. Oxford, BAR International Series.
Bunker, E.C. 2002. Artifacts: Regional styles and production methods. In E.C. Bunker (ed.), *Nomadic Art of the Eastern Eurasian Steppes: The Eugene V. Thaw and other New York collections*, 15–38. New York, NY, Metropolitan Museum of Art.

Bunker, E.C. 2009. First-millennium BCE Beifang artifacts as historical documents. In B.K. Hanks & K.M. Linduff (eds), *Social Complexity in Prehistoric Eurasia: Monuments, metals, and mobility*, 272–95. New York, NY, Cambridge University Press.

Chugunov, K.V., Parzinger, H., & Nagler, A. 2010. *Der Skythenzeiliche Fürstenkurgan Aržan 2 in Tuva*. Mainz, Philipp Von Zabern.

Cunliffe, B. 2017. *By Steppe, Desert, and Ocean: The birth of Eurasia*. Oxford, Oxford University Press.

Demattè, P. 2004. Beyond shamanism: Landscape and self-expression in the petroglyphs of Inner Mongolia and Ningxia (China). *Cambridge Archaeological Journal* 14, 1–20.

Descola, P. 2013. *Beyond Nature and Culture*. Chicago, IL, University of Chicago Press.

Devlet, E., & Jang, S. 2014. *Kamennaya letopis' Altaya/The Stone Chronicle of Altai*. Moscow, IA RAN.

Esin, Y.N. 2012. Drevneyshiye izobrazheniya povozok Minusinskoy kotloviny. *Nauchnoye obozreniye Sayano-Altaya* 1(3), 14–47.

Esin, Y.N., Magay, Zh., Russel'er, E. & Val'ter, F. 2014. Kraska v naskal'nom iskusstve okunevskoy kul'tury minusinskoy kotloviny. *Rossiyckaya arkheologia* 3, 79–88.

Fitzhugh, W.W. 2009. Pre-Scythian ceremonialism, deer stone art, and cultural intensification in Northern Mongolia. In B.K. Hanks & K.M. Linduff (eds), *Social Complexity in Prehistoric Eurasia: Monuments, metals and mobility*, 378–412. Cambridge, Cambridge University Press.

Frankfort, H. 1955. *The Art and Architecture of the Ancient Orient*. Harmondsworth, Penguin Books.

Frey, O. 2004. A new approach to early Celtic art. *Proceedings of the Royal Irish Academy. Section C: Archaeology, Celtic Studies, History, Linguistics, Literature* 104C(5), 107–29.

Garrow, D., Gosden, C. & Hill, J.D. (eds). 2008. *Rethinking Celtic Art*. Oxford, Oxbow Books.

Green, M.J. 1999. Back to the future: Resonances of the past in myth and material culture. In A. Gazin-Schwartz & C.J. Holtorf (eds), *Archaeology and Folklore*, 46–64. London, Routledge.

Guo Wu 郭物. 2012. Ouya caoyuan dongbu de kaogu faxian yu Sijitai de zaoqi lishi wenhua 欧亚草原东部的考古发现与斯基泰的早期历史文化 [Archaeological discoveries in the eastern Eurasian Steppe and the early historical culture of the Scythians]. *Kaogu* (4), 56–69.

Hančar, F. 1952. The Eurasian animal style and the Altai complex. *Artibus Asiae* 15(1/2), 171–94.

Hoppál, M. 1997. Nature worship in shamanism. *Folklore: Electronic Journal of Folklore* 4, 9–26.

Hultkrantz, Å. 1996. A new look at the world pillar in Arctic and sub-Arctic religions. In J. Pentikäinen (ed.), *Shamanism and Northern Ecology*, 31–50. Religion and Society 36. Berlin, de Gruyter.

Hunter, F. 2012. Ursprünglich getrennt – Ponykappe und Hörner von Torrs. In R. Röber, M. Jansen, S. Rau, C. von Nicolai & I. Frech (eds), *Die Welt der Kelten: Zentren der Macht - Kostbarkeiten der Kunst*, 485. Stuttgart, Jan Thorbecke.

Jacobson, E. 1983. Siberian roots of the Scythian stag image. *Journal of Asian History* 17, 68–120.

Jacobson, E. 1993. *The Deer Goddess of Ancient Siberia: A study in the ecology of belief*. Leiden, Brill.

Jacobson-Tepfer, E. 2015. *The Hunter, the Stag, and the Mother of Animals: Image, monument and landscape in ancient North Asia*. Oxford, Oxford University Press.

Jacobsthal, P. 1944. *Early Celtic Art*. 2 vols. Oxford, Clarendon Press.

Jettmar, K. 1967. *Art of the Steppes: The Eurasian animal style*. London, Methuen.

Kantorovich, A.R. 2012. K voprosu ob istokakh i variatsiyakh obrazov grifona i grifonopodobnykh sushchestv v ranneskifskom sverinom stile VII–VI vv. do n.e. In D.V. Zhuravlev & K.B. Firsov (eds), *Evraziya v skifsko-sarmatskoe vremya: pamyati Iriny Ivanovny Gushchinoy*, 106–33. Moscow, Gosydarstvennyy Istoricheskiy Muzey.

Kantorovich, A.R. 2015a. *Skifskiy Zverinyy Stil' Vostochnoy Evropy: Klassifikatsiya, Tipologiya, Khronologiya, Evolyutsiya*. Avtoreferat Dissertatsii. Moscow, MGU (Lomonosov).

Kantorovich, A.R. 2015b. Obrazy sinkreticheskikh sushchestv v vostochnoyevropeyskom skifskom zverinom stile: klassifikatsiya, tipologiya, khronologiya, ikonograficheskaya dinamika. *Istoricheskie issledovaniya* 3, 113–218.

Khazanov, A.M. 2015. The Scythians and their neighbors. In R. Amitai & M. Biran (eds), *Nomads as Agents of Cultural Change: The Mongols and their Eurasian predecessors*, 32–49. Honolulu, HI,

University of Hawai'i Press.

Korolkova, E.F. 2006. *Zverinyy stil' Yevrazii. Iskusstvo plemon Nizhnego Povolzh'ya I Yuzhnogo Priural'ya v skifskuyu epokhu (VII-IV vv. do n.e.). Problemy stilya I etnokul'turnoy prinadlezhnosti.* Saint Petersburg, Peterburgskoye Vostokovedeniye.

Kost, C. 2014. *The Practice of Imagery in the Northern Chinese Steppe (5th - 1st centuries BCE).* Bonn, Vor- und Frühgeschichtliche Archäologie Rheinische Friedrich-Wilhelms-Universität Bonn.

Kubarev, V.D. 1998. Portativnyi «altar'» iz chichkeshi. *Drevnosti Altaya* 3, 49–52.

Künzl, E. 2016. Life on earth and death from heaven: The golden pectoral of the Scythian king from the Tolstaya Mogila (Ukraine). In J. Bintliff & K. Rutter (eds), *The Archaeology of Greece and Rome: Studies in honour of Anthony Snodgrass*, 317–36. Edinburgh, Edinburgh University Press.

Kurochkin, G.N. 1995. Izobrazheniye fantasticheskogo khishchnika iz Byrkanova (po materialam raskopok 1989). In D.G. Savinov (ed.), *Problemy okunevskoy kul'tury*, 53–54. Saint Petersburg, Izdatel'stvo Sankt-Peterburgskogo gosudarstvennogo universiteta.

Kyzlasov, L.R. 1986. *Drevneyshaya Khakasiya.* Moscow, Izdatel'stvo Moskovskogo Universiteta.

Lahelma, A. 2005. Between the worlds: Rock art, landscape and shamanism in subneolithic Finland. *Norwegian Archaeological Review* 38(1), 29–47.

Lepetz, S. 2013. Horse sacrifice in a Pazyryk culture kurgan: The princely tomb of Berel' (Kazakhstan). Selection criteria and slaughter procedures. *Anthropozoologica* 48(2), 309–21.

Loehr, M. 1955. The stag image in Scythia and the Far East. *Archives of the Chinese Art Society of America* 9, 63–76.

Lymer, K.J., Fitzhugh, W.W. & Kortum, R. 2014. Deer stones and rock art in Mongolia during the second to first millennia BC. In K. Baker, R. Carden, & R. Madgwick (eds), *Deer and People*, 159–73. Oxford, Oxbow Books.

Megaw, M.R. & Megaw, J.V.S. 1989. *Celtic Art: From its beginning to the Book of Kells.* London, Thames and Hudson.

Melyukova, A.I. 1989a. Skifskoe iskyusstvo zverinogo stilya. In A.I. Melyukova (ed.), *Stepi evropeyskoy chasti SSSR v skifo-sarmatskoe vremya*, 100–03. Moscow, Nauka.

Melyukova, A.I. 1989b. *Stepi evropeyskoy chasti SSSR v skifo-sarmatskoe vremya.* Moscow, Nauka.

Mithen, S. 2000. Mind, brain and material culture: An archaeological perspective. In P. Carruthers & A. Chamberlain (eds), *Evolution and the Human Mind: Modularity, language and meta-cognition*, 207–17. Cambridge, Cambridge University Press

Moshkova, M.G. 1992. *Stepnaya polosa Aziatskoi chasti SSSR v skifo-sarmatskoe vremya.* Moscow, NAUKA.

Nandinbilig, G. 2016. Stone toys and games among Mongol children. In S. Biagetti & F. Lugli (eds), *The Intangible Elements of Culture in Ethnoarchaeological Research*, 211–16. New York, NY, Springer.

Oborin, V.A. & Chagin, G.N. 1988. *Chudskiye drevnosti Rifeya: Permskiy zverinyy stil'.* Perm, Permskoe knizhnoe izdatel'stvo.

Ol'khovskii, V.S. 1997. Skifskaya triada. *Pamyatniki predskifskogo i skifskogo vremeni na yuge Vostochnoi Yevropy* 1, 85–96.

Pan Ling 潘玲. 2008. Lun lushi de niandai ji xiangguan wenti 论鹿石的年代及相关问题 [On the date of deer stones and related problems]. *ACTA Anthropologica Sinica* (3), 311–36.

Pare, C. 2012. Eastern relations of early Celtic art. In C. Pare (ed.), *Kunst und Kommunikation. Zentralisierungsprozesse in Gesellschaften des europäischen Barbarikums im 1. Jahrtausend v. Chr.*, 153–78. RGZM-Tagungen 15. Mainz, Verlag des Römisch-Germanischen Zentralmuseums.

Parzinger, H. 2006. *Die Frühen Völker Eurasiens: Vom Neolithikum bis zum Mittelalter.* Munich, C.H. Beck.

Peake, H. & Fleure, H.J. 1928. *The Steppe & the Sown.* London, H. Milford.

Perevodchikova, E.V. 1994. *Yazyk zverinykh obrnzov: ocherki iskusstva yevraziyskikh stepey skifskoy epokhi.* Moscow, Vostochnaya literatura.

Piotrovsky, B., Galanina, L. & Grachi, N. 1986. *Scythian Art: The legacy of the Scythian world: mid-7th to 3rd century BC.* Leningrad (Saint Petersburg), Aurora Art Publishers.

Rostovtzeff, M.I. 1922. *Iranians & Greeks in South Russia.* Oxford, Clarendon Press.

Rostovtzeff, M.I. 2000. *The Animal Style in South Russia and China: Being the material of a course of lectures delivered in August 1925 at Princeton University under the auspices of the Harvard-Princeton Fine Arts Club*. Rome, L'ERMA di Bretschneider.

Rozwadowski, A. 2017. Travelling through the rock to the otherworld: The shamanic 'grammar of mind' within the rock art of Siberia. *Cambridge Archaeological Journal* 27(3), 413–32.

Sandars, N.K. 1971. Orient and orientalizing in early Celtic art. *Antiquity* 45(178), 103–12.

Scamander, N. 2001. *Fantastic Beasts & Where to Find Them*. 52nd ed. London, Obscurus Books.

Shao Huiqiu 邵会秋. 2012. Xinjiang Subeixi wenhua yanjiu 新疆苏贝希文化研究 [Research on Xinjiang's Subeixi culture]. *Bianjiang Kaogu Yanjiu* (2), 193–220.

Sher, Y.A. 1988. On the sources of the Scythic animal style. *Arctic Anthropology* 25(2), 47–60.

Sperber, D. 1996. *Explaining Culture: A naturalistic approach*. Oxford, Blackwell.

Taylor, T. 1987. Flying stags: Icons and power in Thracian art. In I. Hodder (ed.), *The Archaeology of Contextual Meanings*, 117–32. Cambridge, Cambridge University Press.

Tchlenova, N.L. 1963. Le Cerf scythe. *Artibus Asiae* 26(1), 27–70.

Vadetskaya, E.B. 1980. Izvayaniya okunevskoy kul'tury. In E.B. Vadetskaya, N.V. Leont'ev & G.A. Maksimenkov (eds), *Pamyatniki okunevskoy kul'tury*, 27–87. Leningrad (Saint Petersburg), Nauka.

Vadetskaya, E.B., Leont'ev, N.V. & Maksimenkov, G.A. eds 1980. *Pamyatniki okunevskoy kul'tury*. Leningrad (Saint Petersburg), Nauka.

Vasil'ev, S. 2000. *K voprosu o proizkhozhdenii syuzheta "Khishchnik, svernuvshiysya v kol'tso" v Skifskom Zverninom Stile. Katalog Izobrazheniy*. St Petersburg, SPGU.

Vasilevich, G.M. 1972. Preshamanistic and shamanistic beliefs of the Evenki. *Soviet Anthropology and Archeology* 11(1), 29–44.

Volkov, V.V. 2002. *Olennye kamni mongolii*. M.A. Devlet (ed). Moscow, Nauchnyi Mir.

Watt, J.C.Y. 2002. The legacy of nomadic art in China and eastern Central Asia. In Bunker 2002, 199–209.

Wells, P.S. 2006. Mobility, art, and identity in early Iron Age Europe and Asia. In J. Aruz, A. Farkas & E. Valtz Fino (eds), *The Golden Deer of Eurasia: Perspectives on the steppe nomads of the ancient world*, 18–23. New York, NY, Metropolitan Museum of Art.

Wengrow, D. 2011. Cognition, materiality and monsters: The cultural transmission of counter-intuitive forms in Bronze Age societies. *Journal of Material Culture* 16(2), 131–49.

Wengrow, D. 2013. *The Origins of Monsters: Image and cognition in the first age of mechanical reproduction*. Princeton, NJ, Princeton University Press.

Whitaker, I. 1981. Tuvan reindeer husbandry in the early 20th century. *Polar Record* 20(127), 337–52.

Windfuhr, G. 2006. The stags of Filippovka: Mithraic coding on the southern Ural steppes. In J. Aruz, A. Farkas & E. Valtz Fino (eds), *The Golden Deer of Eurasia: Perspectives on the steppe nomads of the ancient world*, 46–81. New York, NY, The Metropolitan Museum of Art.

Wu'en Yuesitu 乌恩岳斯图. 2008. *Beifang caoyuan kaoguxue wenhua bijiao yanjiu - qingtong shidai zhi zaoqi Xiongnu shiqi* 北方草原考古学文化比较研究 – 青铜时代至早期匈奴时期 [Comparative research of archaeological cultures in the northern plains: From the Bronze Age to the early Xiongnu period]. Beijing, Kexue Chubanshe.

Zvelebil, M. & Jordan, P. 1999. *Hunter Fisher Gatherer Ritual Landscapes - Questions of time, space and representation*. Oxford, Archaeopress.

Chapter 5

Bodies and objects in Iron Age Europe and beyond: An integrated approach to anthropomorphic imagery

Helen Chittock

Abstract

This paper considers the functions and effects of anthropomorphic imagery from the Middle–Late Iron Age. It uses data from the European Celtic Art in Context project to suggest that anthropomorphic images were not a single category but were deployed in ways that varied in time and space across Europe. It then examines the nature and composition of some of these images to examine broad commonalities in the ways they were created across Eurasia.

Introduction

Images of people form key aspects of artistic traditions in Middle–Late Iron Age Europe, and across other parts of Eurasia. This timeframe broadly covers the latter half of the 1st millennium BC, though exact dates and terminology vary geographically. Although anthropomorphic images appear rarely within the archaeological record, they have been much discussed by archaeologists and interpreted in a range of ways: as deities, mortals and symbols, incorporated into designs as ways of communicating ideas, beliefs or affiliations, or commemorating individuals (*e.g.* Aldhouse-Green 2004; Carlson 2011; Egri 2014, 79; Green 1995). They have also been important in traditions of the stylistic analysis of Iron Age art, being useful in assessing the development of different types of pattern and image over time (see Megaw 1970).

This paper approaches anthropomorphic imagery in a different way by contextualising it within the objects it adorns, considering the functions of these images as aspects of useful and tactile things and considering their effects rather than their meanings. It draws on data from the European Celtic Art in Context (ECAIC) database to examine the frequency and distribution of human images across Europe on different types of objects, showing that their functions varied in time and space.

This paper then broadens its geographical scope to elaborate on the idea that the appearance of 'Celtic' or La Tène art in Europe at around 500 BC was linked to new ways of seeing induced by exposure to images, patterns and ideas from across Eurasia (Wells 2012; Chapter 3, this volume). It considers a group of images that were carefully dressed and choreographed in selective ways seemingly sharing characteristics across a huge area.

Why humans?

This paper explores the fluid ambiguity of the creatures depicted in Iron Age art, and it is important to explain why I have chosen to focus on a single sub-category. Given the frequency of hybrid creatures in Iron Age imagery, the idea of setting up categories of human and non-human creatures may seem unhelpful (see O'Sullivan & Hommel, Chapter 4, this volume). However, the initial analysis of the database created by the ECAIC project suggested that anthropomorphic images occurred within the database far more frequently than images of any other creature. The number of objects with anthropomorphic imagery comprises 36.7% of all objects with identified imagery.[1] Was this because, as modern, Western humans, the researchers on the project were more likely to recognise creatures like ourselves in the patterns that comprise much of Celtic Art? Or does it present a genuine Iron Age pattern, relating to ontological differences between people and other animals, or showing that the depiction of humans in the Iron Age served specific purposes that the depiction of other animals did not? The relative frequency of anthropomorphic imagery in the ECAIC database suggests it warrants attention as an assemblage, although it was highly diverse and context dependent.

Representing people

Although this paper is partially about the representation of people, it aims to move away from the representational approach to art in archaeology: one that is based on the assumption that artworks represent aspects of the identities of those who made them, acting as vehicles for meaning (Jones & Cochrane 2018, 116–17). On examining Iron Age images of humans, it seems instinctive to interpret them as material expressions of the way people saw themselves and others, but, this assumption minimalises the complexity of Iron Age art and those who made it, negating the intended effects of the images. Instead this paper answers calls for the consideration of materials in producing artworks (Jones & Cochrane 2018, 134) and the re-integration of Iron Age images and patterns within the rest of the archaeological record (*e.g.* Gosden & Hill 2008). The core of this paper focuses on objects that fall under the umbrella of 'Celtic Art', a diverse group of Middle–Late Iron Age objects with a problematic name and complex history, which this paper will not discuss further, purely due to space restrictions (although see Chittock 2014; 2017; Collis 2014; Gosden & Hill 2008, 1). Early studies of these objects took an art-historical approach to the imagery found upon

them (see Megaw 1970 for a summary of this), lifting decoration away from objects to examine the development and distribution of different styles and the meanings of images. The effects of the material turn (*e.g.* Hicks 2010) in archaeology, however, have induced a shifting focus towards more holistic studies of objects of decorated objects such as these. The re-integration of Celtic Art (Garrow *et al.* 2008) has already proven useful at a range of scales. Gellian approaches to Celtic Art (*e.g.* Garrow & Gosden 2012; Giles 2008) and considerations of 'the sensory appeal that objects have and through the senses the emotional impacts they are likely to create' (Gosden & Hill 2008, 9) have led to detailed examinations of the lived experiences associated with Celtic Art (*e.g.* Giles 2012). This paper aims to contribute to this new tradition in Celtic Art studies by examining objects including images that *resemble* humans rather than represent them, a distinction that Jones and Cochrane (2018, 134) make. It recontextualises them as parts of useful things and considers their effectiveness as images that existed as parts of a much wider material environment.

Anthropomorphic imagery in Iron Age Europe and beyond: Image and pattern

This section of the paper introduces the diverse assemblage of human imagery from Iron Age Europe. It considers the ambiguous nature of this imagery and the range of materials it has been found on in the archaeological record. It then considers the origins of influences that comparisons with Classical art have had on archaeological interpretations and outlines newer ideas about Eurasian influences on Celtic Art.

Ambiguity in Iron Age art

Ambiguity forms a core principle of Celtic Art, making images and patterns open to multiple interpretations and contributing to the 'technology of enchantment' that forms part of the effectiveness of this body of objects (Garrow & Gosden 2012, 5). As some decorated objects are used and handled, images and patterns materialise and transform, making them difficult to grasp visually. This phenomenon is demonstrated in the context of human faces through an analogy used by Paul Jacobsthal (1941, 308) and later by Vincent Megaw (1970). Jacobsthal and Megaw refer to some faces in Celtic Art as having the qualities of Lewis Carroll's Cheshire Cat, a character in the novel *Alice in Wonderland*. The Cheshire Cat famously had the ability to appear and disappear at will, and Jacobsthal and Megaw both recognised a similar quality when encountering images of human faces in their studies of Celtic Art. Faces sometimes appear as parts of wider patterns, and as objects are handled, perspectives shift and they can snap into focus before disappearing just as quickly (see Megaw 1970, 274). Like the Cheshire Cat, these images are visible one minute and gone the next. Megaw's category of 'pseudo-faces' (1970) raises an important issue regarding the difference between image and pattern: one that was made deliberately blurry in Celtic Art. Jones (2019, 190–91) has recently discussed a similar phenomenon in the context

of Neolithic art from Britain and Ireland, where suggestions of figurative qualities have been noted on objects that, at other times, appear 'abstract'. He describes the figurative aspects of this art as 'conditional or situational' (Jones 2019, 191). The appearances of objects are altered depending on their contexts of use and on who is viewing them. This also applies to Celtic Art, and I argue that it was an important and deliberate aspect of its design.

Dealing with ambiguity

This paper will go on to discuss some aspects of database of the ECAIC project. The project included the construction of a database of over 38,000 European objects, mainly made from bronze and gold but also including some stone statues (see Nimura *et al.*, Chapter 2, this volume, for a full description of the database). Working with a huge and varied assemblage has its challenges, and, as I have emphasised above, Celtic Art is a group of things which do not lend themselves to the types of categorisation needed to study them in large numbers. In addition, almost every piece is unique. Examining human imagery in the ECAIC database necessarily involved separating images from patterns and separating images resembling humans from those resembling non-humans, through a process of grouping objects into nested assemblages at different scales. Given the ambiguity described above and the frequency of hybrid creatures and 'Cheshire cats' in the database, the definition of what makes a human image in this study is loose, and I am keen to emphasise that the process was extremely subjective. It is also important to note that the classification of human imagery was carried out using photographs, meaning that images on certain parts of objects, especially hidden parts, will undoubtedly have been missed. The data presented in the next part of the paper, therefore, relate to a (hopefully) representative sample of human imagery from Iron Age Europe, identified as such by researchers on the ECAIC project and our colleagues (see Nimura *et al.*, Chapter 2, this volume, for details of the sources of data for the ECAIC database).

The materiality and tactility of anthropomorphic imagery in Iron Age Europe

'Celtic Art' is a specific, historic category of Iron Age objects traditionally defined as being made from bronze or gold, and being decorated with swirly La Tène style patterns, although sometimes just one of these criteria apply (see Gosden & Hill 2008, 1; Garrow & Gosden 2012, chapter 2). Pattern and imagery of varied kinds, however, appeared on objects from across the full material assemblage in Iron Age Europe and beyond. This part of the paper aims to briefly introduce the wider assemblage of human images from Iron Age Europe and consider the material interactions involved in making and using them.

The human depictions identified in the ECAIC database are primarily made from bronze and gold. Bronze was often cast to create high-relief, three-dimensional patterns and images. Particularly complex designs appear as part of Paul Jacobsthal's

'Plastic Style', a good example being a terret or rein ring from Ile-de-France, Paris (Jacobsthal 1944, 175; Olivier, Chapter 6, this volume, Fig. 6.6), which bears images of faces that appear and disappear as the viewer moves around the object. Bronze was also worked in sheets and decorated using chasing and repoussé to create sinuous patterns. Engraving was used on both cast and sheet bronze to create fine lines, texture and two-dimensional patterns. Gold, similarly, was both cast and worked as sheet to create anthropomorphic images, sometimes being worked into extremely fine foil-like sheets to create mounts and masks (*e.g.* Eluère 1987, no. 66; Guštin 2014). Hammered sheet gold was also used to create three-dimensional objects that gave the illusion of being cast, in the cases of torc terminals from Late Iron Age Britain (Machling & Williamson 2018, 391–93). Iron also forms a substantial part of the Iron Age archaeological record, and it is not unlikely that human likenesses were made in this material, but the corrosion of iron means that most potential patterns on the surfaces of iron objects are generally not visible today (although see Joy, Chapter 7, this volume).

Small but well-known groups of large anthropomorphic stone statues and heads found in central Europe (6th–3rd century BC) and in southern Gaul (5th–2nd century BC) (*e.g.* Chaume & Reinhar 2011; Frey 1998; Frey & Hermann 1997; Green 1995, 466–67; Megaw & Megaw 1989, figs 82 and 84; see also Armit 2012) are often discussed along-side anthropomorphic images on metal objects (*e.g.* Megaw & Megaw 1989, figs 82 and 84). Both groups are often interpreted as images of warriors due to the weapons and armour they carry (Aldhouse-Green 2004, 40–41; Cassibry 2017, 18–22; Chaume & Reinhar 2011; Frey 1998; Megaw & Megaw 1989, 257). 'Warrior' figurines carved from blocks of chalk also form an important regional tradition in East Yorkshire, UK, where a group of Late Iron Age (*c.* 100 BC–AD 100) chalk figurines have been found (Giles in Frieman *et al.* 2017; Stead 1988), although the small scales of these figurines, many under 100 mm in height, suggest that their functions and effects were very different from those of the life-sized stone warriors made in Continental Europe several centuries earlier.

Decorated bone objects have not historically been discussed alongside metalwork in terms of their patterns (Chittock 2014), but images of humans are rare in this medium. Amongst so-called weaving combs from Iron Age Britain, which form a substantial group of decorated bone objects, just one, from Oxfordshire, has been identified as bearing recognisable anthropomorphic imagery (Thompson 2018). Similarly, although ceramic vessels are the most common finds on Iron Age sites across most of Europe, people are rarely depicted on them, even in regions where they are decorated (for example, Glastonbury wear in southern England; La Tène painted pottery in France). However, a group of *kantharos*-style vessels from eastern Europe have handles formed from the elongated bodies of humans. Depictions of people in organic materials are extremely rare in Europe, due to the generally poor preservation of these materials. A long tradition of depositing wooden figures in wetlands existed in north-west Europe between the Late Neolithic and the Middle–Late Iron Age, with Iron Age examples including the Kingsteinton figure (Coles 1990, 326). Coins, although made of bronze

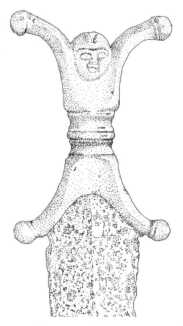

Fig. 5.1. An anthropomorphic bronze sword hilt from Saint-André-de-Lidon, Charente-Maritime, France (Musées de la ville de Saintes) (Illustration: H. Chittock).

and gold and present across most of Europe during the Late Iron Age, are another group of objects that tend to be discussed separately from the main body of Celtic Art. They frequently depict faces and sometimes also show full figures (*e.g.* Cassibry 2017; Talbot 2017). Undoubtedly, the constraints of the small flat surfaces of a coin had effects on the way that people could be depicted: something that is true of many of the small objects upon which human images appear.

Although the nature of the archaeological record means we will only ever see fragments of what the material world looked like in the Middle–Late Iron Age, the paragraphs above have tried to demonstrate that anthropomorphic images were made in a wide variety of materials worked in varied ways, and that some of these fall outside discussions of Celtic Art. The culturally contingent appropriateness of certain materials in making certain types of objects and pattern has been discussed in Iron Age contexts (Fitzpatrick 1997), and it certainly seems true that some materials were used for the purpose of depicting people more than others across Europe, with regional trends emerging when spatial resolution is high enough. The properties of different materials, and the processes used to work them, inevitably had effects on the types of images and patterns they were used to create. In the contexts of anthropomorphic images, gesture and scale were affected by these factors, as well as the impressions they were designed to create. Gesture, particularly the positioning of the arms of figures, has been discussed as being significant in conveying status (Aldhouse-Green 2004, 21); capturing the narratives being told by images (Giles in Frieman *et al.* 2017, 60); and making deliberate statements (Armit & Grant 2008). Material affordances will also have restricted the range of gestures it is possible to depict – creating protruding arms from chalk, for instance, may have been challenging, depending on its hardness, and may have affected the stability of standing figures (see Armit & Grant 2008, 410–11 for discussion of stability). These considerations were tempered by the intended functions of anthropomorphic images as parts of 'purposeful objects' (Fox 1958, v), and the forms these objects took. A good example of this is a group of swords with anthropomorphic hilts, where the sword handles are formed from standing human

figures with their arms outstretched above their heads and their legs splayed apart
(Fig. 5.1). In these images the figures *are* the hilts (Carlson 2011). The torsos of these
figures form the grips of the sword handles, meaning the wielders of these swords
would have been in direct contact with their bodies when holding them, much like
the handles of the ceramic vessels discussed above. Given the tactile nature of Iron
Age art (*e.g.* Aldhouse-Green 2004, 1), direct physical contact with anthropomorphic
images is likely to have been a part of the way they functioned.

The origins of Celtic Art and its anthropomorphic images

The origins of Celtic or La Tène Art have been pondered by archaeologists since the
late 19th century. Scholars have sought to explain its sudden appearance in Europe
and visual contrast with the geometric patterns of Hallstatt art, which was present
in Europe between *c.* 800 and 500 BC (Wells 2012, 1, 201; Chapter 3, this volume).
Traditionally, the influences of Greek and Etruscan art on Celtic Art have been
emphasised (*e.g.* Jacobsthal 1944), based on the appropriation of Greek and Etruscan
motifs, like *anthemia* (see Joy, Chapter 7, this volume, Fig. 7.2, Stage 1) and *peltae* (see
Joy 2008, 97) by Iron Age craftspeople to the north (Jacobsthal 1944, 88). However,
whilst Classical and Celtic Art share some characteristics, the geometry and symmetry
of these two styles are very different. Celtic Art is largely built around circular forms
and features deliberate asymmetry and the depiction of creatures from multiple
perspectives simultaneously, for example (Olivier 2014; Chapter 6, this volume),
whereas Classical art features symmetry and repetition. Contrasts between the
schematic representations of people that feature in Celtic Art and the seemingly
realistic portraits of Classical sculpture have often been commented upon (*e.g.*
Megaw 1970, 269), although it is acknowledged that naturalistic Greek sculpture is
no more realistic than the humans depicted in Celtic Art (Meyer 2013, 15–37), simply
representing a different kind of stylisation. The potential for ontologically different
kinds of body across a culturally diverse area (see Robb & Harris 2013, 2), which
included a colonial frontier, also make this comparison problematic. Nevertheless,
sculptures such as The Dying Gaul, a Roman copy of a Greek statue of a wounded bar-
barian warrior, are frequently compared with Iron Age images of warriors to illustrate
the differing modes of representation evident in these two artistic traditions, often
playing into the colonialist propaganda that these images were originally designed
to spread (Cassibry 2017). Equally problematic is the automatic interpretation of Iron
Age anthropomorphic images as deities, based largely on later written and epigraphic
evidence from Roman-occupied Europe (*e.g.* Aldhouse- Green 2004; Green 1995, 466).
Horned humans and other hybrid or modified humans have often been referred to in
terms of named characters in Greek and Roman mythology: satyrs and janus heads
for example (*e.g.* Jacobsthal 1944; Megaw 1970, 263). It is sometimes argued that Iron
Age deities took on the human forms of Roman Gods as Mediterranean traditions of
iconography influenced Iron Age art during the later Iron Age (*e.g.* Green 1995, 466),

though it is important to note that earlier Classical accounts from the later 1st millennium BC are also interpreted as stating that Iron Age Europeans did not make images of their deities (*e.g.* Diodorus Siculus, *Library of History*, XXII, 9). The bias inherent in Classical sources makes this a complex issue, and the assumption that similar images shared the same meanings over a huge and potentially culturally diverse geographical area is problematic. As was argued above, Celtic Art was designed specifically to be 'situational' and open to multiple interpretations (Garrow & Gosden 2012, 5). No image, therefore, would have had a fixed meaning.

The differences between artistic traditions in the Mediterranean world and the rest of Europe go far beyond modes of depiction. Wells argues that the sudden appearance of La Tène art in Europe in the mid-1st millennium BC was derived from a fundamental shift in the way that people in Iron Age Europe saw the world (Wells 2012, 202). This was induced by broader interactions with people from across Eurasia and resulting exposure to new ideas and patterns (Wells 2012, 207). The idea that La Tène art was influenced by art from regions to the east of Europe is not new. Paul Jacobsthal (1944, 156) was a key proponent of the notion that the art of the Scythians, nomadic groups who ranged across Central Asia during the 1st millennium BC, had influenced Celtic Art via Greece and Etruria, along with Persian art. Wells' work (2012; Chapter 3, this volume), however, shows that the adoption of particular aspects of design was far more than just 'influence', relating to the way that decorated objects were *used* by Iron Age Europeans (see Wells 2012, 9–11), in addition to the ways of seeing that underpinned their worldviews. Contextualising images within the objects they are part of introduces new perspectives on what they were for and what their effects might have been, allowing interpretation to move past what they represented. Acknowledging that Iron Age art is generally not a static art, but was made to be handled, worn, carried and used introduces ideas of movement, dynamism and tactility, adding to the notion that its designs were 'conditional and situational' (see Jones 2019, 191).

The time and space of anthropomorphic imagery: Data from the ECAIC project

The remainder of this paper examines Iron Age anthropomorphic imagery at two different scales to highlight some of the similarities and differences that existed in the way images of humans were created and deployed across Eurasia. This section of the paper will explore some broad trends in the spatial and temporal distribution of European human imagery in data collected and analysed during the ECAIC project. In doing this, it establishes the idea that images of people were important in Celtic Art across Europe, but that their functions and significance varied on regional and supra-regional bases. Like Celtic Art as a broader category, the use of human imagery demonstrates the interpretation of broad stylistic ideas on a regional scale.

The ECAIC project compiled a database containing 38,383 objects from Iron Age Europe (Nimura *et al.*, Chapter 2, this volume). The project has been working to characterise Celtic Art across Europe and examine the long-distance Eurasian connections that resulted in its emergence, through comparing objects from the project's database with groups of objects from the 'Scythian' world, and beyond. This part of the paper focuses on the European database to provide an example of the ways in which the ECAIC project is using this data. Just 517 objects from this database were identified as bearing images of people. Although these 517 objects make up just 1.3% of the whole database, humans were, by far, the creatures most often depicted. Objects with anthropomorphic imagery make up 36.7% of objects bearing depictions within the database.[2] Other creatures often associated with Celtic Art, such as horses and pigs/boar, were much rarer. Objects bearing these creatures make up just 5.7% and 3.4% of all objects with depictions identified within the database, respectively.[2]

The spread of human imagery across Europe (Fig. 5.2) generally reflects the overall distribution of objects within the database, which, as discussed by Nimura *et*

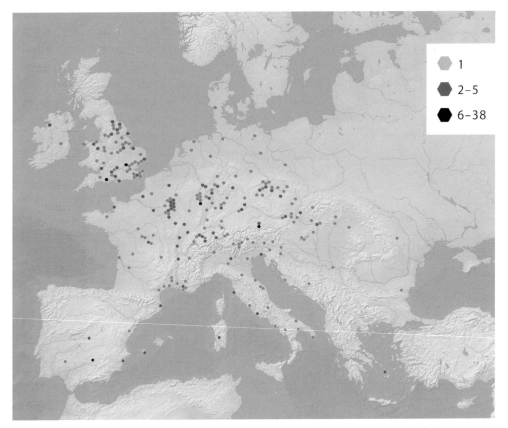

1
2–5
6–38

Fig. 5.2. The distribution of anthropomorphic imagery in the ECAIC database.

al. (Chapter 2, this volume), has been influenced by a wide range of different factors. Human imagery is fairly prevalent in parts of England and Wales, reflecting the major concentration of objects here within the ECAIC project's European database, which is due partially to the composition of the database and potentially also to genuine Iron Age patterns. There is also a broader distribution of human imagery in the area to the north of the Alps, with spots of concentration reflecting the locations of finds-rich sites in the Marne region of France (*e.g.* Chapry 1996; Morel 1898; Olivier 2006–7; Schöenfelder 2004; Stead & Rigby 1999; Stead *et al.* 2006); south-western Germany (*e.g.* Collis 2003, 114–18; Fernández-Götz 2014; Krausse, Chapter 9, this volume); the border between Germany, Poland and the Czech Republic; the western Carpathians (*e.g.* Rustoui 2006); the Swiss Alps (*e.g.* Tori 2004); and the coast around the Gulf of Lion, all of which are areas where concentrations of Celtic Art exist more broadly in the ECAIC database. Whilst the overall geographical distribution of objects adorned with human imagery is reflective of the distribution of objects in the database overall, breaking these data down into particular object types reveals regional and supraregional traditions. Human images had different functions on different objects in different places at different times. The paragraphs below will use examples to demonstrate this, as this paper is too short to discuss the use of human imagery on all object types.

Objects of personal ornament, including brooches, torcs, bracelets and other forms of jewellery, are by far the most frequent objects in the ECAIC database overall, representing 45.4% of the database. The geographical distribution of this group of objects reflects that of the overall database, partly because it makes up such a large percentage of the database. However, the appearance of human imagery on objects of personal adornment, which constitutes 36.9% of human images in the database, has a specific geographical distribution stretching from north-east France in the west to the north-western part of the Carpathian mountain range in the east (Fig. 5.3). A significant part of this distribution is made up by a group of Early La Tène (*c.* 450–380 BC) fibulae known as *Maskenfibeln* (Krausse, Chapter 9, this volume, Fig. 9.11). These brooches have often been excavated from graves in central Europe (*e.g.* Bagley & Schumann 2013, 131–34; Binding 1993; Megaw & Megaw 1989, 84–88). Their cast bronze forms depict exuberant three-dimensional hybrid creatures, sometimes consisting of anthropoid faces linked to other faces by the bow of the brooch, including those of birds, boars and other indeterminate creatures. They have recently been discussed as potential 'prestige goods' (Bagley & Schumann 2013, 130–33) or as being related to individual identity (Megaw & Megaw 1989, 88). They are unlike other forms of hybrid creature in art from Iron Age Europe (but see Megaw & Megaw 1989) but resemble, in a schematic sense, broadly contemporary images of deer from Scythian metalworking traditions at sites such as Pazyryk (Altai Mountains, Siberia) and Fillipovka (Southern Ural Region, Russia), some of whose antler tines end with birds' heads (*e.g.* Jacobson 1995, 224; 2006). The antlers of the deer appear to metamorphose into flying birds (Jacobson 2006, 192), and it is possible that humans and other creatures on European

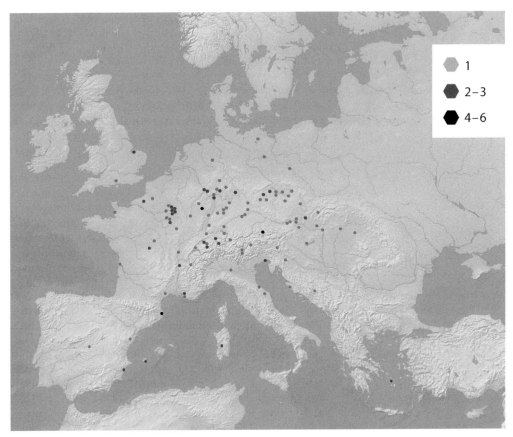

Fig. 5.3. The distribution of anthropomorphic imagery on items of personal ornament in the ECAIC database.

Maskenfibeln are also metamorphosing, captured mid-transformation. During a similar time period, a separate tradition of depicting hidden human faces on torcs and bracelets also existed in the Marne region of France, south-western Germany, Switzerland, generally during the Middle Iron Age (Megaw & Megaw 1989, 136–37). Two examples of torcs with human imagery from the ECAIC database have also been found at Snettisham in Norfolk (UK) (Stead 1991), one of which has a Late Iron Age production date, whilst the other may be significantly older (Joy forthcoming).

The large stone statues and tiny figurines mentioned earlier in the paper present contrast in terms of their size and the scale of their effects, but also in terms of their spatial and temporal distributions. The large stone figures of central Europe (6th–3th century BC) (see Megaw & Megaw 1989, figs 82 and 84) and southern Gaul (5th–2nd century BC) (*e.g.* Green 1995, 466–67) appear in the 'Sculpture' category of the ECAIC database. This contains only a very small proportion of the objects overall (0.2%) but a larger proportion of objects with human images (9.9%). The central European group

includes full-body sandstone examples from the Glauberg (Fig. 5.4), Hirschlanden and Holzerlingen (Germany) (see Megaw & Megaw 1989, 45, 75, 257), male figures that wear various ensembles of weapons and accessories, which are discussed later in the chapter, and stone heads, such as that from Mšecké Žehrovice (Czech Republic) (Megaw & Megaw 1989, 124, pl. XVII). The group of southern Gaulish sculptures also include male figures wearing armour, such as the examples at Lattes and Entremont, and disembodied heads, such as those from Entremont (Cassibry 2017, 18–20; Green 1995, 467), although these appear in different styles to the central European examples.

Conversely, a group of small figurines, generally ranging in size from 20–80 mm in height are generally made from bronze, but also encompass the chalk examples discussed earlier (*e.g.* Giles in Frieman *et al.* 2017; Stead 1988). These figurines, along with a category of small bronze mounts, measuring under 50 mm in height, are concentrated within England and Wales, generally being found as stray finds. They reflect, in part, an apparent explosion in the use of anthropomorphic images in Britain during the Late Iron Age (*c.* 100 BC–AD 43) (Lamb forthcoming). Surviving images of humans from Middle Iron Age Britain (*c.* 400–100 BC) are very rare and tend to be part of broader continental traditions, the primary examples being the group of anthropoid sword and dagger hilts, which were described above (Fig. 5.1). The frequency of small figurines in England and Wales during the Late Iron Age is, perhaps, related to a wider

Fig. 5.4. The Glauberg Statue (c. 500 BC). Height: 186 cm (Keltenwelt am Glauberg) (Illustration: H. Chittock).

Late Iron Age tradition of miniature objects, also including weapons and shields (Farley 2011; Stead 1998), other object types and animals. These miniatures are usually interpreted as votive objects and the act of depositing them has been described as 'the amplification of power and symbolism' (Parker & McKie 2018, 39). The act of creating a miniature version of an object or creature may have been equally as powerful. Conversely, Bailey, Cochrane and Zambelli (2010, 19) discuss the making and use of miniatures as creating spaces or environments for reflection and contemplation. The frequency of small metal objects being deposited seems to have increased dramatically in the Late Iron Age, as first explored by Jundi and Hill (1998) in their 'fibula event horizon', which also occurred on the continent. Lamb (forthcoming) has argued that the increase in human imagery in Late Iron Age Britain, however, is not attributable to changing depositional practices or to the formation of the archaeological record, but to the transitional nature of personhood during this period, with emphasis shifting from more 'expansive' and permeable communal concerns towards individual bodies.

The proportion of anthropomorphic images found on objects of armour and weaponry in the ECAIC database is roughly comparable to the proportion of the overall database made up of these objects. However, looking in detail at this category reveals a focus for the depiction of humans on the handles of swords and daggers, in the specific way that was described earlier in the paper (Fig. 5.1). Of the 50 objects of armour and weaponry in the ECAIC database with human images, 41 are bladed weapons and 25 of these weapons have anthropoid hilts. In addition, the pommels of 5 further examples take the forms of human heads. This group of objects is concentrated within the Champagne region of France, but they also appear in other parts of France, Hungary, the Czech Republic, Britain and Ireland, for example (*e.g.* Carlson 2011; Clarke & Hawkes 1956, 199, 225–57; Megaw & Megaw 1989, 164–66; Stead 1979, 61, fig. 22, 1; White 1979, 4), and have a long history in the Middle–Late Iron Age. As mentioned previously, the wielders of these swords and daggers will have been in direct contact with the torsos of the figures whilst using the weapons, and this is, perhaps, part of how these images functioned (or part of the reason why weapon handles were chosen as media for the depiction of bodies).

The examples given above have presented vignettes of a very complex scene, where human imagery was employed in varied ways that sometimes coalesced into 'traditions' with differing spatial and temporal reach. As I suggested earlier in this paper, the functional forms of objects and the capacities of the materials they were made from may have partly governed the types of images produced. All Celtic Art objects were useful, tactile and 'purposeful things' (Fox 1958, v). More recent discussions have continued in a similar vein, advancing the argument to suggest that the patterns that adorned these objects were part of what made them effective (Garrow & Gosden 2012; Garrow *et al.* 2008). Anthropomorphic images were part of the 'technologies of enchantment' (Garrow & Gosden 2012; Gell 1992; 1998) that contributed to the effects Celtic Art. It seems that human images were deployed in specific spheres of activity, which varied in time and space across Iron Age Europe: jewellery, weaponry, hand-held figurines and imposing statues; deposited in graves or rivers or displayed above ground. The data presented in this section of the chapter supports the idea that anthropomorphic images in Iron Age Europe were situational and that the significance and function they had was not fixed but dependent on regional and local context as well as the spheres of activity in which they were employed. Like the category of 'Celtic Art' it is sometimes seen to belong to, the human imagery discussed is extremely diverse in terms of its functions and effects, and could similarly be seen to represent not one category but many.

Depicting dress: Warrior beauty and ways of seeing in Iron Age Eurasia

So far, this paper has looked at images of humans in the contexts of the purposeful objects on which they appear to consider their functions and effects and the ways these varied across a large geographical area. Whilst the employment of anthropomorphic

images was locally and regionally contingent across Europe, however, some schematic aspects of this imagery appear to manifest themselves in similar ways much more broadly across parts of Europe and beyond, across the Eurasian steppe. Human features are abstracted or downplayed, whilst the objects they wear and carry are depicted in detail. The following paragraphs discuss the combination of people and objects in Iron Age art and seek to explain the commonalities that appear to exist broadly in time and space.

Dress in the archaeological record

Many of the objects mentioned in this paper are objects that can be worn. Groups of personal ornament and dress components include items of jewellery, accessories and fittings from garments. These are objects that seemingly perform their primary purposes whilst or by being worn. However, the category of worn objects quickly expands when other objects carried on the body are considered. Objects related to appearance – mirrors and toilet sets, for example – can be worn upon the body and arguably had aesthetic functions that were heightened whilst being worn. Weapons, although their primary functions are often seen as being related to physical combat, formed vital visual aspects of some Iron Age outfits. Sword scabbards from across Europe have suspension loops, allowing them to be worn on a belt or across the back, and helmets were, perhaps, as much garments as they were armour. Some weapons are discussed as 'parade' or 'display' weapons, designed to intimidate rather than physically injure opponents, the Battersea Shield being a particularly famous example (Bradley 2009, 38; Giles 2008). Discussion of the visual effects of Iron Age weapons (Garrow & Gosden 2012; Giles 2008) from a Gellian perspective (Gell 1992) suggest the functions of weapons in causing injury and intimidation were inextricable and perhaps equally important. Tools could easily have been carried around in a similar fashion to weapons, and some have suspension loops perhaps used for the purpose of wearing them around the neck or belt (*e.g.* Chittock 2014).

In addition to the durable accessories described above, garments in organic materials also formed important visual features of Iron Age outfits. Classical accounts and depictions form important (but often unreliable) sources on Iron Age dress. In these sources, descriptions of Iron Age clothing vary from portrayals of Iron Age people as naked, wearing only animal skins (*e.g.* Caesar, *Gallic War*, V, 14; Herodian *Roman History*, III, 14, 6–8), to renderings of elaborately decorated clothing in bright hues (Diodorus Siculus, *Library of History*, V, 30; see Foulds 2017, 1), the depictions of Scythian archers on Greek painted pottery described by Gleba forming a good example of the latter (Gleba 2008). Surviving woven fabrics from Iron Age Europe are rare, but the fragments that do exist are often vividly coloured with complex weaves. Early–Middle Iron Age textiles recovered from Hallstatt and Durrnberg salt mines are a good example of this (Gleba & Pásztókai-Szeőke 2013; Gromer *et al.* 2013), and well-preserved fabrics from Siberian permafrost sites of the Scythian Period paint a

similar picture. At sites where this level of preservation is not possible, the mineralised impressions of textiles are occasionally found in the corrosion products of iron brooches, which had originally pinned garments together (*e.g.* Crowfoot 1991). Like fabric, leather rarely survives in the archaeological record, but in the conditions of the Durrnberg salt mine in Austria, whole shoes, for example, have survived (see Stöllner *et al.* 2003). Bog bodies from north-west Europe also provide evidence for the wearing of smaller-scale accessories made from organic materials. Lindow Man, for example, was found wearing only a fox fur armband (Giles 2009, 83), whilst Old Crogan Man wore a plaited leather armband decorated with copper alloy fittings (Giles 2009, 84; Mulhall & Briggs 2007, 73). When suites of garments and accessories were combined, the overall visual effects may have been extremely striking, perhaps contesting views of the Iron Age that see this period of time as having been fairly plain in terms of colour and pattern (*cf.* Joy 2011).

Dressing anthropomorphic images

The paragraphs above have briefly summarised the wide range of objects and materials that are thought to have constituted dress in the Iron Age (see Gleba 2008 for a detailed discussion of evidence for Scythian dress). Significantly, only a small proportion of these objects appear in anthropomorphic images from the ECAIC database. This part of the paper will discuss the selection of objects depicted, suggesting it may have been part of the presentation and performance of a particular category of person.

The dataset referred to here is small, representing a small proportion of the anthropomorphic imagery discussed earlier in the paper. In the ECAIC database, 149 full-body or partial-body depictions, where limbs and torsos are included, have been identified, ranging from life-sized stone statues to tiny bronze figurines, and many of them are stylised and/or naked. The disembodied heads often favoured by Iron Age craftspeople (Armit 2012) also limit the range of garments and accessories that can be depicted. Perhaps unsurprisingly, the frequencies of the objects depicted on figures do not reflect the frequencies of these objects in the archaeological record. Brooches, the most frequent objects within the ECAIC database (20.2%), have not been identified on any anthropomorphic images in the database. Torcs, conversely, were the most frequent personal ornaments depicted, despite comprising only 4.0% of the database. The most common type of object that appears in anthropomorphic images in the ECAIC database is headgear, which appears rarely in the archaeological record, due to its organic nature (although see Reeves 2015, 2). Across Europe, images of people can be seen wearing large ear-like headdresses or *Blattkronen* (leaf-crowns) (Fitzpatrick 2007, 304; Fitzpatrick & Schöenfelder 2014; Frey 2002), and a wider range of other organic headdresses are also represented in anthropomorphic imagery, for example a birch bark hat resembling remains found in the Late Hallstatt princely grave at Hochdorf can be seen on the large stone statue of a similar date at Hirschlanden (Reeves 2015, 2, 17). The frequency of both torcs and headgear in anthropomorphic

imagery is, undoubtedly, due partly to the Iron Age focus on depicting the human head (Armit 2012). However, the combination of these items with other garments and accessories in full-body depictions suggests that other factors were also at work.

Weaponry and armour are also recurring features in full-body anthropomorphic images across parts of Iron Age Europe and beyond. The Gaulish stone figures at Entremont wore chainmail. Garments depicted on the Glauberg statue; a bronze vessel from Barrow 1 also from Glauberg (Frey 1998, 9–11; Frey & Hermann 1997; Megaw & Megaw 1989, 257); a scabbard from Hallstatt (Megaw & Megaw 1989, 80–81); and a statue of a seated figure from Roquepertuse (Jacobsthal 1944, no. 4; Megaw & Megaw 1989, 168–70) are interpreted as fringed leather or fabric armour (Frey 1998, 11), with some examples appearing to bear punched decoration. Swords and shields are frequently worn with armour. Swords form focal points for the gestures of the chalk figurines of Late Iron Age East Yorkshire, where one hand reaches behind their heads to grasp the hilts of the swords they wear on their backs (Giles in Frieman *et al.* 2017). Swords and shields are seen on the Hirschlanden statue, Greek-made Braganza brooch, and the Glauberg statue (Frey 1998, 6; Megaw & Megaw 1989, 257), for example, and shields and spears are carried on the Hallstatt scabbard (Megaw & Megaw 1989, 168–70). Gleba (2008, 19–20) describes a large group of 7th–4th century BC Scythian stone statues in the northern Black Sea region that also generally wear similar suites of armour, weapons and torcs.

Outside this limited repertoire of torcs, headgear, armour and weaponry, few objects accompany anthropomorphic images in the ECAIC database, other than a lyre, which appears in a stone figure from Paule (France). As emphasised in this paper, the ECAIC database contains a limited range of materials and the fragmentary nature of the Iron Age archaeological record means that it is impossible to know the full range of images that existed. But it is possible to argue, given the evidence presented, that there was a bias towards the depiction of humans carrying and wearing particular objects within the assemblage of bronze, gold and stone objects examined. Significantly, the torcs, headgear and weapons described above were (almost) all depicted as parts of figures with penises, moustaches and other features that, according to modern, Western categories, would generally qualify them as 'male'. Conversely, only five images were identifiable as 'females' across the ECAIC database (plus five possible females and one figure with breasts and male genitalia). It is acknowledged that essentialist, binary views of sex and gender in prehistory are as problematic (Robb & Harris 2018) as they are today – it is likely that sex and gender in the Iron Age were multilayered and multifaceted in different ways to how they are in the 21st century. However, a pattern of selectivity does appear to emerge.

How can this selectiveness be explained? I argue that, perhaps, the making of these images was part of the performance of a particular category of identity associated with the wearing of this specific uniform of objects and garments. Paul Treherne's work on Bronze Age warrior beauty, which he describes as a pan-European phenomenon (Treherne 1995; recently revisited by Frieman *et al.* 2017), argues that the leading of a particular lifestyle and the use of a particular

set of objects – personal weaponry, drinking equipment, bodily ornamentation, grooming tools, horse harnesses and wheeled vehicles – contributed to the performance of a particular category of masculine identity: that of 'the warrior' (Rebay-Salisbury in Frieman *et al.* 2017, 40; Treherne 1995, 105). Although the idea of a prehistoric warrior can be examined and critiqued (*e.g.* Hunter 2005), images of well-groomed males wearing torcs in the ECAIC database do look very similar to the picture of the warrior that Treherne conjures up. Importantly, Treherne's warrior identity was one of one of many 'divergent, multiple masculinities' (Rebay-Salisbury in Frieman *et al.* 2017, 41; Treherne 1995, 91). The fluidity of personal identity means that the role of the warrior may have related to a particular life course (Bruck in Frieman *et al.* 2017, 40), age group or status group (Rebay-Salisbury in Frieman *et al.* 2017, 42). It may have been temporary and context dependent (Giles 2012, 242).

Given the selective depiction of male figures wearing and carrying a specific suite of objects within the ECAIC database, perhaps it can be argued that 'warrior beauty' existed in a different form during the Iron Age, constituting a particular facet of male identity. This is not to suggest that weapons, torcs and armour were exclusively associated with males. Rebay-Salisbury (2016, 7.6.4), writing on Early Iron Age central Europe, explains the use of images of weaponry to express a particular facet of female identity. It could be said, however, that the creation of images of people with torcs, weapons, penises and moustaches was part of the performance of one aspect of male identity, perhaps even a particular gender, which other types of presentation of the male body also contributed to: male 'warrior burials' (Giles 2012, 26–27); and the performative aspects of male violence (Giles in Frieman *et al.* 2017), for example. This brief discussion has tried to move beyond a representational approach to images of 'warriors'. If we think of the crafting, use, display and deposition of warrior images as part of multilayered performances, they take on new functions. Instead of representing, venerating or commemorating great warriors, we can perhaps see the making of these images as part of an active process.

Importantly, the potential warrior images described were present in relatively small numbers in different localities across Europe and further east in the northern Black Sea region (Gleba 2008, 19–20) and at different points in the Middle–Late Iron Age. Given the discussion of the effects and functions of anthropomorphic imagery as situational and variable earlier in the paper, we cannot view these images as a homogenous group, rather as variations on a theme, particularly given their spatial and temporal distance. They were made, used and deposited in different ways and can be found on different types of object, making the performances associated with them variable.

Objects and bodies: Selective realism or a particular way of seeing?

The final part of this paper briefly explores a second aspect of the selectivity involved in creating anthropomorphic imagery in the Iron Age, examining in greater detail the relationships between images of humans and the objects depicted with them. Across

Iron Age Eurasia, anthropomorphic images deliberately emphasise particular bodily characteristics while downplaying others (Aldhouse-Green 2004, 179–93; Gleba 2008, 20–21). Aldhouse-Green (2004, 179–93) describes the enlargement of certain features, such as hands and eyes. My focus here, however, is on the differing treatments of humans and objects. The humans depicted in the ECAIC database are generic and often highly stylised. Conversely, the objects depicted are detailed, and, in some cases, they resemble closely particular objects found within the archaeological record. A good example from Iron Age Europe is the torc worn by the Glauberg statue, which appears very similar to a gold torc found in Grave 1, within an adjacent mound (Frey 1998, 4–6; Megaw & Megaw 1989, 257). Other objects pictured on the statue also resembled some of the objects from Grave 1 (Frey 1998, 4–6). The Glauberg warrior himself, however, is almost cartoon-like, with blank, staring eyes, a downturned mouth and exaggerated leg muscles (see Fig. 5.4). Similar observations can be made of a group of stone statues attributed to the Scythians (Gleba 2008). The deerstones of the Eurasian steppe, dated broadly to the 1st millennium BC (*e.g.* Adelchanov *et al.* 2016; see also O'Sullivan & Hommel, Chapter 4, this volume), present a more extreme version of this scenario, where (except in a handful of cases) all identifiable human features are absent, while their ornaments and the tools hanging from their belts are immediately recognizable (Peter Hommel, pers. comm.).

Objects and humans were, therefore, given differing treatments in Iron Age art, stretching across a very broad area, reflecting the contingent nature of the body, which underwent major shifts at several points during later prehistory (Harris *et al.* 2013). It is tempting to suggest that these images were deliberately composed in a way that emphasised ontological differences between people and things. One of the effects of these images is that the features we use to identify a particular individual are suppressed (*e.g.* face shape and features) whilst the individuality of objects is emphasised. Could the suppression of human individuality be a way of highlighting the individuality of important objects, which was an important concern in Iron Age Europe (Garrow *et al.* 2009, 111), or should we see it not as suppression, rather a different level of abstraction?

It is, perhaps, most significant that similar ways of marking this distinction between people and things seem to have existed across different parts of Eurasia. The question of whether realism was being systematically manipulated on a large geographical and temporal scale is problematic for a number of reasons, not least the culturally contingent nature of realism itself, which I discussed earlier in the paper. I have emphasised both the idea that Iron Age was situational and conditional (see Jones 2019, 191) and the idea that Iron Age Eurasians saw the world in distinct, culturally specific ways (Wells 2012; Chapter 3, this volume), making the idea that it is possible for me to judge levels of realism in these images from any position but my own untenable. In addition, given the variable functions of anthropomorphic images in time and space, the idea that such a tradition existed over such a wide geographical area and timescale is problematic, especially given

the emphasis on regional difference present in the ECAIC database. I suggest, instead, that the similar treatments of bodies and objects across Eurasia are a feature of the distinct ways of seeing the world that were present across Eurasia in the Iron Age.

An integrated approach to human imagery: Final thoughts

This paper has presented similarities and differences in the performance and purpose of Iron Age art across a huge geographical area. I have worked at several different spatial scales, considering a particular aspect of this art at a pan-European scale and looking further afield to other parts of Eurasia, whilst also examining regional trends (see Harris 2017; Robb & Pauketat 2013). In doing this, I have sought to describe the complexity and regional variation in Iron Age art across Europe, whilst also acknowledging that broad commonalities may have been at work. Whilst the purposes and appearances of anthropomorphic images varied in time and space throughout Middle–Late Iron Age Europe, their dynamic and tactile elements, and perhaps their roles in performance, were similar.

Acknowledgements

This paper was written as a result of my time working on the European Celtic Art in Context Project during 2017–18. I am hugely indebted to my colleagues on the project, Chris Gosden (PI), Courtney Nimura and Peter Hommel, and to the project's expert Advisory Board. I also owe my thanks to Leverhulme Trust for funding the project. Thanks also to the delegates of the Art in the Eurasian Iron Age workshop, and to the two reviewers of the paper for offering their invaluable comments.

Notes
1, 2 Objects depicting multiple species were counted multiple times in this analysis.

References

Adelchanov, K., Zharkenova, A., Kolumbaeva, Z., Muratbekkyzy, B., Erdenbekova, Z. & Selkebayeva, A. 2016. Steppes deer stones. *The Anthropologist* 26(1–2), 1–4.
Aldhouse-Green, M.J. 2004. *An Archaeology of Images: Iconology and cosmology in Iron Age and Roman Europe*. London, Routledge.
Armit, I. 2012. *Headhunting and the Body in Iron Age Europe*. Cambridge, Cambridge University Press.
Armit, I. & Grant, P. 2008. Gesture politics and the art of ambiguity: The Iron Age statue from Hirschlanden. *Antiquity* 82, 409–22.
Bagley, J.M. & Schumann, R. 2013. Materialized prestige: Remarks on the archaeological research of social distinction based on case studies of the late Hallstatt golden necklaces and early La Tène Maskenfibbeln. In R. Karl & J. Leskovar (eds), *Interpretierte Eisenzeiten. Fallstudien, Methoden, Theorie. Tagungsbeiträge der 5. Linzer Gespräche zur interpretativen Eisenzeitarchäologie. Studien zur Kulturgeschichte von Oberösterreich*, 123–36. Studien zur Kulturgeschichte von Oberösterreich 37. Linz, Landesmuseum.

Bailey, D., Cochrane, A. & Zambelli, J. 2010. *Unearthed: A comparative study of Jōmon dogū and Neolithic figurines.* Morwich, Sainsbury Institute for the Study of Japanese Arts and Culture.

Binding, U. 1993. *Studien zu den figürlichen Fibeln der Frühlatènezeit.* Universitätsforschungen zur prähistorischen Archäologie 16. Bonn, Habelt.

Bradley, R. 2009. *Image and Audience: Rethinking prehistoric art.* Oxford, Oxford University Press.

Caesar, J. *Gallic War.* Translated by A. McDevitte & W.S. Bohn 1869. New York, NY, Harper & Brothers.

Carlson, J. 2011. A symbol — but of what? Iron Age daggers, Alessi corkscrews and anthropoid embellishment reconsidered. *Antiquity* 85(330), 1312–24.

Cassibry, K. 2017. The tyranny of the *Dying Gaul*: Confronting an ethnic stereotype in ancient art. *The Art Bulletin* 99(2), 6–40.

Chapry, J.-J. 1996. Les celtes en Champagne du VIe au IIIe siecle avant J.-C.: la nécropole de Dormans (Marne) dans son contexte régional [The Celts in Champagne from the 6th to 3rd centuries BC: the cemetery at Dormans (Marne) in the surrounding area]. Unpublished PhD thesis, Ecole pratique des hautes études.

Chaume, B. & Reinhar, W. 2011. Les statues du sanctuaire de Vix-Les Herbues dans le contexte de la statuaire anthropomorphe hallstattienne in Stèles et statues du début de l'âge du Fer dans le Midi de la France (VIIIe-IVe s. av. J.-C.): Chronologies, fonctions et comparaisons. Actes de la table ronde de Rodez. Textesréunis par Philippe GRUAT et Dominique GARCIA. *Documents d'Archéologie Méridionale* 34, 293–310.

Chittock, H. 2014. Arts and crafts in Iron Age Britain: Reconsidering the aesthetic effects of weaving combs. *Oxford Journal of Archaeology* 33(3), 313–26.

Chittock, H. 2017. Pattern and Purpose in Iron Age East Yorkshire. Unpublished PhD thesis, University of Southampton.

Clarke, R. & Hawkes, C. 1956. An Iron anthropoid sword from Shouldham, Norfolk with related Continental and British weapons. *Proceedings of the Prehistoric Society* 21, 198–227.

Coles, B. 1990. Anthropomorphic wooden figures from Britain and Ireland. *Proceedings of the Prehistoric Society* 56, 315–33.

Collis, J. 2003. *The Celts: Origins, myths, interventions.* Stroud, Tempus.

Collis, J. 2014. The Sheffield Origins of Celtic Art. In Gosden *et al.* 2014, 19–27.

Crowfoot, E. 1991. The textiles. In I. Stead, *Iron Age Cemeteries in East Yorkshire*, 119–25. London, English Heritage.

Diodorus Siculus. *Library of History, Volume III: Books 4.59-8.* Translated by C.H. Oldfather. 1939. Loeb Classical Library 340. Cambridge, MA, Harvard University Press.

Diodorus Siculus. *Library of History, Volume XI: Fragments of Books 21-32.* Translated by F.R. Walton. 1957. Loeb Classical Library 409. Cambridge, MA, Harvard University Press.

Egri, M. 2014. Heads, masks and shifting identities: A note about some Danubian kantharoi with anthropomorphic decoration. In Gosden *et al.* 2014, 73–85.

Eluère, C. 1987. *L'Or des Celtes [The Gold of the Celts].* Paris, Bibliothèque des Artes/Fribourg, l'Office du Livre.

Farley, J. 2011. The deposition of miniature weaponry in Iron Age Lincolnshire. *Pallas: Revue d'etudes antiques* 86, 97–121.

Fernández-Götz, M. 2014. Understanding the Heuneburg: A biographical approach. In M. Fernández-Götz, H. Wendling & K. Winger (eds), *Paths to Complexity: Centralisation and urbanisation in Iron Age Europe*, 24–34. Oxford, Oxbow Books.

Fitzpatrick, A. 1997. Everyday Life in Iron Age Wessex. In A. Gwilt & C. Haselgrove (eds), *Reconstructing Iron Age Societies*, 73–86. Oxford, Oxbow Books.

Fitzpatrick, A. 2007. Druids: Towards an archaeology. In P. de Jersey, C. Gosden, H. Hamerow & G. Lock (eds), *Communities and Connections: Essays in honour of Barry Cunliffe*, 287–315. Oxford, Oxford University Press.

Fitzpatrick, A. & Schönfelder, M. 2014. Ascot hats: An Iron Age leaf crown helmet from Lincolnshire? In Gosden *et al.* 2014, 296–306.

Foulds, E. 2017. *Dress and Identity in Iron Age Britain: A study of glass beads and other objects of personal adornment*. Oxford, Archaeopress.

Fox, C. 1958. *Pattern and Purpose: A survey of Early Celtic Art in Britain*. Cardiff, The National Museum of Wales.

Frey, O-H. 1998. The stone night, the Sphinx and the Hare: New aspects of early figural Celtic Art. *Proceedings of the Prehistoric Society* 64, 1–14.

Frey, O.-H. 2002. Menschen oder Heroen? Die Statuen vom Glauberg und die Frühe Keltische Grossplastik. In H. Baitinger & B. Pinsker (eds), *Das Rätsel der Kelten vom Glauberg. Glaube-mythos-wirklichkeit*, 208–18. Stuttgart, Theiss.

Frey, O-H. & Hermann, F.R. 1997. Ein frühkeltischer Fürstengrabhügel am Glauberg im Wetteraukreis, Hessen. Berichtüber die Forschungen 1994–1996. *Germania* 75, 459–550.

Frieman, C., Brück, J., Rebay-Salisbury, K., Bergerbrant, S., Montón Subías, S., Sofaer, J., Knüsel, C.J., Vankilde, H., Giles, M. & Treherne, P. 2017. Aging well: Treherne's 'Warrior's Beauty' two decades later. *European Journal of Archaeology* 20(1), 36–73.

Garrow, D. & Gosden, C. 2012. *Technologies of Enchantment? Exploring Celtic Art: 400 BC to AD 100*. Oxford, Oxford University Press.

Garrow, D., Gosden, C. & Hill, J.D. (eds). 2008. *Rethinking Celtic Art*. Oxford, Oxbow Books.

Garrrow, D., Gosden, C., Hill, J.D. & Bronk Ramsey, C. 2009. Dating Celtic Art: A major radiocarbon dating programme of Iron Age and Early Roman metalwork in Britain. *Archaeological Journal* 166, 79–123.

Gell, A. 1992. The technology of enchantment and the enchantment of technology. In J. Coote & A. Shelton (eds), *Anthropology, Art and Aesthetics*, 40–66. Oxford, Clarendon.

Gell, A. 1998. *Art and Agency: An anthropological theory*. Oxford, Oxford University Press.

Giles, M. 2008. Seeing red: The aesthetics of martial objects in the British and Irish Iron Age. In Garrow *et al.* 2008, 59–77.

Giles, M. 2009. Iron Age bog bodies of north-western Europe: Representing the dead. *Archaeological Dialogues* 16(1), 75–101.

Giles, M. 2012. *A Forged Glamour: Landscape, identity and material culture in the Iron Age*. Oxford, Windgather Press.

Gleba, M. 2008. You are what you wear: Scythian costume as identity. In M. Gleba, C. Munkholt & M.L. Nosch (eds), *Dressing the Past*, 13–28. Oxford, Oxbow Books.

Gleba, M. & Pásztókai-Szeőke, J. (eds). 2013. *Making Textiles in Pre-Roman and Roman Times: People, places, identities*. Ancient Textiles Series vol. 13. Oxford, Oxbow Books.

Gosden, C. & Hill, J.D. 2008. Introduction: Re-integrating Celtic art. In Garrow *et al.* 2008, 1–14.

Gosden, C., Crawford, S. & Ulmschneider, K. (eds). 2014. *Celtic Art in Europe: Making connections*. Oxford, Oxbow Books.

Green, M.J. 1995. The gods and the supernatural. In M.J. Green (ed.), *The Celtic World*, 465–88. London, Routledge.

Gromer, K., Kern, A., Reschreiter, H. & Rosel-Mautendorfer, H. 2013. *Textiles from Hallstatt: Weaving culture in Bronze Age and Iron Age salt mines* [*Textilien aus Hallstatt: Gewebte Kultur aus dem bronze- und eisenzeitlichen Salzbergwerk*]. Budapest, Archaeolingua Alaptvny.

Guštin, M. 2014. The human masks of unknown provenience. In Gosden *et al.* 2014, 68–72.

Harris, O. 2017. Assemblages and scale in archaeology. *Cambridge Archaeological Journal* 27(1), 127–39.

Harris, O.J.T., Rebay-Salisbury, K., Robb, J. & Stig-Sorensen, M.L. 2013. The body in its social context. In J. Robb & O.J.T. Harris (eds), *The Body in History: Europe from the Palaeolithic to the future*, 64–97. Cambridge, Cambridge University Press.

Herodian of Antioch. *Roman History*. Translated by E.C. Echols. 1961. Berkley, CA, University of California Press.

Hicks, D. 2010. The material-culture turn: Event and effect. In D. Hicks & M.C. Beaudry (eds), *The Oxford Handbook of Material Culture Studies*, 25–98. Oxford, Oxford University Press.

Hunter, F. 2005. The image of the warrior in the British Iron Age – coin iconography in context. In C. Haselgrove & D. Wigg-Wolf (eds), *Ritual and Iron Age Coinage in North-west Europe*, 43–68. Studien zu Fundmünzen der Antike 20. Mainz: von Zabern.

Jacobson, E. 1995. *The Art of the Scythians: The interpenetration of cultures at the edge of the Hellenic world.* Leiden, Brill.

Jacobson, E. 2006. The Filippovka deer: Inquiry into their North Asian sources and symbolic significance. In J. Aras, J. Farkas & E. Valtz Fino (eds), *The Golden Deer of Eurasia: Perspectives on the ancient nomads of the Steppe world.* New York, NY, Metropolitan Museum of Art.

Jacobsthal, P. 1941. Imagery in Early Celtic Art. *Proceedings of the British Academy* 37, 301–20.

Jacobsthal, P. 1944. *Early Celtic Art.* 2 vols. Oxford, Clarendon Press.

Jones, A.M. 2019. Remarkable objects, multiple objects: The ontology of decorated objects in Neolithic Britain and Ireland. In A.M. Jones & M. Diaz-Guardamino. *Making a Mark: Image and process in Neolithic Britain and Ireland*, 183–95. Oxford, Oxbow Books.

Jones, A.M. & Cochrane, A. 2018. *The Archaeology of Art: Materials, practices, affects.* London/New York, Routledge.

Joy, J. 2008. Reflections on Celtic Art: a re-examination of mirror decoration. In Garrow *et al.* 2008, 78–99.

Joy, J. 2011. Fancy objects in the British Iron Age: Why decorate? *Proceedings of the Prehistoric Society* 77, 205–30.

Joy, J. forthcoming. A timeless object? The aura of the so-called 'Grotesque' Iron Age torc. *Oxford Journal of Archaeology* 38(4).

Jundi, S. & Hill, J.D. 1998. Brooches and identities in first century AD Britain: More than meets the eye? In C. Forcey, J. Hawthorne & R. Witcher (eds), *Proceedings of the Seventh Annual Theoretical Roman Archaeology Conference, Nottingham 1997*, 125–37. Oxford, Oxbow Books.

Lamb, A. 2019. La Tène anthropoid art in Britain: Changes in style and people. *Archäologisches Korrespondenzblatt* 49(1), 83–94.

Machling, T. & Williamson, R. 2018. 'Up Close and Personal': The later Iron Age Torcs from Newark, Nottinghamshire and Netherurd, Peeblesshire. *Proceedings of the Prehistoric Society* 84, 387–403.

Megaw, J.V.S. 1970. Cheshire Cat and Mickey Mouse: Analysis, interpretation and the art of the La Tène Iron Age. *Proceedings of the Prehistoric Society* 36, 261–79.

Megaw, M.R. & Megaw, J.V.S. 1989. *Celtic Art: From its beginning to the Book of Kells.* London, Thames and Hudson.

Meyer, H.-C. 2013. *Greco-Scythian Art and the Birth of Eurasia: From Classical antiquity to Russian modernity.* Oxford, Oxford University Press.

Morel, L. 1898. *La Champagne Souterraine: Matériaux et Documents ou Résultats de Trénte-Cinq Années de fouilles archéologiques dans la Marne.* Reims, H. Matot fils.

Mulhall, I. & Briggs, E.K. 2007. Presenting a past society to a present day audience: Bog bodies in Iron Age Ireland. *Museum Ireland* 17, 71–81.

Olivier, L. 2006–7. Trois pièces d'art méconnues provenant de Bussy-le-Château (Marne). *Antiquités Nationales* 38, 89–98.

Olivier, L. 2014. Les codes de représentation visuelle dans l'art celtique ancien [Visual representation codes in Early Celtic Art]. In Gosden *et al.* 2014, 39–55.

Parker, A. & McKie, S. 2018. Introduction: Materials, approaches, substances, and objects. In A. Paker & S. McKie (eds), *Material Approaches to Roman Magic: Occult objects and supernatural substances*, 1–8. TRAC Themes in Archaeology. Oxford, Oxbow Books.

Rebay-Salisbury, K. 2016. *The Human Body in Early Iron Age Central Europe: Burial practices and images of the Hallstatt world.* New York, NY, Routledge.

Reeves, C. 2015. Head and Shoulders Above the Rest: Birch-bark hats and elite status in Iron Age Europe. Unpublished MA thesis, University of Wisconsin-Milwaukee.

Robb, J. & Harris, O. 2018. Becoming gendered in European prehistory: Was Neolithic gender fundamentally different? *American Antiquity* 83(1), 128–47.

Robb, J. & Harris, O.J.T. 2013. O brave new world, that has such people in it. In J. Robb & O.J.T. Harris (eds), *The Body in History: Europe from the Palaeolithic to the future*, 1–6. Cambridge, Cambridge University Press.

Robb, J.E. & Pauketat, T.R. (eds). 2013. *Big Histories, Human Lives: Tackling the problem of scale in archaeology*, 3–33. Sante Fe, NM: SAR Press.

Rustoui, A. 2006. The Celts between Tisa and the Carpathians before and after the Great Invasion in the Balkans. In V. Sârbu (ed.), *Thracians and Celts. Proceedings of the International Colloquium from Bistriţa. 18-20 May 2006*, 213–28. Cluj-Napoca, Editura Mega.

Schöenfelder, M. 2004. Le Casque de la tombe à char de Somme-Tourbe 'La Gorge-Meillet' (Marne). *Antiquités nationales* 36, 207–14.

Stead, I.M. 1979. *The Arras Culture*. York, Yorkshire Philosophical Society.

Stead, I.M. 1988. Chalk figurines of the Parisi. *The Antiquaries Journal* LXVIII(part 1), 9–29.

Stead, I.M. 1991. The Snettisham Treasure: Excavations in 1990. *Antiquity* 65(248), 447–64.

Stead, I.M. 1998. *The Salisbury Hoard*. Gloucestershire, Tempus.

Stead, I.M. & Rigby, V. 1999. *The Morel Collection: Iron Age antiquities from Champagne in the British Museum*. London, British Museum Press.

Stead, I.M., Flouest, J.-L. & Rigby, V. 2006. *Iron Age and Roman Burials in Champagne*. Oxford, Oxbow Books.

Stöllner, T., Aspöck, H., Boenke, N., Dobiat, C., Gawlick, H., Waateringe, W., Irlinger, W., von Kurzynski, K., Lein, R., Lobisser, W., Löcker, K., Megaw, V., Megaw, R., Morgan, G., Pucher, E. & Sormaz, T. 2003. The economy of Dürrnberg-Bei-Hallein: An Iron Age salt-mining centre in the Austrian Alps. *The Antiquaries Journal* 83, 123–94.

Talbot, J. 2017. *Made for Trade: A new view of Icenian coinage*. Oxford, Oxbow Books.

Thompson, S. 2018. Early to Middle Iron-Age and later settlement at Grove Road, Harwell. *Oxoniensia* 83, 139-96.

Tori, L. 2004. *La necropoli di Giubiasco (TI) (Vols I-III)*. Zürich, Museo nazionale svizzero/Schweizerischen Landesmuseum.

Treherne, P. 1995. The warrior's beauty: The masculine body and self-identity in Bronze-Age Europe. *Journal of European Archaeology Archive* 3(1), 105–44.

Wells, P.S. 2012. *How Ancient Europeans Saw the World: Vision, patterns, and the shaping of the mind in prehistoric times*. Princeton, NJ, Princeton University Press.

White, A. 1979. Antiquities from the River Witham. *Lincolnshire Museums Information Sheet, Archaeology Series* 12, 1–6.

Chapter 6

How Celts perceived the world: Early Celtic art and analogical thought

Laurent Olivier

Do not seek to follow in the footsteps of the wise. Seek what they sought.
Matsuo Bashō (1644–1694)

Abstract

When dealing with prehistoric artefacts, scholars are often embarrassed by the question of art, and European Celtic art is no exception. Therefore, it has usually been interpreted as a succession of styles, more or less influenced by Mediterranean models - transforming the study of Early Celtic art into a poor and minor branch of art history in antiquity. Most scholars have indeed failed to approach the production of Celtic art from inside, as a technology of visualisation. As an early European native art, the construction of images in Celtic art is based on a series of rules, or visual constraints, that are different from those of the Mediterranean cultures. It is another way of seeing and representing the world, whatever imaginary or tangible. But what makes Celtic art difficult to grasp for contemporary viewers is that the building of images is based on an untold agreement about visuality, which is shared between the creators and their receivers. This paper will focus on the basic dimensions of images - time and space - and aim to uncover the constraints driving the construction and reception of Celtic art through its historical transformation.

The origins of Celtic art

'Early Celtic Art has no genesis,' said Paul Jacobsthal (1944, 158). Driven out of Germany by the Nazis in 1935, at age 55, this pre-eminent historian of Greek art spent the remainder of his life attempting to determine the inspirational sources and evolutionary phases of Late Iron Age Celtic art. But as he acknowledged time and again, he was confounded by 'the same enigma', namely, that Celtic art showed none of 'the new rhythms [that] gradually supplant and defeat the old geometric forms', none of the usually numerous 'intermediate phases' and 'manifold blends of old and new', which are apparent, for example, in the Greek art of the Orientalising period (Jacobsthal 1944, 156). Historians of Greek and Roman art found Celtic art oddly devoid of roots and, above all, direction.

For a German scholar schooled in the academic tradition of Johann Joachim Winckelmann (the scholar who first defined the Greek, Roman and Greco-Roman art traditions), the statement was tantamount to an admission of powerlessness.

Jacobsthal's masterpiece, *Early Celtic Art* (1944), drew scant attention when it first appeared at the height of WWII – the entire world was focused on the Allies offensive launched against 'Fortress Europe' that the Nazis had erected on the continent. Interest in the book would not come until decades later with the regeneration of European archaeology, well after Jacobsthal's death in 1957 in Oxford, where he had sought refuge. But in spite of postwar scholars' newfound interest in Celtic art, for which Jacobsthal was largely responsible, there was no one really to continue his study of the dynamics of Celtic works of art and the logic behind the forms. By demonstrating that there existed a Celtic art analogous to the classical art of the Mediterranean, Jacobsthal opened a vast field of study, but scholars would not begin to investigate it fully until the 1970s and 80s, in the wake of the pioneering work carried out by Ruth and Vincent Megaw (1970). Even then, researchers focused their attention primarily either on the chronology and the spatial rendering of the various stylistic phases of Celtic art (Frey 2007), or the cultural, and in particular the Mediterranean, influences on Celtic art (Kruta 2015). Up until quite recently, very few scholarly works (Garrow & Gosden 2012; Wells 2012) addressed what one might call the 'anthropology of Celtic art', which involves identifying the concepts, or the collective behavior, that lay behind the images and the dynamics of their transformations. The 'enigma' of Celtic art has effectively remained, for the researchers who followed Jacobsthal have essentially been 'commentators' (Megaw 1970, 8).

I am not so presumptuous as to pretend to resolve a matter that has eluded art historians and archaeologists alike. In the search for a solution, this chapter rather hopes to propose approaches that lie outside these disciplines, which are essentially the two within which Celtic art has been studied ever since its discovery by British researchers at the end of the 19th century (Collis 2014; Kemble 1863). I shall look to the theory and the anthropology of art for ways in which to understand the manner in which the figurations of Celtic art were constructed. Having attempted elsewhere to demonstrate that Celtic images adhere to certain codes of visual representation – most notably that of the unfolding of figures into two-dimensional planes that is characteristic of 'intellectual realism' (Luquet 1930; Olivier 2014) – I hope to define here the ways in which these images deal with space and time. In effect, I shall try to identify the properties peculiar to the 'visuality' of Celtic art, so as to understand more fully both how it is different from the visuality found in the art of classical Mediterranean societies and how it is linked to Eurasian types of representation.

Art, image and visuality

I need to explain first what I understand about the 'anthropology of Celtic art.' When applied to prehistoric archaeological cultures, the term 'art' proves fundamentally ambiguous for, as Megaw (1970, 7) pointed out, along with the 'great cult statues and

the panoply of ornaments in precious metals, which were the natural accoutrements of a warrior society', one has to include 'more mundane objects' like those that fall under the heading of 'folk crafts' or 'pottery, tools, and weapons'. Given such a catchall framework, we would be better served to look at the images as they were made and received: whether they are figurative, represent beings or represent anything that 'is' or of an abstract nature, such as those composed of geometrical patterns. This was the path taken by the anthropologist Philippe Descola, who defined his approach as 'an anthropology of figuration or of rendering through image, rather than as an anthropology of art' (Descola 2015, 135). In a book that has profoundly influenced the anthropological approach to the so-called 'primitive' arts, Alfred Gell (1998) effectively showed that the most compelling way in which to deal with images is neither from the point of view of the meaning to be ascribed to them nor in terms of our notions of the beautiful and the exceptional to which they might correspond. Rather, we should consider them as 'agents endowed (by their artists and/or the recipients of these images) with intention and with the capacity to affect their surroundings' (Gell 1998 as cited by Descola 2015, 131). Images have the power to act upon those who look at them because they are a representation of reality, rendered by what the semiologist Charles Peirce called 'signs' (1978). To acquire meaning and thereby a measure of pertinence and effectiveness, they have to be interpreted.

As John Berger (2008, 9) noted, 'an image is a sight which has been recreated or reproduced'. Otherwise stated, all images offer the viewer the appearance of something not visible in that place or at that time, or something that is in and of itself not visible, such as supernatural beings (*e.g.* religious or magical). But Berger (2008, 10) points out that for an image to be recognised the act of seeing has to be reciprocal: I draw what I see, or what I imagine, and you see what I have drawn because we apprehend this representation of reality in the same way. The person who creates the image and the person who apprehends it share a common faculty based on a tacit agreement with regard to how reality is seen, and thus how it can be represented through an image. This convention, which is far less obvious than it might seem, is what I call visuality. Every image, even the most directly optical, such as a photograph, derives from what Berger called 'a way of seeing' peculiar to it and of which the image is a manifestation.

There is nothing more cultural than the canons of visuality manifest in these ways of viewing images, which are bound by codes of visual representation. In general terms, the representational modes of European Celtic art subscribe to 'intellectual realism' rather than to the 'visual realism' to which we are accustomed. Whereas intellectual realism presents figures in their entirety by laying out in detail their morphological components, 'optical' representations conceal parts of them or distort them, in particular through the use of perspective (Luquet 1930, 68–69; Olivier 2014, 39–43). Megaw (1970, 11) does well, in this regard, to point out how our values can mislead us when we deal with works of ancient civilisations different from our own: 'We tend to forget that ultimately most of our definitions of art are in fact based

on definitions of classical Greek and Roman art'. We need to bear in mind that the images of European Celtic art adhere to other principles of visual figuration. Celtic art requires us to distance ourselves from the conventional ways of representing figures to which we are accustomed.

The invention of the line

To deal with images we need first to understand how they are constructed, that is, by drawn lines. To quote the artist Paul Klée (1879–1940), 'dots along with linear, planar, and spatial energies are the basic elements of graphic art'. In effect, every drawn image has a surface on which various graphic signs, basically dots and lines, are placed. These lines may circumscribe an area that can either be filled in or left 'negative' through openwork. Celtic art, even as old as it is, is no exception to this rule, which affirms the fundamental importance of a line's movement. In his Bauhaus lectures of 1921–22, Klée distinguished between kinds of lines, which he described as dots that move across a surface and leave a trail or imprint behind. Some of the lines of this 'active linearity' (Linear aktiv) amble along – Klée likened their movement to 'going for a walk' – while others, which he claimed to be of a new sort, are 'pressed for time,' for their aim is 'to move as quickly as possible from point 1 to point 2 and then on to point 3 and so on' (Fig. 6.1).

For Klée, the connecting lines that take the most direct path possible to link dots or areas suggest a 'business trip' in comparison with those that meander along, making turns and evasive movements and taking detours. The ambling lines, he says, are free, whereas the paths of the connecting lines are pre-determined by the location of the dots or areas of the image that they connect. Otherwise put, whereas the latter attach, join or assemble parts of a drawing, the former border, walk alongside or skirt them, which is true of both motifs and figurative images.

Klée believed that these 'new' connecting lines were a distinctive innovation of Modern Art in its attempt to reveal the life-giving movement and structure of the living world. He associated ambling lines with the most basic functions of a drawing, namely outlining, in particular, shapes and areas, the latter of which are often represented with a particular material or way of being filled in. This was the type of line used during the Bronze Age and at the beginning

Fig. 6.1. Paul Klée's 'ambling lines' (A) and 'connecting lines' (B).

Fig. 6.2. Openwork disk. Bronze. Somme-Bionne, L'Homme Mort (Marne). London, British Museum (© Trustees of the British Museum. All rights reserved).

of the Iron Age in Europe, both in figurative representations and geometric patterns. But connecting lines, far from being new, were actually characteristic of European Celtic art. They initially appeared as circular arcs drawn with a compass to connect points of a network. This was the first time lines made perfect connections on a surface, for the arc, as Klée put it, is the line that results from 'the ideal tension between two points'.

This new graphic concept based on arcs drawn with a compass appeared remarkably early. For example, the Bettelbühl grave discovered near the Heuneburg hillfort in southern Germany yielded part of a bronze-plated horsehead protective covering with a circular motif composed of eight small, equidistant circles linked by an inverted double arc in the form of an S (Krausse, Chapter 9, this volume). Dating from the first quarter of the 6th century BC, it is one of the earliest examples of connecting lines in Early Celtic art (Krausse 2017). The aristocratic gravesite found in Lavau, in north-central France, which dates from the second quarter or middle of the 5th century BC (Collective 2018, 482–509), yielded other examples of the earliest stages of Celtic art: compass-drawn motifs such as interlocking combinations of arcs on an iron fibula with a long, bilateral spring as well as on a silver-plated goblet stem and, even at this early date, mistletoe motifs drawn with curves, such as those on the silver overlay of the handle of a piece of Attic pottery. A few generations later, at the end of the 5th century BC, Celtic artists produced works featuring combinations of circular arcs of mind-boggling complexity, such as those on the circular harness ornaments found in the wagon grave in Somme-Bionne in Champagne (Morel 1898) (Fig. 6.2).

A brief history of Celtic art

Far from a simple succession of styles more or less influenced by Mediterranean civilisations, Celtic art was an evolving exploration of plastic and graphic possibilities, the significance of which needs to be understood. The numerous centres of artistic activity that were spread across Europe and the sparse documentation at our disposal make it extremely difficult for us to identify a clear evolutionary sequence of 'stylistic phases', as Jacobsthal effectively noted. But the successive transformations of Celtic works provide an opportunity to explore the potential of the concept of connecting lines.

Fig. 6.3. Painted motif exemplifying anamorphosis. Ceramic. Thuisy (Marne). Saint-Germain-en-Laye, Musée d'Archéologie nationale, Inv. MAN 27676 (Photo: MAN).

In an initial experimental stage, which corresponds to what is known as the Early Style of the 5th century BC, Celtic artists explored the wide range of forms that could be obtained with a compass through the precise division of a circle into perfect geometric shapes such as squares, equilateral triangles and pentagons. They then quite naturally moved from arcs to curves, which allowed them to create even purer and more complex forms. At the same time, they experimented with the graphic innovations which could be obtained by distorting the surfaces they worked on. To create new shapes inside motifs, they made the openwork on a two-dimensional surface convex, either through cambering or by placing their motifs on toric or globular surfaces, such as those of torcs, bracelets or even pottery, and obtained in this way elongations and enlargements whose overall effect approached anamorphosis (Fig. 6.3).

The 4th century BC saw the final phase of the 'classical' period known as the Waldalgesheim Style; experimentation slowed, and the designs developed during the preceding period tended towards stereotype. Celtic art shifted from the exploration of forms to a baroque period that corresponds to the Plastic Style of the 3rd century BC, which saw motifs presented in full relief. In this most elaborate and spectacular phase of European Celtic art, artists inscribed curved lines on three-dimensional surfaces and interlocking perfect geometric shapes into non-Euclidean spaces.

The Celts' encounters with Mediterranean societies – first the Greek and then the Roman – and their introduction to naturalistic modes of representation, which were foreign to Celtic art, produced a 'crisis in image-making' marked by the general decline in their elaborateness and quantity that was evident in the 2nd and 1st centuries BC. Coin art, on the other hand, which had been introduced at the end of the preceding period, flourished. Mediterranean models that were in bas-relief, such as a head in profile on the face of a coin with a two horse-drawn chariot on the back, underwent exuberant transformations, with the component parts of the original transposed on a surface into juxtaposed individual shapes whose layout created patterns.

The post-history of European Celtic art evolved in the context of the Roman Conquest and played out differently in the British Isles and on the continent. In Britain, the Roman presence gave rise to a resurgence of Plastic Style-like works, whereas on the continent, where indigenous stylistic traditions remained visible in the new graphic language imposed by the conquerors, it yielded creolisations. Such was, in broad outline, the nature of the stylistic transformations that central and western European Celtic art underwent in the course of its long history.

The making of Celtic images

As opposed to naturalistic images, where the intention to represent a particular figure precedes the tracing of lines and the constitution of a surface, in Celtic art the anthropomorphic, zoomorphic and above all composite beings intended to be represented are not pre-determined. Each rather appears as an emerging aspect of the ongoing construction of connecting lines. Shapes and motifs are usually generated from a geometric grid obtained by partially overlapping two circles. The mandorla, or *vesica piscis*, as delineated yields areas that generate squares, equilateral triangles forming hexagons, or pentagons. The patterns of dots in the grids allow one to trace arcs of circles of varying radii to connect nodal points or to generate curves joined through abutment.

The method recalls that of the sand drawings of certain traditional societies in the Pacific and in Africa (Bernard Deacon & Wedgwood 1934; Gerdes 1995–2000). The process is mnemonic: it involves following the generally pre-established paths within a grid of dots that predetermine the emergence and layout of the shapes eventually created. The geometric complexity of these shapes is thus the result of a cumulative process: shapes are not so much reproduced, as they are in visual realism, as they are 'revealed' in the numerous visual projection planes created by the tessellation of the grid that divides the area into its various shapes.

In addition to the fundamentally mathematical and geometrical aspect of these images, what fully distinguishes them from naturalist depictions is the absence of visual depth. The encompassing form in which the subject of an image appears is the product of the multiple tensions based on numbers, or the relation between numbers, derived from the tessellation of the grid and made visible by connections in the form of arcs. To put it differently, the way in which figures are drawn is determined by the force lines immanent to patterns that generate, from a distance and in fragmented form, the 'beings' represented by the image.

It should be noted as well that, whereas time is frozen in the captured instant of a work of visual realism, for works of intellectual realism time is part of the constructive process through which the form of the image is revealed. For someone looking at a work of Celtic art, time is constantly unfolding. Here again, as Paul Klée noted, 'the time factor comes into play as soon as a dot begins moving and becomes a line, or when the movement of a line creates a surface, or when movement goes from surfaces to areas' (Klée 1985, 37). Just as with the works of Modern Art to which Klée was referring, time is inscribed within Celtic images in so far as artists and initiates see it as the logical succession of morphological changes that generate the forms that are progressively revealed.

'Super-images' and 'furtive figures'

As opposed to what has so often been said, Celtic art does not eschew the representation of figures or scenes. It rather represents them in a manner radically different from the naturalist approaches to visual realism of the so-called classical arts. Celtic works of art are largely based on fragmentation and the use of connecting lines; they do

Fig. 6.4. Linchpin with zoomorphic motif. Bronze and iron. Roissy, La Fosse Cotheret (Val-d'Oise), wagon grave 1002. Saint-Germain-en-Laye, Musée d'Archéologie nationale, Inv. MAN 89206.023 (Photo: MAN).

Fig. 6.5. Openwork plate with dragon motif. Bronze. Cuperly (Marne). Saint-Germain-en-Laye, Musée d'Archéologie nationale, Inv. MAN 27719 (Photo: MAN).

not attempt to reproduce what we see with our eyes, which is the province of naturalist figuration. Rather than dealing in discrete images that represent single optical sights, Celtic art offers 'super-images' that include multiple sights presented on a variety of visual planes (Fig. 6.4).

There do exist examples of 'naturalist' artists creating 'super-images', that is, sights that contain other sights. One of the best known is Holbein's 1533 painting, *The Ambassadors*, which, when looked at from a certain angle, reveals a human skull between the two human figures. In 1940, Salvador Dali juxtaposed two women in silhouette in the background of his *Slave Market with the Disappearing Bust of Voltaire* to make the Enlightenment philosopher's face jump off the canvas. But the painters of these trompe l'œil works of visual realism used visual depth to create these startling figures that emerge, as it were, through the different spatial planes.

None of that is possible in works that adhere to intellectual realism such as those of the Celts, for they are devoid of spatial depth, as we have just noted. To represent volume and space, Celtic artists presented figures in combinations of frontal and lateral (right and left) planes (Olivier 2014). Because they could not make use of the visual depth of images, as their naturalist counterparts did, they took advantage of what we might call the spatial expanse of a work by unfolding, so to speak, lateral planes on either side of a frontal plane. The resulting figuration appears to us to be doubled or tripled, even though in the real world beings simultaneously appear to us in all of their visual planes (Fig. 6.5).

Fig. 6.6. Yoke ring with human mask motif. Bronze. Paris (Seine). Saint-Germain-en-Laye, Musée d'Archéologie nationale, Inv. MAN 51399 (Photo: MAN).

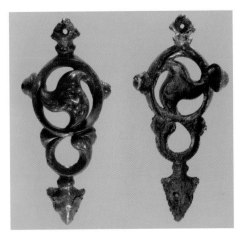

Fig. 6.7. Decorative plate with human profile inscribed in a triskelion. Bronze. Roissy, La Fosse Cotheret (Val-d'Oise), wagon grave 1002. Saint-Germain-en-Laye, Musée d'Archéologie nationale, Inv. MAN 89206.011 (Photo: MAN).

Celtic artists also worked with all four elementary modes of isometric transformation that Alfred Gell identified – reflection, translation, rotation and glide reflection (1998, fig. 6.4/1) – to manipulate in a great variety of ways the visual planes on which their prototypes were presented, thus generating great numbers of 'furtive figures' of which one could see only the eyes or a partial silhouette.

Celtic art is thus not at all one of 'elusive images,' as Megaw suggested (1970). It is in fact quite the opposite. The guiding principle was not to 'hide' figures by only partially evoking their presence; it was rather to present a figure in fragmented form in a multiplicity of visual planes. We find these fragmented, deconstructed Celtic images baffling only because we persist in trying to see them whole and above all coherent according to our own codes of visual representation. Similarly, the Plastic Style of the 3rd century BC, which corresponds to a 'baroque' evolution of the preceding 'classical' period known as the Continuous Vegetal Style, has nothing in common with the Disney Style to which Megaw likened it. The human face, which appears, often partially, in the form of masks, is not 'broken down into a number of curvilinear geometric forms – crescents, ovals, circles, and the like' (Megaw 1970, 30); it rather emerges from the motifs laid out on the various visual planes of the image (Fig. 6.6). In other words, Celtic artists were not interested in deconstructing figurative forms into something grotesque or cartoon-like. Quite the contrary, by multiplying the planes of the image they sought to bring out the networks of correspondences linking discontinuous elements of furtive figures (Fig. 6.7).

Moreover, as opposed to the naturalist representations of classical artists of the Mediterranean basin, Celtic artists did not seek to visually reproduce objectively

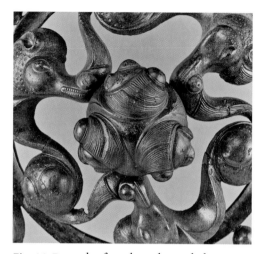

Fig. 6.8. Example of condensed morphology. Dome with dragons. Bronze. Roissy, La Fosse Cotheret (Val-d'Oise), wagon grave 1002. Saint-Germain-en-Laye, Musée d'Archéologie nationale, Inv. MAN 89206.022 (Photo: MAN).

given, 'natural' models, nor did they seek to 'simplify' them through stylisation, as Megaw also contended. They rather sought to reveal the patterns, which were essentially geometrical and mathematical, through which these prototypes come into existence and manifest a capacity to act symbolically. We enter here the realm of representations that belong, in Descola's (2005) classification, to an 'analogical' kind of ontology whose deep affinity with Celtic works of art we have spoken of elsewhere (Olivier 2018, 278; Olivier forthcoming). This is the realm of chimera and mythical creatures, at once fragmentary and composite, human and non-human. It is also a world whose codes of visual representation are manifest in the symmetrical unfolding of figures onto the various planes of an image, or through the process of morphological contraction by which figures are reduced to an assemblage of anatomical details or odd-looking forms (Fig. 6.8) (Ginoux, Chapter 8, this volume). During the Iron Age, this 'ontological formula' was clearly prevalent throughout the Eurasian continent, from the warring kingdoms of ancient China to the Scythian art of the nomadic tribes of the Steppes and as far west as the Celtic cultures of western Europe.

Celtic art, analogical art

As Philippe Descola (2015) noted, each of the four basic modes in which we apprehend reality – the animism of today's Amazon region and Siberia, the naturalism of Europe from the classical age on, the totemism of aboriginal Australia, and the analogism of ancient China and pre-Columbian Mesoamerica – not only produces particular kinds of images but also determines the specific means by which they are composed. Thus, for those who perceive the world analogically, 'each element is distinguished from the others ontologically, which compels us to find stable connections between them' (Descola 2015, 138). Presenting images in this way, by 'displaying them over multiple surfaces', brings to light their 'fragmented interiorities'. In other words, Descola (2015, 142) says,

> the idea is to present a grouping of faintly discontinuous but coherent entities, either directly in one figure whose composite nature is obvious, or indirectly by showing that the image is metonymic ..., or by making it clear that each element has meaning and agency only because it is part of an aggregate of disparate elements structured spatially, through alignments ... or concentric enclosures, ... or temporally, simply with regular additions to the whole.

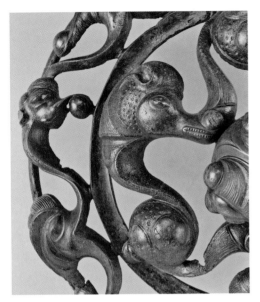

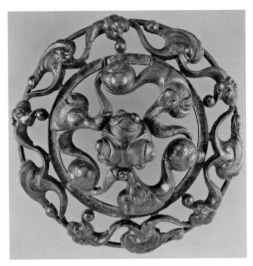

Fig. 6.10. Dragons and monsters on a dragon dome. Bronze. Roissy, La Fosse Cotheret (Val-d'Oise), wagon grave 1002. Saint-Germain-en-Laye, Musée d'Archéologie nationale, Inv. MAN 89206.022 (Photo: MAN).

Fig. 6.9. Detail of dragons and monsters on a dragon dome. Bronze. Roissy, La Fosse Cotheret (Val-d'Oise), wagon grave 1002. Saint-Germain-en-Laye, Musée d'Archéologie nationale, Inv. MAN 89206.022 (Photo: MAN).

We do not know what these creatures represented or evoked in Celtic art are, but we can identify their particularities and establish, one might say, their identity. Each composite animal-like figure, in particular dragons, griffons and other mythical creatures, presents in its corporality a variety of traits, some of them conflicting but nonetheless coherent, all of them reduced to some anatomical detail such as an ear, a maw or a mane (Fig. 6.9). Each trait suggests a certain behaviour that had undoubtedly been made legendary in tales or even mythologies long since lost, which is why these staid mythical creatures could be shown devoid of aspect and attributes. These composite figures of Celtic art exemplify what Descola (2010, 172) referred to as 'an interwoven world', for they present the dual nature of analogism, at once 'the heterogeneity of the component parts and the coherence created by the connections that link them'.

The structure of these super-images of Celtic art is thus that of entities presented as indexes simultaneously displayed on different visual planes and connected by the geometric patterns created inside numerous aggregates of a variety of entities of various kinds (Fig. 6.10). It is a mode of figuration that seeks to bring out from the image, through these series of 'embeddings', an overall structure of heterogeneous relations between figures of limited affinity. As opposed to the naturalist images of classical art, Celtic works of art do not seek morphological resemblance to their prototypes.

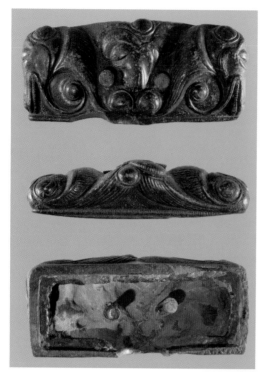

Fig. 6.11. Linchpin head of undetermined provenance. Bronze. Saint-Germain-en-Laye, Musée d'Archéologie nationale, Inv. MAN 91157 (Photo: MAN).

Rather they draw on visual mechanisms, expressed in particular through the geometry of circles and curves, to present aggregates of ordered indexes, the spatial and temporal patterns within an image, and the correspondences between levels of interpretation and scales of representation. Celtic art is thus fundamentally 'meta-relational'; it fully deserves to be considered a manifestation of 'intellectual realism'.

Conclusions and perspectives: Revisiting the Eurasian continent

We seriously need to reassess the idea in conventional research that defines Celtic art as 'essentially aniconic' (Megaw & Megaw 1989, 21). Celtic artists were not opposed to images and life-like figurations. They simply did not find in the naturalist representations favoured by the urban civilisations of the Mediterranean basin the possibilities for expressing the affinities and connections between the human and the non-human in their 'interwoven' universe (Fig. 6.11) offered by the analogical kind of intellectual realism. That is why they disregarded the abundant and, to their eyes, prosaic images of gods and heroes that adorned lavish Greco-Etruscan pieces. They preferred to rework figures that they could transcribe into their own graphic language: friezes of vegetable motifs such as palmettes and lotus blossoms that could be divided, inverted and elongated at will and then reassembled in multiple visual planes. Celtic art did not undergo the influence of the art of Mediterranean societies; it rather drew on what seemed useful in pursuing the exploration of form.

There thus existed two opposing worlds each defined by its distinct mode of apprehending reality, roughly situated in the Mediterranean basin on the one hand and on continental Europe on the other. In Greco-Roman culture, where the visual realism of naturalist perception prevailed, representations were 'objectal' whereas Celtic representations were relational, informed by an analogical perception of reality expressed through a kind of intellectual realism. The connections that generate Celtic figures, be it through assembly or opposition, appeared as networks of correspondences that would progressively emerge as the visual dimensions of the image took shape, a process

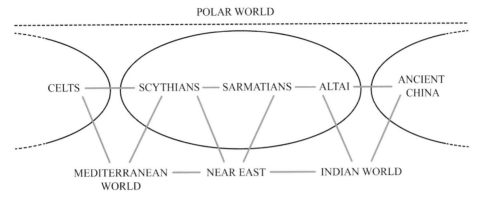

Fig. 6.12. Diagram of cultural networks in Eurasia.

that revealed the symmetries and polarities linking the human to the non-human and the living to the inanimate. Thus, time and space were inscribed within the images of Celtic art, each image being the unique experience of a form gradually taking shape.

Alternatively, Mediterranean art focused on the physical appearance of animate beings, both real and imagined. At the same time that Celtic art was thriving, the great classical sculptors were masterfully representing tensed muscles and veins, the drape of cloth, the flow of hair and manes, even the surface and glow of youthful skin, all of which the creators of Celtic art were completely impervious to. The point is not to oppose, as has been the case for far too long, the civilised societies of the Mediterranean to the barbaric world of the Celts, or original works of art to crude imitations, or perfection to distortion, or beauty to caricature; this is not a matter of setting great art against 'works that are almost uniformly minor' (among others, Duval 1977, 235–36). Nor is it a matter of turning things around and claiming that Celtic artworks are intellectually superior to the jejune figurations of classical art of Hellenistic inspiration. The point is to see that Celtic representations derive from a distinct view of reality, one which is neither inferior nor superior to that of Mediterranean civilisations, but simply, and above all, different from it.

In effect, European Celtic art offers insight into an ontological perception of reality that is radically different from our own. As Jacobsthal noted (1944, 163), the artworks of ancient civilisations reveal more about their mentality and their religious sense than any of their other material constructions. Freud (2015, 112) himself said that even in our own culture the domain par excellence in which 'omnipotent thought' rules is none other than art. Celtic images are in this way, above all, the product of 'Celtic thought'. They are a great deal more than individual works characterised by the fancy, or imagination, or 'taste for dreaming' of their creators (Duval 1977, 237). They are the faithful transcription of a true system of thought that is today lost to us.

It is striking to note, as the essays contained in this volume show, that results analogous to those Celtic artists obtained in their exploration of the potential of forms can be found in other ancient civilisations of the Eurasian continent. It is once again Jacobsthal (1944, 162) who pointed out that the 'Celts were the westernmost outpost of a vast Eurasian belt stretching east to China' and 'where there was no anthropomorphic art, where beast and mask were all and everything, where the tale of mythology was told in zoomorphic disguise'. These resemblances, or rather these affinities that developed over such great distances, were clearly not the result of the traditional workings of cultural influences that art historians generally trade in (Fig. 6.12). This was rather a case of similar ways of viewing reality generating similar visual representations. There now opens before us a vast continent long obscured, stretching from the British Isles in the Atlantic to the Steppes of the Urals and on to ancient China, a continent wherein lies other origins of European civilisation that have long lain hidden in the shadows of the Roman conquest.

References

Berger, J. 2008. *Ways of Seeing*. London, Penguin Books.

Bernard Deacon, A. & Wedgwood, C.H. 1934. Geometrical drawings from Malekula and other islands of the New Hebrides. *Journal of the Royal Anthropological Institute* 64, 129–75.

Collective. 2018. *Archéologie dans l'Aube. Des premiers paysans au prince de Lavau. 5300 à 450 avant notre ère*. Ghent, Snoeck.

Collis, J. 2014. The Sheffield origins of Celtic Art. In C. Gosden, S. Crawford & K. Ulmschneider (eds), *Celtic Art in Europe: Making connections*, 19–27. Oxford, Oxbow Books.

Descola, P. 2005. *Par-delà nature et culture*. Paris, Gallimard.

Descola, P. 2010. Un monde enchevêtré. In P. Descola (ed.), *La Fabrique des images. Visions du monde et formes de la représentation*, 165–83. Paris, Somogy, Musée du Quai Branly.

Descola, P. 2015. La double vie des images. In E. Alloa (ed.), *Penser l'image II. Anthropologies du visuel*, 131–45. Paris, les Presses du Réel.

Duval, P.-M. 1977. *Les Celtes*. Paris, Gallimard.

Freud, S. 2015. *Totem et tabou*. Paris, Presses universitaires de France.

Frey, O.-H. 2007. *Keltische Kunst in vorrömischer Zeit*. Marburg: Kleine Schriften aus dem Vorgeschichtlichen Seminar Marburg, 57.

Garrow, D. & Gosden, C. 2012. *Technologies of Enchantment? Exploring Celtic Art: 400 BC to AD 100*. Oxford, Oxford University Press.

Gell, A. 1998. *Art and Agency: An anthropological theory*. Oxford, Oxford University Press.

Gerdes, P. 1995–2000. *Une tradition géométrique en Afrique. Les dessins sur le sable*. Paris, L'Harmattan.

Jacobsthal, P. 1944. *Early Celtic Art*. 2 vols. Oxford, Clarendon Press.

Kemble, J.M., Franks, A.W., Latham, R.G. 1863. *Horae Ferales. Studies in the Archaeology of the Northern Nations*. London, Lovell Read and Co.

Klee, P. 1985. *Théorie de l'art moderne*. Paris, Denoël.

Krausse, D., Ebinger-Rist, N., Million, S., Billamboz, A., Wahl, J., Stephan, E. 2017. The 'Keltenblock' Project: Discovery and excavation of a rich Hallstatt grave at the Heuneburg, Germany. *Antiquity* 91(355), 108–23.

Kruta, V. 2015. *L'Art des Celtes*. London, Phaidon.

Luquet, G.-H. 1930. *L'Art primitif*. Paris, Gaston Douin.

Megaw, J.V.S. 1970. *Art of the European Iron Age: A study of the elusive image*. New York, NY, Harper & Row.

Megaw, M.R. & Megaw, J.V.S. 1989. *Celtic Art: From its beginning to the Book of Kells*. London, Thames and Hudson.

Morel, L. 1898. *Album de la Champagne souterraine. Période gauloise d'avant la conquête romaine*. Reims, Matot-Braine.

Olivier, L. 2014. Les codes de représentation visuelle dans l'Art celtique ancien [Visual representation codes in Early Celtic Art]. In C. Gosden, S. Crawford & K. Ulmschneider (eds), *Celtic Art in Europe: Making connections*, 39–55. Oxford, Oxbow Books.

Olivier, L. 2018. *Le Pays des Celtes. Mémoires de la Gaule*. Paris, le Seuil.

Olivier, L. forthcoming. In the eye of the dragon: How the ancient Celts viewed the world. In W. Morrison & T. Martin (eds), *Barbaric Splendour: The use of image before and after Rome*. Oxford, Archaeopress.

Peirce, C.S. 1978. *Écrits sur le signe*. Paris, Le Seuil.

Wells, P.S. 2012. *How Ancient Europeans Saw the World: Vision, patterns, and the shaping of the mind in prehistoric times*. Princeton, NJ, Princeton University Press.

Chapter 7

How can Celtic art styles and motifs act? A case study from later Iron Age Norfolk

Jody Joy

Abstract

In recent years, the study of the motif has gone out of favour in Celtic art studies, with greater emphasis rightly placed on situating the art within its historical and artefactual context, as well as examining what art does. In this paper, it is argued there is still a place for motifs if they are approached from the perspective of what motifs do. Through the example of the decoration on torcs from Snettisham, Norfolk, UK, and inspired by a paper by Alfred Gell which highlights the potential of motifs to act as retentions from the past and protentions to the future, it is argued that the decoration on certain torcs created relationships between artefacts and people past, present and future.

Introduction

Until recently, the study of early Celtic art from Britain took place in a separate arena from wider Iron Age research, with a different language and set of questions (*cf.* Gosden & Hill 2008, 4; Macdonald 2007a, 334). The majority of studies worked within a traditional art historical framework, and the shadow of Jacobsthal's (1944[1969]) magisterial book *Early Celtic Art* loomed large, with investigations drawing heavily on his methods of exhaustive recording of designs and motifs, stylistic comparison and identification of 'schools' of artists or workshops, as well as speculations on the meaning of the art (*e.g.* Fox 1958; Jope 2000; Macgregor 1976). Above all, scrupulous examination of motifs facilitated the construction of artistic 'grammars' and stylistic sequences (*e.g.* Stead 1985a) used to date artefacts and inform wider chronologies. Yet in recent years, the study of the motif has gone out of favour, with greater emphasis placed on situating the art within its historical and artefactual context, as well as examining what art does (Bradley 2009, 34; Chittock 2014, 314; Gosden & Hill 2008, 9; Joy 2011, 206). In this paper, through the example of the decoration on later Iron Age torcs from Snettisham, Norfolk, it is argued that there is still an important role for the motif in Celtic art research if

they are examined from the perspective of 'what do motifs do?'. Drawing on arguments presented by Gell (2013[1985]), I will focus on works of art after they are made and show how motifs on torcs can connect and create networks. More specifically, I argue relations were made visible through the art by makers when mixing and re-articulating styles and motifs at the time of production, but also throughout the life of the artefacts as they moved between contexts. In other words, designs influenced makers in the production of further artefacts (Jones 2001, 339) and continued to be instrumental through an object's life.

Throughout, this paper is informed by wider debates within archaeology on both the relationships between motifs and processes (*cf.* Fowler 2013a; 2013b; 2017; Jones 2001; Lucas 2012) and on process and its relationship to form (*cf.* Gosden & Malafouris 2015; Malafouris 2013). But before introducing the case study and theoretical perspective, it is first necessary to situate this research within the context of past investigations of the motif in British Celtic art research.

Celtic art research in Britain

Art historical methods can be painstaking, meticulous and exhaustive, involving stylistic analysis and broad comparison of motifs and styles and should not be undervalued as feats of scholarship. Similar to the creation of artefact typologies more generally, it is also arguably a necessary step in examining and ordering the art (*cf.* Fowler 2017, 95). Nevertheless, one could suggest that the predominance of these research methods has held Celtic art studies back. This is because, in general, little is said about the art beyond concise and often virtuoso descriptions of the artefacts and their decorations (Garrow & Gosden 2012). The method of recording separate motifs presents art as static (Jones & Díaz-Guardamino 2019, 13), ignoring the influence of time on the object and their makers. Also, by separating patterns and motifs from the artefacts they adorn through their illustration in vast compendiums of art, comparison of decoration on objects often widely separated in time, space and context, is too easily facilitated (Jones 2001, 338; Joy 2010; 2011). One outcome of this method of presentation is to promote speculative conclusions about past links or shared meanings across wide expanses of time and space because artefacts have motifs or designs in common (Joy 2010, chapter 4). Catalogues, unless fully contextualised, can also create an artificial impression of the frequency of the art. The people who made and used Celtic art are unlikely ever to have seen so many examples presented side-by-side as those illustrated in vast compendiums or blockbuster exhibitions (*cf.* Farley & Hunter 2015). Rather, the makers of decorated objects were a part of local and regional networks. They worked to the restrictions and affordances of specific materials (Ingold 2013). Decoration also followed conventions and specific working practices of design construction (*cf.* Joy 2008; 2010, chapter 4). We should also consider the influence on makers of designs on objects glimpsed from a distance or half remembered rather than through close scrutiny

(Spratling 2008). In sum, by restricting itself to art historical methods, Celtic art studies in Britain in the latter 20th century had entered an intellectual cul-de-sac, limited to the description of designs and fitting new discoveries into ever more complicated stylistic sequences with little relevance to wider research other than as a comparative dating method. It is telling that few, if any, PhD dissertations focusing on Celtic art were undertaken between Spratling's (1972) examination of decorated metalwork from southern Britain and Macdonald's (2000; 2007b) study of the non-ferrous metalwork from Llyn Cerrig Bach. But by the beginning of the 21st century, there were signs that attitudes were changing, particularly with the advent of the so-called 'material turn' (Hicks 2010) in the social sciences where researchers again turned to the material but with less focus on what objects mean, and rather, what they do. There was also a parallel recognition within Iron Age studies of a critical need for more materials specialists (Haselgrove *et al.* 2001, 16), encouraging funded doctorates examining Iron Age material culture (*e.g.* Adams 2013; Farley 2012; Joy 2008). These factors were important, but arguably the main impetus for a rejuvenation of Celtic art studies was the 'Technologies of Enchantment' project which culminated in the publication of an influential book (Garrow & Gosden 2012) and a seminar hosted at the University of Oxford in 2006 and published in 2008 (Garrow *et al.* 2008). The seminar was particularly important because it brought together students and established experts in the field. Many of the studies at the Oxford seminar, and parallel discussions elsewhere (*e.g.* Fitzpatrick 2007; Joy 2011; MacDonald 2007a), sought to break free from traditional methods of studying the art and took inspiration particularly from the work of the social anthropologist Alfred Gell (1992; 1998). Gell's ideas on how art acts as a mind trap or enchants the viewer through its technological virtuosity have been particularly influential, transforming our understanding of Celtic art. For example, Giles (2008) noted how the seeming complexity of designs can draw the viewer in, leading the eye in different directions. The potential ambiguity of designs has also been much commented upon and it is viewed as an art style intentionally made to be interpreted in different ways (*cf.* Olivier 2014; Spratling 2008).

Whilst welcoming the vibrancy and recognising the merit of this recent work, it is noticeable how detailed examination of styles and particularly motifs has dropped out of favour (but see Joy 2010, chapter 4). As has been set out, there are many good reasons for this, but the main stimulus behind this paper is to argue that art styles and motifs are still worthy of study. As I suggested in the introduction, this is because they can be used as a tool to question what art does. In the words of Küchler, motifs can provide the brain with 'a special thing-like tool for thinking' (Küchler 2013, 27). Motifs and designs create links and relationships between artefacts, not necessarily in the sense of implying shared meaning or contacts between regions as is promoted by traditional art historical approaches, but also in a process of engagement with its audience. This does not just hold for Celtic art studies, but also investigations of art from other regions and periods.

A brief excursion to Wiltshire

The inspiration for this paper is an innocuous looking object which is part of the upper band of a cauldron (Fig. 7.1). The cauldron is one of 17 deposited in a hoard at Chiseldon in Wiltshire and dated to the late 4th or early 3rd century BC (Baldwin & Joy 2017). The choice of raised decoration is interesting as when illuminated from below by flickering firelight, the pattern would have appeared to move or dance. Of interest in the context of this paper, is that the decoration employs two different styles within the same composition. Jacobsthal (1944[1969]) identified a series of styles or stages of Celtic art in Europe. Quoting an unpublished paper by Jacobsthal, de Navarro (in Wheeler 1943, 388–94) modified and extended this categorisation for British art. Stead (1985a; 1985b; 1996) incorporated de Navarro's scheme into his influential classification. Stead defined several 'stages' of art dating from the 4th century BC to the 1st century AD. The cauldron is decorated with a palmette (Fig. 7.1, far left) which is characteristic of Stead's Stage I. The palmette motif resembles the fan-shaped leaves of a palm tree and is a design used in some of the earliest Celtic art alongside other modified vegetal motifs such as the lotus flower (Joy 2015a, 56). The rest of the decoration on the cauldron is curvilinear and conforms to Stead's Stage II (see Fig. 7.2 for an explanation of all of Stead's Art Stages). Without developing the argument further at this stage, it is contended that this combination of styles is not just of interest to Celtic art specialists like me, it would have been apparent to an Iron Age audience and not just the makers of the art.

 There are several reasons why the decoration on the cauldron from Chiseldon is not a good case-study to use as the basis for an examination of the mixing of motifs in different styles within the same composition. First and foremost, little Stage I or II art has been identified from Britain (Baldwin & Joy 2017; Joy 2015b; Stead 1996), making comparisons extremely difficult without looking to the continent. By drawing inferences from the decoration of artefacts which may be far removed in time and space from the Chiseldon cauldrons, we run the risk of removing decoration from the immediate

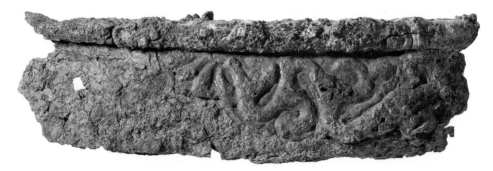

Fig. 7.1. Decorated cauldron (SF10) from Chiseldon, Wiltshire showing the palmette motif with fronds on the left just under the rim, with curvilinear decoration to the centre and right making up most of the design (©Trustees of the British Museum).

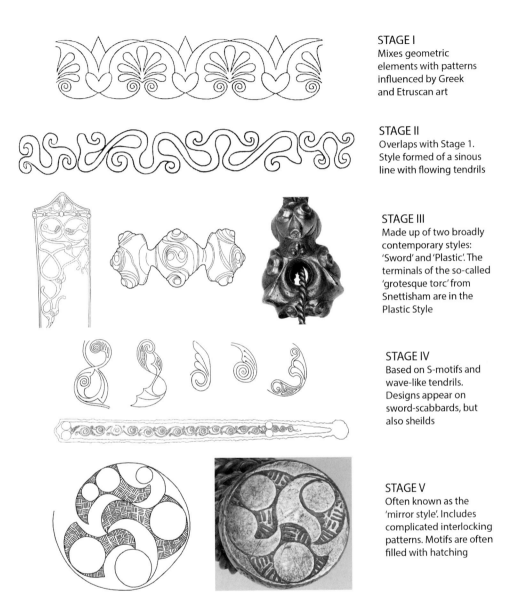

STAGE I
Mixes geometric elements with patterns influenced by Greek and Etruscan art

STAGE II
Overlaps with Stage 1. Style formed of a sinous line with flowing tendrils

STAGE III
Made up of two broadly contemporary styles: 'Sword' and 'Plastic'. The terminals of the so-called 'grotesque torc' from Snettisham are in the Plastic Style

STAGE IV
Based on S-motifs and wave-like tendrils. Designs appear on sword-scabbards, but also sheilds

STAGE V
Often known as the 'mirror style'. Includes complicated interlocking patterns. Motifs are often filled with hatching

Fig. 7.2. A diagram showing Stead's art stages discussed in the text (Drawing: Jody Joy after Stead 1996).

context of the object, as well as its importance to the people who made and used it. This is especially important in this instance because there have also been questions surrounding how these styles were related on the continent (*e.g.* Frey 1976; Verger 1987). Instead, sharing of motifs from different styles in the same composition will be explored through the example of the decoration on torcs from Snettisham, Norfolk, where several examples have been identified (Stead 2009). These artefacts are therefore associated by their deposition context in addition to their decorations.

The Snettisham torcs and their decorations

For the last 70 years, precious and base metal artefacts, particularly torcs but also rings, bracelets, coins and ingots, have been unearthed from at least a dozen separate hoards at Ken Hill close to the modern Norfolk village of Snettisham, UK. The hoards were labelled alphabetically (A, B, etc.) in order of discovery. The find spots of Hoards A–E were investigated in the 1950s by Clarke (1954), with further excavations by Ian Stead (1991) in the early 1990s following the discovery of a hoard of around 600 artefacts (Hoard F) by a metal detector user. Based on the presence of dated coins, most of the hoards were deposited during the last quarter of the 2nd century BC to the mid-1st century BC. It should be stressed that this is the date of deposition and not when the artefacts were manufactured (Joy 2016). The site is unprecedented in terms of the quantity and quality of artefacts recovered, but unfortunately, the comprehensive publication is yet to be completed (Joy & Farley forthcoming). Stead (1991) suggested the artefacts could represent a form of tribal treasury. Fitzpatrick (1992) thought there was also a ritual component to their deposition. Snettisham is located in a prominent position on higher ground overlooking the Wash, so its location and aspect may also have been important, and it was possibly a site of religious significance (*cf.* Davies 2008; Hutcheson 2004).

Items from Snettisham such as coins and a bracelet are decorated, but the focus in this paper is torc ornament. In total, over 150 complete, or near complete, torcs have been recovered (Joy & Farley forthcoming). Two broad groups can be identified, twisted and tubular, and examples of both are decorated. As the moniker implies, the neck-rings of twisted wire torcs are made of wires. These were twisted according to a huge variety of combinations and numbers. Terminals were formed by looping the wires, or they were made separately and fixed onto neck-rings (*cf.* Machling & Williamson 2018). Owing to the distribution of finds, particularly a concentration in East Anglia, twisted wire torcs are thought to have been manufactured in Britain (Hautenauve 2005). Tubular torcs on the other hand have neck-rings that are formed of sheet metal. They are often hollow in the middle, although sometimes voids are filled with iron or even a wax-like material (*cf.* Meeks 2014). Tubular torcs are not restricted to Britain. Similar examples to those from Hoard A at Snettisham have been found elsewhere, including France, Belgium, Northern Ireland and Switzerland (Fitzpatrick 2005; Furger 2015; Hautenauve 2005). Although the Snettisham tubular

torcs are not necessarily imports, similarities with continental examples suggests pooled or collected knowledge, possibly by exchange of artefacts or through contact between metalworkers, providing tubular torcs with an international currency not shared by twisted wire torcs (*cf.* Joy 2015b). Decoration on twisted wire torcs occurs most often on the terminals. Techniques vary, but cast decoration sometimes shows signs of additional tooling and overworking (Meeks *et. al.* 2014). Ornament on sheet metal terminals was largely produced by raising, created by hammering the inside surface of the torc. Further decorative details were added by punching and tooling on the outside surface.

The decoration on the Snettisham torcs has been studied extensively by Stead (1991; 2009). In line with the dominant research blueprint already outlined, Stead focused his analysis on identifying styles, dating and seeking parallels, but as is explained in more detail below, I think there is much more we can say about torc decoration. Most designs, particularly on the terminals of twisted wire torcs, conform to Stead's Stage V (*cf.* Stead 1985a; 1985b; 1996). This type of decoration is found on other artefacts, particularly mirrors, but also sword scabbards and horse trappings, potentially linking torcs to these other artefacts through manufacturing traditions or by referencing relationships between important artefacts and people. Stage V art is characterised by the use of the trumpet motif, with patterns often organised into set schemes such as the lyre loop and reverse-S patterns (Joy 2008; 2010). Stead also identified other art stages on the decoration of a smaller number of torcs, including Stage III on the so-called grotesque torc (see Fig. 7.2) and a series of what he labelled 'palmettes' in the patterns of a limited number of torcs, primarily made of sheet metal. He did not attribute the palmettes to one of his stages, but instead suggested they may date to La Tène I (Stead 2009, 328–29). According to Stead's categorisation, both the grotesque torc and the torcs decorated with palmettes significantly pre-date their burial, meaning the objects were already old at the time of their deposition; but as we shall see below, this is not the only explanation.

Torc BM 1991,0501.29

My discussion now focuses on the ornament of a single torc decorated with an overall pattern which Stead (2009, fig. 1f) described as a palmette (Fig. 7.3), but also with reference to others from the Snettisham hoards. A tubular torc fragment from Hoard F, it comprises a single terminal and part of the neck-ring. It was originally found completely crushed but has been reshaped subsequent to its discovery by a British Museum conservator (Joy & Farley forthcoming). The terminal is elaborately ornamented with the design arranged around a lyre-shaped framework (Fig. 7.4A). Incorporated within this blueprint is a series of motifs framed within panels (Fig. 7.4A–E). Parallels to these motifs are readily identifiable, for example following only a brief survey of compendiums of British Celtic art such as Fox (1958) and

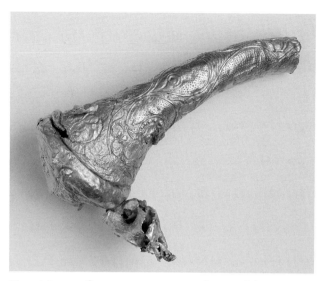

Fig. 7.3. Image of torc BM 1991,0501.29. The raised decoration is clearly visible, and motifs have been delineated by raised lines. Further texture has been added by punching the surface with small dots (© Trustees of the British Museum).

Jope (2000), resemblances for the motif, labelled 'E' in Figure 7.4, were identified on the Witham shield and a sword scabbard from Wetwang Slack both categorised by Stead (1996, 75) as Stage IV. I could no doubt have found many more and could repeat the same exercise for the other motifs set within panels. The manner in which the individual motifs are each contained within individual panels or cells is also reminiscent of the inscribed decoration on the Wandsworth shield boss, which is contained within separate sections of raised ornament.

It is probable that another researcher looking at these motifs would find other different parallels, underlining some of the limitations of stylistic analysis, as well as representations as two-dimensional line drawings and photographs (*cf.* Jones 2001). But it is clear that torc BM1991,0501.29 is decorated in multiple styles: a palmette outline with Style IV motifs set within individual cells.

As already outlined, Stead (2009, 328–29) suggested that the torcs ornamented with his palmette designs were old when they were put in the ground. Following this line of reasoning, we could speculate that our torc was manufactured sometime as early as the 3rd century BC and buried in Hoard F in the late second or first half of the 1st century BC. Unfortunately, because of its crushed state when found, it is difficult to determine evidence for damage or wear – which is readily apparent on other torcs such as the grotesque torc from Hoard L (*cf.* Joy 2016, 248) – and which might point to its antiquity. The chronological significance and integrity of Stead's stylistic stages has recently been called into question (Garrow & Gosden 2012; Macdonald 2007a). Researchers such as Macdonald (2007a) have identified other examples of Celtic art decorated in multiple styles undermining the successive basis for the art stages proposed by Stead. Garrow and Gosden (2012, 80) have also suggested Celtic art styles should not be viewed as sequential, but rather accumulative, arguing '... some motifs are earlier than others, but their lifespan is not described by a simple battleship curve. Rather, older motifs can be referenced in later works either deliberately or unconsciously. Celtic art becomes more complex as time goes by and new motifs are added to old. Otherwise it has no clear directional or successive character'. Viewed

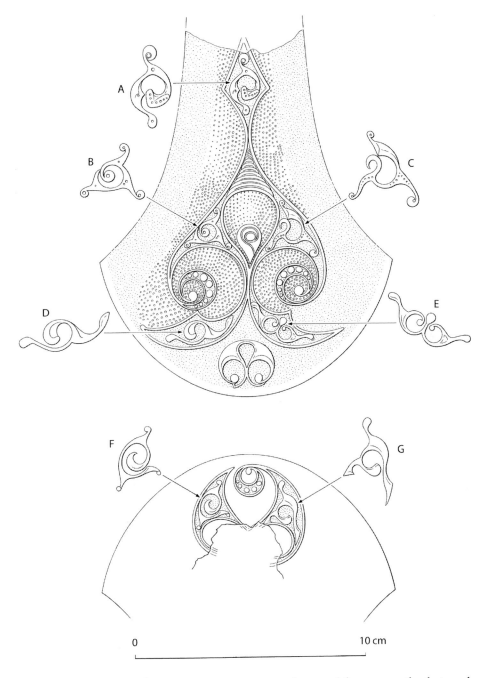

Fig. 7.4. This line drawing of torc BM 1991,0501.29 extrapolates and flattens out the design, clearly showing the various motifs. Of particular note are the so-called palmette motifs (labelled A–G) which are each contained in individual cells (Drawing: Jim Farrant; © Trustees of the British Museum).

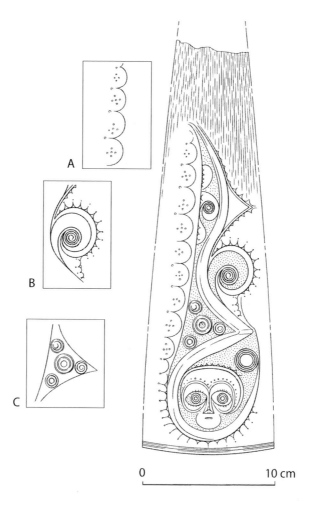

Fig. 7.5. Illustration of torc BM 1991,0407.40. Various different styles of motifs within the decorative scheme are labelled A–C. A face is also clearly visible at the bottom. (Drawing: Jim Farrant; ©Trustees of the British Museum).

from this perspective, our torc does not necessarily have to have been especially old to have been decorated with its unique combination of motifs. Rather, we can see how the people who created its design could have drawn upon a range of different motifs. This conclusion is supported by the fact that other torcs from Snettisham are also decorated in styles that do not easily fit into Stead's stages. For example, the outline on the decoration on the torc terminal illustrated in Figure 7.5 is in the fluid style of Stage V but the design incorporates various motifs and even the outline of a face.

In the context of this paper, I want to stress two conclusions from the analysis of the decoration on our torc. First, without supplementary information such as evidence

for wear and repair, on current evidence it is not possible to infer its age based on the presence of palmette patterns or Stage IV motifs in its design. Its exact age at burial is probably unknowable and further speculation seems pointless. Second, the palmette motifs are significantly different from designs seen on other torcs deposited at Snettisham. I argue that this discrepancy was just as obvious, if not more so, to an Iron Age audience than to a specialist in the study of early Celtic art like me. In this instance, therefore, identification of styles might be misleading in terms of dating the object, but comparison with the decoration on related artefacts has aided in isolating 'deviations from the norm'. Even if our torc was old when it was deposited, which is highly possible, its unusual decoration would have been apparent to the individuals who selected it for deposition and buried it.

'The network of standard stoppages' and the anachronic renaissance

To try to tease some of these ideas out further, I now want to draw on some of the ideas developed in Gell's paper 'The network of standard stoppages'. Written around 1985, it was published posthumously in 2013 (Gell 2013[1985]). Gell was concerned with the so-called *oeuvre* of an artist, explicitly the work of the artist Marcel Duchamp. To examine this, Gell drew on ideas expressed by the philosopher Edmund Husserl, specifically what he termed 'retentions' and 'protentions'. For Husserl, the present was not a line separating the past and the future, but rather formed of retentions of recent experiences and protentions to the near future. Gell argued that Duchamp's *oeuvre* could be viewed as a network of stops with relationships drawn between artworks, or stops, through retentions from past artworks and protentions towards future ones. In other words, later works by Duchamp were anticipated in earlier ones and retentions of earlier works can be found in later ones.

Focusing particularly on the social relationships obtaining from protention and retention, Jones (2001) applied Gell's later examination of the artistic *oeuvre* (Gell 1998) to examine similarities and difference in the archaeology of early Bronze Age Britain. Following Butler (1993), Jones saw decorative motifs as a form of material citation, establishing 'relations of similitude' between artefacts (Jones 2001, 342; see also Jones 2007, chapter 7). Recent theoretical discussions examining how types emerge have also highlighted the importance of citation of past acts (*e.g.* Lucas 2012, 195–201). For example, Fowler (2017, 97, original emphasis) applied assemblage theory to Early Bronze Age burials and suggested, '...each thing in a series is produced in a reiteration of a past event, in the formation of a *similar productive assemblage*'. All of these ideas are valuable and go some way towards the perspectives I want to put forward here. But I have also been influenced by recent work in art history, particularly by Nagel and Wood (2010, 9), which points to the plurality of art:

> No device more effectively generates the effect of a doubling or bending of time than the work of art, a strange kind of event whose relation to time is plural. The artwork is made or

designed by an individual or group of individuals at some moment, but it also points away from that moment, backward to a remote ancestral origin, perhaps, or to a prior artefact, or to an origin outside of time, in divinity. At the same time, it points forward to all its future recipients who will activate and reactivate it as a meaningful event. The work of art is a message whose sender and destination are constantly shifting.

This notion, I think, comes closer to Gell's initial thoughts on the artistic *oeuvre*, protentions and retentions outlined in 'The network of standard stoppages' (Gell 2013[1985]), before they were redeveloped for his book *Art and Agency* (1998). It is the interplay between past, present and *future*, rather than citation, which I think provides a particular dynamism to Gell's theory.

Drawing on these ideas could, I argue, provide a fruitful avenue for addressing the question of what the 'rogue' palmette patterns and motifs on torc BM1991,0502.29 might do. In the context of Hoard F and the Snettisham hoards more broadly, unlike modern reproductions which are formed with a view to recreating the past, retentions are an interpretation of the past in the present but with protentions also to the future. Since it is virtually impossible to make an exact replica by hand, the monikers 'reproduction' or 'copy' are not applicable to Iron Age artefacts, and we should think of them instead as retentions. As each object, whether original or reproduction, is a creative act, there is also little merit in making the distinction anyway (*cf.* Cochrane 2018). Retentions, therefore, can be seen to create a modified picture of time through the plurality of the artefact. We cannot examine the *oeuvre* of individual Iron Age artists or craftspeople as their identities are now lost to us, but we can take objects within a given region or time as a 'set of related artworks' (*cf.* Fowler 2017; Gell 1998). I view the Snettisham torcs as a set of related artworks. These are related in deposition as well as by their decorations. In questioning what retentions and protentions do, it is important to consider who had access to the decoration on torcs (*cf.* Spratling 2008). They were worn at the neck and therefore occupied a highly conspicuous position on the body, acting to frame the face. Decoration is often raised with infilling and other decorative techniques such as stippling adding further texture to the designs. These decorative techniques create different surfaces which catch the light in different ways, making decoration visible from far away. It is thought that some of the larger torcs, the ones most likely to have been decorated, rather than being worn everyday were worn on special occasions, acting to transform the wearer, rather like a mayoral chain (Hill 2006). Yet to perceive the fine detail of the decoration would require intimate access to the object and/or the person wearing it (*cf.* Spratling 2008). Also, we do not know who had the right to handle these objects when they were not in use or how or where they were kept, but knowledge of them and their decorations may have been restricted, adding further layers of complexity. We know from the example of the grotesque torc, but also others where it has been possible to radiocarbon date organic components, that many of the torcs were old when put in the ground. We might label these objects and their decorations as anachronisms, but it is more complicated because it is impossible to know how past designs were perceived. Whether they were viewed as old fashioned, linked to events

or people in the past and so on. More importantly, because they are represented in the hoards, designs of different styles must have been familiar to the people seeing and handling the objects, certainly at the time of deposition. Indeed, deposits such as Hoard L which were collections of old and new objects, including the grotesque torc, shows there was a concern for collecting and depositing artefacts representing previous generations (Joy 2016). Perhaps inclusion of these objects and the representation of 'older' motifs in the designs of torcs selected for deposition, these 'retentions', were preserved with an eye not only to what had passed but also with a view to the future, collapsing time and involving past generations in the activities of the living.

Motifs as manifestations of relations

I have argued in this paper that motifs can manifest relations, creating connections between artefacts past and present. Motifs and their study therefore maintain their intellectual currency but are not independent of the artefacts they adorn or the context in which the art was made, lived a life and was deposited. When returning to the question 'what did art do?', I think, in addition to leading the eye in different directions, or acting as a technology of enchantment, the inclusion or retention of relict motifs in designs also caused an effect on the viewer. The re-use of past or different styles of art can be viewed as an example of retention. Motifs were incorporated into new designs or artefacts decorated with relict styles may have been preserved and selected for special deposition as could be the case at Snettisham. Objects incorporating motifs from particular styles were therefore rearticulated. The retentions included in their designs could have been experienced and manipulated in different ways. Returning to Gell (2013[1985]), it is not necessarily the stop – the individual artwork – that is important, rather, it is the connections and relationships created between artefacts and people past, present and future.

Acknowledgements

I would like to thank the session organisers for inviting me to attend the conference, as well as Helen Chittock, Julia Farley, Jim Farrant and Craig Williams for their help at various stages in the preparation of this paper. Thanks also must go to the two anonymous reviewers for their constructive comments on a previous draft.

References

Adams, S.A. 2013. The First Brooches in Britain: From manufacture to deposition in the Early and Middle Iron Age. Unpublished PhD thesis, University of Leicester.
Baldwin, A. & Joy, J. 2017. *A Celtic Feast: The Iron Age cauldrons from Chiseldon, Wiltshire*. London, British Museum Research Publication 203.
Bradley, R. 2009. *Image and Audience: Rethinking prehistoric art*. Oxford, Oxford University Press.
Butler, J. 1993. *Bodies that Matter*. London, Routledge.

Chittock, H. 2014. Arts and crafts in Iron Age Britain: Reconsidering the aesthetic effects of weaving combs. *Oxford Journal of Archaeology* 33(3), 313–26.

Clarke, R.R. 1954. The early Iron Age treasure from Snettisham. *Proceedings of the Prehistoric Society* 20, 27–86.

Cochrane, A. 2018. Creativity. In S.L. López Varela (ed.), *The Encyclopedia of Archaeological Sciences*. Oxford, Wiley. DOI: 10.1002/9781119188230.saseas0140.

Davies, J. 2008. *The Land of Boudica: Prehistoric and Roman Norfolk*. Oxford, Oxbow Books.

Farley, J. 2012. At the Edge of Empire: Iron Age and early Roman metalwork in the East Midlands. Unpublished PhD thesis, University of Leicester.

Farley, J. & Hunter, F. (eds). 2015. *Celts: Art and identity*. London, British Museum Press.

Fitzpatrick, A.P. 1992. The Snettisham, Norfolk, hoards of Iron Age torques: Sacred or profane? *Antiquity* 66, 395–98.

Fitzpatrick, A.P. 2005. Gifts for the golden gods: Iron Age hoards of torques and coins. In C. Haselgrove & D. Wigg-Wolf (eds), *Iron Age Coinage and Ritual Practices*, 157–82. Studien zu Fundmünzen Antike. Mainz, von Zabern.

Fitzpatrick, A.P. 2007. Dancing with dragons: Fantastic animals in the earlier Celtic art of Iron Age Britain. In C. Haselgrove & T. Moore (eds), *The Later Iron Age in Britain and Beyond*, 339–57. Oxford, Oxbow Books.

Fowler, C. 2013a. *The Emergent Past: A relational realist archaeology of Early Bronze Age mortuary practices*. Oxford, Oxford University Press.

Fowler, C. 2013b. Dynamic assemblages, or the past is what endures: Change and the duration of relations. In B. Alberti, A.M. Jones & J. Pollard (eds), *Archaeology after Interpretation: Returning materials to archaeological theory*, 235–56. Walnut Creek, CA, Left Coast Press.

Fowler, C. 2017. Relational typologies, assemblage theory and Early Bronze Age burials. *Cambridge Archaeological Journal* 27(1), 95–109.

Fox, C. 1958. *Pattern and Purpose: A survey of Early Celtic Art in Britain*. Cardiff, The National Museum of Wales.

Frey, O.-H. 1976. Du Premier style au Style de Waldalgesheim Remarques sur l'évolution de l'art celtique ancien. In P.-M. Duval & C. Hawkes (eds), *Celtic Art in Ancient Europe: Five protohistoric centuries*, 141–65. London, Seminar Press.

Furger, A. 2015. Der Goldfund von Saint-Louis bei Basel: Keltische Hortfunde mit Münzen und Ringschmuck im Kontext. *Zeitschrift für schweizerische Archäologie und Kunstgeschichte* 39, 1–47.

Garrow, D. & Gosden, C. 2012. *Technologies of Enchantment? Exploring Celtic Art: 400 BC to AD 100*. Oxford, Oxford University Press.

Garrow, D., Gosden, C. & Hill, J.D. (eds) 2008. *Rethinking Celtic Art*. Oxford, Oxbow Books.

Gell, A. 1992. The technology of enchantment and the enchantment of technology. In J. Coote & A. Shelton (eds), *Anthropology, Art and Aesthetics*, 40–63. Oxford, Oxford University Press.

Gell, A. 1998. *Art and Agency: An anthropological theory*. Oxford, Oxford University Press.

Gell, A. 2013[1985]. The network of standard stoppages (c. 1985). In L. Chua & M. Elliott (eds), *Distributed Objects: Meaning and mattering after Alfred Gell*, 88–113. Oxford, Berghahn.

Giles, M. 2008. Seeing red: The aesthetics of martial objects in the British and Irish Iron Age. In Garrow *et al.* 2008, 59–77.

Gosden, C. & Hill, J.D. 2008. Introduction: Re-integrating 'Celtic' Art. In Garrow *et al.* 2008, 1–14.

Gosden, C. & Malafouris, L. 2015. Process archaeology (P-Arch). *World Archaeology* 47(5), 701–17.

Haselgrove, C., Armit, I., Champion, T., Creighton, J., Gwilt, A., Hill, J.D., Hunter, F. & Woodward, A. 2001. *Understanding the British Iron Age: An agenda for action*. Salisbury, Wessex Archaeology.

Hautenauve, H. 2005. *Les Torcs D'Or du Second Âge du Fer en Europe: Techniques, typologie et symbolique*. Rennes, Association du Travaux du Laboratoire d'Anthropologie de l'Université de Rennes 1.

Hicks, D. 2010. The material-culture turn: Event and effect. In D. Hicks & M.C. Beaudry (eds), *The Oxford Handbook of Material Culture Studies*, 25–98. Oxford, Oxford University Press.

Hill, J.D. 2006. Are we any closer to understanding how Later Iron Age societies worked (or did not work)? In C. Haselgrove (ed.), *Les Mutations de la fin de l'âge du Fer (IIe-Ier s. av. J.-C.)*, 169–79. Glux-en-Glenne, Collection Bibracte 12/4.

Hutcheson, N. 2004. *Later Iron Age Norfolk: Metalwork, landscape and society*. Oxford, BAR British Series 361.

Ingold, T. 2013. *Making: Anthropology, archaeology, art and architecture*. London, Routledge.

Jacobsthal, P. 1944[1969]. *Early Celtic Art*. 2 vols. Oxford, Clarendon Press.

Jones, A. 2001. Drawn from memory: The archaeology of aesthetics and the aesthetics of archaeology in Earlier Bronze Age Britain and the present. *World Archaeology* 33(2), 334–56.

Jones, A. 2007. *Memory and Material Culture*. Cambridge, Cambridge University Press.

Jones, A.M. & Díaz-Guardamino, M. 2019. *Making a Mark: Image and process in Neolithic Britain and Ireland*. Oxford, Oxbow Books.

Jope, E.M. 2000. *Early Celtic Art in the British Isles*. 2 vols. Oxford, Clarendon Press.

Joy, J. 2008. Reflections on Celtic Art: A re-examination of mirror decoration. In Garrow *et al.* 2008, 78–99.

Joy, J. 2010. *Iron Age Mirrors: A biographical approach*. Oxford, BAR British Series 518.

Joy, J. 2011. 'Fancy objects' in the British Iron Age: Why decorate? *Proceedings of the Prehistoric Society* 77, 205–99.

Joy, J. 2015a. Stylistic variation in Early Celtic art. In J. Farley & F. Hunter (eds), *Celts: Art and identity*, 56–57. London, British Museum Press.

Joy, J. 2015b. Connections and Separation? Narratives of Iron Age art and its relationships with the Continent. In H. Anderson-Whymark, D. Garrow & F. Sturt (eds), *Continental Connections: Exploring cross-channel relationships from the Mesolithic to the Iron Age*, 145–65. Oxford, Oxbow Books.

Joy, J. 2016. Hoards as collections: Re-examining the Snettisham Iron Age hoards from the perspective of collecting practice. *World Archaeology* 48(2), 239–53.

Joy, J. & Farley, J. forthcoming. *The Snettisham Treasure*. London, British Museum Press.

Küchler, S. 2013. Threads of thought: Reflections on art and agency. In L. Chua & M. Elliott (eds), *Distributed Objects: Meaning and mattering after Alfred Gell*, 25–38. Oxford, Berghahn.

Lucas, G. 2012. *Understanding the Archaeological Record*. Cambridge, Cambridge University Press.

Macdonald, P. 2000. A Reassessment of the Copper Alloy Artefacts from the Llyn Cerrig Bach Assemblage. Unpublished PhD thesis, University of Wales Cardiff.

Macdonald, P. 2007a. Perspectives on insular La Tène art. In C. Haselgrove & T. Moore (eds), *The Later Iron Age in Britain and Beyond*, 329–38. Oxford, Oxbow Books.

Macdonald, P. 2007b. *Llyn Cerrig Bach: A study of the copper alloy artefacts from the insular La Tène assemblage*. Cardiff, University of Wales Press.

Macgregor, M. 1976. *Early Celtic Art in North Britain*. Leicester, Leicester University Press.

Machling, T. & Williamson, R. 2018. 'Up Close and Personal': The later Iron Age Torcs from Newark, Nottinghamshire and Netherurd, Peeblesshire. *Proceedings of the Prehistoric Society* 84, 387–403.

Malafouris, L. 2013. *How Things Shape the Mind: A theory of material engagement*. Cambridge, MIT Press.

Meeks, N., Mongiatti, A. & Joy, J. 2014. Precious metal torcs from the Iron Age Snettisham treasure: Metallurgy and analysis. In E. Pernicka & R. Schwab (eds), *Under the Volcano*, 135–56. Rahden/Westf., Forschungen zur Archäometrie und Altertumswissenschaft 5.

Nagel, A. & Wood, C.S. 2010. *Anachronic Renaissance*. New York, Zone Books.

Olivier, L. 2014. Les codes de representation visuelle dans l'art celtique ancien [Visual representation codes in Early Celtic Art]. In C. Gosden, S. Crawford & K. Ulmschneider (eds), *Celtic Art in Europe: Making connections*, 39–55. Oxford, Oxbow Books.

Spratling, M.G. 1972. Southern British Decorated Bronzes of the Late Pre-Roman Iron Age. Unpublished PhD thesis, University of London.

Spratling, M. 2008. On the aesthetics of the Ancient Britons. In Garrow *et al.* 2008, 185–202.

Stead, I.M. 1985a. *The Battersea Shield*. London, British Museum Press.

Stead, I.M. 1985b. *Celtic Art in Britain before the Roman Conquest*. London, British Museum Press.

Stead, I.M. 1991. The Snettisham Treasure: Excavations in 1990. *Antiquity* 65(248), 447–65.

Stead, I.M. 1996. *Celtic Art in Britain before the Roman Conquest*. 2nd ed. London, British Museum Press.

Stead, I.M. 2009. The chronology of La Tène art in Britain. In G. Cooney, K. Becker, J. Coles, M. Ryan & S. Sievers (eds), *Relics of Old Decency: Archaeological studies in later prehistory*, 323–32. Dublin, Wordwell.

Verger, S. 1987. La genèse celtique des rinceaux à triscèles. *Jahrbuch des R-G Zentralmuseums Mainz* 34, 287–339.

Wheeler, R.E.M. 1943. *Maiden Castle, Dorset*. Oxford, Society of Antiquaries.

Chapter 8

Visual memory and perceptions in ancient Celtic art

Nathalie Ginoux

The Greeks, from the later fourth century BC onwards, blend abstract or floral ornaments with human faces, and quite possibly Greek forms, through the medium of the Etruscans, had an influence on the Celts. But to the Greeks a spiral is a spiral and a face is a face, and it is always clear where the one ends and the other begins, whereas the Celts 'see' the faces 'into' the spirals or tendrils: ambiguity is characteristic of Celtic art

PAUL JACOBSTHAL (1941, 10)

Abstract

This paper considers the principles that lie behind so-called Celtic art at its European scale. It moves beyond the search for meaning in the imagery and pattern of this art form to argue that it was founded on ambiguity and the manipulation of forms, rather than the desire to depict. Iron Age craftspeople are compared to the poets and bards evidenced in Classical and early medieval historical sources, whose work inhabited a space between worlds and formed powerful mnemonic devices. It is argued that time is inscribed into the designs of Celtic art objects via a process of 'iconographic concentration' to produce vivid sensory effects.

Paul Jacobsthal is arguably the founding father of scholarship on La Tène period Celtic art (5th–1st century BC). From the beginning, his contributions formed an important aspect of research on ornament, augmenting the work of the Viennese art historian Alois Riegl (1893). Since then, many approaches to ancient Celtic art have been devoted to developing the genealogy of this art form, described through its repertoire of motifs (its grammar) combined with a set of formal, geographical, technical and characteristic features to form its 'styles'. These lines of enquiry have led to questions essentially oriented towards the search for workshops and distribution and the establishment of chronologies and historical landmarks. Others have sought coherence in symbolic, magical or religious content: 'global images [images-monde]' (Kruta 2015). Ideas concerning the psychology of artistic imagination, such as the idea

of a 'Cheshire Cat Style' (Jacobsthal 1941; Megaw 1970) or 'Double reading' (Ginoux 2012), underlie a more or less primitivist perception of Celtic art, a perception that is found, for example, in Ernst Gombrich's writings and studies of other European protohistoric arts (*e.g.* Bianchi Bandinelli 1956). Celtic art is an art whose sophisticated format is recognised in its many technical qualities and formal inventiveness, but whose ambiguity seems to be one of the major keys to understanding it (Lenerz de Wilde 1982; Megaw 1970).

The idea of selective borrowing put forward by Venceslas Kruta (1988) engages ancient Celtic art in an interpretative approach that is no longer heteronomous (*e.g.* the filiation of a Celtic art object to its Mediterranean or oriental models) or, *a contrario*, autonomous from an abstract and primitivist aesthetic form; this new approach is derived from a conception of iconography as a full historical source (Ginoux 2003). The scope of studies on Iron Age iconographic systems has recently expanded to include new perspectives on the perceptual processes at play and their social implications through an approach that combines archaeology and anthropology (Farley & Hunter 2015, see especially Hunter 2015 on 'powerful objects' and Joy 2015 on 'approaching Celtic Art'; Garrow & Gosden 2012).

The quest for intentionality considered from the point of view of both creators and commissioners remains a central problem in the contexts of the unwritten cultures and societies of the second European Iron Age (the latter 1st millennium BC). This search must take into account the materiality and pragmatic and ritual functions of the objects (Megaw & Megaw 1989), since it is agreed by many scholars that La Tène art reflects Iron Age culture, or at least that it was integral to it. Therefore, one can infer firstly that Celtic art acted as a widely shared language for Iron Age societies that were pre-literate, non-unified and strongly stratified since at least about 530–520 BC in the west Hallstatt area, as shown by the phenomenon of princely power centres including elite funeral rites (Cunliffe 2018, 110). Secondly, images served as interactive agents for social practices – beliefs, mental concepts, technical knowledge and ideas – operating between the visible earthly world of the people and the invisible enduring communities of gods and goddesses, heroes or ancestors. Images conveyed the long-lasting record of collective memory.

Issues of meaning

Different types of hypothesis have been formulated in attempts to explain the most enigmatic forms of Celtic art. These include the opinion that there was a form of sensitivity among Iron Age people that predisposed them to 'intellectual reverie' (Duval 1977), the imaginary and the fantastic. To a certain extent (psychologically) this position is consistent with the testimony of Diodorus Siculus (*Library of History*, V, 31), who wrote about the obscure and concise expressions of Ancient Gallic. However, the methods of comparative linguistics and philology have shown that within the linguistic family of which Celtic languages are a part (Cunliffe 2018, 55), poets interpreted aspects of the sacred world as simultaneously inhabiting the levels of the cosmos,

gods, rites and terrestrial life. This was achieved through the use of very complex, obscure formulas, using techniques such as metaphors, assonances and grammatical ambiguities.[1] Poets, like druids, were subjected to very long learning processes based on memorisation training (Caesar, *Gallic War*, VI, 14). These memories – shared between the earthly worlds, the cosmos and the worlds where the gods and heroes supposedly lived – were the privilege of the few who had mastered the poetic art, the sciences that governed the world and the cosmos (numerical sciences, observation of the stars), law, magic, medicine, divination and rites (Sergent 1995, 388). Poets (*filid* in Old Irish), who were the equivalents of the Greek *aoidos* (oral epic poets), documented the memories of these societies, which were dominated by the figure of the warrior and whose praise and exploits they sang. Poems were long, and their refined metric served as a mnemonic process.

Poetry and versification were present in the earliest Irish writings from around the 6th century AD (Watkins 1963), including in the first legal treaties written in Ireland from the 7th century AD onward (Picard 2000). Druids and poets were able to communicate with the gods, whose language they shared, in a learned and obscure language.[2] Within the Greek world, this principle is known through the Delphic oracles, where poets in origin myths are among the creators who are concerned with 'making', just like craftsmen (Detienne 1989). It is also found in the metaphorical and obscure style of the Sanskrit hymns of the Rig Veda and in the circumlocutions known as the kennings in Skaldic poetry, which are metaphors often of mythological origin (Boyer 1997; Desplanques 2015).

Thus, for most of their history, until the Christianisation of Ireland in the mid-5th century AD, Iron Age Celtic societies favoured the living word over written, frozen documentation. As there is no written corpus by the Celts of antiquity (whose intellectual elites spoke and wrote Greek perfectly as indicated by inscriptions and funeral dedications), their art is the only means of expression left to us. The art remains largely indecipherable, but it is a window into their way of seeing and thinking: 'Through the art [however] we can glance fleetingly into the Celtic soul' (Raftery 1994, 163).

Celtic art as ornamental art

The capacity of *the creator* as described above, which can be defined as 'genuine performative ability', is equally that of *the craftsman*. This ability – the mastery of process and secret know-how – is duly memorised and contained within the artefact. Such an artefact is therefore a creation in its own right, encompassing knowledge, accomplishment and many temporalities, just like an epic or a long literary poem. According to Peter Handke (1987) in his poetic meditation *To Duration* [*Gedicht an die Dauer*], the artefact's elaboration is refreshed and reproduced, endlessly, by the beholder's eyes in the past and present: 'a dialectical unfolding: to recognise in the ephemeral, in the fragile what is lasting and to preserve it in a poem, a work of art – this synonym of terrestrial eternity'.

Celtic art is often classified in the category of decorative arts, as it is considered as ornamentation applied to utilitarian, mobile and mostly small objects. Iconographic compositions must therefore adapt to spaces that are initially flat, but often limited and fragmented by curved and discontinuous planes (Ginoux 2002; Joy 2011). In his book devoted to the ancient civilisations of Europe, Guido Mansuelli (1967, 215) rightly pointed out that unlike Scythian art, in which the decorative form guides that of the medium, Celtic art *is* the form of the medium that strictly dictates the form of the decoration (*cf.* Romankievicz 2018). A fundamental question about Celtic craftsmen is, therefore, that of *the plan*. The evolution of the formal structure of La Tène art is, from this point of view, a history of technical and plastic solutions as well as con- tributions and failures. The (decorative) line is linked to the same constraints as the object which supports it: the stress distribution on the plane corresponds to those of the line. The line in La Tène art is therefore a major innovation, and the generating element that succeeds the rigid line of previous art styles.

The formal and conceptual framework in which La Tène art flourished in the 5th century BC immediately set strong constraints, including what appears to be a reluctance to use the human form to represent gods (Kruta 1992; Diodorus Siculus, *Library of History*, XXII, 9). These schemas/strict limits are the visible remainders of a structural rigidity that seems to have stimulated the inventiveness of craftsmen in the service of the social valorisation of elites, who were keen to manifest their power and wealth through emblematic goods.[3] Previously only affected by occasional Mediterranean influences, the transalpine iconographic repertoire from the mid-5th century BC opened more widely to themes and motifs of Middle Eastern and Hellenic origin (transmitted through Greek and Etruscan craftsmen and trade), with possible influences from the eastern world of the steppes and the regions of the north-west Black Sea. The eastern connections were very strongly considered by Jacobsthal (1944) who hypothesised an 'Orientalising' origin. The 5th century BC, when the first historical records of the Celts (Κελτοί) appeared in the writings of Greek geographers and historians (*e.g.* Hecate of Milet, Herodotus), therefore saw a radical change in the iconographic system of the interior European populations. This century is the formation period of so-called ancient Celtic art, which (coinciding with the second Iron Age in the Near East) extended across the continent and lasted until the new millennium, with further extensions in the northern British Isles and Ireland until the middle of the 5th century AD.

The scarcity of figurative representations in Celtic art raised questions among the first La Tène period specialists, such as Joseph Déchelette. A pioneer in Celtic research, he described and classified European La Tène artefacts and data (what he called an ornamental art) with 'its characters, its origins and its relics [ses caractères, ses origines et ses survivances]'. About 15 pages of his *Prehistoric, Celtic and Gallo-Roman Archaeology* manual are entirely devoted to this effort (Déchelette 1914, 1513–27). In this, Déchelette (1914, 1508) compared Celtic art, classified as inorganic, to the multi- plicity of historical scenes that characterise Veneto art. According to him, there was

an opposition between the interior of Europe (including in centres of activity such as Champagne and southern Germany) and regions of the Mediterranean that were in direct contact with the Greeks (such as the east coast of Iberia, the Illyrian territory, and even southern Gaul). In interior Europe there is a distinct absence of anthropomorphic divinity among the Celtic populations as opposed to the Mediterannean regions, which produced anthropomorphic statues or carved stones. Despite this qualitative opposition between the figurative arts – which deal with the human image – and an art in which the human figure is exceptional, Déchelette (1914, 1511) did not misunderstand the skill of craftsmen: among the fundamental principles of Celtic art, he identified symbolic function and the strong constraints of iconographic conventions. Celtic art is, therefore, an *ornamental art*, strongly imbued with an abstract geometric tradition inherited from the religions of Neolithic and Bronze Age inhabitants, which cut short any naturalistic impulse. La Tène art, according to Déchelette (1914, 1509), is 'a purely decorative art that kept this character until the Roman conquest [un art purement décoratif et qui conserva ce caractère jusqu'à la conquête romaine]'. Later, the same idea was emphasised by Jacobsthal (1944, 161), for whom, Celtic art '...is an art of ornament, masks and beasts, without the image of man'. At the time he wrote his book on ancient Celtic art, the only known realistic anthropomorphic depiction from a La Tène context was the front plate of the scabbard from Grave 994 in the Hallstatt cemetery (Austria) – he attributed this to a foreign craftsman (Jacobsthal 1944, 15).

Ornament as process

We have now addressed the thorny issue of defining Celtic art as a decorative/ornamental art. There is now the issue of understanding ornament as a process, or to use E.H. Gombrich's formula (1979), the search for a 'pure decorative form' from three operations: framing, filling and linking. However, in the absence of evaluation criteria, the existence of such a pure decorative form is mere conjecture (Ginoux 2002; Zerner 1997). One should certainly not look for its traces in the serial and complex geometric compositions of the Early Style Celtic art, whose mathematical intellectual dimension has been proven (Baccault & Flouest 2003; Kruta 2015).[4] Ornament is still too often contrasted with figurative or symbolic arts – which 'have meaning' – and is assigned less value. This is an idea that supports a hierarchy in the arts according to supposed levels of meaning, although this has been challenged by many studies that have focused on the task of deciphering ornament. The formalist conception of a meaningless formal arrangement is now highly contested. The decoding of ornament – which cannot be treated globally but only in the social, cultural and technical context of a given environment – therefore forms part of the quest to understand *intentionality* (Bonne 2010, 30).[5] In addition, we can recall Gombrich's (1963, 201) limits of the description and identification of the content of symbols; his example is the tale of Ali-Baba and the forty thieves, who, by multiplying the signs drawn with chalk on the door, destroyed a meaning of the symbol without having to erase it (Ginoux 2003, 261).

There is also a necessity to distinguish between processes involved in observation and observation from the interpretation stage. As the French researcher Marie-Salomé Lagrange (1973, 102) clearly demonstrated in her book *Semiotic Analysis and History of Art* [*Analyse sémiologique et histoire de l'art*] published in 1973: 'The confusion between the pure and simple observation and the interpretation seems to us to contribute largely to the inefficiency of these two stages of the work of the Art historian or the Archaeologist [La confusion entre le constat pur et simple et l'interprétation nous paraît contribuer largement à l'inefficacité de ces deux étapes du travail de l'historien de l'Art ou de l'Archéologue]'. The first obstacle to traditional classification is the 'implicit' complicity between specialists, which results in relative incompleteness or inaccuracy of basic data (conditions). The second point of criticism concerns the use of illustrations as 'exhibits', which removes precision from descriptive analysis, and in so doing can lead the reader down the path of misinterpretation, if written information is deficient (Ginoux 2003a).

Visual intricacy (intrication) and interactivity of ancient Celtic art

In La Tène Celtic art, figurative expression and zoomorphic representation raise questions about the relevance of the idea of imitation (*modèle*) (most often assumed to originate from the Mediterranean or the east). Formal imitation does not seem to have been at the heart of the concerns of image designers and commissioners, who memorised and transmitted in an essentially oral and visual communication system. Thus, for the ancient Celts, like the Scythians and nomads of the steppes, the lack of interest in mimetic images strongly stimulated the implementation of complex processes – developed both conceptually and technically – combining schematisation, recomposition and organisation of motifs, most often reduced to signs by symbolic, perceptual and visual conventions (Fig. 8.1). In such a system, playing with light on metal was essential (often used in opposition: matte/gloss, dark/light, white/gold); these included the polychromy of metals and the use of coloured and specific organic materials such as amber and Mediterranean red coral (*Corallium rubrum*). We can think that the Celts' assertive taste for the composite was due to their unfixed vision of things and beings, to metamorphosis as a dynamic process and, most probably, to an ontology that did not separate different forms of life (Poplin 2000), that did not separate human and nature. However, this did not exclude a certain naturalism in La Tène art, as with much of Scythian art; often animals are not represented according to the canons of realism of Greek art, but they can be captured in relationship to their natural environment. Yann Deberge (2010) provides a possible example with a series of 2nd century BC Arverni vases with animal decoration. Despite highly schematic figuration, the frieze compositions exemplify precise observations of cervid postures during the breeding period (between September and October in our latitudes): combat, approaches and fertility events.

In the chapter entitled 'The science of the real [La science du concret]', as an introduction to his beautiful book, *The Savage Mind* [*La Pensée sauvage*], the anthropologist Claude Lévi-Strauss (1962) uses a large number of examples to establish the sophistication

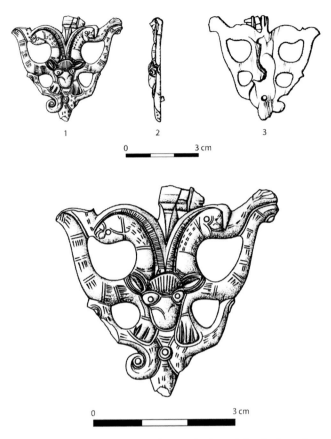

Fig. 8.1. Bronze plate from Hradiště Plešivec (Bohême) (Stolz & Sankot 2011).

of the vocabulary (number of words, precision) of so-called 'primitive' peoples to designate fauna and flora. He demonstrated, on the one hand, the existence of abstract thought and, on the other hand, the subtle nature of a system of thought that cannot be reduced to the utilitarian domain alone. In the eyes of scientific thought, this mythical thinking at work in this complex system is the equivalent of a handyman as compared to an engineer. According to Lévi-Strauss (1962, 31–32), mythical thinking 'is always halfway between percepts and concepts ... But a link exists between the image and the concept: it is the sign [se situe toujours à mi-chemin entre des percepts et des concepts Or un lien existe entre l'image et le concept: c'est le signe]'. In this context, 'art comes in halfway between scientific knowledge and mythical or magical thought; because everyone knows that the artist is both scholar and handyman [l'art s'insère à mi-chemin entre la connaissance scientifique et la pensée mythique ou magique; car tout le monde sait que l'artiste tient à la fois du savant et du bricoleur]' (Lévi-Strauss 1962, 37).

Making visible the ambiguity of visual perception until the complete reconstruction of an image, which is primarily a mental image, cannot be based solely on a formal

attitude but one which refers to a learned and intellectual conception of Celtic art that denotes, records and memorises information and intentions. This is also the very foundation of 'plastic metamorphosis' (Duval 1977): metamorphosis being a dynamic, temporal process, as opposed to the transformation that results from it.

Craftsmen have used the compass effectively to build these ambiguous compositions. In the 5th century, on the Somme-Bionne phalera, floral motifs were decomposed and then recomposed and distributed both filled in and empty, making it impossible to establish any hierarchy in the image (compare Hunter 2016; Romankiewicz 2018). From the same period, the intensive use of openwork probably exceeded solely decorative concerns. Déchelette (1914, 1524) emphasised the appearance of openwork in the beautifully crafted pieces unearthed in the chariot-burials of the Marne and southern Germany. According to him, these were not a Celtic creation, but were borrowed from the crafts of southern Italy, particularly from a Samnite background. Whatever way this ornamental technique was introduced into the Celtic environment – there is little reason to disagree with the idea that the craftsmen of the Early Style acquired it south of the Alps – it is remarkable to see how intelligently the Celts used and renewed it. In my hypothesis explained above, the constraints of planes and surfaces were fundamental evolutionary drivers of Celtic art. Openwork allows one to open the surface of a closed and reduced iconographic field. It also allows the doubling of symmetries, the axis then being located on the plane, which orders positive and negative motifs. Finally, and undoubtedly this is the fundamental reason for its success, openwork favours a double reading, allowing for the accumulation of versions of the same theme by playing on the reversibility of the figures. The openwork belt buckles of the 5th century BC found in the Marne area are good examples of this. They are similar to the ambiguous 'Duck-Rabbit' image used by the American psychologist Joseph Jastrow and made famous by Ludwig Wittgenstein in his *Philosophical Investigations* (1953[1994]) as a means of describing two different ways of seeing: 'seeing that' v 'seeing as', or as a subtler opposition between 'empty (void)' and 'full' (Ginoux 2012a).

Paul Jacobsthal argues that one of the major features of Celtic art is the tendency to merge the representation of the human face with the decorative form. This process may have already been present in the ornamentation of the Early Style as, for example, on the decoration of the Jogasse torc (Jacobsthal 1944, no. 211). However, he emphasises that it is in the Plastic Style that this is most frequent:

> In this particular mask-style the line dividing human form and ornament is blurred …. one can often hesitate whether a face is intended or not. There is something fleeting and evanescent about these masks which often are not even complete faces, only bits of a face. … It is the mechanism of dreams, where things have floating contours and pass into other things. If it were not too frivolous, one might call this the Cheshire style: the cat appears in the tree and often just the grin of the cat (Jacobsthal 1944, 19).

Vincent Megaw also dealt with this topic from the theoretical angle of the psychology of perception (Megaw 1970b; see also Chittock, Chapter 5, this volume). Most scholars agree on this point: representations of the human head found in Celtic art, like those of

the face, respond to conventional forms that do not imitate the human physiognomy but rather refer to a transposition, an experience.

The processes that lead to the identification of the face have been examined in great depth by E.H. Gombrich (1960[1996]) in chapter 3 of his famous book, *Art and Illusion: A study in the psychology of pictorial representation*. To this end, he used various works on the processes of classification, drawing some of his references from the research of the ethology pioneer, Konrad Lorenz (Gombrich 1960[1996], 86–87).[6] The reactions and behaviour of different categories of animals towards decoys, or misleading images reduced to their elementary expressive particularities were analysed. Despite the possibility to control reality, the recognition of facial features for human beings is an innate ability guided by the perspective of the species' biological survival. Thus, according to Gombrich, as soon as any shape likely to resemble a face in any way appears in our field of vision our attention is immediately alerted and responds strongly. This detour through the thoughts of one of the greatest art historians of the 20th century is not a simple digression. Even if he was not interested in protohistoric art, or only anecdotally and tangentially in *Art and Illusion*, Gombrich set out to establish what he described as the framework of a formal conditioning of representation. This dictates within a given context the limits of the choices and possibilities that an artist (or any creator) has and, therefore, seeks to expand (Gombrich 1960[1996], 319). His theory that artists operate not by imitation but by successive adjustments of tests and corrections of memorised conventional schemes, offers a theoretical scope that seems appropriate to address some essential points of Celtic art, including:

- The supposed imitation of naturalistic models,
- The use of a restricted repertoire, subject to strict conventions,
- The stylistic attribution in a technical perspective.

In his 1963[1986] *Meditations on a Hobby Horse and Other Essays on the Theory of Art*, Gombrich approached the foundations of representation – its visual and symbolic dimensions – highlighting the role of memory. This is of great importance to a theoretical framework for approaching non-figurative representational arts, including Celtic art. He shows that representation does not derive from visual appearance but is a substitute for need. In other words, function takes precedence over appearance (alternatively, according to Garrow & Gosden 2012, the appearance is part of the function). By placing in the foreground all the conditions (*i.e.* the context) which comprise the entire technical environment in which iconographic compositions are developed, they are no longer reduced to the outcome of a visual experience but are reconstructed elements of a model structure (Gombrich 1963[1986]).

To date, there is no known association between a text and image, nor between a name and a portrait, that could describe Iron Age iconography. This also applies to coinage, which is a major documentary source for Celtic epigraphy and iconography north of the Alps, first appearing at the beginning of the 3rd century BC. For example, various epigraphic specimens from the Pannonian Boii (north-west of the Carpathian

basin) have provided about 15 names in the Latin alphabet, in particular the 'Biatec type' coins minted around the beginning of the 1st century BC. Undoubtedly, the most emblematic case is that of the 27 known coins minted in the name of Vercinge-torix, which bear portraits and the legends VERCINGETORIXS or VERCINGETORIXIS. As J.-B. Colbert de Beaulieu and B. Fischer (1999) demonstrated, we cannot speak of these portraits as if they were exact, analogical representations; Caesar's writings on a young Arverni chief did not draw a literary portrait other than an indication of his age (Caesar, *Gallic War*, VII, 4). Indeed, the diverse facial features the engravers gave to the beardless young man on the Arverni staters (inspired by the effigy of Apollo in Macedonian minting) prevents these representations from being explicitly related to an identifiable character. Therefore, specialists have concluded that the image of the young warrior was freely invented and based on the conventions of the representation of the Hellenistic Apollon head (Colbert de Beaulieu & Lefèvre 1963).

Therefore, there was no willingness to represent a real (and anatomically correct) person at the beginning of the La Tène period (6th and 5th centuries BC), as exemplified by the life-size statues of warriors certainly erected for commemorative or honorific purposes, such as at the Glauberg, Germany (Frey & Hermann 1997). Nor was there a willingness at the end of the La Tène period, as exemplified on coinage. We find objects, divine and military, represented with great accuracy (for memory's sake), while the effigy itself is treated as a three-dimensional silhouette (see also Chittock, Chapter 5, this volume). The differential treatment of the human anatomy and the significant emblems of the status and function of these figures is so realistic that one can immediately iden-tify the smallest details (armament, flexible armour, torc, headdress) by analogy to the material culture deposited in contemporary tombs. This demonstrates, once again, the absurdity of the criterion of realism as a descriptive condition or an evolutionary step in La Tène art. This differentiated relationship to reality, in representational memorials of the war elite, appears a long time before the initial period of the La Tène Iron Age, more precisely at the end of the Bronze Age in the western Mediterranean. This is very explicit in the group of stone stelae dated between the 10th and 8th centuries BC located in the south-west Iberian Peninsula. They have engraved depictions (perhaps commemorative) of a small human figure with an assortment of realistic artefacts emblematic of those with warlike functions (Cunliffe 2017, 243; Díaz-Guardamino 2014). Therefore, a great deal of knowledge is stored in these images and forms that were imagined, crafted and used in a long-standing tradition that avoided naturalistic imagery.[7]

It is worth returning briefly to the relatively thorny issue of the so-called Cheshire Cat Style (Jacobsthal 1941; Megaw 1970b). Majolie Lenerz de Wilde (1982, 102) devoted an article to this 'characteristic phenomenon of Celtic art'. In it, she aimed to discover the 'centre of gravity' of the Cheshire Cat Style in order to situate it within the general framework of Celtic art. She questions this concept from a historical point of view, and from the place occupied by what she calls the *Cheshire Phenomenon* in the stylistic development of Celtic art. According to Paul Jacobsthal (1941) and Vincent Megaw (1970b) in his study on the 'Cheshire Cat and Mickey Mouse', the Cheshire Style can

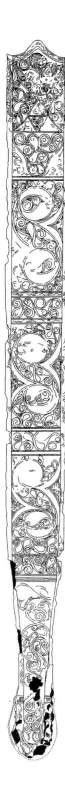

describe two situations: 1) geometric or curved ornaments with no intention of explicitly representing a face; or 2) flowering anthropomorphic/theriomorphic features or inverted animal decoration. Lenerz de Wilde (1982) observed that the latter case is so frequent in the La Tène art that it cannot be the criterion for a style.

To 'entangle' and 'disentangle' [intriquer, désintriquer]' (Bonne 2000) are two interactive cognitive processes that reflect the perceptual complexity involved in the almost 'fractal' conception of ancient Celtic iconography, which multiplies both scales and points of view. We can use the example of the Flavigny iron sword scabbard from the mid-3rd century BC, which was discovered in the 19th century in a cremation in Champagne (not far from Cernon-sur-Coole, Marne). It was the recent subject of restoration, which revealed a composition covering the entire front plate (Rapin 2002). Two techniques – chasing and repoussé – were used to create two single motifs in eight registers: the S-shape and the ornithomorphic triskele. The perceptual complexity mentioned above is particularly evident on this surface, which is entirely saturated by afocal decoration (*i.e.* without any visible hierarchy regarding direction or the images). The first register acts as a summary of the entire design, which is based on the variation of the two simple signs that are repeated with modifications in the next seven registers: the S-shape and the triskele (Fig. 8.2). The composition principle is based on the alternation of binary and ternary patterns. The very heart of the iconographic device is an equilateral triangle, each side measuring 3 cm. It is divided into four other equilateral triangles with 1.5 cm sides. Each of these triangles contains a triskele, rotating to the right, the centre of which is marked with a small triangle. Below it, another larger triskele develops in mirror form, each of the three legs of which ends in a triskele oriented in the same direction. The importance of this part of the design is visible both in its central position and in its relief execution. The spatial relationship between the whole composition and the iconic units (S-shapes and triskeles) is based on the multiplicity of points of view, the different scales (global vision, intermediate vision, detailed vision) and the use of light. The intention is a lability (instability) that generates sinuous and entangled forms requiring mental reconstruction work (therefore, a visual memory process) through the observer's eyes in order to untangle (*désintriquer*) them. This form of iconography cannot

Fig. 8.2. Drawing of the Flavigny sword scabbard decoration (Marne, France) (Rapin 2003).

therefore be captured at the outset. It is at the same time eminently interactive and is the opposite to the classical principle of mimesis.

Iconographic concentration as an art of memory

Among the iconographic conventions that have been in place since the formative phase of Celtic art in the 5th century BC, the representation of the mask already expresses, through its frontal aspect, the notion of concentration that I suggest to apply to Celtic art of the 3rd century BC.

The faces of Celtic art are not derived from preoccupations with mimetic or naturalistic copies but concentrate multiple forms, processes and double or triple 'readings' in a single visual field. To seize a figure in a single glance exemplifies the 'petrification' power of the mask in the interplay of glances and intentions (Vernant 1995). This interaction is already present from the very beginning of Celtic art, as seen on the bronze belt plate from Weiskirchen (Saarland) (Haffner 1976, 217–19): the continuous movement of metamorphosis through hybridity is opposed to the fixed nature of the form, which seems eternal (Fig. 8.3).

The analogical status of hybridity and imaginary creatures has not been analysed as a whole in ancient Celtic art unlike other cultural areas such as, for example, pre-Hispanic Mesoamerica. Imaginary creatures or fantastic bestiary are among the wordings that cut any link with the real world (Karadimas 2014, 8). The formalisation of figuration and graphic combination of ideas related to myths and religion give rise, in La Tène iconography, to what I will call here a kind of 'exquisite corpse [cadavre exquis]'. One of the clearest examples of this is found on the four gold torcs from the Erstfeld deposit (Switzerland), dated no later than the first decades of the 4th century BC (Guggisberg 2000). On these masterpieces, the fragmentation of images and the dissemination of figures abolish any sense of hierarchy in or 'reading' of the overall composition. Describing, naming and interpreting are entirely based on our ability to reconstruct a mental framework in the absence of direct knowledge about ancient Celtic myths, nomenclatures and taxonomies. As Dimitri Karadimas (2014, 8) writes: 'Beyond the seizure of life by the senses, the composition of composite beings is based above all on the powers of perception and naming [Au-delà de la saisie du vivant par les sens, la composition des êtres composites repose avant tout sur les facultés de perception et de nomination]'.

Iconographic concentration

I would now like to explain the theory of 'iconographic concentration', which I borrow from the theory of 'Plastic concentration' by the German art historian Carl Einstein, a specialist in African sculpture. Einstein (1915[1998], 38–39) introduced the idea of plastic concentration in his seminal book, *African Sculpture* [*Negerplastik*].[8] With all the prudence required when using notions borrowed from another culture, I think its use

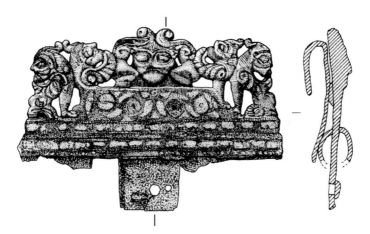

Fig. 8.3. Belt plate 1 of Weisskirchen Tumulus 1 'Schanzenknöppchen', Germany (after Reinhard 2003, pl. 100, 2).

is justified to reflect the mastery which enabled the Celts to give the image an intensity that far exceeded natural reality.

In the context of Celtic art, I define 'iconographic concentration' as an integrated concept of different processes (and therefore of different temporalities) contained in the materiality of the decorated objects. These temporalities refer to:

- the time of the transformation of raw materials into the object that will hold the iconography, the elaboration of the object and the realisation of its decoration.
- the perceptual, sensory and mnemonic temporalities engaged to mentally reconstruct the image, before understanding it as a whole and grasping its details. This is the experience renewed by the researcher who sketches and draws in order to analyse. This is what I mean by the 'mental path', which allows the creative process to unfold in both directions and with all senses (optical, haptic,[9] even touch) in order to reach a full understanding: unfold, unwind, recompose, rotate the image at different levels of interpretation.

The use of the term 'concentration' seems appropriate to reflect the outcome of experiments in Celtic iconography in the 3rd century BC, which had been in process since the beginning of the La Tène period. Concentration appears to be the result of a long process of acquisition and maturation which reveals part of the underlying experimental framework: technical means, plastic means, the mastery of all symmetry and isometry systems, structural rhythms. Concentration, therefore, involves different levels of intentionality and information. It is the most accomplished degree in the integrative capacity to establish a dialectical (and therefore cognitive) relationship between the designer (Romankievicz 2018) and the 'beholder'.

Technological development is the essential corollary that leads from the stage of fusion, developed in the 4th century Continuous Vegetal Style, to that of concentration. It is important to recall here the major role of the Danube workshops, which developed advanced technology and special skills in the production of copper alloys from the beginning of the 3rd century, and which were capable of reconciling ductility and mechanical strength to produce very thin sheets in high volumes. The openwork technique, often used in 3rd century craft traditions, also dates back to the early days of La Tène, with pieces that are among the most accomplished of the Early Style, such as the gold trimmings of Schwarzenbach (Rhineland) and Eigenbilzen (Limburg, Belgium), the openwork phalera of Somme-Bionne, Cuperly (Marne) and, naturally, the male openwork belt plates (Déchelette 1914, 1237, fig. 524). In its 3rd century BC version, this technique assimilates all the dynamic graphic properties of the *Continuous Vegetal Style* (continuity and strength of the line that surrounds, delimits and connects) and those of the passing through the third dimension of the Plastic Style.

However, after the profound renewal of La Tène art in the Celtic-Italian melting pot of the 4th century BC, there was a fruitful encounter between the La Tène plastic spirit and the decorative traditions of Greek and Etruscan art. In this Celtic art of the mature 3rd century, craftsmen, bronzers, blacksmiths, engravers and chisellers were able to benefit from the earlier achievements and the most recent technological solutions of iron and bronze metallurgy. In this most accomplished phase of La Tène art, during the 3rd century BC, craftsmen simultaneously drew on an old tradition and the most recent technological solutions of iron metallurgy, which implies a rigorous organisation of learning and transmission of skills.

One of the technological achievements of this century is the appearance of wire meshes with consistent diameters. This iron technology did not exist in such a successful way in the 5th century, when openwork iron staples appeared. The openwork at that time was carried out by a simple removal of material by combining several processes: tracing, drilling with a small drill, deburring and polishing. In 3rd century BC art, however, the wire is treated as a shaped line. For this to be achieved, the wire must possess a combination of two mechanical qualities: ductility and mechanical strength. The discrepancy between the development of technical solutions and iconography has already been mentioned, particularly with regard to the ornamentation of sword scabbards (Ginoux 1994, 9). More generally, the American anthropologist Franz Boas (1927, 310) established this criterion of technological evolution as a necessary condition for the development of art.

The example of the refined decoration of the sword scabbard from the cart-burial no. 1004 of Plessis-Gassot (Val-d'Oise) and the few known examples elsewhere in the Celtic world (Ginoux & Ramsl 2014) are representative of 'iconographic concentration': the way in which the concentration points are distributed, both on the raised parts and in the voids, and the way in which the forces emanating from them are distributed according to the rhythm of the line's continuous course. If the principle

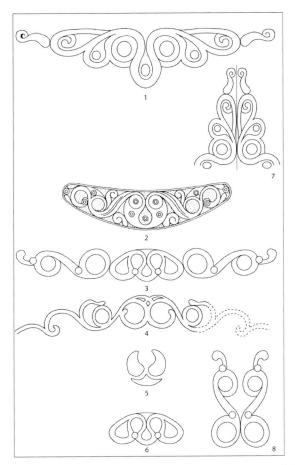

Fig. 8.4. (1) Le Plessis-Gassot (scabbard grave no. 1002); (2) Brunn am Steinfeld (after Jacobsthal 1944); (3, 6-8) Le Plessis-Gassot (scabbard grave no. 1004) (Graphics: N. Ginoux/I. Pasquier; Ginoux & Ramsl 2014). (4) Gournay-sur-Aronde (after Lejars 1994); and (5) openwork motif on the spearhead from Le Plessis-Gassot (Graphics: N. Ginoux/I. Pasquier after Ginoux 2003b).

of 'doubling' inherent in the antagonistic symmetry of the Early Style (Ginoux 2002; Olivier 2014) has disappeared, it is replaced here by another principle, which I will define in terms of 'resonances'. The concentration points of the decoration are made up of the motifs, which appear either in a positive form in the outline or in a negative form in the voids. In both cases, the concentration points are still strong. The larger areas, which correspond to the fields of distribution of these points of strength, define the different versions of the same theme: the Tree of Life and its guardians (Fig. 8.4).

The famous small bronze mount (100 mm high) from a deposit of objects of the same metal found in Stanwick (North Yorkshire, Great Britain), one of the most

Fig. 8.5. Right: Stanwick (Yorkshire) (after Duval 1977) and left: bracelet from Grave 31 from Brno-Malomĕřice cemetery (Moravie) (after Kruta 1987).

remarkable pieces of Celtic art, represents an equine head, an apparently simple shape but of skilled complexity (Fig. 8.5). The plate is embossed in high relief, a graphic-plastic type of representation, and a good example of the cursive and linear style characteristic of the creators of pre-Roman insular art. A magnificent example of concentration, three major and inseparable themes are intertwined on this small and curving format: the coiffed head, the palmette mask and the horse/bird association. The motif is based on a double-leaf pattern. This piece dated to the late La Tène period is, in terms of composition, comparable in every way to the mask on the Brno-Malomĕřice bracelet dated from the 3rd century BC (Kruta 1987). We can also see here the representation of the central mask. The particular animal physiognomy of the Stanwick mask comes from the iconographic concentration on several levels of the assemblage of motifs that constitute it. Indeed, the horse's snout is made up of both a 'double-leaf' pattern and two profiles arranged in mirror symmetry, which are those of a head with a long spiral beak and an almond eye – this motif is generally interpreted as a 'dragon's head'. One of the most accomplished versions of this motif, which is omnipresent in Sword Style decoration, can be found on the reverse plate of the sword scabbard of Cernon-sur-Coole (Marne, France) (Duval & Kruta, 1986). The aspect that holds our attention here is the arrangement of the two heads joined together in profile to form a single face. In this head we find the characteristics of the mask (frontal view, exophthalmos), but above all and on a formal level, a mode of composition that is quite comparable to that of the 'split representation'. This mode has been analysed in the context of North-west American so-called 'primitive art', as well as those in Siberia and China (Boas 1927; Lévi-Strauss 1973). On the Brno-Malomĕřice bracelet and on the insular bronze fitting, the intensity of the 'closed form' (Einstein 1915[1998]) is based on the same principle of concentration

Fig. 8.6. Orval 'Les Pleines' (Photo: © Hervé Paitier, Inrap 2010; Design: N. Ginoux).

and requires a reading on several levels and a mental deployment of the image to fully understand it.

The same principle of the relationship between assemblage and iconographic concentration is at the origin of the anthropomorphic, but nevertheless enigmatic, composition which is executed with repoussé and chisel on each of the two chariot linchpins found at Orval 'Les Pleines' (Manche, France) in the burial excavated in 2006 (INRAP) (Lepaumier *et al.* 2011). The context is that of an aristocratic burial dated around the middle of the 3rd century BC with very strong analogies to the chariot-burials of the Paris region and also those of the British Isles.

The arrangement of the shapes results in an anthropomorphic mask with its traditional La Tène characteristics, the same as those of the Weiskirchen belt-plate: frontal view and prominent eyes. It is shaped in three lateral and interlocking planes (cheeks and nose) (Fig. 8.6); the arch of the eyebrows is very marked. Two curved strands (forming a kind of beard) rise symmetrically on either side of the lower face, towards the cheeks in a curve, while the hairstyle is divided into two strands, equally symmetrical, on either side of the mask.

Fig. 8.7. Ornithomorphs in ternary pattern. (1) Fibula from Villeneuve-la-Guyard (Yonne, France): (a) detail of the decorated cabochon; (b) developed from the main motif; (c) developed from the ornithomorphic motif of the scabbard from Cernon-sur-Coole (Marne) (after Duval & Kruta 1986); (d) developed from the whole decoration (after Rapin & Baray 1999). (2) Decoration on the four rivet heads decorating the warrior's shield of tomb n°1002 of Plessis-Gassot (Val-d'Oise) (N. Ginoux; Graphics: I. Pasquier, INRAP after Ginoux 2003).

This central figure is framed by two opposing profiles, also anthropomorphic, topped with two locks of hair. These three figures are directly connected to each other (Lepaumier *et al.* 2011, fig. 15). Therefore, one can suppose that this ternary composition presents, unfolded in a single shot, three different visions of the same hybrid. This deployment of the image on a flat plane contrasts with the iconographic concentration of the central form, the closed form of the mask, which is actually made up of four 'dragon' heads, a concept like Stanwick's equine mask. On the Orval linchpins, four profiles are nested and alternately arranged through a device based on symmetry and asymmetry (Fig. 8.6). These two pairs of 'dragon' heads form the central mask of each linchpin and are a very effective example of the so-called split representation: '…either the animals are represented as split in two so that the profiles are joined in the middle, or a front view of the head is shown with two adjoining profiles of the body' (Boas 1927, 223–24; Levi-Strauss 1973, 289).

The iconographic device uses two operations: a translation and reversal (Fig. 8.6). The three parts that shape the central mask are emphasised by the ternary pattern formed by the pair of eyes and the mouth. It is the iconographic equivalent of the ornithomorphic triskele, which is the central motif in the composition of Flavigny's sword scabbard and other masterpieces, related to the second phase of the Plastic Style (Fig. 8.7). This integrative concept of image is built on the mental path of the line that must be followed entirely with the eyes and on the whole duration of its path, if we want to reconstitute the graphic and thematic assemblage. The temporality of the line is inscribed there, permanently (Ingold 2007[2018], 97; Jakobi 2004, 36) masking a present but 'off-screen' visibility, 'in reserve'.

In conclusion

Celtic art of the 3rd century BC thus marks the completion point of an experimental framework that began in the 5th century to serve ambivalent iconic and plastic devices. With the Plastic Style, the Celts invented very powerful interactive devices, based on sensory experiences: optical and haptic. The designs sometimes occupy flat planes and sometimes curving surfaces. Subtle surface treatments are added, and the use of the chisel plays with light to alter or increase perception. This motivation of colour could explain the Celts' privileged use of metal chisels, which would be in line with Riegl's (1901) observations about the use of the bevelled size (*keilschnitt*) of late antique bronze object productions.

The movement of light is, by modifying the sensory experience, an active agent of creation in ancient Celtic art. Light vibration and contrast effects play on space as well as line and trajectory rhythms. Light and movement are therefore at the heart of Celtic art thought. Purely virtual movement can be created by visual illusions. Iconographic devices unfold and transform themselves before our eyes, as can be seen on the elements of the chariot from Paris or on those that form the splendid ensemble of the Roissy chariot-grave known as 'of the bronzes [des bronzes]' (Val-d'Oise) (Lejars 2005; Olivier 2012). The Celtic art object is not designed for contemplation, but it is a vivid experience of metamorphosis, a unique way of thinking about the world and reflecting it halfway between perceptions and concepts. Time is at work, inscribed in the images we study, which are updated every time we look at them. There are many mental maps, and as many ways to connect visible and invisible worlds throughout time.

Notes

1 The comparative study conducted by the linguist Calvert Watkins (1995) in his masterful book *How to Kill a Dragon* demonstrates the importance and depth of such linguistic devices over time and space.
2 Diogenes Laertius (1853) in *The Lives and Opinions of Emiment Philosophers* quotes Sotion of Alexandria at the beginning of the prologue, in which Sotion describes the druids as 'semnotheoi', men 'venerable towards the gods'.

3 See Gombrich 1960[1996, 319] about 'the constraint' as a source of artistic achievement.
4 From the Irish art of the early middle ages, and mainly from the *Book of Kells*, Gombrich draws part of his arguments to distinguish the symbolic arts (which are part of the quest for meaning) from the decorative arts (which are part of the sense of order).
5 According to Jean-Claude Bonne (2010): 'But the ornamental can be understood in a completely different way, no longer in terms of local devices but of inherent and transversal *modus operandi* for all artistic productions (representational or not). This is observed in the great formal and chromatic rhythms that go through figures and compositions from within, and that are irreducible to their iconographic functions (such as the folds and gestures of the characters or the figuration of mandorles in theophanies). This ornamentality, directly intricate to the figures, cannot be interpreted in purely 'stylistic' terms (as has been the case for a long time), because it plays a constructive and expressive role with regard to what it affects and highlights [Mais l'ornemental peut s'entendre d'une tout autre manière, non plus en termes de dispositifs locaux mais de *modus operandi* inhérent et transversal à toutes les productions artistiques (représentationnelles ou non). Cela s'observe dans les grands rythmes formels et chromatiques qui traversent de l'intérieur les figures et les compositions, et qui sont irréductibles à leurs fonctions iconographiques (comme les plis et les gestes des personnages ou la figuration des mandorles dans les théophanies). Cette ornementalité, directement intriquée aux figures, ne peut être interprétée en termes purement 'stylistiques' (comme cela a été longtemps le cas), car elle joue un rôle à la fois constructif et expressif à l'égard de ce qu'elle affecte et met en valeur]'.
6 'I do not go so far as to think that the study of the behavior of seagulls should allow us one day to clear up the mystery of Raphael's works. And I stand wholeheartedly alongside those who warn us against any risky speculation about the innate and fatal nature of man's behavior [Je ne vais cependant pas jusqu'à penser que l'étude du comportement des mouettes devrait nous permettre un jour d'éclaircir le mystère des œuvres de Raphaël. Et je me range sans réserve aux côtés de ceux qui nous mettent en garde contre toute spéculation hasardeuse sur le caractère inné et fatal du comportement de l'homme]' (Gombrich 1960[1996], 86–87).
7 About the issue of the factors that lead to the conservatism of the craft traditions, Gombrich (1960[1996], 233) writes: 'An interesting suggestion in this respect has recently been made by Konrad Lorenz, who compared the tenacity of conventions in the traditional crafts with the process that students of animal behaviour call 'ritualization'. In both cases, so he argues, the rigid stereotype facilitates communication and preservation. The movements and actions the craftsmen perform must also be correctly handed down to the next generation'.
8 Einstein (1915[1998], 29) argues that style is fixed by religious canons and can only be modified by other religious canons and that three-dimensionality is a process of emergence of form as much as occultation.
9 The idea of haptic (from the Greek verb aptô, touch) was developed by Alois Riegl (1901) in another of his fundamental works, *Spätromische Kunstindustrie*, the first edition of which was published in Vienna, Austria in 1901. This idea, which is based on a complementarity between sight and touch, refers both to the level of perception (intuition) and to a material reality, that of the hand. It is therefore an eminently interactive concept, according to Riegl operating to reflect the barbaric arts of the late antiquity but also, from my point of view, the interactive experience to which Celtic art leads us.

References

Bacault, L. & Flouest, J.-L. 2003. Schémas de construction des décors au compass des phalères laténiennes de Champagne. In Buschenschutz *et al.* 2003, 145–70.
Bianchi Bandinelli, R. 1956. *Organicità e astrazione*. Milan, Feltrinelli.
Boas, F. 1927. *Primitive Art*. Oslo, Aschehoug & Co.

Bonne, J.-C. 2000. Intrications (à propos d'une composition d'entrelacs dans un évangile celto-saxon du VIIe siècle). In P. Ceccarini, J.-L. Charvet, F. Cousinié & C. Leribault (eds), *Histoires d'ornement. Actes du colloque de l'Académie de France à Rome, Villa Medicis, 27–28 juin 1996, Paris, Rome 2000*, 75–108. Paris/Rome, Klincksieck/Académie de France à Rome.

Bonne, J.-C., Denoyelle, M., Christian Michel, C., Nouvel-Kammerer O. & Coquery, E. 2010. Y a-t-il une lecture symbolique de l'ornement? *Perspective: Actualité en histoire de l'art*. Available at: http://journals.openedition.org/perspective/1206 (Accessed 23 February 2018).

Boyer, R. 1997. *Héros et dieux du Nord: Guide iconographique*. Paris, Flammarion.

Buschenschutz, O., Bulard, A., Chardenoux, M.-B. & Ginoux, N. (eds). 2003. *Décors, images et signes de l'âge du Fer européen, Actes du XXVI colloque de l'Association Française pour l'Etude de l'Age du Fer*. Revue Archéologique du Centre de la France Supplément 24. Tours, Feracf.

Caesar, J. *Gallic War*. Translated by A. McDevitte & W.S. Bohn 1869. New York, Harper & Brothers.

Colbert de Beaulieu, J.-B. & Lefèvre, G. 1963. Les monnaies de Vercingétorix. *Gallia* 21(1), 11–75.

Colbert de Beaulieu, J.-B. & Fischer, B. 1999. Recueil des inscriptions gauloises (RIG) vol. IV « les légendes monétaires ». *Revue Numismatique* 6(154), 372–74.

Cunliffe, B. 2017. *On the Ocean: The Mediterranean and the Atlantic from prehistory to AD 1500*. Oxford, Oxford University Press.

Cunliffe, B. 2018. *The Ancient Celts*. 2nd edition. Oxford, Oxford University Press.

Deberge, Y. 2010. Nouvel ensemble de vases à décors peints en territoire averne. *Jahrbuch des Römisch-Germanischen Zentralmuseums Mainz* 57, 123–49.

Déchelette, J. 1914. *Manuel d'archéologie préhistorique, celtique et gallo-romaine. Vol. II*. Paris, Picard.

Desplanques, E. 2015. *L'Arbre de Vie et ses substituts dans les mondes celtes anciens*. Mémoire de Master 1. Paris, Université Paris-Sorbonne.

Detienne, M. 1989. *Les dieux d'Orphée*. Paris, Gallimard.

Díaz-Guardamino, M. 2014. Shaping social identities in Bronze Age and Early Iron Age western Iberia: The role of funerary practices, stelae, and statue-menhirs. *European Journal of Archaeology* 17(2), 329–49.

Diodorus Siculus. *Library of History, Volume IV: Books 9-12.40*. Translated by C.H. Oldfather. 1946. Loeb Classical Library 375. Cambridge, MA, Harvard University Press.

Diogenes Laertius. *The Lives and Opinions of Eminent Philosophers*. Translated by C.D. Yonge. 1853. London, Henry G. Bohn.

Duval, P.-M. 1977. *Les Celtes*. Paris, Gallimard.

Duval, P.-M. & Kruta, V. 1986. Le fourreau celtique de Cernon-sur-Coole (Marne). *Gallia* 44, 2–27.

Einstein, C. 1915[1998]. *Negerplastik*. Leipzig, Verlag der Weißen Bücher. French translation in L. Meffre, *La Sculpture nègre*. 1998. Paris, l'Harmattan.

Farley, J. & Hunter, F. (eds) 2015. *Celts: Art and identity*. London, British Museum Press.

Frey, O.-H. & Hermann, F.R. 1997. Ein frühkletischer Fürstengrabhügel am Glauberg im Witteraukreis, Hessen. *Germania* 75(2), 459–550.

Garrow, D. & Gosden, C. 2012. *Technologies of Enchantment? Exploring Celtic Art: 400 BC to AD 100*. Oxford, Oxford University Press.

Ginoux, N. 1994. Les fourreaux ornés de France du Ve au IIe siècle avant J.-C. *Etudes Celtiques* XXX, 7–86.

Ginoux, N. 2002. La figuration et sa déconstruction: l'exemple de la paire d'animaux fantastiques affrontés sur les fourreaux d'épée laténiens. In Z. Karasová & M. Lička (eds), *Figuration et abstraction dans l'art de l'Europe ancienne (8ème-1ers: av. J.-C.). Actes du Colloque International de Prague, Musée National, 13-16 juillet 2000*, 71–82. Serie A 56. Prague, Národní Muzeum.

Ginoux, N. 2003a. La forme, une question de fond dans l'expression non figurative des sociétés sans écriture. In Buschenschutz et al. 2003, 259–73.

Ginoux, N. 2003b. L'excellence guerrière et l'ornementation des armes aux IVe et IIIe siècles av. J.-C: découvertes récentes. *Etudes Celtiques* 35, 33–67.

Ginoux, N. 2012a. Doppeldeutigkeit. In S. Sievers, H.U. Otto & P.C. Ramsl (eds), *Lexikon zur Keltischen Archäologie, Praehistorische Kommission (phil.-hist Klasse)*, 434. Wien, Oesterreichische Akademie der Wissenschaften.

Ginoux, N. 2012b. Images and visual codes of Early Celtic warrior elites (5th–4th centuries BC). In C. Pare (ed.), *Kunst und Kommunikation Zentralisierungsprozesse in Gesellschaften Des Europäischen Barbarikums Im 1. Jahrtausend V. Chr.*, 179–90. Mainz, Verlag des Römisch-Germanischen Zentralmuseums.

Ginoux, N. & Ramsl, P.C. 2014. Art and craftsmanship in elite-warrior graves: From Boii to Parisii and back again... In C. Gosden, S. Crawford & K. Ulmschneider (eds), *Celtic Art in Europe: Making connections*, 284–95. Oxford, Oxbow Books.

Gombrich, E.H. 1960[1996]. *Art and Illusion: A study in the psychology of pictorial representation* [*L'art et l'illusion: Psychologie de la représentation picturale*]. French translation by Guy Durand. Revised edition. Paris, Gallimard.

Gombrich, E.H. 1963[1986]. *Meditations on Hobby Horse and Other Essays on the Theory of Art* [*Méditations sur un cheval de bois et autres essais sur la théorie de l'art*]. French translation by Guy Durand. Mâcon, Éditions W.

Gombrich, E.H. 1979. *The Sense of Order: A study in the psychology of decorative art*. Ithaca, NY, Cornell University Press.

Guggisberg, M.A. 2000. *Der Goldschatz von Erstfeld: Ein keltischer Bilderzyklus zwischen Mitteleuropa und der Mittelmeerwelt*. Antiqua 32. Basel, Schweizerische Gesellschaft für Ur- und Frühgeschichte.

Haffner, A. 1976. *Die Westliche Hunsrück-Eifel-Kultur*. Römisch-Germanischen Forschungen 36. Berlin, W. de Gruyter.

Handke, P. 1987. *Poème à la durée* [*To Duration/Gedicht an die Dauer*]. Translation from German by G.-A. Goldschmidt. Paris, Gallimard.

Hunter, F. 2015. Powerful objects: The uses of art in the Iron Age. In J. Farley & F. Hunter (eds), *Celts: Art and identity*, 80–105. London, British Museum Press.

Hunter, F. 2016. Tracing troops: An Upper German belt-fitting from Roman Scotland. *Britannia* 47, 266–71.

Ingold, T. 2007[2018]. *Lines: A brief history* [*Une brève histoire de lignes*]. 9th edition. Le Kremlin-Bicêtre, Zones Sensibles.

Jacobsthal, P. 1941. Imagery in early Celtic art (Sir John Rhŷs Memorial Lecture). *Proceedings of the British Academy* 27(1941), 301–20.

Jacobsthal, P. 1944. *Early Celtic Art*. 2 vols. Oxford, Clarendon Press.

Jakobi, M. 2004. *Paul Klee, Cours du Bauhaus. Weimar 1921-1922: Contributions à la théorie de la forme picturale*. Paris, Hazan.

Joy, J. 2011. 'Fancy objects' in the British Iron Age: Why decorate? *Proceedings of the Prehistoric Society* 77, 205–29.

Joy, J. 2015. Approaching Celtic Art. In J. Farley & F. Hunter (eds), *Celts: Art and identity*, 36–51. London, British Museum Press.

Karadimas, D. 2014. Voir une chenille, dessiner un serpent à plumes. Une relecture analogique de l'hybridité et des êtres imaginaires en Mésoamérique préhispanique. *Journal de la société des américanistes* 17 September 2014, 7–43. Available at: http://journals.openedition.org/jsa/13673 (Accessed 10 February 2018).

Kruta, V. 1987. Le masque et la palmette au IIIe s. avant J.-C.: Loisy-sur-Marne et Brno-Malomerice. *Etudes Celtiques* XXIV, 13–32.

Kruta, V. 1988. L'art celtique laténien du Vᵉ siècle avant J.-C.: le signe et l'image. In J.-P. Mohen, A. Duval & Eluère, C. (eds), *Les princes Celtes et la Méditerranée: recontres de l'Ecole du Louvre*, 81–93. Paris, La Documentation Française.

Kruta, V. 1992. Brennos et l'image des dieux: la représentation de la figure humaine chez les Celtes. *Comptes Rendus des Séances de l'Année* 1992, 821–46.

Kruta, V. 2015. *L'Art des Celtes*. Paris, Phaidon.

Lagrange, M.-S. 1973. *Analyse sémiologique et histoire de l'art*. Paris, Klincksieck.

Lejars, T. 1994. *Gournay III, les fourreaux d'épée. Le sanctuaire de Gournay-sur-Aronde et l'armement des Celtes de La Tène moyenne*. Paris, Errance.

Lejars, T. 2005. Le cimetière celtique de La Fosse Cotheret, à Roissy (Val-d'Oise) et les usages funéraires aristocratiques dans le nord du Bassin parisien à l'aube du III^e siècle avant J.-C. In Buschenschutz *et al.* 2003, 73–85.

Lenerz de Wilde, M. 1982. Le 'Style de Cheschire cat' un phénomène caractéristique de l'art celtique. In P.-M. Duval & V. Kruta (eds), *L'art celtique de la période d'expansion, IVe et IIIe siècles avant notre ère: actes du colloque organisé sous les auspices du Collège de France et de la IVe section de l'Ecole pratique des hautes études, du 26 au 28 septembre 1978, au Collège de France à Paris*, 101–14. Genève, Droz.

Lepaumier, H., Giazzon, D. & Chanson, K., with Féret, L., Guitton, V. & Corde, D. 2011. Orval, « Les Pleines » (Manche). Habitats enclos et tombe à char en Cotentin. In P. Barral, B. Dedet, F. Delrieu, P. Giraud, I. Le Goff, S. Marion & A. Villard-Le Tiec (eds), *L'Âge du fer en Basse-Normandie: gestes funéraires en Gaule au second âge du fer: actes du XXXIIIe Colloque international de l'AFEAF (Caen, 20-24 mai 2009)*, 315–31. Besançon: Presses universitaires de Franche-Comté.

Lévi-Strauss, C. 1962. *La Pensée sauvage*. Paris, Plon.

Lévi-Strauss, C. 1973. Le dédoublement de la représentation dans les arts de l'Asie et de l'Amérique. Reprinted in *Anthropologie Structurale* II, 269–94. Paris, Plon.

Mansuelli, G. 1967. *Les Civilisations de l'Europe ancienne*. Paris, Arthaud.

Megaw, J.V.S. 1970a. *Art of the European Iron Age: A study of the elusive image*. Bath, Adams & Dart.

Megaw, J.V.S. 1970b. Cheshire cat and Mickey Mouse: Analysis, interpretations and the art of La Tène Iron Age. *Proceedings of the Prehistoric Society* 36, 261–79.

Megaw, M.R. & Megaw, J.V.S. 1989. *Celtic Art: From its beginning to the Book of Kells*. London, Thames and Hudson.

Olivier, L. 2012. La tombe à char aux bronzes d'art celtique de Roissy (Val-d'Oise). *Antiquités nationales* 43(2012), 79–138.

Olivier, L. 2014. Les codes de représentation visuelle dans l'Art celtique ancien [Visual representation codes in Early Celtic Art]. In C. Gosden, S. Crawford & K. Ulmschneider (eds), *Celtic Art in Europe: Making connections*, 39–55. Oxford, Oxbow Books.

Picard, J.-M. 2000. Les procédures judiciaires en Irlande au haut Moyen Âge. In *Actes des congrès de la Société des historiens médiévistes de l'enseignement supérieur public, 31 congrès, Angers, 2000. Le règlement des conflits au Moyen Âge*, 67–81. Paris, Publications de la Sorbonne.

Poplin, F. 2000. Le corail: entre animal, végétal, minéral et au cœur de la matière. In J.-P. Morel, C. Rondi-Costanzo & D. Ugolini (eds), *Corallo di ieri Corallo di oggi, Atti del convegno, Ravello, Villa Rufolo, 13-15 dicembre 1996*, 265–75. Bari, Edipuglia.

Raftery, B. 1994. *Pagan Celtic Ireland: The enigma of the Irish Iron Age*. London, Thames and Hudson.

Rapin, A. 2002. Nos concepts modernes d'abstraction et de figuration sont-ils adaptés aux analyses de l'art laténien? In Z. Karasová & M. Lička (eds), *Figuration et abstraction dans l'art de l'Europe ancienne (8ème-1ers: av. J.-C.). Actes du Colloque International de Prague, Musée National, 13-16 juillet 2000*, 45–56. Sborník Národního Muzea v Praze Serie A 56. Prague, Národní Muzeum.

Rapin, A. 2003. Les analyses sémiologiques de l'image: l'iconographie du deuxième âge du Fer. In Buschenschutz *et al.* 2003, 49–62.

Rapin, A. & Baray L. 1999. Une fibule ornée dans le « Style Plastique » à Villeneuve-la-Guyard (Yonne). *Gallia* 56, 415–26.

Reinhard, W. 2003. *Studien zur Hallstatt- und Frühlatènezeit im südöstlichen Saarland*. Blesa 4. Bliesbruck-Reinheim, Parc archéologique européen.

Riegl, A. 1893. *Stilfragen: Grundlegungen zu einer Geschichte der Ornamentik*. Berlin, Siemens.

Riegl, A. 1901. *Spätrömische Kunstindustrie*. Vienna, Österreichische Staatsdruckerei.

Romankiewicz, T. 2018. The line, the void, and the current: Iron Age art from a design theory perspective. *Oxford Journal of Archaeology* 37(1), 45–59.

Sergent, B. 1995. *Les Indo-Européens: histoire, langues, mythes.* Paris, Payot & Rivages.

Stolz, D. & Sankot, P. 2011. Nový soubor Nálezů z hradiště Plešivec u rejkovic, okr. Příbram. *Archeologie ve středních Čechách* 15(2011), 385–94.

Vernant, J.-P. 1995. *La mort dans les yeux: figures de l'Autre en Grèce ancienne.* Paris, Hachette.

Watkins, C. 1963. Indo-European metrics and archaic Irish verse. *Celtica* 6(1963), 194–249.

Watkins, C. 1995. *How to Kill a Dragon: Aspects of Indo-European poetics.* Oxford, Oxford University Press.

Wittgenstein, L. 1953[1994]. *Philosophical Investigations.* Oxford, Blackwell.

Zerner, H. 1997. Le sens du sens. In *Ecrire l'histoire de l'art. Figures d'une discipline*, 101–15. Paris, Gallimard.

Chapter 9

Celtic art before the Early Style: Some new data from south-west Germany and the Heuneburg

Dirk Krausse

Abstract

Ever since the studies made by Paul Jacobsthal in 1944, the question as to where, when, and how the Early Style of La Tène art evolved has been discussed controversially. This paper presents some new finds and data from south-west Germany showing that art and style changed dramatically between 600 and 450 BC. New evidence from the Heuneburg indicates that an avant-garde of artists and craftsmen developed a kind of a proto-La Tène art as early as the 6th century BC. Influenced by Mediterranean style and techniques, they overcame the rigidity of the strictly geometrical Hallstatt art and created something genuinely new. In this paper, some recently discovered examples of this experimental phase of early Celtic art, such as the horse chamfron or the gold jewelry from a princely grave near the Heuneburg are discussed.

The question from where, when, how and what La Tène art evolved has been discussed controversially for many decades (Krausse 2006; Milcent 2006; Müller 2009). This paper presents a number of new finds and data which might help to improve our understanding of some of the processes that occurred during the later Hallstatt period, which led to the emergence of the Early Style art in La Tène A (c. 450 BC). It will focus on south-western Germany, specifically on the Early Iron Age site of the Heuneburg in Baden-Württemberg, which was part of the so-called Western Hallstatt culture in the 7th and 6th centuries BC (Müller-Scheeßel 2000).

Regarding 'art', the archaeological record of the Hallstatt culture of south-western Germany is quite poor. Animal depictions and any form of narrative or figurative elements are extremely rare. The almost total lack of anthropomorphic representations during the 8th and 7th centuries BC in the region could even indicate a kind of ideological or religious taboo. In south-west Germany since the Urnfield culture (Kimmig 1940), pottery and metal objects were richly ornamented, but in a purely geometrical style. During Ha C and D (800–450 BC), linear and angular ornaments that divide the surface of the artefacts into small sections are predominant. This kind of geometrical style, deeply rooted in the Urnfield culture, differs remarkably

from the Early Style La Tène art, which is exemplified by objects (*c.* 450 BC) from the famous burial chamber in the Kleinaspergle mound in Baden-Württemberg (Kimmig 1988). This raises the question of what happened between 600 BC, when Iron Age Art in this region was still purely geometrical, and 450 BC, when a radical new style with exuberant figurative and narrative elements replaced traditional Hallstatt art.

Since the 19th century, most scholars have been of the opinion that La Tène culture, and La Tène art respectively, evolved from Early Iron Age cultural groups west of the Rhine, like the Aisne-Marne or Hunsrück-Eifel cultures (Dechelette 1914; Pauli 1972). However, during the 1980s, Alfred Haffner (1991; 2003a; 2003b), following Kimmig (1973; 1988) and Fischer (1984), developed an alternative viewpoint. He argued that Early La Tène art evolved in the heart of the Hallstatt culture, in centres like the Heuneburg and Hohenasperg in Baden-Württemberg or Mont Lassois in Côte-d'Or, France. Haffner stressed the fact that some artists had already moved beyond geometrical, traditional style art in the second half of the 6th century BC – at least two generations before the Early Style La Tène art had evolved. He called this proto-La Tène period the 'experimental phase' of La Tène art and connected it to masterpieces of metalworking like the torques of the Vix burial near Mont Lassois or some of the finds from the princely grave of Hochdorf in Baden-Württemberg (Haffner 2003b, 186 f.). New data from recent excavations might confirm Haffner's theses.

In 2016, the very last remains of a wagon grave, almost completely destroyed over centuries by ploughing and erosion, were discovered south-east of the Heuneburg, near the village of Unlingen (Hansen & Meyer 2019). Based on the typology of the pottery and some bronze fittings of the wagon, the burial can be dated to Ha C, probably around the first half or middle of the 7th century BC. While the pottery and fittings are ornamented in the traditional geometric style of the Hallstatt culture, a small bronze figurine of a rider on a two-headed horse represents something entirely unusual and novel in this cultural context (Fig. 9.1). As far as we know, this bronze figurine is the oldest representation of a horse rider

Fig. 9.1. Bronze figurine from the newly discovered wagon-grave of Unlingen, early 7th century BC (Photo: Y. Mühleis; © Landesamt für Denkmalpflege Baden-Württemberg).

Fig. 9.2. Gold-plated navicella fibulae and pendants from the child's burial, Bettelbühl necropolis mound 4 (© Landesamt für Denkmalpflege Baden-Württemberg).

in Germany and one of the oldest in the Hallstatt culture. Parallels for this object can be found in the south-eastern group of the Hallstatt culture, in particular the famous Strettweg wagon (Egg 1996), or in Central Italy (Hansen & Meier 2019). However, the figurine found in Unlingen does not seem to be imported from the south or south-east. In fact, the two-headed riding horse itself is unique. The rider's form, with his bald head and large nose, indicate that this object had not been cast in Italy, but north of the Alps, most likely in the Heuneburg region itself. This would mean that as early as the first half of the 7th century BC, some craftsmen designed and created figurative art, even representations of humans, which differed radically from the un-iconical, strictly geometrical art of the Hallstatt tradition. This new find could indicate that members of the regional elite, and the artists working for them, started to move past the restrictions of the regionally traditional artistry one or two generations before the Heuneburg centre was established.

Other recently discovered finds demonstrate this early development, which continued as the Heuneburg established itself as a proto-urban centre around 620 BC (Krausse 2016). In 2005, a richly furnished grave of a three-year-old child, most likely a girl, was discovered and excavated in the Bettelbühl necropolis, 2.4 km south of the Heuneburg (Kurz & Wahl 2006). The jewelry found in the grave included two

Fig. 9.3. Two gold navicella-type fibulae from the woman's grave, Bettelbühl necropolis mound 4, main chamber (Photo: Y. Mühleis; © Landesamt für Denkmalpflege Baden-Württemberg).

gold-plated navicella-type fibulae and a pair of gold pendants (Fig. 9.2). The filigree technique used to create the pendants is quite remarkable as this decoration technique is extremely rare north of the Alps during the Hallstatt period, rather it is typical for Etruscan gold jewelry.

The excavation revealed that the child's grave was in fact a secondary burial situated at the bottom of a mound, next to a shaft with a central chamber grave of an adult woman (Krausse 2017; Krausse & Ebinger-Rist 2018). The wooden floor and some timbers of this central chamber, excavated since 2010, were well preserved and date the burial precisely to 583 BC. Some objects from this grave, such as the two navicella fibulae from the adult woman's grave (Fig. 9.3), shed new light on the question of when and how art styles changed during the western Hallstatt culture. It is remarkable how they contain the same ornamentation as the much smaller fibulae of the child. All four fibulae were ornamented using identical tools (Krausse & Ebinger-Rist 2018), which indicates that both pairs of brooches were 'mass customizations' probably made by one and the same artist individually for the girl and the 'lady'.

In the woman's upper torso area, five gold spheres decorated with filigree were also found (Fig. 9.4). The filigree decoration of the spheres is unique, its only close parallel being the pendants of the girl's grave from the same mound. Additionally, the girl's pendants display a very close relationship to a gold strip earring found in the central grave (Fig. 9.5). New settlement finds of gold filigree files from the Heuneburg plateau (Fig. 9.6) suggest that as early as the first half of the 6th century BC, Hallstatt craftsmen working on the Heuneburg had already mastered and refined filigree-goldsmithing techniques that originated in the Mediterranean. Thus, the gold jewelry from the graves of the girl and woman were most likely produced by a workshop operating at the Heuneburg settlement itself (Krausse & Ebinger-Rist 2018, 88–89).

Fig. 9.4. Gold spheres from the woman's grave, Bettelbühl necropolis mound 4, main chamber (Photo: Y. Mühleis; © Landesamt für Denkmalpflege Baden-Württemberg).

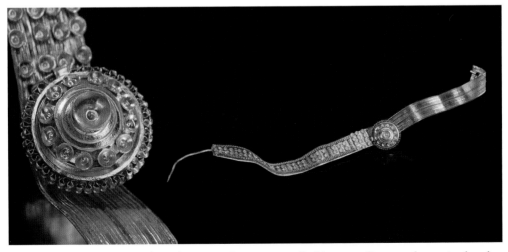

Fig. 9.5. Golden strip earing from the woman's grave, Bettelbühl necropolis mound 4, main chamber (Photo: Y. Mühleis; © Landesamt für Denkmalpflege Baden-Württemberg).

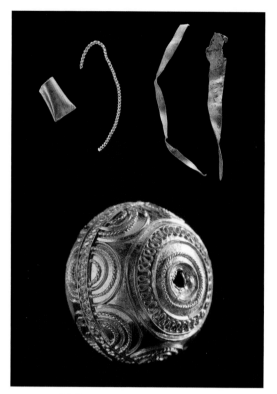

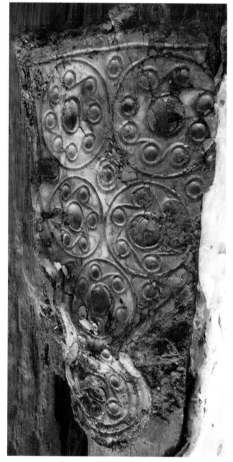

Fig. 9.6. Gold file and offcuts of goldsmith's workshop found in a sunken house of the early 6th century on the Heuneburg. The twisted file is identical to the wires of the spheres in Figure 9.5 (Photo: Y. Mühleis; © Landesamt für Denkmalpflege Baden-Württemberg).

Fig. 9.7. The bronze chamfron in situ, Bettelbühl necropolis mound 4, main chamber (© Landesamt für Denkmalpflege Baden-Württemberg).

These craftsmen had not only brilliant technical skills, but they were also highly innovative designers. This is demonstrated by another artefact found in the Bettelbühl princely grave. Directly on the timbers of the chamber laid a bronze sheet 40 cm long and decorated with six phalera-like circular elements each displaying a central circular boss (Krausse & Ebinger-Rist 2018, 91–94). Smaller circles linked by tangential lines form rings around each boss (Figs 9.7–9.8). This motif is a rare find in the central area of the Hallstatt culture and is almost unknown in the west. Actually, it represents quite the antipode to the geometrical, angular motifs and traditional style in the western Hallstatt culture. At first glance, you could take this piece as an atypical example of Early La Tène Style. However, this object, which can be classified as horse forehead armour, or chamfron respectively, was made more than 100 years before the beginning of the Early Style. Apart from the 'Torrs-pony-cap'

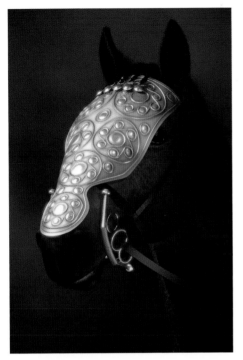

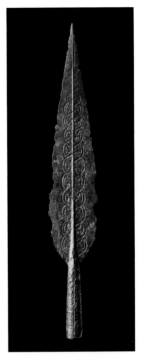

Fig. 9.8. Illustration of the bronze chamfron (Graphics: Faber-Courtial; © Landesamt für Denkmalpflege Baden-Württemberg).

Fig. 9.9. Bronze lance head from the central grave under barrow 1 of the Gießübel-Talhau cemetery at the Heuneburg (Photo: H. Zwietasch; © Landesmuseum Württemberg, Stuttgart).

(Briggs 2014) decorated in the 'Sword style', there is no archaeological evidence for head armour of horses from the entire region north and north-west of the Alps during the Iron Age. Such items were, however, in use since the 9th century BC in various parts of the Near East, and later in Cyprus, Italy and the Pontic steppes (Krausse 2017, 118–19). In my opinion, the maker of this bronze chamfron from the Bettelbuehl grave belonged to a small avant-garde group of artists, who were highly innovative and anticipated some design elements, which only much later became common in the 5th century BC.

Another masterpiece of this so-called experimental phase of Hallstatt art, dating to around 530/520 BC, is the famous bronze lancehead found in mound 1 of the Giesübel Talhau necropolis at the Heuneburg (Kurz & Schiek 2002) (Fig. 9.9). Its curvilinear design holds close similarities to a number of bone and antler objects (Fig. 9.10) from the settlement layers of the Heuneburg, showing that since the late 6th century BC, artists incrementally moved past the strict geometrical, rectangular traditional style and established something genuinely novel (Haffner 1986; Lenerz-de-Wilde 1977;

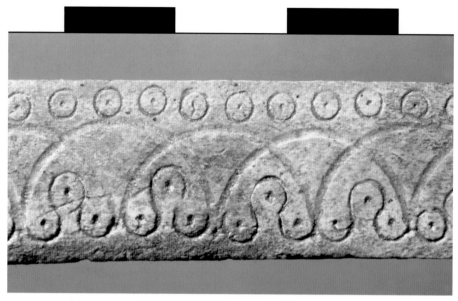

Fig. 9.10. Bone and antler pendants from the Heueburg settlement with circular ornaments in proto-La
Tène style (Photo: Y. Mühleis; © Landesamt für Denkmalpflege Baden-Württemberg).

Fig. 9.11. Bronze mask-fibula (5th century BC) found in the Danube valley below the Heuneburg (Photo:
Y. Mühleis; © Landesamt für Denkmalpflege Baden-Württemberg).

Sievers 1984). However, it took another 30 to 50 years for this new style to develop into the classical Early Style La Tène art of the second half of the 5th century BC.

The town of the Heuneburg was abandoned before the La Tène period, thus only very few finds of 'real' La Tène art are known from the Heuneburg region (Fig. 9.11). However, there can be no doubt that the Heuneburg played an important role as one of the centres where proto-La Tène art, or the experimental phase of La Tène art (Haffner 2003), overcame the rigidity of the geometrical art of the Urnfield-Hallstatt tradition during the 6th century BC.

References

Briggs, C.S. 2014. The Torrs chamfrein or head-piece: Restoring 'A very curious relic of antiquity'. In C. Gosden, S. Crawford & K. Ulmschneider (eds), *Celtic Art in Europe: Making connections*, 341–55. Oxford, Oxbow Books.

Déchelette, J. 1914. *Manuel d'archéologie préhistorique, celtique et gallo-romaine II, Troisième partie*. Paris, Editions Picard.

Egg, M. 1996. *Das hallstattzeitliche Fürstengrab von Strettweg bei Judenburg in der Obersteiermark*. Römisch-Germanisches Zentralmuseum Monographien 37. Mainz, Verlag des Römisch-Germanischen Zentralmuseums.

Fischer, F. 1984. Württemberg und der Dürrnberg bei Hallein. *Fundberichte Baden-Württemberg* 9(1984), 223–48.

Haffner, A. 1986. Buchbesprechung: Susanne Sievers, Die Kleinfunde der Heuneburg. *Fundberichte aus Baden-Württemberg* 11, 395–98.

Haffner, A. 1991. Zum Forschungsstand der Hallstatt- und Frühlatènezeit im Hunsrück-Eifel-Raum. In A. Haffner & A. Miron (eds), *Studien zur Eisenzeit im Hunsrück-Eifel-Raum*, 9–22. Beihefte Trierer Zeitschrift 12. Trier, Rheinisches Landesmuseum Trier.

Haffner, A. 2003a. Le torque en or de la tombe princière de Vix. *Dossiers d'Archéologie* 284(Juin 2003), 44–50.

Haffner, A. 2003b. Le torque. Type et fonction. In C. Rolley (ed.), *La tombe princière de Vix, vol. 1*, 176–88. Paris, Picard et Société des amis du musée du Châtillonais.

Hansen, L. & Meyer, M. 2019. Außergewöhnliche hallstattzeitliche Grabfunde aus Unlingen (Lkr. Biberach). *Archaeologisches Korrespondenzblatt* 48(2018), 493–521.

Kimmig, W. 1940. *Die Urnenfelderkultur in Baden. Untersucht aufgrund der Gräberfunde*. Römisch-germanische Forschungen 14. Berlin, De Gruyter.

Kimmig, W. 1973. In W. Kimmig & O.-W.-v. Vacano, Zu einem Gußform-Fragment einer etruskischen Bronzekanne von der heuneburg ad. oebren Donau. *Germania* 51(1973), 72–79.

Kimmig, W. 1988. *Das Kleinaspergle: Studien zu einem Fürstengrabhügel der frühen Latènezeit bei Stuttgart*. Forschungen und Berichte für Vor- und Frühgeschichte in Baden-Württemberg 30. Stuttgart, Theiss.

Krausse, D. 2006. The Prehistory of the Celts in South-West Germany. In D. Vitali (ed.), *La Préhistoire des Celtes. Actes de la table rionde de Bologna 2005*. Collection Bibracte 12(2), 131–42.

Krausse, D. & Ebinger-Rist, N. 2018. *Das Geheimnis der Keltenfürstin. Der sensationelle Fund von der Heuneburg*. Darmstadt, Konrad Theiss.

Krausse, D., Ebinger-Rist, N., Million, S., Billaboz, A., Wahl, J. & Stehan, E. 2017. The 'Keltenblock-Project': Discovery and excavation of a rich Hallstatt grave at the Heuneburg, Germany. *Antiquity* 91(355), 108–23.

Krausse, D., Fernández-Götz, M., Hansen, L. & Kretschmer, I. 2016. *First Towns North of the Alps: The Heuneburg and the Early Iron Age princely seats*. Budapest, Archaeolingua.

Kurz, S. & Schiek, S. 2002. *Bestattungsplätze im Umfeld der Heuneburg.* Forschungen und Berichte zur Vor- und Frühgeschichte in Baden-Württemberg 87. Stuttgart, Theiss.

Kurz, S. & Wahl, J. 2006. *Zur Fortsetzung der Ausgrabung in der Heunburg-Außensiedlung. Archäologische Ausgrabungen in Baden-Württemberg 2005.* Stuttgart, Theiss.

Lenerz-de Wilde, M. 1977. *Zirkelornamentik in der Kunst der Latènezeit.* Münchner Beiträge zur Vor- und Frühgeschichte 25. München, Beck.

Milcent, P.-Y. 2006. Premier Age du Fer médio-atlantique et genèse multipolaire des cultures matérielles laténienns. In D. Vitali (ed.), *La Préhistoire des Celtes. Actes de la table rionde de Bologna 2005.* Collection Bibracte 12(2), 81–105.

Müller, F. 2009. *Die Kunst der Kelten. 700 v. Chr. bis 700 n. Chr.* Stuttgart, Belser.

Müller-Scheeßel, N. 2000. *Die Hallstattkultur und ihre räumliche Differenzierung: Der West- und Osthallstattkreis aus forschungsgeschichtlich-methodologischer Sicht.* Espelkamp, Marie-Leidorf.

Pauli, L. 1972. Untersuchungen zur Späthallstattzeit in Nordwürttemberg. *Hamburger Beiträge zur Archäologie* 2(1), 1–166.

Sievers, S. 1984. *Die Kleinfunde der Heuneburg. Die Funde aus den Grabungen von 1950–1979.* Heuneburgstudien V. Römisch-Germanische Forschungen 42. Mainz, Philipp von Zabern.

Chapter 10

Sign o' the times: The re-use of pre-Roman Iron Age British and European symbols on Late Iron Age Irish equestrian equipment

Rena Maguire

Abstract

The relief designs of Irish Late Iron Age equestrian equipment (referred to throughout as tack), particularly the Y-piece, vary according to type. Some specimens of the Raftery/Haworth 2a type are decorated with an uncommon zoomorphic motif on their terminals. This symbol is present on a small group of other Northern British Iron Age objects, taking their inspiration from designs such as those used on the Middle Iron Age Witham Shield found in Lincolnshire. Likewise, different symbols found on Rhineland statuary of the La Tène period are also present on selected Late Iron Age Irish snaffle types. Over two centuries passed before these motifs were used on Irish metalwork. This paper examines the interconnectivity of Britain, Ireland and Europe through the pre-Roman period, and suggests a possible reason for the use of the anachronistic decoration style in Late Iron Age Ireland.

Introduction

Decorative symbols have biographies as much as any artefact. Many start their 'lives' communicating concepts such as life, death, time or memory, but gather complex nuances, which are capable of shifting over time. Technology assists in telling the story by making the symbols tangible, as material artefacts and the decorations used upon them.

When analysing Irish metal artefacts decorated with La Tène-derivative symbols, we are limited in developing a wider understanding of what objects may have been associated with particular symbols, as the objects which have survived are mostly representative of martial and feasting activities of an elite group (Raftery 1994, 141). Some of the motifs used on the metalwork may well be purely apotropaic, while others may be symbols declaring identities, alliances and loyalties, a visual shorthand means of expressing and illustrating the cultural 'girders' which held particular groups of people together (Robb 1998, 332).

Table 10.1 A table explaining Irish Iron Age chronology in comparison to the terminology used for Britain and Europe.

Britain	La Tène/European	Ireland
Middle Iron Age Pre-100 BC	Ireland	Developed Iron Age 400 BC–AD 1
Late Iron Age 80–20 BC	La Tène D2	Late Iron Age AD 1–400
Pre-Conquest 20 BC–AD 40	Roman Conquest period	Late Iron Age AD 1–400
Early Roman AD 40–65	Roman controlled Europe	Late Iron Age AD 1–400
AD 70–100	Roman controlled Europe	Late Iron Age AD 1–400
AD 100+	Roman controlled Europe	Late Iron Age AD 1–400

It is likely that we will never truly know what the symbols actually mean, apart from their importance to Iron Age groups and their repeated use on objects. We observe the bare bones of these cultures, rather than their heartbeat or muscle. This is especially the case with Ireland, which has a different Iron Age chronology than either Britain or mainland Europe, as the island was not conquered by the Roman Empire (see Table 10.1). As the 'invisible people' (Raftery 1994, 112) of the Irish Iron Age come into focus by means of new research in the 21st century, this paper offers observations and questions regarding the re-use of anachronistic designs on some Irish equestrian artefacts from the Late Iron Age, and possible reasons why this occurred.

Anachronistic decoration on Irish equestrian equipment of the Late Iron Age

Sir William Wilde (1860, 608–609) wrote in his catalogue of the Royal Irish Antiquaries collection that 'scarcely a year passes without some bronze spur-shaped articles being found in our bogs'. New specimens of Irish Y-pieces, the object described by Wilde, are no longer commonplace, although equestrian equipment make up a substantial amount of Iron Age metalwork finds in Ireland. The dates of Y-pieces and snaffle bits have been uncertain until recently, when new research using alloy composition and zinc content analysis (Maguire 2018) has placed them in between the first decades AD and AD 200, using Dungworth's (1995, 41) alloy index of Romanisation. Currently, the earliest known brass production in Ireland is securely dated via context and radiocarbon dates of charcoal to AD 60 (Young 2011), which makes Irish technological chronology similar to that of northern Britain (Dungworth 1995; 1997). The delay in northern Britain, and perhaps Ireland, in adopting brass making technologies brought by Roman contact is likely due to southern Britain's earlier exposure to Romanisation, with Caesar's invasion of 55–54 BC (Pitts 2010).

The Irish Y-piece in particular had long been relegated to being a ritual object, with archaeologists of the past having some idea that they were connected to equestrian activity, due to their presence in a few scant hoards alongside snaffle bits (Wakeman 1903, 230–32; Wood-Martin 1895, 246), but there was little genuine interest in pursuing their actual purpose. It was not until the end of the 20th century that the

first scholarly examination of the Y-piece was conducted by Richard Haworth (1969; 1971). Barry Raftery (1983) developed Haworth's ideas further, by fusing his father Joseph Raftery's (1940) general work on Iron Age chronologies with Haworth's typological classifications to create his seminal catalogue of Iron Age antiquities found throughout Ireland.

Recent analysis (Cahill-Wilson 2014, 35–36; Maguire 2014a) has demonstrated that these objects were functioning components of Iron Age bridle assemblages, hybrids of mechanical hackamore and martingale, not dissimilar to the Roman *psalion*, a metal head-stall inhibiting movement or tossing of the horse's head. It was also a contemporary analogue of the Germanic *Kehlberge*, just as suggested by Conrad Engelhardt (1866, 62) during the 19th century, when the excavations at Thorsberg Moor produced a number of specimens.

Unlike the Germanic pieces, which rely on precious metals like silver for embellishment (Lau 2014), the Irish Y-pieces are often decorated with La Tène-derivative symbols. These designs were a major factor in the typological classifications created by Haworth and Raftery. Despite Palk (1991) attempting a reclassification of Irish tack, the original Haworth/Raftery categories of both bit and Y-piece types remain the most streamlined and intuitive. Bits were classified into one of five bit types, labelled A to E, and Y-pieces into two main variations, Types 1 and 2, with six sub-categories in Type 1 and three in Type 2, based on their decoration styles (Fig. 10.1).

The Type 2a Y-piece is the most decorative variation. It was cast as a single frame, with the pronged upper terminals included within the mould (Maguire 2014a, 79–80). These perforated upper prongs often display fine cast relief work around their outward-facing surface. The butt of the stem, however, was often cast on separately and decorated differently.

Most decorated Y-piece variants have matching designs on both the upper prongs and the butt of the stem, often a triskele. However, the triskele design seen on the stem is not present on the outward facing pronged terminals of any known Type 2a specimen. Instead, the prong terminals of a number of Type 2a Y-pieces are decorated with a design resembling a stylised and simplified animal head, most likely equine, bovine or possibly cervine. This can be seen clearly on intact specimens from Roscommon and Tara/Skreen Valley in Co. Meath, among others. The design is distinctive, with a strong resemblance to the style of the Monasterevin discs (Stevick 2006), objects of unknown function, although the animal head design is absent on the discs.

Waddell (2012, 343–45) has argued that the distinctive symbols on the Monasterevin discs represented solar boats or carts deliberately stripped of detail, and that they were influenced by the Bronze Age petroglyphs of Bohuslän, Sweden. However, he offers no explanation as to how Scandinavian symbols of the 2nd millennium BC reached Ireland, and why no other similar Bronze Age designs are found on Irish Late Iron Age artefacts. Jope (2000, 135), more conservatively, saw commonalities with early Roman period northern Britain, and the (possibly earlier) torcs from Broighter and Snettisham.

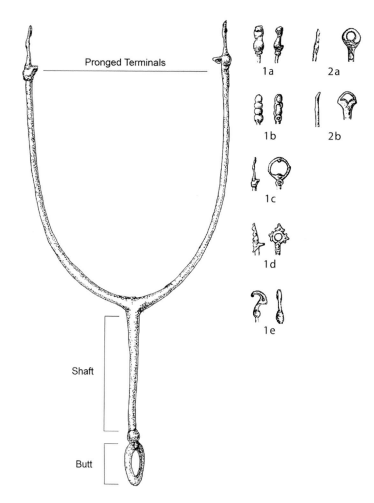

Fig. 10.1. Parts of the Irish Y-piece and the various types (Illustrations: R. Maguire). Y-pieces typically measure approximately c. 280 mm in length; 1a to 2b are prong finials. Not to scale.

The symbols on the Irish Y-piece appear to be pared-down versions of a specific zoomorphic design used on the roundels on the Witham Shield, from Lincolnshire, England, which may date between the 2nd and 3rd centuries BC (Fig. 10.2). The ornate swirls and trumpets of the Witham design are reduced to simple sweeping arcs, where the shape is more important than the micro-detail held in the Witham Shield's features.

The Witham Shield: Roundels and symbols

The iconic Witham Shield was found at an unknown point of the River Witham, Lincoln-shire, England in 1826, between Washingborough and Fiskerton (Field *et al.* 2003, 16).

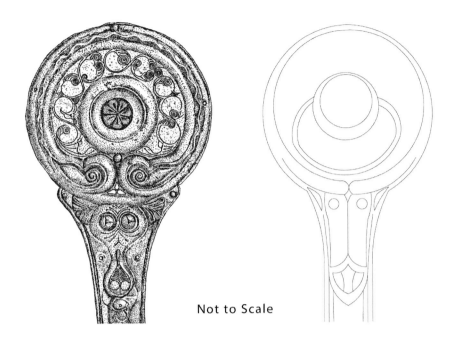

Not to Scale

Fig. 10.2. A comparison between the Witham shield's lower roundel and the Tara/Skreen Valley Type 2a Y-piece prong finial. Not to scale. Left: Witham shield roundel, c. 98 mm in diameter (Illustration: H. Chittock). Right: Tara/Skreen Valley Type 2a Y-piece, c. 40 mm in diameter (Illustration: R. Maguire).

A wooden structure found on the river at Fiskerton was used as a deposition platform, with timbers dating to the early to mid-4th century BC (Fitzpatrick & Schönfelder 2014, 286–88). The deliberate disposal of prestige metal objects from wooden platforms into rivers or lakes, especially martial equipment, is a pan-European practice through the Bronze Age and Iron Age (Fontijn 2008, 96).

The shield itself has been considered to be one of the masterpieces of Britain's pre-Roman Iron Age by La Tène art specialists, from Jacobsthal (1944) to Jope (2000). What remains is the sheet-bronze facing from a wooden shield, sub-rectangular in shape with curved edges, slightly waisted in the centre. A repoussé spine runs down the middle of the shield, with a central boss and roundels at the top and bottom, highly decorated in La Tène style. Detailed examination revealed the faint outline of a boar in the background: an image, now lost, which was once riveted to the facing of the shield. Jacobsthal believed he could see influences of Hungarian La Tène styles in the Witham shield, as well as the Scottish Torrs pony cap, and the Lisnacrogher scabbards from Northern Ireland (Jacobsthal *et al.* 2014, 215), noting these in personal correspondence to the archaeologist Henry Hencken. Fitzpatrick (2007) has generally agreed with Jacobsthal's opinions, while Harding (1974, 219; 2007, 149) has sided with Jope's (1971, 61; 2000, 54–62) thoughts, viewing the entire shield to be the result of

southern European La Tène influences from the 7th century BC, although the shield itself likely dates to the 3rd century BC (Jope 2000, 61).

While a great deal has been written by art scholars regarding the styles employed on the complete Witham Shield, it is purely the form of the roundels which is examined here, as a comparison to the decorative motifs which appear much later in Ireland. Jope (2000, 56–57) saw these roundels as being stylised animal heads, possibly horse, deer or ox, each with a circular halo, as if it were bearing the sun or moon between its ears or horns, with La Tène-style palmettes enhancing the overall effect. Beneath the muzzle of the animal, Jope (1971, 62) noted a lolling S-shaped tongue, which integrated the roundel back into the design of the shield itself. The bovine head detail of a mount found at Mâcon, France (Jope 2000, pl. 156, fig. h) is possibly the most similar to the Witham Shield's animal head detail, although it is more naturalistic, perhaps an indication of designs shifting in variations of style and emphasis through both time and region. The animal face design is not a common motif in Britain, although there may be a hint of this design incorporated into the carnyx mouthpiece from Deskford, Scotland (MacGregor 1976, fig. 188), and the Late Iron Age bow and fantail brooch found at Great Chesters, Northumberland (MacGregor 1976, fig. 251). It may also be, arguably, incorporated into the design of the Stanwick equine face (Fitts *et al.* 1999), and the cheek-ring detail of the snaffle found at Kingston upon Hull (Palk 1984, fig. C46), in Yorkshire. Each of these are Late Iron Age (most likely 1st century AD), making them reasonably contemporary with the decorated Irish Y-pieces.

Wheels and warriors: Who made the Witham Shield?

Most recent scholarship places the dates of the shield between the 3rd and the 2nd centuries BC (Farley 2011, 81; Harding 1974, 186). Certainly the pre-Roman people of the region were known for equestrian activity (Harding 2004, 23). Regardless of which regional group they belonged to, the owner of the Witham Shield would probably have had experience of both weaponry and equestrianism.

The tack found within the 2nd and 3rd centuries BC chariot burials of Arras and Wetwang Slack (Giles 2012; Jay 2012; Stead 1979) demonstrate well the desire to make a visually impressive statement of power, utilising very specific designs. During the pre-Roman Iron Age, the people of the chariot burial territories of Yorkshire's East Riding maintained a specific method of bitting, with an emphasis on driving rather than riding. While the Iron Age Yorkshire snaffle cheek-pieces are infinitely more flamboyant, the mouthpiece styles were partially derived from Europe and Eurasia, where driving was practiced from the 10th century BC (Dietz 1998; Hüttel 1981; Thrane 1963), at least 500 years before the decades to which East Yorkshire's chariot burials have been attributed (see Garrow *et al.* 2009; Jay *et al.* 2012). The mouthpieces of the snaffles from burials at Arras (East Yorkshire), such as the King's and Lady's Barrows, may be closer in style and function to the drop-shaped (*tropfenförmigen Riemenösen*) early Hallstatt period (8th and 9th centuries BC) bits of the Carpathian region (*cf.*

Metzner-Nebelsick 2002, 232), but are interpreted with their own unique regional flourishes of design.

The now-lost Ulceby bit from Lincolnshire (Cuming 1859, 225–27), also of a bulbous drop-shape, stands unique among all the tack finds of Britain and Ireland for its extravagant La Tène-style decoration on an oversized stud placed on the cheek ring. The cheek ring stop-studs are also decorated with small floral patterns, not unlike the design on the mount found at Lambay Island, which Lloyd Morgan (1976, 217) referred to in his paper as deriving from the 'Continental Menapii'. The date of the Ulceby bit is extremely uncertain, for while the mouthpiece was similarly shaped to 1st century AD examples from Stanwick in North Yorkshire (Fitts *et al.* 1999, 42–44) – a site associated with the Roman period Brigantes – the exceptionally fine relief work exhibited on the piece suggests a slightly earlier chronology.

Demographic changes throughout Britain in the 2nd century BC are not fully understood (Champion 2016, 156), but the abandonment of previous settlements, reforestation and the development of nucleated habitats is not so far removed from the phenomenon in Ireland known as the 'Late Iron Age Lull', which is also considered to indicate some kind of cultural stress (Coyle-McClung 2013). It may be that the fluctuations in pre-Roman Iron Age British settlements also reflect a series of turbulent societal changes, the reasons for which are lost to time.

We know that regular contact between Britain and Europe continued through the Iron Age. Jay and colleagues' isotopic analysis of human remains from the chariot burials at Wetwang Slack and Kirkburn have indicated that the interred individuals differed from the rest of the population in that, despite being born within the area, there are signs of regular mobility between two unspecified locations throughout their lives (Jay *et al.* 2013, 287–88). It has been suggested by Melanie Giles (2012, 30) that the people of Iron Age East Yorkshire adopted some Continental styles as a means of enhancing their own social status, which must open debate as to whether the meaning of the symbols used (and re-worked) on the artefacts found in the chariot burials were understood in the same way as they had been in Europe. They may represent continuity of meaning or indicate the fusion of cultures, with different inflections on what concepts were important enough to depict, appropriate and re-imagine.

Hella Eckhardt's (2014, 128–33) examination of distribution patterns of the bow and fantail brooches (Hattatt 2000, 315, fig. 174, nos. 74, 818 and 819) of the Romano-British Corieltauvi and Parisi tribes has stimulated fresh questions about re-negotiated symbols and identities between the pre- and post-Roman Iron Age in Britain. The enamel designs on the Romano-British brooches often reflect the early patterns and styles of decoration found on the bits at Arras and Wetwang Slack, which date *c.* 200 BC (Jay *et al.* 2013). This suggests that some preservation of group identity or awareness via design – whatever it represented – was maintained well into the Roman period, an avenue of research robustly explored by Eckhardt (2014) using comparisons of regional distribution.

Gradually, a better understanding of the complexity of movement and communication between Britain and Europe through the pre-Roman Iron Age is developing

(Fernández-Götz 2016; Sharples 2014; Webley 2015), but we have little knowledge of the transmission of material culture and ideas between Ireland, Britain and Europe during the pre-Roman Iron Age. Ireland's Iron Age differs considerably from that of Britain or Europe (see Table 10.1), making the chronology of Irish metalwork problematic. Unlike Britain, there are no known Irish mortuary depositions of this period and a paucity of accurate provenances for finds. However, projects such as the Republic of Ireland's Discovery Programme's *Late Iron Age and Roman Ireland* (LIARI) have started to address the complex interactions between Ireland and the Roman Empire at the end of the Iron Age.

Ireland remained a boundary of the Roman Empire as much as northern Britain and Scotland, reflecting a similar fusion of ideas, technologies and re-imagining of selective patterns on regional metalwork during the 1st and 2nd centuries AD (Hunter 2015a, 136). However, the reasons for the re-imagining of traditional, archaic European Celtic/La Tène period designs and motifs, hundreds of years later, on bridle components which are stylistically unique to Late Iron Age Ireland, remain largely unexplored.

Stop-stud designs on Irish bits and continental connections

With evidence of very direct connections between Britain and Europe, it is easy to see how European La Tène decorative symbols were incorporated into British metalwork, and how some design traditions on either side of the channel developed in parallel. The subtle and reciprocal nature of the exchange of materials and ideas between Britain and continental Europe has been demonstrated in recent years (*e.g.* Garrow *et al.* 2009; Webley 2015). Such a holistic approach, however, is yet to be completed in the context of Ireland and the coastal borders of Roman Britain. All we can do regarding Ireland is propose possible models for the use of these 'foundation' designs, which originated earlier in other European regions – this research area is very much a work in progress. The decoration used on Irish Late Iron Age tack may be the final variations of themes started in Europe, with the few surviving examples representing a very small sample of earlier and probably constantly changing designs. It is possible that their re-use was a means of expressing half-remembered beliefs or identities, which had moved westwards from the La Tène Europe of the mid-5th century BC, making their way to Ireland, although exactly how, why and when remain uncertain. They may be, as Giles (2012, 30) hypothesised about Iron Age East Yorkshire artefacts, objects made in emulation of other non-indigenous motifs, made fashionable by regular communication between Ireland and the peoples of the Roman Empire. While acknowledging these are simplified models in the absence of any other for Late Iron Age Ireland, they commence an exploration of why re-interpreted versions of the Witham 'beasts' were used on the Irish Type 2a Y-piece terminals, as well as the use of a particular kind of arc pattern on the stop studs of Irish Late Iron Age bridle cheek-rings.

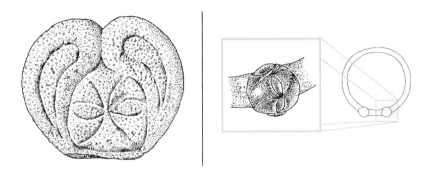

Fig. 10.3. A comparison between motifs on the Heidelberg Keltenfürst statue and the stop studs of an Irish bridle bit (Illustrations: H. Chittock). Left: Detail from the Heidelberg Keltenfürst statue, Kurpfälzisches Museum der Stadt Heidelberg. Right: Detail of Irish Iron Age stop-stud design, British Museum. External diameter of ring c. 100 mm.

The cheek rings of all Irish, and some British, snaffle bits are held in place by stop-studs either side of the cannon, the part of a bit's mouthpiece from the internal joint to the ring. These are known as eggbutt snaffle types, made to create a fixed pressure on the outer part of the mouth, as well as offering some protection against pinching. The studs of the British bits from Ulceby and Ringstead are uniquely decorative, making them markedly different from the Irish Late Iron Age pieces, which have simple decorations on the stop studs. One of the Irish designs is a curvilinear pattern, which resembles elongated almond-shaped loops which Jope (2000, 385) called the 'yin/yang' design. These studs are found almost entirely on the oversized cheek rings of the Irish Type B bit, although there are also a few present on the Type D bits (Maguire 2018, 88).

The design on the Irish Type B cheek ring stop-stud (Fig. 10.3) is visually very similar to the decoration on the back of the fragmentary La Tène 'warrior' heads found in Heidelberg (Jacobsthal 1935, plate II, fig. E) and Glauberg (Frey & Herrmann 1998). All such 'warrior' statues have been found at sites with special status, be it burial grounds or *Viereckshanzen* (rectangular ditched enclosures), suggesting they may have been ritual or boundary objects, and are believed to date to between the 6th and 2nd centuries BC (Megaw 2003, 63, 68).

The appearance of the Irish Late Iron Age stop-studs may echo the Glauberg and Heidelberg heads' sweeping curves on sight, but when analysed, the stop-studs consist of a skewed 'S' shape instead of the arc and lozenge decorating the statuary heads. Even so, the design arrangement of two S-shaped arcs and lozenges interlinked, per the Irish stop-studs, is uncommon in La Tène-derivative artefacts of Britain and Ireland, although may be present, albeit re-imagined, in the Stanwick horse-plaque (Fitts *et al.* 1999), the Pitkelloney armlets (MacGregor 1976, no. 243), and the massive armlet found in Newry Co. Down (Raftery 1983, 177). The resemblance may be coincidental, but

Waddell's (2018) recent work has started exploring connections between Late Bronze Age Ireland and Europe, especially regarding symbols used which may be connected to ideologies, an area which has not been examined in any detail in the past. Questions must now be asked as to why symbols similar to those from Europe of the 3rd century BC may have been reused in Late Iron Age Ireland on surviving equestrian equipment.

Relations and connections across pre-Roman Britain and Europe

Ptolemy's map of Ireland, from the 2nd century AD indicates that Roman traders already had a good understanding of Ireland's geography (Abshire *et al.* 2017). Irish tribes are named within the map, with some of the names being the same as those of British tribes. The Celtic scholar, Thomas O'Rahilly (1946, 25, 34), attempted a separation of Irish and British tribal identities using linguistics, and concluded that the Brigantes shown on the Ptolemy map, occupying what is now modern Wexford, were a branch of the Yorkshire Brigantes, the northern neighbours of the Corieltauvi. This association with British and European tribes has also been examined by Richard Warner (1991, 50). Tacitus (*Germania*, XXIV, 368) also opined that there was little difference between Iron Age British tribes and that of the Irish, although his views may have been coloured by a mix of Roman propaganda, a dislike for Britain and his affection for his father-in-law Agricola (Birley 2009).

The constant trade in gold during the Early Bronze Age (Standish 2015), along with the quantity of Irish metal artefacts found across Bronze Age Europe attests to the high mobility of prehistoric peoples who were directly involved in social and trade networks. The growth of the Roman Empire at the end of the Iron Age allowed technological innovations and new ideas from different regions to spread further and faster. The sudden appearance of extremely sophisticated equestrian equipment in Late Iron Age Ireland indicates the arrival of such new ideas from elsewhere, be that Britain or the Continent.

Britain's proximity to Europe allowed a ready and accessible reciprocal flow of material and technological influences, including the establishment of chariotry, which could be selectively adopted and adapted to suit each regional preference, although it is important to note Jope's (2000, 156) observation that the vehicles and tack assemblages of the Yorkshire burials of the 3rd and 2nd centuries BC were often paler interpretations of earlier continental vehicles. Equestrian equipment developed differently in Britain than in Europe, as wheeled vehicles continued to be used well into the 1st century AD, while the rest of Europe adopted riding as a more flexible means of transport and warfare (Moore-Colyer 1994, 7).

There is little evidence for the use of the horse during the Late Bronze Age in Ireland, with only two possible, currently undated antler cheek-pieces (Scott forthcoming), which are from the crannóg sites of Moynagh and Lagore, both in Meath. The type of bridle these organic cheek-pieces would have fitted on was reconstructed and tested on modern horses, with results indicating that it was best fitted to a sedate

leading pace, unless the method of riding or driving used was reliant on other equitation aids other than bit control (Maguire forthcoming). It is only during the Late Iron Age that we have evidence that Ireland adopted formal metal lorinery, and it is very clear from the beautifully crafted tack that the riders cannot be considered as anything other than an elite social group.

There is currently no evidence of a vehicle culture in Ireland of the pre-Roman Iron Age, be it the lightweight dog-carts or sulkies of East Yorkshire or the Marne region in France, or the solid wagons of the Hallstatt period. While lack of preservation may well be an issue here, it is as if Ireland skipped the chariot tradition and adopted riding, straight from 1st century AD Europe instead. Yet there is no ready appropriation of Roman equestrian equipment, such as the *capistrum* or mechanical hackamore/*psalion* during the Late Iron Age either. Instead, there is a selectivity which indicates the maintenance of an identity, combined with enough knowledge to make the most responsive and function-specific bits of the ancient world, with subtle additions of non-indigenous motifs.

Raftery (1974, 8) was most likely correct in his suggestion that a developed form of equestrianism occurred over a brief period, but that their unique morphology was the result of insular interpretations. The chronological lag between the regional Irish interpretations of designs which had been used in La Tène Europe, however, may represent missing links in the puzzle, or indicate more than the time taken for styles to make it to the most westerly border of Europe.

Continuity of meaning and re-use of identity symbols

In both Ireland and Britain, 'sacred' sites such as Neolithic cairns and megaliths regained significance of meaning during the late 1st century AD, with cult activity attested at these places (Hutton 2011). In Ireland, the great chambered cairn of Newgrange became a focal point for the deposition of Romano-British objects as offerings (Carson & O'Kelly 1977; Gibbons & Gibbons 2016) after centuries of apparent inactivity, while the anachronistic deposition of Y-pieces and bits at the Neolithic cairn of Knockmany, Co. Tyrone, and at Drumanone portal tomb, near Boyle, Co. Roscommon (Maguire 2014b, 2, 38–39, pls. 3, 71), indicate that spiritual or social significance had returned to these ancient sites, in a similar manner to practices in Britain. These megalithic structures were significant places within landscapes of shared, group experience, reinforcing connections with the ancestors or the supernatural (Leigh *et al.* 2018), and as such, may well have acted as rallying points for Iron Age identities, be they redefined or re-invented – they were again meaningful symbols, although within a new landscape.

The intensification of equitation, as evinced by the sophisticated snaffles and Y-pieces, indicates exposure to technological change and a cultural interface during the 1st century AD in Ireland. The brass crucibles, *c.* AD 60, found at Platin, near Drogheda (Young 2011) show that Ireland was receiving Roman technological innovation contemporaneously with northern Britain (Dungworth 1997) which was being used to create lorinery.

The decorative symbols on the bits and Y-pieces borrow from and re-invent an eclectic and wide range of regional styles and symbols. An example of this is embellishment of the Streamstown bits in the National Museum of Ireland, Dublin (Raftery 1983, nos. 83 & 84) which is similar to the sprite-like faces on the Carlingwark Loch tankard handle (Corcoran 1953, 92; Horn 2015, fig. 10, 326). It is worth mentioning that Horn (2015, 318) noted design parallels between northern British tack and Iron Age tankard metalwork. Likewise, the Type 1d Y-pieces from Ballykean Bog, Co. Offaly, with their heavy, cast kite and roseate designs (*cf.* Maguire 2014b, 27–29, pls. 51–54) resemble the organic forms of the Netherurd torc and Ulceby bit, displaying more than just insular Irish influences of art styles.

The Late Iron Age in Ireland appears, then, to be a kaleidoscope of new technology and remembered or appropriated symbols and identity, perhaps because of interactions with peoples from across the Roman Empire curious to explore, trade and possibly even settle down (Cahill-Wilson 2014, 22–23). The revamping and re-negotiation of already-old symbols was occurring during a period of monumental change and uncertainty which finds a strong parallel in northern Britain (Hunter 2015b). With the introduction of new technology, new equitation skills and the presence of the Roman Empire across the Irish Sea, established traditions may well have felt threatened by a potentially invasive force.

These 'time lapse' symbols may equally represent new arrivals into Ireland, perhaps connected to increased communication with Roman Britain and Europe. After all, the glass funeral urn recorded at Stoneyford (Bourke 1989; Ó'Drisceoil 2013, 10) indicates a standard Roman cremation ceremony, and the group of structures at Freestone Hill equally reflect Romanisation (Ó'Drisceoil 2013, 8–10). It may be that the incorporation of the S-arc and lozenge symbols onto the small details of Irish tack represented the re-imagining of an archaic talisman for elite members of society, or particularly for warriors, as the original La Tène statues have been considered to be ancestral warrior protectors (Armit & Grant 2008). There is, of course, always the chance that the design may be purely coincidental, but with the constant re-imagining of old designs in both northern Britain and Ireland, during the period of Romanisation, this seems less likely.

While established trade networks and alliances had existed across Europe from at least the Early Bronze Age (Mount 2000), it is likely that the manner in which 'business' was conducted among the relevant societies was different from trading with the Roman Empire (Runciman 1983, 157). For a start, the scope of trade and selection of goods from the furthest reaches of the Empire was much wider. The Late Iron Age is the era in which Irish equestrianism reached its apex, after what appears to be a sudden and swift introduction. There would have been individuals who adjusted readily to social and trade interactions induced by a wider worldview, and almost certainly others finding such changes challenging and intimidating. In such times of change we often find the perception of great instability and uncertainty, and a nostalgic yearning for a past which is perceived as more secure (Wildschut *et al.* 2010).

A re-negotiation of material objects on cultural frontiers was noted by Hodder (1982, 13–30) in his study of the Baringo region of Kenya. The results of his study

suggested that boundaries between distinct identities and cultures produced objects with more defined identity markers on each side of the frontier, which became more emphasised during periods of social stress (Hodder 1982, 37–58, 185–90). Joy (2014, 323) has also referred to the artefacts produced along the Roman Empire's frontiers as 'boundary objects', with design being an intrinsic part of expressing renegotiated identities, which he linked to the Scottish frontiers of the Roman Empire.

Jo Stoner's research (2019, 9) notes how heirloom artefacts, particularly high status metalwork, are passed through generations, entangling the past, present and future user/owner in the same story, the objects' status being 'based upon the value of memories for future generations, and the ability to hark back to past ancestors'. Symbols used on that metalwork is also part of that narrative. The decoration, as much as the morphology, of Irish Late Iron Age tack represents a cultural filter, and an important narrative of societal flux. This renegotiation of decoration and identity may represent a newly ascended, and socially fragile elite who wanted to display an association with earlier Iron Age symbols and patterns, to denote ancestral or foundation connections. The other possibility may be, because of the increased communication with the Roman Empire, that these motifs may represent an elite population who could claim more than one region as their origin and wished prestige objects to reflect that.

The Awesome Mix: Nostalgia, fear and memory in the 2nd century AD

In *Memory and Material Culture*, Andrew Jones (2007, 159) reminds us that past technologies of memory retention and commemoration are not unlike that of our own era. Jones noted that the decorative lozenge or triangular motifs on beakers and food from mortuary contexts in eastern Scotland are similar to those used on Early Bronze Age artefacts made of jet and metal (Jones 2007, 145–46). Even the sumptuous Irish gold lunulae of the Early Bronze Age are decorated with lozenge designs similar to those used on Scottish Neolithic food vessels (Jones 2007, 147, fig. 18). It could be argued that the transition between the Neolithic and the Early Bronze Age may well have been a period of turmoil, where established methods of living were challenged by new technologies and ideas. Re-imagining old symbols on new objects created using that technology may have offered a way to remember the past in a visible (and therefore shared) manner, providing connectivity to a past which may have been perceived by the people of the Early Bronze Age as more secure.

We need look no further than our own volatile 21st century to see the appeal of vintage memorialisation. There has been a surge of nostalgia-driven television, harking back to a time of perceived wellbeing and the foundation of current ideologies. Cult shows such as *Twin Peaks* and *X-Files* have been re-vamped, with recognisable themes of the 1990s, but adding contemporary tropes. The Marvel Studios *Guardians of the Galaxy* franchise (Deppe 2014) re-introduced the use of the defunct Walkman personal sound system while the soundtracks of the films created a past viewed through emotion more than accurate historical memory. Re-released vinyl music

albums have surged in popularity, as people buy into an idealised past, with market-ing exacerbating that yearning (Bartmanski & Woodward 2015). Yet, the records are not accurate representations of the past. The sound has often been remastered with digital technology, and the compounds used for making the vinyl are not the same as in an original from 1976 – they may look similar, but differences exist, although the music remains the same.

When looking at the various animal face and eye artefacts throughout Britain, such as the Great Chester fantail brooch mentioned earlier, the Stanwick 'horse-mask' (MacGregor 1962), and possibly even one of the fragmentary cheek-rings from the Seven Sisters hoard in Wales (Davis 2014, 148), it may well be that particular features of the bovine/equine design of the Early Iron Age were picked out, according to mem-ory or tradition, for re-interpretation in a regional manner. The nuance may have been slightly different in the re-working, but the magic or meaning was the same, and offered some kind of shared, displayed security. These objects have been found in northern Britain and Wales and all date to the 1st century AD. Hunter (2015a, 133) has noted that the most distinctive decorative pieces of metalwork are from flash-points along the boundaries of Roman Britain – Wales, Scotland, northern Britain – where maintaining identity through symbols was presumably important. Ireland's adoption of non-indigenous symbols on metalwork is currently an enigma.

The hypothesis offered here for these anachronistic designs appearing on Irish tack of the Late Iron Age is based on a need to deliberately invoke the past. During a period of increased social stress, where many people may well have been antici-pating a Roman invasion, the desire to activate the beliefs and symbolism of a more secure past through the replication of iconic symbols may have seemed a good idea. If some of the indigenous Irish did indeed have ancestral ties to British and Conti-nental groups of the Late Bronze and Early Iron Ages, then the fear of the erosion of identity through the forced introduction of new ideas and technologies from an invader might also have been present as part of the *Zeitgeist*. This area of research, currently unexamined for Ireland, will likely prove productive and informative in the future for a better understanding of the Irish Iron Age and its place in the late prehistoric world.

References

Abshire, C., Durham, A., Gusev, D.A. & Stafeyev, S.K. 2017. Ptolemy's Britain and Ireland: A new digital reconstruction. In *Proceedings of the 28th International Cartographic Conference*. Available at: https://www.proc-int-cartogr-assoc.net/1/1/2018/ica-proc-1-1-2018.pdf (Accessed 09 July 2019).

Armit, I. & Grant, P. 2008. Gesture politics and the art of ambiguity: The Iron Age statue from Hirschlanden. *Antiquity* 82(316), 409–22.

Bartmanski, D. & Woodward, I. 2015. The vinyl: The analogue medium in the age of digital reproduction. *Journal of Consumer Culture* 15(1), 3–27.

Becker, K. 2012. Redefining the Irish Iron Age. In C. Corlett & M. Potterton (eds), *Life and Death in Iron Age Ireland*, 1–15. Bray, Wordwell Publishing.

Birley, A. 2009. The Agricola. In A.J. Woodman (ed.), *The Cambridge Companion to Tacitus*, 47–59. Cambridge, Cambridge University Press.

Bourke, E. 1989. Stoneyford: A first-century Roman burial from Ireland. *Archaeology Ireland* 3(2), 56–57.

Cahill-Wilson, J. 2014. Romans and Roman material in Ireland: A wider social perspective. In *Late Iron Age and 'Roman' Ireland*, 11–59. Dublin, Wordwell Publishing.

Carson, R.A.G. & O'Kelly, C. 1977. A catalogue of the Roman coins from Newgrange, Co. Meath and notes on the coins and related finds. *Proceedings of the Royal Irish Academy Section* C 77, 35–55.

Champion, T. 2016. Britain before the Romans. In M. Millett, L. Revell & A. Moore (eds), *The Oxford Handbook of Roman Britain*, 150–73. Oxford, Oxford University Press.

Corcoran, J.X. 1953. Tankards and tankard handles of the British Early Iron Age. *Proceedings of the Prehistoric Society* 18, 85–102.

Coyle McClung, L. 2013. The Late Iron Age Lull – not so Late Iron Age after all! *Emania* 21, 73–83.

Cuming, S. 1859. On Celtic antiquities exhumed in Licolnshire and Dorsetshire. *Journal of British Archaeological Association* 15(3), 225–31.

Davis, M. 2014. Technology at the Transition: Relationships between culture, style and function in the Late Iron Age determined through the analysis of artefacts. Unpublished PhD thesis, Cardiff University.

Deppe, B. 2014. Guardians of the Galaxy [online]. *Guardian (Sydney)* 1654 (03 Sep 2014), 4. Available at: https://search.informit.com.au/documentSummary;dn=566396243941371;res=IELAPA. ISSN: 1325-295X (Accessed 04 June 2018).

Dietz, U.L. 1998. *Spätbronze-und früheisenzeitliche Trensen im Nordschwarzmeergebiet und im Nordkaukasus* XVI 5. Stuttgart, Franz Steiner Verlag.

Dungworth, D.B. 1995. Iron Age and Roman Copper Alloys from Northern Britain. Unpublished PhD thesis, Durham University.

Dungworth, D. 1997. Roman copper alloys: analysis of artefacts from Northern Britain. *Journal of Archaeological Science* 24, 901–10.

Eckhardt, H.E. 2014. *Objects and Identities: Roman Britain and the North-western provinces*. Oxford, Oxford University Press.

Englehardt, C. 1866. *Denmark in the Early Iron Age*. London, Williams and Norgate Publishers.

Farley, J. 2011. The deposition of miniature weaponry in Iron Age Lincolnshire. *Pallas* 86, 97–121.

Fernández-Götz, M. 2016. Urban experiences in Early Iron Age Europe: Central places and social complexity. *Contributions in New World Archaeology* 9, 11–32.

Field, N., Parker Pearson, M. & Rylatt, Y. 2003. The Fiskerton Causeway: Research–past, present and future. In S. Catney & D. Start (eds), *Time and Tide: The archaeology of the Witham Valley*, 16–32. Lincoln, Witham Valley Archaeological Research Committee.

Fitts, L., Haselgrove, C., Willis, S. & Lowther, P. 1999. Melsonby revisited: Survey and excavation 1992–95 at the site of the discovery of the 'Stanwick', North Yorkshire, hoard of 1843. *Durham Archaeological Journal* 14, 1–52.

Fitzpatrick, A.P. 2007. Dancing with dragons: Fantastic animals in the earlier Celtic art of Iron Age Britain. In C. Haslegrove & T. Moore (eds), *The Later Iron Age in Britain and Beyond*, 339–57. Oxford, Oxbow Books.

Fitzpatrick, A.P. & Schönfelder, M. 2014. Ascot hats: An Iron Age leaf crown helmet from Fiskerton, Lincolnshire? In C. Gosden, K. Ulmschneider & S. Crawford (eds), *Celtic Art in Europe: Making connections*, 286–97. Oxford, Oxbow Books.

Fontijn, D. 2008. Everything in its right place? Selective deposition, landscape and the construction of identity in later prehistory. In A. Jones (ed.), *Prehistoric Europe: Theory and practice*, 87–106. London, Wiley-Blackwell.

Frey, O-H. & Herrmann, F.R. 1998. Ein frühkeltischer Fürstengrabhügel am Glauberg im Wetteraukreis, Hessen. Bericht über die Forschungen 1994–1996. *Germania* 75, 459–550.

Garrow, D., Gosden, C., Hill, J.D. & Bronk Ramsey, C. 2009. Dating Celtic art: A major radiocarbon dating programme of Iron Age and Early Roman metalwork in Britain. *Archaeological Journal* 166, 79–123.

Gibbons, M. & Gibbons, M. 2016. The Brú: A Hiberno-Roman Cult Site at Newgrange? *Emania* 23, 67–78.

Giles M. 2012. *A Forged Glamour: Landscape, identity and material culture in the Iron Age*. Oxford, Windgather Press.

Harding, D.W. 1974. *The Iron Age in Lowland Britain*. London, Routledge.

Harding, D. 2004. *The Iron Age in Northern Britain: Britons and Romans, natives and settlers*. London, Maney Publishing.

Harding, D.W. 2007. *The Archaeology of Celtic Art*. London, Taylor and Francis.

Hattatt, R. 2000. *A Visual Catalogue of Richard Hattatt's Ancient Brooches*. Oxford, Oxbow Books.

Haworth, R. 1969. The Horse Harness of the Early Irish Iron Age. Unpublished BA dissertation, Queen's University Belfast.

Haworth, R. 1971. The horse harness of the early Irish Iron Age. *Ulster Journal of Archaeology* 34(3), 26–49.

Hodder, I. 1982. *Symbols in Action: Ethnoarchaeological studies of material culture*. Cambridge, Cambridge University Press.

Horn, J.A. 2015. Tankards of the British Iron Age. *Proceedings of the Prehistoric Society* 81, 311–41.

Hunter, F. 2015a. The impact of Rome, *c.* AD 50–250. In J. Farley & F. Hunter (eds), *Celts: Art and identity*, 128–52. London, British Museum Press.

Hunter, F. 2015b. Interpreting Celtic art on the Roman frontier – the development of a frontier culture in Britain? In *Limes XXII: Proceedings of the 22nd International Congress of Roman Frontier Studies Ruse, Bulgaria, September 2012. Bulletin of the National Institute of Archaeology* 42, 1619–30. Sofia, National Institute of Archaeology with Museum Bulgarian Academy of Sciences.

Hüttel, H.-G. 1981. *Bronzezeitliche Trensen in Mittel- und Osteuropa. Grundzüge ihrer Entwicklung. Prähistorische Bronzefunde, Abteilung XVI*. Munich, C.H. Beck.

Hutton, R. 2011. Romano-British reuse of prehistoric ritual sites. *Britannia* 42, 1–22.

Jacobsthal, P. 1935. Early Celtic Art. *The Burlington Magazine for Connoisseurs* 67(390), 113–27.

Jacobsthal, P. 1944. *Early Celtic Art*. 2 vols. Oxford, Clarendon Press.

Jacobsthal, P., Ulmshneider, K. & Crawford, S. 2014. Leopold Bloom I and the Hungarian Sword Style. In C. Gosden, K. Ulmschneider & S. Crawford (eds), *Celtic Art in Europe: Making connections*, 213–23. Oxford, Oxbow Books.

Jay, M., Haselgrove, C., Hamilton, D., Hill, J. & Dent, J. 2012. Chariots and context: New radiocarbon dates from Wetwang and the chronology of Iron Age burials and brooches in East Yorkshire. *Oxford Journal of Archaeology* 31, 161–89.

Jay, M., Montgomery, J., Nehlich, O., Towers, J. & Evans, J. 2013. British Iron Age chariot burials of the Arras culture: A multi-isotope approach to investigating mobility levels and subsistence practices. *World Archaeology* 45(3), 473–91.

Jones, A. 2007. *Memory and Material Culture*. Cambridge, Cambridge University Press.

Jope, E.M. 1971. The Witham Shield. *The British Museum Quarterly* 35(1), 61–69.

Jope, E.M. 2000. *Early Celtic Art in the British Isles*. 2 vols. Oxford, Clarendon Press.

Joy, J. 2014. Brit-Art: Celtic art in Roman Britain and on its frontiers. In C. Gosden, S. Crawford & K. Ulmschneider (eds), *Celtic Art in Europe: Making connections*, 317–24. Oxford: Oxbow Books.

Lau, N. 2014. *Das Thorsberger Moor: die Pferdegeschirre*. Schleswig, Zentrum für Baltische und Skandinavische Archäologie.

Leigh, J., Stout, G. & Stout, M. 2018. A pathway to the cosmos at Newgrange Farm. *Archaeology Ireland* 32(4), 25–29.

Lloyd-Morgan, G. 1976. A note on some Celtic discs from Ireland and the province of Lower Germany. *Proceedings of the Royal Irish Academy Section C* 76, 217–22.

MacGregor, M, 1962. The Early Iron Age metalwork hoard from Stanwick, N.R. Yorks. *Proceedings of the Prehistoric Society* 28, 17–57.

MacGregor, M. 1976. *Early Celtic Art in North Britain*. Leicester, Leicester University Press.

Maguire, R. 2014a. The Y-piece: Function, production, typology and possible origins. *Emania* 22, 78–99.

Maguire, R. 2014b. On-line supplementary material to: The Y-piece: Function, production, typology and possible origins. *Emania* 22, 77–99. Available at: http://www.navan-research-group.org (Accessed 16 September 2019).

Maguire, R. 2018. Irish Iron Age Horse Tack in its Insular and Continental Context of Design, Function and Depositional Practice. Unpublished PhD thesis, Queens' University Belfast.

Maguire, R. forthcoming. Let's do the tine warp again: Reconstructing a Late Bronze Age bridle from Moynagh Lough, County Meath, Ireland. *EXARC Journal* 2019(3).

Megaw, V. 2003. Celtic foot(less) soldiers? An iconographic note. *Gladius* XXIII, 61–70.

Metzner-Nebelsick, C. 2002. *Der Thrako-Kimmerische Formenkreis aus der Sicht der Urnenfelder- und Hallstattzeit im südöstlichen Pannonien. Vorgesch. Forsch. 23.* Rahden, Westf., Liedorf.

Moore-Colyer, R.J. 1994. The horse in British prehistory: Some speculations. *Archaeological Journal* 151(1), 1–15.

Mount, C. 2000. Exchange and communication: The relationship between Early and Middle Bronze Age Ireland and Atlantic Europe. In J.C. Henderson (ed.), *The Prehistory and Early History of Atlantic Europe*, 57–72. Oxford, BAR International Series 861.

Ó'Drisceoil, C. 2013. Kilkenny and the Roman World. *Old Kilkenny Review* 65, 7–19.

O'Rahilly, T.F. 1946. *Early Irish History and Mythology.* Dublin, Dublin Institute for Advanced Studies.

Palk, N. 1984. *Iron Age Bridle Bits from Britain, No.10.* Edinburgh, University of Edinburgh.

Palk, N.A. 1991. Metal Horse Harness of the British and Irish Iron Ages. Unpublished PhD thesis, University of Oxford.

Pitts, M. 2010. Re-thinking the southern British oppida: Networks, kingdoms and material culture. *European Journal of Archaeology* 13(1), 32–63.

Raftery, B. 1974. A decorated Iron Age horse-bit fragment from Ireland. *Proceedings of the Royal Irish Academy Section C* 74, 1–10.

Raftery, B. 1983. *A Catalogue of Irish Iron Age Antiquities.* 2 vols. Marburg, Veröffentlichung des Vorgeschichtlichen Seminars.

Raftery, B. 1994. *Pagan Celtic Ireland.* London, Thames and Hudson.

Raftery, J. 1940. A suggested chronology of the Irish Iron Age. In J. Ryan. (ed.), *Féil-Sgríbhinn Eoin Mhic Néil*, 272–82. Dublin, Three Candles.

Robb, J. 1998. The archaeology of symbols. *Annual Review of Anthropology* 27, 329–46.

Runciman, W.G. 1983. Capitalism without classes: The case of classical Rome. *British Journal of Sociology* 4(3), 157–81.

Scott, B.G. forthcoming. Some notes on horseriding in the Irish Later Bronze Age. *Journal of Irish Archaeology* XXVIII.

Sharples, N.M. 2014. Are the developed hillforts of southern England urban? In M. Fernandez-Gotz, H. Wendling & K. Winger (eds), *Paths to Complexity: Centralisation and urbanisation in Iron Age Europe*, 224–32. Oxford, Oxbow Books.

Standish, C.D., Dhuime, B., Hawkesworth, C.J. & Pike, A.W. 2015. A non-local source of Irish Chalcolithic and Early Bronze Age gold. *Proceedings of the Prehistoric Society* 81, 149–77.

Stead, I.M. 1979. *The Arras Culture.* York, Yorkshire Philosophical Society.

Stevick, R. 2006. The forms of the Monasterevin-style discs. *Journal of the Royal Society of Antiquaries of Ireland* 136, 112–40.

Stoner, J. 2019. *The Cultural Lives of Domestic Objects in Late Antiquity.* Late Antique Archaeology Supplementary Series 4. Amsterdam, Brill.

Tacitus. *The Histories, Germania and The Agricola.* Translation by Murphy, A. 1903. London, Everyman Library.

Thrane, H. 1963. De første broncebidsler i Mellem-og Nordeuropa. *Aarbøger for Nordisk Oldkyndighed og Historie,* 50–99.

Waddell, J. 2012. Tal-y-Llyn and the nocturnal voyage of the sun. In W.J. Britnelland & R.J. Silvester (eds), *Reflections on the Past: Essays in honour of Frances Lynch*, 337–50. Welshpool, Cambrian Archaeological Association.

Waddell, J. 2018. *Myth and Materiality*. Oxford, Oxbow Books.

Wakeman, W. 1903. *Wakeman's Handbook of Irish Antiquities*. Dublin, Hodges and Figgis.

Warner, R.B.W. 1991. Cultural intrusions in the early Iron Age: Some notes. *Emania* 9, 44–52.

Webley, L. 2015. Rethinking Iron Age connections across the Channel and North Sea. In H. Anderson-Whymark, D. Garrow & F. Sturt (eds), *Continental Connections: Exploring cross-channel relationships from the Mesolithic to the Iron Age*, 122–44. Oxford, Oxbow Books.

Wilde, W. 1860. *A Descriptive Catalogue of the Antiquities in the Museum of the Royal Irish Academy: Articles of animal materials, and of copper and bronze*. Dublin, Royal Irish Academy.

Wildschut, T., Sedikides, C., Routledge, C., Arndt, J. & Cordaro, F. 2010. Nostalgia as a repository of social connectedness: The role of attachment-related avoidance. *Journal of Personality and Social Psychology* 98(4), 573–86.

Wood-Martin, W.G. 1895. *Pagan Ireland: An archaeological sketch. A handbook of Irish pre-Christian antiquities*. London, Longman.

Young, T. 2011. *Archaeometallurgical residues from Platin/Lagavooren 1 (01E0822), Co. Meath, Northern Motorway (J2009)*. Caerphilly, GeoArch.

Chapter 11

'Damn clever metal bashers': The thoughts and insights of 21st century goldsmiths, silversmiths and jewellers regarding Iron Age gold torus torcs

Tess Machling and Roland Williamson

Abstract

This paper examines Iron Age gold torus torcs through the eyes of modern jewellers and goldsmiths. The craftspeople chosen are from a number of different gold-working traditions and trained in a range of techniques, with differing levels of age and experience. The paper derives from discussions with them regarding the manufacture, possible techniques used, the difficulties of creation and the practicalities involved in gold torus torc production. As experienced gold-workers, their comments provide an insight into the complexity of these items and the skills needed to create them. In addition, they offer differences and similarities in response, leading to a better understanding of the objects in question. This approach is valuable, as all too often these objects are examined with an archaeological or scientifically analytical eye; aspects that only a worker in gold might notice can sometimes be overlooked.

Introduction

This paper is the product of the many conversations, emails, telephone calls and meetings that the authors have had with goldsmiths, silversmiths, jewellers and craftspeople over the last four years. It is an attempt to see gold working through the eyes of those who work with the material, and it is our hope that this paper will encourage the reader to think not just of the torcs, but also of the people who made them. This paper endeavours to give an insight into some practicalities of gold working and to look at some of the considerations that guide the goldsmiths' approach to their craft.

This approach is all too often lacking in archaeology, where skilled craftspeople are rarely asked to comment on objects made by the skilled craftspeople of the past. This research does not aim to be definitive and results are speculative, as the working environment, methods of learning and life expectancy and health today are

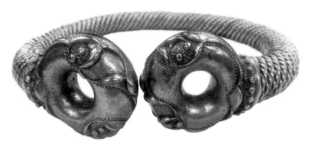

Fig. 11.1. The Newark torc.

different from those experienced in the past. But, regardless, gold has certain properties which will only allow it to be worked in certain ways. In addition, several of the goldsmiths we spoke to work using methods and tools that would be recognisable to later prehistoric goldsmiths. As such, we argue that the goldsmiths of today have insights relevant to the study of Iron Age torcs and can enable a conversation, albeit a limited one, with the peoples of the past.

Archaeologists and precious metals

Gold seems to bring out a particular reaction in many academic archaeologists – little of the fundamental metrology or visual characteristics commonly recorded in other artefact types is carried out on prehistoric goldwork. Prior to our research, many of the torcs in our study had yet to be accurately measured, drawn or recorded in detail. Many had undergone complex scientific analysis (*e.g.* X-Ray Fluorescence and Scanning Electron Microscopy), but little attention had been paid to the basic visual and technological attributes of the artefacts which could be seen with the naked eye or basic magnification (Fig. 11.1).

For example, in the case of the Snettisham torc material (Cartwright 2012; La Niece 2018; Meeks 2014) the recent published research is almost exclusively based on scientific analysis. In our opinion, this has skewed the direction of academic discourse towards theories of manufacture that tend to encourage generalisation, under the guise of scientific objectivity, and discourage more nuanced and pluralistic (even if subjective) studies of the material in question. As Armbruster (2015, 417–18) has noted, 'most archaeologists are, despite the fact that they express themselves on technology, rarely trained to recognise technological features on prehistoric artefacts'.

Talking to goldsmiths

What follows is based on canvassing the practical experience and knowledge gained by people who have worked with gold and other precious metals over a number of years. It is an agglomeration of many conversations: initially a survey was devised, but this soon proved to be of little use as responses became fixed, and the natural flow of thoughts and ideas (which often proved to be incredibly insightful and wide-ranging) was hampered by 'answering questions'. Instead, after being sent around 150–300 photos and examples of published material for each of the torcs in our study, responses came from general conversations in which the contributors chose areas of discussion

most interesting to them. In some cases, where there was a difference of opinion, we returned to contributors for comment. However, most conversations were organic and non-specific to this paper.

The conversations were entirely positive, and we found that all our contributors used the ideas and thoughts of others to develop and clarify their own thoughts. Differences of opinion amongst the people we spoke to were only ever differences in approach or style, rather than one person being 'right' or another being 'wrong'. This was a truly egalitarian and productive exercise – one which we can imagine might have been seen in a gathering of Iron Age goldsmiths, which may well have resulted in the obvious similarities seen in the torcs concerned.

We started this paper with a desire to find out how the torcs were made, to gain insights into who made them, and how the practice of being a goldworker in the 21st century might, or might not, be comparable to prehistoric goldsmithing. As such, this paper, although providing some results specific to British Iron Age gold torcs, offers a methodology that can be applied to goldworking anywhere in the prehistoric world. In fact, we would go so far as to suggest it is an approach that can be applied to the understanding of any craft object from any time in history: if you want to know about an object, talk to those who are experienced in working with that material. This approach is becoming more common in British Bronze Age metalwork studies with, for example, pioneering work by Brian Clarke on ribbon torcs (2014) and Barbara Armbruster (2015) and Giovanna Fregni (2014; 2019) on Bronze Age metalworking. A similarly pluralist approach is taken by the recently initiated AHRC-funded project 'Research network on gold in Britain's auriferous regions, 2450–800 BC', which aims to examine gold sources, production, and 'how the know-how to extract and work gold was passed on' (National Museum of Scotland 2018). Despite these advances in Bronze Age metalwork research, this is the first time we know of such a method being used to examine Iron Age metal artefacts.

This paper is, by its very nature, subjective: craft skill and knowledge are not, on the whole, passed on through books, but rather are taught and learned by watching and doing. These skills develop from a conversation between knowledge and experience, and the passing on of this knowledge is a very visual conversation, often difficult to translate into words. As such, there are few references to published research, and comments have been anonymised to allow the flow of ideas and thoughts. A full list of contributors is appended, and their professional reputations, experience and training act as a reference list. Anonymised comments from the goldsmiths, silversmiths and craftspeople we talked to can be found in italics throughout the text and are used as 'jumping-off' points for further thought.

In the beginning

'They are thought to have had the terminals cast directly onto the rope collar... It is far too risky a method I think.'

In May 2015, a chance email conversation about Iron Age hollow-torus (ring) torcs between the authors began with the apparently innocuous comment above by Roland Williamson. Although it sounds like a random hunch, it was a comment informed by 35 years of crafting museum-quality replicas and other items. Thirty-five years of experience, knowledge, learning and mistakes said there was something wrong about the way scholars assumed these torcs had been made.

> '*I would never advocate the casting onto the wires of the terminal. It is just too likely to fail with complex shapes like a hollow-torus.*'

Because of this, we began to search the academic literature to see why and how this casting-on theory had developed. Our search showed that although casting-on was assumed to be the manufacturing method in all cases (Cartwright 2012, 26–7; Eluère 1987, 34; Hautenauve 2004, 120–21; Jope 2000, 253; Joy 2015, 41; La Niece 2018, 418; MacGregor 1976, pl. 191; Meeks 2014, 150–51; Stead 1991, 454), there was, and is, very little evidence for many of the hollow-torus torcs to back up this assumption. The results of our work have resulted in two papers (Machling & Williamson 2018; Machling & Williamson forthcoming), which describe a new, gold sheet-working, manufacturing method for several of the torcs, and offer some ideas of the implications of these new findings. In addition, for those gold hollow-torus torcs that have cast terminals, we have shown that none are cast-on, as had been previously assumed, but were instead cast separately before being attached to the wire neck rings (Machling & Williamson forthcoming).

Looking at torcs

> '*Those are complex pieces, some are made up of several parts fused together, wonderful work.*'

The torcs in question are the Netherurd torc terminal (Feachem 1958), the Great and Grotesque torcs of Snettisham (Brailsford 1951; Clarke 1954; Stead 1991), and the Newark (Atherton 2016; Hill 2005) and Sedgeford (Brailsford 1971; Hill 2004) torcs. The Netherurd, Great and Grotesque torcs have been identified as having a sheet-work terminal construction, whilst the Newark and Sedgeford torcs have cast terminals which were connected to their wire neck rings through a complex riveting system, in the case of Sedgeford, and the skilled use of (possibly) solder, in the case of Newark (Machling & Williamson forthcoming). An illustration of all torcs can be found in Machling & Williamson 2018, Fig. 9.

> '*The people who made these must have had an amazing vocabulary of techniques.*'

All five torcs are related to each other by: decorative finishing (in the case of Netherurd and Newark, a specific pattern of tooling has been identified that appears to show the hand of a single maker/finisher); size (Newark and Sedgeford have almost identical

size torus', as do the Netherurd and Great torc terminals); or technique (Netherurd and the Great and Grotesques torcs are linked by their 'apple core' and 'donut' terminal construction technique and Newark and Sedgeford by their terminal casting technique).

However, all five torcs also show differences – Netherurd is sheet-work and Newark is hybrid cast/hammered, the decoration and tooling on Newark and Sedgeford are dissimilar, as are the neck ring fixing methods for the terminals of each torc. The Grotesque terminals are of an unusual shape and show a different style of decoration to both the Netherurd and Great torc terminals, which in turn are very decoratively distinct from each other (Machling & Williamson 2018, 11). Interrogating these similarities and differences is key to understanding these torcs.

> 'An immense amount of info can be gained from assessing the weight, balance, give, texture and discerning colour differences (indication of solder or fusing) of the metal.'

> 'I would be able to understand the making and construction far better by examining the actual pieces.'

Time and time again when we talked to people, despite offering a huge number of images for examination, the first response was: 'if only I could hold it', 'I'd really like to get a closer look' and 'I'd feel much better if I'd actually seen it in the flesh'. The tactile and visual evidence of these objects – how they feel in the hand, the changes in the visibility of working traces as the item moves in the light, the weight and colour – are all impossible to gauge from images. Even we, neither of whom are goldsmiths, found it difficult to comment on the torcs without first seeing them in the flesh. We are certain that far more insights could be gained if the goldsmiths could handle the torcs.

All too often in archaeological literature, the visual qualities – such as lustre, colour and decoration – of these items are emphasised (Hutcheson 2007, 362; La Niece 2018, 409), while handling characteristics, tactile qualities and weights are omitted. We suggest that the tactile qualities be explored equally with this material, as the high relief work, punched details and varied weights provide very different tactile experiences; these are relevant to our understanding of these objects and how they were perceived in the past (Sophia Adams, pers. comm.).

We also believe a critical part of this research is to see the torcs in quick succession, while the memories of the previously seen torcs are still fresh in the mind. However, the torcs are scattered in location and, due to their considerable value and fragility, are not easily examined or moved. Never have all torcs of this type been together in a room, and it is unlikely that we will ever have the chance to sit around a table and compare and contrast the Netherurd, Newark, Snettisham Great, Snettisham Grotesque and the Sedgeford torcs. Archaeological knowledge will always be the poorer for this.

This last observation may also be relevant to the Iron Age: the similarity of form and decoration suggest that Iron Age goldsmiths were aware of each other's work, or that the pool of goldsmiths was incredibly small and tight knit, perhaps with only a handful of people working on this particular style of torc. One of our contributors

noted that goldsmiths have '*very good memories for work*' and that, after only having seen an object once, would be able to go away and produce something similar at a distance. Indeed, when we showed our contributors the torcs, they were immediately able to decode their manufacturing and decorating techniques. This ability to remember and then reproduce what had been seen, in an age where notebooks and photography were unavailable, is likely to have been a highly important quality for a goldsmith.

Technology

'*I really can't believe that anyone ever thought that these weren't made of sheet.*'

This was the comment we heard most often regarding both the Snettisham Great torc and the Netherurd terminal. Even before handling the torcs, their sheet-work construction seemed obvious, even to us. The tell-tale signs were in contrast to the texture of the, clearly cast, Sedgeford torc. They had dents in the terminals, showing that the material was hollow and thin; there was planishing/punching in areas that would have been impossible to reach had they been cast (*e.g.* in the valley between the collar and terminal); and they had lines of irregular cracking in areas where the gold was thin and had been overworked. The biggest giveaway was their difference in weight. The Netherurd terminal, despite being some 10 mm larger in all dimensions, weighs almost exactly the same as the detached Sedgeford terminals (Netherurd: 114 g; Sedgeford: 117 g); they must have been made from much thinner gold. The visual examination of the interior of the Netherurd terminal further confirmed this (Machling & Williamson 2016). Taken together, and supported by the goldsmiths' comments, it is surprising that the cast-on theory ever evolved.

However, the Newark torc was misleading, and we originally identified it as being sheet-work (Machling & Williamson 2018). It showed many of the characteristics seen in both the Snettisham Great torc and the Netherurd terminal, and supposed repoussé was visible on an earlier X-Ray Computed Tomography scan. When recently x-radiographed at 450 kV, it became apparent that the core seam was caused by some form of cast or hammered core being added to the terminal, and the relief decoration appeared cast (Machling & Williamson forthcoming). We now argue that the Newark terminals represent some form of cast/hammered hybrid which was made separately before being attached to the wires. The precise mechanism of this torc's production is currently being investigated, however, for the Netherurd and Snettisham Great and Grotesque torcs, the answers are more obvious.

'*If asked to make something like those terminals I would also use sheet.*'

Those who felt confident in their ability to make torcs suggested that sheet-working would be the only sensible method to make many of them. As such, Roland's initial reaction was proved correct: casting-on would be messy, difficult and wasteful of material, whereas sheet-working would allow control and accuracy. It would also allow the

gold to go much further. The archaeological torc evidence supports this interpretation. Hollow casting is seen in all the separately cast, and cast-on, torus torcs identified to date (including Sedgeford and the many lower quality metal cast torus torcs from Snettisham). However, they all (apart from Newark, which as discussed shows a hybrid technique) show casting faults in the form of cracking, cold shuts, metal dribbles or incomplete casts (Machling & Williamson 2018, 14). Sheet-work is the obvious preferred solution to create a torus torc.

> '*Why use more metal than really needed. The whole trick was to make it spread as far as possible. More bang for your buck, so to speak.*'

The creation of sheet-worked torcs that maximised the use of gold seems to be a recurrent theme in Iron Age torcs, not just in torus torcs. Perhaps the greatest expression of the sheet-working technique can be seen in the tubular torcs found at Snettisham in 1948 (Clarke 1954, 49). Tubular torc 2, despite being 190 mm in diameter, weighs only 110 g. If seen at a distance – or if held, once it was filled with the internal iron and sand support – this torc would appear to have been made with far more gold than it actually was. The same can be said of the Snettisham Great torc (1084 g), which weighs almost the same as the Ipswich torc 2 (1044 g) (Brailsford & Stapley 1972, 221). Despite having a similar diameter, the Great torc is much wider in the neck ring and has far larger terminal dimensions.

Goldsmiths

> '*To be locked in one place would somewhat hinder their outlook, I feel.*'

When we came to consider the places where goldsmiths might have worked, archaeology offers little clues. Evidence of gold working is sparse in the Later Iron Age, and no confirmed examples of gold sheet-working workshops have yet been identified. There are a few suitable tool kits from the latter part of the period, most notably the blacksmith's kit from Waltham Abbey (Stead 1985, 14). The portable nature of these might suggest itinerant working. One of our goldsmiths thought travel would be essential for goldsmiths to develop their craft and absorb ideas and styles from others. Our respondents believed the level of skill shown in the torcs did not grow in isolation, and considering the tools used (see below), this suggests that the goldworkers were itinerant.

> '*I don't relish cold days in the workshop.*'

> '*It is difficult to make jewellery and the like if one is cold.*'

Although the group of people we talked to are used to the comforts of 21st century living, such as central heating and lighting, they were still affected by aspects that would have concerned their Iron Age antecedents. Cold was the biggest dread: an inability

to keep hands warm whilst working. Warmth would of course have been possible by having fires (a functional necessity for the annealing process), or during warm summer days, but it is difficult to imagine how this might have been achieved successfully on the coldest of winter days. And those days would also have been shorter and darker.

'Most jewellery work I do now is done just as much by feel as by sight.'

Everyone we spoke to suggested that goldsmiths need strong, diffuse light and, even today, most prefer working in natural light, with several expressing a preference to be north facing (due to the consistency of the light). In the days before window glass, this light must have been provided by a large aperture or doorway or perhaps even working outside. The requirement for good light may have made goldworking a highly visible activity, in contrast to the hidden and indoor working required for other metals such as iron, where darkness is needed to be able to watch for changes in metal colour during the heating process. The goldsmiths expressed some adaptations that could accommodate for poorer light: the ability to feel what one is doing and the almost unconscious working of the hands that comes with many years of experience and skill.

The light requirements seem obvious, but when considered in the context of Iron Age buildings (which apparently have no windows and large areas of darkness within), it becomes increasingly difficult to comprehend how Iron Age goldsmiths carried out their work. An element of seasonal working, to take advantage of good light and warmth, seems a possibility.

'I have a large safe where I keep my materials and work in progress.'

Gold today, due to its rarity and value, is treated securely and workshops/factories where gold is crafted or worked are often hidden from sight, in undisclosed locations, or away from shop fronts. Security was likely a concern in the Iron Age, but the requirement for good light suggests it was possible for goldsmiths to work in plain sight with less of a need to hide their products. This could have been due to a sense of physical security or perhaps gold was taboo to ordinary Iron Age peoples. Many gold torcs were buried at Snettisham and lay undisturbed, despite their presence likely being known by many, possibly suggesting gold and gold workers, and the theft of such material, were protected by social/religious taboo. Perhaps as Diodorus Siculus (*Library of History*, V, 27) suggested in regard to the gold given by Celtic peoples at temples: 'a great amount of gold has been deposited...and not a native of the country ever touches it because of religious scruple.'

'I can't get over the level of craft virtuosity in the Peebles [Netherurd] torque. That was some skill level by any standard.'

If Diodorus Siculus was correct, the workers of such materials could have had a magical or ritual status. The unique, untarnished, glittering nature of gold combined with the sheet-worker's ability to turn a *c.* 40mm × 40mm × 40mm lump of gold alloy into a

Great torc or ac. 10mm × 10mm × 10mm piece of gold into a tubular torc would have strengthened the appearance of a goldworker's great, possibly magical, skills. These skills would have been accompanied by other practical benefits. In a time of limited gold resources (Northover 1995, 301), the ability to create torcs that appeared to contain more gold than they actually did would have been a sought-after skill with a commercial benefit to all concerned.

> 'Experience counts for a lot, however the enthusiasm and naivety/innocence of youth does too, certainly in the way that it has not yet put restraints upon itself.'

> 'I was at my peak around mid- to late 30s with regard to abilities and lack of physical impairment.'

The antecedents of the modern apprenticeship system were first established with the founding of craft guilds around the 12th century and then more formally in 1563. This is when the Statute of Artificers (Snell 1996, 303) laid down the precise terms of apprenticeship where young sons were apprenticed to master craftsmen to learn their trade for a term of seven years. The apprenticeship system remained largely unchanged until the mid-20th century.

Several of our older goldworkers were taught under the apprenticeship system. They talk of having to file casts and make wires before they could be trusted with anything important, and of the mundane and repetitive hammering required to ensure the clean and even stroke that could only come from much practice. Several people we spoke to, however, were immediately put to work with precious metals, and often with gold. As they mentioned, getting used to working with gold quickly was of benefit for both practical and commercial reasons: the sooner they were trained, the sooner they could be profitably employed. Several of them also talked of the impetuosity they had when they were younger, knowing they could not do something and attempting it anyway – sometimes successfully, and sometimes with disastrous results! On the whole, most suggested experimentation took place when young. Of course, a certain amount of experimentation was carried out in later years, but then learnt skill allowed more predictable results to be achieved when new processes were attempted.

All of the above is likely to have been the case in Iron Age Britain. In a time before writing, goldsmiths' skills could only be passed on from person to person, and it seems logical to imagine older, practised, craftspeople passing on their knowledge to the young. They would perhaps have honed their skills through repetitive practice, learned what worked – and what didn't – and adapted and developed their own ideas. The authors feel this is the key to understanding British Iron Age gold torcs: they are not the product of a single generation, but appear to be the result of many years of accrued knowledge in how to technically process, manipulate and decorate the gold torcs, and yet which show differing decorative styles (fashions?) that changed over time. This is perhaps best exemplified in the Grotesque and Netherurd and Great torcs. The probable two-hundred-year-old 'apple core and torus' sheet-work technique can

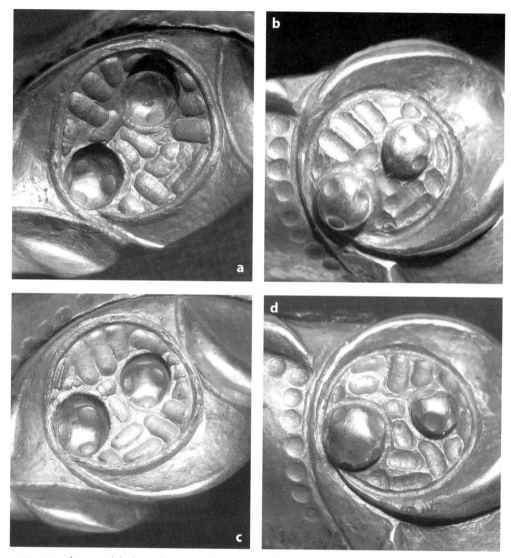

Fig. 11.2. The roundels from the Newark torc, with the possible 'apprentice'-executed Roundel d.

be seen in all three torcs, and yet the decorative style in the earlier Grotesque torc is completely different to that seen in both the Netherurd and Great torcs.

In the case of the Newark torc, the authors believe one of the four roundels may show the hand of an apprentice or learner, as the strokes within this roundel show less definition and a hesitancy of action not seen in the other roundels of the torc (Fig. 11.2, Roundel d). It is also interesting that the Newark torc includes an area of decoration where the craftsperson's tool has slipped and gouged into the collar; this error has been roughly burnished out so that it is no longer visible to the naked eye (Fig. 11.3).

Fig. 11.3. The Newark collar, showing the slip of the tool during the decoration of the collar.

'Now I'm older, I have to view things at an arm's length in low light levels... I would suppose that the older workers would have been full of advice and still able to contribute.'

But what of those craftspeople whose work time was coming to an end as they grew older or suffered health problems, such as failing eyesight or reduced manual dexterity? Several people we spoke to reported that, from around forty years of age, their eyesight had deteriorated to the point where they needed glasses or magnifiers to continue working. In addition, several reported a loss of strength and/or manual dexterity from around this time. Others in their late fifties/sixties, however, reported no such changes. Eyesight in modern times is purportedly worsening due to increased screen time and book work (Mirshahi 2010), so it is possible that Iron Age metalsmiths had productive working lives which ranged from childhood through to later middle age, potentially some forty years plus.

'Would I feel confident in making one - well not really.'

'I think that this could be a learning curve for me too.'

'Yes. I could make one. I wouldn't expect it to be too troublesome.'

Over the course of our conversations, it became obvious that not all our modern metalworkers felt confident about making the torcs, and several felt they would need to practice the techniques before attempting the final item. Gender was not relevant and, although apprentices and goldsmiths were traditionally viewed as male occupations, there is no evidence to suggest that this was ever the case in later prehistory. Women and girls would have been as capable of making the torcs as boys and men.

Those who were older, had more experience and trained in a more traditional manner felt confident that they would be able to produce a raised torus, from sheet,

in a couple of hours and could produce a finished and decorated terminal within a week. This suggests that an item such as the Snettisham Great torc or a complete Netherurd or Grotesque torc was the product of weeks, rather than months, of work. Others felt daunted by the task. They were unfamiliar with the techniques used but believed they could probably achieve it after attempting it first in copper or silver. This supports the interpretation that, although not '*difficult*' for an experienced goldsmith, a high level of skill and experience was necessary to create torcs like the Netherurd or the Snettisham Great torcs. As one goldsmith said, '*although I would not find it a challenge, this would take everything I've learnt over 35 years to do.*' The task also requires a specific toolset.

Tools

'*My impression of torc construction is that there is in fact quite a restrained number of tools used in the process.*'

'*Iron or even bronze tools could be used but I also have box wood shaping mallets and doming punches. I can raise bowls with a blocking mallet and a torque made in 22-24 carat thin gold with wooden punches and mallets would be easy.*'

Everyone we spoke to believed only a limited number of portable tools were needed to make a torc. Once the (1) gold had been refined, or re-cycled, into a puddle or bar ingot; (2) hammers and a small anvil or stake would be necessary to raise or beat out the sheet; (3) stakes, punches, and possibly snarling irons were needed to create the decorative relief work; and (4) punches and chasing tools would be utilised to finish the decoration on the exterior. Some sort of pitch pot would possibly be required, although for most of the goldsmiths it was argued that pitch, or some other similar medium, might only be needed to provide support for the exterior finishing work. Several people we spoke to felt they would be happy to make a torc using tools made of antler and wood, which would leave no trace in the archaeological record. Several people also mentioned they had favourite tools that they would always choose to use if they could: these were often trusted, simple tools – almost talismanic items – which had been owned for many years.

The suites of tools discussed, as mentioned previously, are not unknown from the archaeological record (Stead 1985, 16). A number of punches, awls and other tools are recorded in the Portable Antiquities Scheme online database (https://finds.org. uk/). Tools of this type, needed to carry out the matting, tooled lines, etc. on the torcs, are often identified as Bronze Age (*e.g.* PAS records SUR-7147F6, BUC-23F078, PUBLIC-A84EB2 & SUSS-AEB91C), but could be equally at home in the Iron Age tool kit.

Individual insights

A number of themes arose from our conversations regarding the individual characteristics of the torcs in question. These are detailed below.

'Impurities can make even 22ct gold very difficult to work.'

One of the goldsmiths stated that unless all impurities were removed, gold became very difficult to work. They had previously worked with refined natural gold and commented on how, even with modern methods, the refining had not been straight-forward. Several people also mentioned how the addition of increasing amounts of copper would have reduced the workability of the gold alloy. This offers insights into why the Newark and Sedgeford torcs, which have a higher percentage of copper than the Netherurd torc and the Great and Grotesque torcs of Snettisham, might have been cast: was the alloy too unmalleable to work in sheet and therefore had to be cast? Or was the addition of copper, as might be suspected, a response to a diminished supply of purer gold (Northover 1995, 301)? These questions are beyond the remit of this paper but will be explored in a forthcoming paper (Machling & Williamson forthcoming).

'I would be fascinated to know what material they used as a support to the gold.'

We cannot be sure whether the goldsmiths of the Iron Age were using pitch pots or whether they were relying on some other medium such as beeswax – this was success-fully used by goldsmith Wojciech Kochman to create replicas of the Bronze Age Knowes of Trotty discs (Sheridan 2018). Whatever the case, everyone we spoke to agreed that some form of pitch/tar/resin/wax support would have been necessary in the interior of the terminals to provide support for the exterior decorative tooling and chasing. As no such material remains in the interior of the terminals, this appears to have been removed prior to the attachment of the terminals.

'The repoussé work to create the volume on the ring could be done before the metal was bent up into a ring (like a serviette ring).'

The precise order of creating and decorating the torc terminals prompted diverse responses. Some suggested that the torus could have been made from a raised narrow vase, which had the bottom removed to leave a cylinder that could be divided to pro-vide both the torus and core. One section could then be bent into a torus shape and the other splayed in the case of the core. Others suggested that the torus and core could be made from rectangular sheets which were then curved into a tube and then seamed (although to date, no joining seams have yet been identified in x-radiographs and so seems unlikely). One suggested that a rod ingot could have been bored and expanded to form tubes for both torus and core, although this seems more labour intensive, and thus perhaps less likely.

There were contrasting opinions about the stage at which the decorative features were added. Some suggested the basic repoussé/relief work could be carried out before the torus was curved, and others suggested the torus should be curved before the repoussé/relief was added. All, however, agreed that the main repoussé/relief work was carried out prior to the addition of the core and collar and the final detailed tooling and chasing seen on the exterior was carried out only once the torus, core and collar were fully joined and complete.

'I see evidence of a planishing punch over the entire surface, there is also evidence of hand scraping with a sharp instrument to give finish in some areas.'

All of the torcs in our study show evidence of having been smoothed and planished on the exterior, and the Netherurd and Great torcs show evidence that this was carried out across the entire surface. Newark, despite apparently being cast, also shows such evidence (Fig. 11.1). This may be indicative of its relationship to the Netherurd terminal. In contrast, the Sedgeford torc appears generally unplanished, or perhaps has been burnished to remove such evidence. However, there are planished areas on the surface of the Sedgeford torc terminals, where additional gold alloy has been added to cover some of the faults that resulted from the casting of the terminals. These repairs (which include a number of rivets inserted to support the crack) are assumed to have been carried out soon after casting (the rivets match those used to attach the terminal to the neck ring wires). The authors believe that the terminals of this torc are mostly as they were when the torc was first complete, and therefore the planishing only took place in the vicinity of the added alloy.

'It doesn't seem like a solder joint.'
'Soldering a thin torc terminal onto a chunky ring of twisted wires is no easy task.'

The precise mechanism of attachment of the torus to the core and the terminals to the wire neck ring again prompted contrasting opinions. It appears that very little, if any, solder was used to attach the core to the torus and torus to the collar. Some suggested that the overlapped sheet joins (seen in the Netherurd and Snettisham Grotesque and Great torcs) could be achieved using purely mechanical pressing and smoothing. Others suggested that the evidence seen in the torcs could be representative of a very controlled use of minimal amounts of solder, or even diffusion bonding.

We initially thought the cracks in the margins of the central 'apple core' visible on the x-radiograph of the Snettisham Great torc core (Joy 2017) were evidence of the gold having been cut to allow the splaying of the core. One of the goldsmiths, however, suggested that such cracks were the natural result of the gold thinning and cracking due to hammering at the margins of the core. The remaining presence of these tiny cracks (only tenths of millimetres in width) support the manual attachment theory, as any solder or excessive heat used would likely have filled and obliterated their presence.

Some goldsmiths argued, in the case of the Netherurd, and perhaps the Snettisham Great and Grotesque torcs, that very little, if any, solder had been used to join the collar and neck ring. The 'lip' of collar material visible on the Netherurd torc (and also interestingly seen on the apparently unrelated sheet-work Clevedon [Jope 2000, pl. 120] buffer terminal) was largely a mechanical join. This lip of material could have been moulded and smoothed around the wires. Indeed, all the x-radiographed torcs – the Newark and Snettisham Great and Grotesque torcs – show very little evidence of solder in the vicinity of the wires. This is echoed in the visual evidence of the interior of the Netherurd collar, which shows a minimal amount of solder used

to provide apparently the lightest of joins (Machling & Williamson 2018, 4). In the case of Sedgeford, it appears that the rivets which pass through the collar of each terminal – seen within the detached terminal – were clearly added after the terminals were cast and seem to be related to the attachment of the torc's terminals.

The Snettisham Great torc has an intriguing anomaly about which several people commented. The exterior of the neck ring to collar join is messy – there are bubbles, solder that ran down the wires, and several cracks in several of the wires closest to the collar join. However, in x-radiograph, the amount of solder surrounding the wires on the interior of the collar is apparently minimal (Farley 2017; Joy 2017).

Two of the goldsmiths suggested the solder was a rather messy (and to their goldsmiths's sensibilities, shocking) exterior repair carried out later in the torc's lifetime. A rather large amount of inexpertly added solder or gold was used to make the terminals secure perhaps after they became loose. We have argued (Machling & Williamson forthcoming) that the Snettisham Great torc is not as perfectly made as previously assumed. For example, the neck ring is not wide enough to fit the terminal aperture. In all other torcs, the neck ring joins straight to the terminal collar aperture, whereas the Great torc's neck ring wire ropes were splayed to fit the space. We suggest this problem occurred either because there was an error in the making of the wires or terminals, or because the Great torc terminals were not originally made to fit the Great torc wires and were reused. Whatever the case, the repairs to the collar/neck ring attachment further support the interpretation that the neck ring was ill-fitting, and that the clumsy original attachment perhaps needed to be repaired and strengthened later in the torc's lifetime. Closer examination will be necessary before this theory can be proved.

Conclusions

Torus torcs are often seen as homogenous entities linked by their overall similarity of form and comparable 'Snettisham gold style' (Jope 2000, 81) of Celtic art. However, by closely looking at the torcs, and by recording and decoding their various attributes, they immediately become works of craftsmanship that show the artistic style and developed skill of individual makers and workshops. To decode their evidence, it is beneficial to think like a goldsmith. As we have shown here and in our previous work, each of the torcs has aspects that are similar and dissimilar to its siblings, and each torc has at least one aspect that makes it unique. This uniqueness shows the hand of the maker.

In the case of the Netherurd terminal, the hand of the maker/finisher is shown in the tiny tooling marks on the roundels – that same hand can be seen in the roundels of the Newark torc. For the Snettisham Great torc, the maker's hand can be seen in the inexpert terminal fixing, and also in the tooling marks which show a style of conformity and regularity that contrasts greatly with the fluidity and confidence of the Netherurd and Newark torcs' manufacture. In Sedgeford, the riveted terminal attachment method is very different to the apparently finely soldered attachment seen in the cast Newark

terminals, and these in turn contrast with the finely moulded/soldered attachment of the sheet-worked terminals of the Netherurd and Snettisham Great and Grotesque torcs.

Had the insights of goldsmiths been sought at any time over the last seventy years, we are certain that the production and distribution narratives of torus torcs would have developed beyond our current state of knowledge. As we have discussed (Machling & Williamson 2018, 12), the recent identification of a previously unrecognised sheet-working technique and the related tooling patterns of two torcs, Netherurd and Newark, has opened up new avenues of research. This research has far ranging implications and the potential to alter current theories regarding the manufacture, dating and trade/exchange of the torcs (Machling & Williamson 2018, 15).

The goldsmiths, silversmiths, jewellers and craftspeople we interviewed have refined this research and provided an element of understanding of the lives, training, experience and technical skill of Iron Age goldsmiths. They have provided insight into the likely tools used and the working environment and practical considerations that the Iron Age gold-worker would have faced, and which would have limited or allowed him or her to carry out their craft. In addition, they have highlighted areas of interest in the torcs which can now be examined more closely.

But perhaps, most importantly, the goldsmiths have provided a very human voice for the lost gold-workers of prehistory. This voice is not often heard in academic texts, and it is a voice that brings to life the *'damn clever metal bashers'* of Iron Age Britain.

Contributors

Hamish Bowie is a retired goldsmith, jeweller, writer and lecturer with over sixty years' experience. Hamish was apprenticed at William Griffith and Son and then trained and lectured at the Birmingham School of Jewellery.

Abigail Brown is a silversmith who trained at Loughborough University School of Art & Design and Edinburgh School of Art. Abigail also teaches silversmithing.

Ann-Marie Carey is Associate Professor in Jewellery at the School of Jewellery, Birmingham City University (BCU). She trained at Central St Martins, the Royal College of Art, the Birmingham School of Jewellery and the University of Liverpool.

Bob Davies is a silversmith, jeweller, pattern maker and sword maker with thirty years' experience. He trained at the Birmingham School of Jewellery.

Stephen Fisher is a retired silversmith with over sixty years' experience who trained and lectured at the School of Jewellery in Birmingham and continues his association through attending silversmithing classes.

Giovanna Fregni is an experienced jeweller and metalsmith with a PhD in archaeological metals. She wrote her thesis on metalsmithing tools in the British Bronze Age.

Ford Hallam is a goldsmith who is also trained in the Japanese metalworking tradition. He also teaches and restores and replicates ancient Japanese metalwork artefacts.

Jackie Harold is a silversmith who trained at the Birmingham School of Jewellery. She is making a replica of one of the Leekfrith Iron Age torcs.

Michael Lloyd is a silversmith who specialises in chasing. Michael trained at the Birmingham School of Jewellery and has used refined Scottish gold in his work.

Roland Williamson is a museum replica maker and re-enactor of thirty-five years' experience.

Acknowledgements

We would like to thank all the wonderful goldsmiths, silversmiths and jewellers above who so generously shared their ideas with us. We would also like to acknowledge and thank the following people whose input and ideas proved invaluable: Barbara Armbruster, Kurt Ronnkvist, Graham Taylor, Wharton Goldsmiths and a myriad of social media respondees who provided insights into their skilled craft and metalworking activities. We would also like to thank Rob Brooks and the Materials Group of the National Physical Laboratory and Kenny Watson of GE Inspection Technologies for all their help and advice. However, all interpretations and omissions remain the authors' own.

References

Armbruster, B. 2015. Approaches to metalwork: The role of technology in tradition, innovation, and cultural change. In T. Moore & X-L. Armada (eds), *Atlantic Europe in the First Millennium BC: Crossing the Divide*, 417–38. Oxford, Oxford University Press.

Atherton, R. 2016. The Newark Iron Age torc. *Transactions of the Thoroton Society of Nottinghamshire* 120, 43–53.

Brailsford, J.W. 1951. The Snettisham Treasure. *British Museum Quarterly* 16(3), 79–80.

Brailsford, J.W. 1971. The Sedgeford Torc. *British Museum Quarterly* 35(1), 16–19.

Brailsford, J.W. & Stapley, J.E. 1972. The Ipswich Torcs. *Proceedings of the Prehistoric Society* 38, 219–34.

Cartwright, C., Meeks, N., Hook, D., Mongiatti, A. & Joy, J. 2012. Organic cores from the Iron Age Snettisham torc hoards: Technological insights revealed by scanning electron microscopy. In C. Cartwright, N. Meeks, D. Hook & A. Mongiatti (eds), *Historical Technology, Materials and Conservation*, 21–29. London, Archetype.

Clarke, B. 2014. *Unlocking the Secrets of the Ribbon Torc.* Ribbon torc productions, Ireland. Video available at: https://vimeo.com/116055183 (Accessed 17 September 2019).

Clarke, R.R. 1954. The early Iron Age treasure from Snettisham, Norfolk. *Proceedings of the Prehistoric Society* 20, 27–86.

Diodorus Siculus. *Library of History, Volume III: Books 4.59-8.* Translated by C.H. Oldfather. 1939. Loeb Classical Library 340. Cambridge, MA, Harvard University Press.

Eluère, C. 1987. Celtic gold torcs. *Gold Bulletin* 20, 22–37.

Farley, J. 2017. Great torc image. Twitter, 13th June 2017. Available at: https://twitter.com/julia_farley/status/874669667532627969 (Accessed 17 October 2017).

Feachem, R.W. 1958. The 'Cairnmuir' hoard from Netherurd, Peeblesshire. *Proceedings of the Antiquaries of Scotland* 91, 112–16.

Fregni, E.G. 2014. The Compleat Metalsmith: Craft and technology in the British Bronze Age. Unpublished PhD thesis, University of Sheffield.

Fregni, E.G. 2019. Looking over the shoulder of the Bronze Age metalsmith: Recognising the crafter in archaeological artefacts. In C.T. Burke & S.M. Spencer-Wood (eds), *Crafting in the World: Materiality in the making*, 37–49. Cham, Springer.

Hautenauve, H. 2004. Technical and metallurgical aspects of Celtic gold torcs in the British Isles (3rd–1st c. BC). In A. Perea, I. Montero & Ó. García-Vuelta (eds), *Tecnología del oro antiguo: Europa y América* [*Ancient Gold Technology: Europe and America*], 119–26. Anejos de Aespa 32. Madrid, Consejo Superior de Investigaciones Científicas, Instituto de Historia, Departamento de Historia Antigua y Arqueología.

Hill, J.D. 2004. Portable Antiquities Scheme, record number: PAS-F070D5. Available at: https://finds. org.uk/database/artefacts/record/id/508203 (Accessed 09 May 2017).

Hill, J.D. 2005. Portable Antiquities Scheme, record number: DENO-4B33B7. Available at: https:// finds.org.uk/database/artefacts/record/id/751306 (Accessed 09 May 2017).

Hutcheson, N.C.G. 2007. An archaeological investigation of Later Iron Age Norfolk: Analysing hoarding patterns across the landscape. In C. Haselgrove & T. Moore (eds), *The Later Iron Age in Britain and Beyond*, 358–70. Oxford, Oxbow Books.

Jope, E.M. 2000. *Early Celtic Art in the British Isles*. 2 vols. Oxford, Clarendon Press.

Joy, J. 2015. Approaching Celtic art. In J. Farley & F. Hunter (eds), *Celts: Art and identity*, 37–51. London, British Museum Press.

Joy, J. 2017. Great torc image. *Twitter*, 25 July 2017. Available at: https://twitter.com/jodypatrickjoy/ status/889891248064090112 (Accessed 17 October 2017).

La Niece, S., Farley, J., Meeks, N. & Joy, J. 2018. Gold in Iron Age Britain. In R. Schwab, P-Y. Milcent, B. Armbruster & E. Pernicka (eds), *Early Iron Age Gold in Celtic Europe: Society, technology and archaeometry. Proceedings of the International Congress (Toulouse, France, 11-14 March 2015)*, 407–30. Rahden, Marie Leidorf GmbH.

Machling, T. & Williamson, R. 2016. The Netherurd torc terminal – insights into torc technology. *PAST: The Newsletter of the Prehistoric Society* 84(Autumn 2016), 3–5.

Machling, T. & Williamson, R. 2018. 'Up Close and Personal': The later Iron Age Torcs from Newark, Nottinghamshire and Netherurd, Peeblesshire. *Proceedings of the Prehistoric Society* 84, 387–403.

Machling, T. & Williamson R. forthcoming. The technology of later Iron Age torus torcs. *Historical Metallurgy*.

MacGregor, M. 1976. *Early Celtic Art in Northern Britain*. Leicester, Leicester University Press.

Meeks, N., Mongiatti, A. & Joy, J. 2014. Precious metal torcs from the Iron Age Snettisham treasure: Metallurgy and analysis. In E. Pernicka & R. Schwab (eds), *Under the Volcano: Proceedings of the International Symposium on the Metallurgy of the European Iron Age* (SMEIA), 135–56. Rahden, Marie Leidorf GmbH.

Mirshahi, A., Ponto, K.A., Hoehn R., Zwiener, I., Zeller, T., Lackner, K., Beutel, M. & Pfeiffer, N. 2010. Myopia and level of education results from the Gutenberg Health Study. *Ophthalmology* 121(10), 2047–52.

National Museum of Scotland. 2018. *AHRC Research Network on gold in Britain's auriferous regions, 2450-800 BC*. Available at: https://www.nms.ac.uk/collections-research/our-research/featured-projects/prehistoric-gold/ (Accessed 30 August 2018).

Northover, P. 1995. The technology of metalwork: Bronze and gold. In M.J. Green (eds), *The Celtic World*, 285–309. London, Routledge.

Sheridan, A. 2018. The Knowes of Trotty Discs. Available at: https://www.nms.ac.uk/collections-research/our-research/featured-projects/prehistoric-gold/gold-object-of-the-week/gold-object-of-the-week-3/ (Accessed 20 September 2018).

Snell, K.D.M. 1996. The apprenticeship system in British history: The fragmentation of a cultural institution. *History of Education* 25(4), 303–21.

Stead, I.M. 1985. *Celtic Art*. London, British Museum Press.

Stead, I.M. 1991. The Snettisham treasure: Excavations in 1990. *Antiquity* 65, 447–64.

Chapter 12

Refugees, networks, politics and east–west connections in Early Celtic art: Paul Jacobsthal's 'History of a Monster' in context

Sally Crawford and Katharina Ulmschneider

Abstract

In 1938, German Jewish refugee scholar Paul Jacobsthal, recently appointed Reader in Celtic Archaeology at the University of Oxford, gave a paper to the Oxford Philological Society (OPS). In it, he discussed one motif in Early Celtic art - the double-bodied, single headed monster - with only the slightest of references to European Iron Age material culture. In this chapter, we place this curious episode in its historical context, showing how Jacobsthal may have been tailoring his paper to leverage the support and patronage of the OPS at a time when his refugee status meant he was at risk of being sent back to Nazi Germany. Jacobsthal also used the OPS meeting as an opportunity to test a new hypothesis on extensive east–west transmission of art styles in Celtic art which he was never able to fully explore in his own lifetime.

On the evening of Friday, 3 June 1938, a meeting of the Oxford Philological Society (OPS) was held at the Ashmolean Museum, Oxford. The attendance list reads like a 'who's-who' of the Oxford great and good from the world of classics and philology: 'The President [classical scholar A.S. Owen], Professors Beazley, Dodds, Fraenkel and Murray', as well as 'Dr Lowe, Mrs Fraenkel, Miss Dale, Miss Hartley, Miss Taylor, Messrs Beaumont, Dunbabin, Geary, D.G. Hardie, Higham, Hignett, MacGregor, Mynors, Page and Syme, and four guests' (*OPS Minute Book*; Crawford & Ulmschneider 2017, 141). Following on from the usual private business of proposing and electing new members and reading and signing minutes, the meeting turned to its main attraction, 'a paper entitled 'History of a Monster', to be read by Dr Paul Jacobsthal'. The paper explored the history of a particular type of motive recurring throughout antiquity, a 'twin-beast' (Fig. 12.1), with mainly 'two bodies but only one head' and occasionally 'three or four bodies' (Chapter 13, this volume). Jacobsthal traced its history, which he was to argue 'covers 3000 years', and its 'distribution-pattern', which 'would cover the lands from Western Europe to China' (Chapter 13, this volume).

Fig. 12.1. Weisskirchen bronze fragment (Jacobsthal 1944, pl. 160, no. 317). Reproduced courtesy of the Institute of Archaeology, Oxford.

In this chapter, we will investigate the personal and political background which determined Jacobsthal's choice of material for 'History of a Monster' and trace its intellectual after-life in Jacobsthal's later work. The manuscript of Jacobsthal's 'Monster' paper, which was never published, was re-discovered in the Archive at the Institute of Archaeology as part of Sally Crawford, Katharina Ulmsch-neider and Chris Gosden's *Jacobsthal Project* (http://projects.arch.ox.ac.uk/jacobsthal-project.html). It survives in a number of drafts, cut and pasted together (Fig. 12.2), with handwritten numbers indicating where Jacobsthal intended to show his images (*Jacob-sthal Archive*, Box 14). The final and most complete of these versions is presented in this volume (Chapter 13). The title of Jacobsthal's talk 'The History of a Monster' draws directly on that used by two French scholars, as acknowledged by Jacobsthal in his introduction: 'L'histoire d'une bête' published in 1910 by Edmond Pottier (1910, 429–36), and the 1935 article of the same name by Anne Roes (1935, 313–28).[1]

To the modern reader interested in the history of Early Celtic art as a research topic, Jacobsthal's lecture presents both a challenge and a puzzle. It was a surprising offering for a man who by now was the University's first Reader in Celtic Archaeology, because in this paper to the OPS, Jacobsthal mentions only one piece of Celtic art, the tiny Weisskirchen bronze fragment of an 'owl-like lion'. All the other (non-Celtic) examples of double beasts mentioned in the OPS paper were also included in Jacobsthal's 1944 *Early Celtic Art* in a section on 'Double Beasts', but there the double-bodied beasts are presented firmly in the context of Celtic art, where many more Celtic examples are also cited (Jacobsthal 1944, 46–59). According to his footnote in *Early Celtic Art*, Jacobsthal had already written this section before 1930, and therefore at least eight years before presenting this paper. As far as we know, the OPS lecture was Jacobsthal's first attempt to present a pioneering theory of Celtic art to an English audience. In the lecture, he argues for a transcontinental east–west transmission and deliberate acquisition of art styles across long tracts of time and space. Yet his paper, which sets out some of the fundamental principles on which his monumental work *Early Celtic Art* was founded, barely mentions Early Celtic art. Why?

The answer to this question may lie in the historical background to Jacobsthal's paper. For most academics, presenting a paper is an opportunity to test out new

Fig. 12.2. Jacobsthal's talk, letters, images and folder on 'Doppeltiere' from his archive. Jacobsthal Archive, Box 14, Institute of Archaeology, Oxford.

research and to attract feedback. For Jacobsthal, the stakes may have been much higher. The opportunity of presenting to the prestigious OPS could not have come at a more crucially important time: Jacobsthal was a refugee from Nazi Germany. Having been dismissed from his chair '*aus rassischen Gründen*' in 1935, he had been offered refuge at Christ Church, Oxford from 1936. Although he had been made Reader in Celtic Archaeology in 1937, he was still without any long-term prospects or security. 1938 would mark a pivotal moment in deciding his future.

Jacobsthal had reason to be worried. There had been a rapid escalation of tension in world events in the months leading up to the date of this paper. In February of 1938, Adolf Hitler had abolished the war ministry to take direct control of the German military, sacking swathes of leaders he considered to be inimical to his policies. In March, Austria was annexed by Germany, and in April, a General Election and

referendum resulted in an alleged vote of 98.9% for a Nazi leadership and the annexation of Austria. Throughout May, Hitler agitated for the invasion of Czechoslovakia, a move that everyone believed would lead to a general European War.

Throughout this time, Jacobsthal's archive shows that he was preparing furiously for what was to come, engaging in a desperate bout of correspondence, writing letter after letter to his former colleagues in Germany. There can be little doubt that he had a good grasp of what was taking place in Germany, and being of Jewish origin, he was aware that his safety, and that of his wife 'Guste' (*i.e.* Emma Auguste Dorothee Bräuning; Ulmschneider & Crawford 2011, 235), depended on being able to stay in Oxford. Although he had secured a Readership and a place at Christ Church, Jacobsthal's position in England was highly vulnerable. At the time he delivered his paper, his stay in the country depended on a one-year visa. Ever since his arrival, Jacobsthal and his wife had had to renew their visas annually, hoping each time that they would be able to work their way through the hoops of British bureaucracy. Charles Seligman, writing to Jacobsthal to ask him for advice on a 'matter of Celtic and Chinese art' on 12 March 1937 acknowledged that this was 'a busy and troublous time' for Jacobsthal (*Jacobsthal Archive*, Box 28, Letter 55).

Jacobsthal knew that the people attending the Philological Society that evening included Oxford classicists with very useful connections in the Home Office, Foreign Office, the Government and British Intelligence, as well as being important academics within the University hierarchy (Ulmschneider & Crawford 2017, 166–67). Sir John Beazley had already helped Jacobsthal to secure his place at Christ Church (Grenville 2004). These were people whose good will towards Jacobsthal could potentially help to oil the wheels which would provide him with permanent residence and save him from what was, at that time, a real risk of having to go back to Germany. Jacobsthal's task, in this paper, was to secure his position in Oxford's classical network and to show that he could offer something Oxford needed: a classicist with a broad expertise in European and Eastern art and a wide-ranging knowledge of the antique world extending from the Weisskirchen Celts to the Chinese tombstone of Tai and his wife.

In this context, Jacobsthal's decision to minimise the Celtic aspect of his work may also have reflected a sensitivity to the attitude of English classicists towards post-classical archaeology. When Jacobsthal had first aired the idea of investigating the relationship between Celtic art and Ancient Greek colonies in 1930, Beazley had thrown cold water on the concept, arguing that 'I can understand that La Tène is a fruitful field [for Jacobsthal's 'next big project'], but I shall naturally vote for the other [Polygnotus, a 5th century BC painter]' (*Beazley Archive*, Letter of 3 March 1930, uncatalogued).

Nonetheless, although he downplayed Celtic art in this lecture, the paper marks a key moment in the discipline, because here we see Jacobsthal testing, on this critical audience, an important early attempt to study and understand the long-distance connections and influences on art, and especially Eurasian 'animal art', across periods and continents. The scope and breadth of the talk shows a man comfortable with a

wide range of objects across cultures and periods, drawing on his extensive knowledge of European and Asian archaeology, classical art and literature, and scholarly contacts. This should come as no surprise. Jacobsthal started life as a classical scholar, studying at Berlin – where he attended lectures by the great Ulrich von Wilamowitz-Moellendorff-Göttingen, and Bonn, followed by extensive travel in Italy, Greece and Asia Minor, before being made professor and director of the archaeological seminar at the University of Marburg, Germany in 1912. From early on in his career, however, he also showed a keen interest in exploring other periods and related fields, an idea eventually monumentalised in the building of the Ernst-von-Hülsen-Haus at Marburg, which combined archaeological, ancient and art historical branches under one roof, and in masterminding the foundation of the first chair for prehistoric archaeology in Germany in 1927. The latter coincided with his own rising interest in Celtic objects and art (Ulmschneider & Crawford 2011).

While Jacobsthal's wider art historical, Celtic and Eurasian interests had not yet found written expression in his articles and books, by the time of the 'Monster' lecture they were certainly reflected in the objects surrounding him. Apart from building up an archaeological teaching collection for the seminar, Jacobsthal had long been a private collector of animal art in all forms for himself and his wife. Perhaps his most iconic private purchase in the context of this volume on Eurasian contacts was that of a large Chinese pottery camel of the Tang period in 1924, now housed at the Ashmolean Museum Oxford, but formerly stabled in his rooms at the Archaeological Institute in Marburg, where it greeted his visitors and students (Ulmschneider & Crawford 2016). It represents a Bactrian camel, commonly used for carrying goods (and art) along the Silk Roads. Jacobsthal could hardly have chosen a better symbol for the type of connections linking the West with Asia. This was not his only purchase of artefacts illustrating animal art across northern Eurasia. Also belonging to him were a number of Scythian Ordos bronzes (Fig. 12.3) in the shape of stags, a horse, and an ox, still held in a private collection.

In a letter from 1930 to John Beazley, Jacobsthal confesses his 'great love of animals, also alive ones, and I visit all zoological gardens', though he is 'not fond of birds. I prefer predators' (*Beazley Archive*, Letter of 12 June 1930, uncatalogued). This long-standing interest in animal art was shared by Guste. Lodged among a series of volumes of photographic prints of artefacts, which had been collected by Jacobsthal up to 1935, entitled *Archäologisches Seminar Marburg Photographien*, are a number of small bronze animal sculptures including a frog and a deer. They represent part of what would have been the Marburg collection of 'Frau Prof. Jacobsthal', and had been obtained via what was at the time the flourishing art trade in Paris (*Beazley Archive*).[2] They were all part of what his later collaborator, Martyn Jope, would remind members of the Seventh International Congress of Celtic Studies long after Jacobsthal's death as his 'whole gallery of real and imaginary animals' (Jope 1986; further explored by Megaw & Megaw 1998).

Fig. 12.3. Jacobsthal's collection of Ordos bronzes as shown at the Jacobsthal exhibition, Oxford Town Hall, 2012. Private collection.

The reworking of the 'Monster' lecture, as it later appears in *Early Celtic Art*, shows that while Jacobsthal may have been downplaying the Celts in the version he presented to the OPS, all the evidence he put forward was part of proving the larger thesis on which his whole approach was founded. In *Early Celtic Art*, Jacobsthal structures this argument by *starting* with the double-bodied Weisskirchen monster, taking the reader through other examples of double-bodied monsters in the past, and ending with the example of the correspondence between the Chiusi Cippus and the Isfahan base, and the Sentimello Cippus and the San Paola candelabrum. In the OPS paper, Jacobsthal pauses at this point to say 'Still one puzzling problem asks for discussion. What is the affiliation of the Chiusi Cippi and Persia?'. In *Early Celtic Art*, Jacobsthal answers the question: 'I presume that the base copies an old-Persian model, either directly or with a Sassanian intermediate' (Jacobsthal 1944, 52). Jacobsthal is beginning to present a theory of transmission of art styles that will explain a phenomenon such as the appearance of almost identical La Tène sword styles in Hungary and Ireland with no apparent evidence for communication between the two places over time or space (Ulmschneider & Crawford 2014).

In *Early Celtic Art*, from the spring-board of the double-headed animal style, Jacobsthal then investigates a second strand of proof (the second body on the double-headed beast of his theory), the occurrence of animal and floral ornament in the Celtic world, the Greek world, the Scythian world and the East, until at last he reaches his ground-breaking conclusion: 'The Celtic Animal Style has a physiognomy of its own, and even a layman, looking at the beasts of the Lorraine flagons, of the Weisskirchen girdle-hook, and at others of their kind cannot fail to realize their Eastern character' (Jacobsthal 1944, 59).

Jacobsthal made the same point in a paper delivered to the British Academy in 1941 (Jacobsthal 1941). Observing similarities between the girdle-hook from Langenlonsheim and a Chinese bronze sword-hilt from the Louvre, he insists that 'The likeness is not accidental and is by no means an isolated fact: it is due to connexions which actually existed between the two distant arts and civilizations. Not that China worked directly on the Celts: both arts were influenced from centres in the Near East, which are not yet localized with certainty' (Jacobsthal 1941, 309–10). Turning to the monsters in his paper, he argues, again, that the double-headed monster of the Celts was connected with the same imagery in China and India. More importantly, though, he argues that the appearance of Eastern imagery in Celtic art is not passive or accidental, but dynamic and active: 'This Celtic world of weirdness and horror, shaped with great vigour, is not due to 'stylistic influences', but to willing and active reception of the East: the Celts in their early life become the westernmost outpost of that vast Eurasian girdle – stretching east as far as China … where mask and beast were everything, where the tale of mythology was told in zoomorphic disguise' (Jacobsthal 1941, 320).

During the war, Jacobsthal continued to investigate links between the Celtic world and the East, an investigation which included collaboration with Ellis Minns, author of *Scythians and Greeks* (1913). Minns, impressed by Jacobsthal's work, drew up a preparatory 'Sketch Map of the Eurasian Steppes and the Surrounding Territories' for him, incorporating geography, terrain and both Ancient and Chinese place-names (Fig. 12.4). The map bears a beautifully drawn Latin dedication to '*Paulo Jacobsthal: Graecorum Discipulo Celtarum Indagatori*' ('Paul Jacobsthal, a disciple of the Greeks and an investigator of the Celts') by Ellis H. Minns '*Archiscytha*' (a made-up Greek name translating as 'Ruler of the Scyths'). Originally stretching from the Mediterranean to Mongolia, the map, only parts of which are reproduced here, appears to have been number one in a series of further maps, which subsequently seem to have been lost, and itself now only survives as a poor photocopy in the Jope Archive at the Institute of Archaeology, Oxford (*Jope/Jacobsthal Archive*, Box 9). The dedication helpfully also provides a date 'ID.OCT.A.MCMXLII' (Idibus Octobribus Anno), the *ides* of October in the year 1942 (15 October 1942).

The idea of the importance of east–west connections continued to drive Jacobsthal with new vigour after the war. He worked extensively with Frank Savery on Luristan, Scythian and Ordos bronzes, obtaining a series of grants from the Griffith Institute, Oxford, for a proposed '*Corpus Luristanum*' in and before 1947 (*Griffith Institute Jacobsthal*

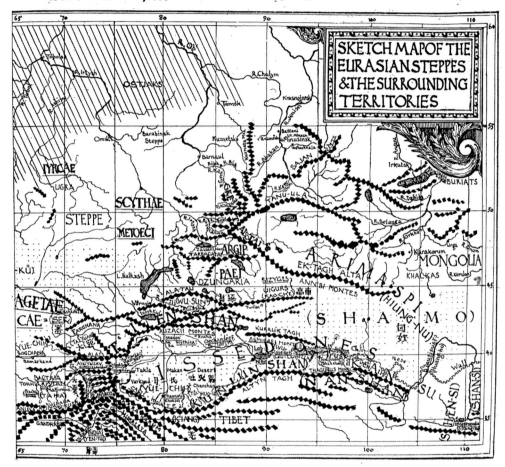

PAVLO IACOBSTHAL
GRAECORVM DISCIPVLO CELTARVM INDAGATORI
ELLIS H.MINNS
ID.OCT.A.MCMXLII ARCHISCYTHA

Fig. 12.4. *Extract of a map drawn by Ellis H. Minns and dedicated to Paul Jacobsthal, 1942.* Jope/ Jacobsthal Archive. *Reproduced courtesy of the Institute of Archaeology, Oxford.*

Archive, Special Meeting 13 May 1947). He also pursued the origins of Celtic horse trappings and textiles, and other art forms with Oriental scholars which, he hoped, would provide the links in the chain of communication from East to West (*e.g.* correspondence in the *Jacobsthal Archive* with Basil Gray, Stanley G. Robinson, Professor Ishida, Charles Seligman, R.D. Barnett, and Oswald Sirèn). In a further unpublished paper, the *European Face of Archaic Greece*, read in August 1948, he firms up his views of China as 'an outpost of European Hallstatt civilization' (*Jope/Jacobsthal Archive*, Box 9, MS page 7).

Jacobsthal unfortunately did not live long enough to publish his research on Celtic art in its eastern context. By 1951, he was having to face the hard fact that he had little chance of finishing all that he had begun (*Beazley Archive*, Letter to Frank Savery, 11 June 1952, uncatalogued), and in an undated letter to Gero von Merhart, he acknowledged that the time needed to research chamfreins from China to the Celtic world was 'not proportional to my "Expectation of Life"' (*Jacobsthal Archive*, Box 49, Letter 397). It has taken over 70 years for scholars at Oxford to take up the challenge laid down by Jacobsthal in his visionary 'Monsters' paper, and to investigate what seemed evident to him, the wider context of Celtic art as the 'western-most expression of dynamic, shape-shifting traditions of art' which spreads east to the borders of China (Jacobsthal 1944; ECAIC 2016). Although the notion of indirect diffusion of art styles does not find much currency in contemporary Celtic art studies, scholars are still attempting to understand the shared characteristics of Animal Style and La Tène art (especially with Early Celtic art, see Pare 2012, 153–54) and wider eastern connections in the Iron Age (Gosden *et al.* 2016; 2018; Wells, Chapter 3, this volume).

Did Jacobsthal's lecture have the intended effect on his security? The short answer is 'yes'. In mid-July, Jacobsthal had a meeting with George Stuart Gordon, incumbent Vice-Chancellor of the University, who also happened to have studied classics as an undergraduate. Gordon proceeded to write to the Home Office citing Jacobsthal's 'recognized authority' in the field of Celtic Archaeology and the way Jacobsthal was 'greatly respected here both on personal and scholarly grounds' (*Christ Church Archive*, Jacobsthal file; Ulmschneider & Crawford 2017, 176–77). On 2 January 1939, the time-limit on the Jacobsthals' visas was duly lifted.

Jacobsthal's key legacy for Celtic art lay in his magisterial publication, *Early Celtic Art* (1944). The date is telling: at a time when the nation was suffering paper shortages and there were serious questions about the survival of civilisation and democracy, Oxford University Press was intent on publishing benchmark books that would survive the test of time: *Early Celtic Art*, a hefty two-volume production, was one of these books. When it came out, Jacobsthal had already begun researching and writing what was intended to be a book to do full justice to the Celtic world of his host country in the form of a follow-up volume entitled: *Early Celtic Art in the British Isles* (ECABI). The war prevented him from carrying out his research: museums had put their objects in store and the keepers had more urgent needs than to answer his enquiries, while the restrictions he was under as an enemy alien meant he could not travel. After the war, ill-health began to dog Jacobsthal. His manuscript for *ECABI* had made substantial progress when he hired a young archaeologist and scientist, Martyn Jope, as his research assistant. Within two years, Jacobsthal was dead. Just one day after his death on 27 October 1957, Professor Christopher Hawkes, founder of the Institute of Archaeology at Oxford, wrote to the Dean of Christ Church to 'condole' and ask for Jacobsthal's archive, 'to do everything possible now to secure the future of the tradition he has founded' and thank the House for guaranteeing that the 'prime opportunity for holding the central position in these studies now shall lie with Oxford'

(*Christ Church Archive*, Jacobsthal file, letter of 28 October 1957, uncatalogued). Jope was commissioned by Oxford University Press to tidy up and submit Jacobsthal's manuscript, which he promised would reach the press in 1960 (Colin Roberts in a letter to Martyn Jope: *Jope/Jacobsthal* Archive, Box 2, Letter 4). Unfortunately, *ECABI* did not reach publication until 2000, following Martyn Jope's own death, and under Jope's name only (Jope 2000).

The last piece of Jacobsthal's vision for a catalogue of Early Celtic art is being fulfilled in the form of Vincent Megaw's eagerly awaited OUP volume *Early Celtic Art in Europe Supplement*, which will be published just short of a century after Jacobsthal, 'one day in the cold and hungry winter of 1921', first saw 'the painted Attic cup from the Klein Aspergle chieftain grave' and began to think about Early Celtic art in Europe (Jacobsthal 1944, vi).

Acknowledgements

The authors are grateful to Peter Stewart and Giles Richardson at the Beazley Archive, to the Griffith Institute, Oxford for access to their archives, to Adrian Kelly and Balliol College for access to the OPS Minute Book, and to Judith Curthoys and Christ Church for access to their Jacobsthal files. We thank the editors for their kind invitation to publish this commentary on Jacobsthal's talk and set it in its wider context. We are very grateful for the help of Peta Fowler, Worcester College, Oxford, with the Latin translations in this text. We thank the anonymous reviewer for thoughtful feedback and suggestions.

Notes

1 'History of a Monster' was performed with some of its original images at a seminar by Helen Chittock and Peter Hommel in 2018.
2 Images no. 2430 'Marburg, Besitz Frau Prof. Jacobsthal, Bronze-Frosch', and nos 2431-3 'Reh aus Bronze. Aus Pariser Kunsthandel'.

References

Beazley Archive. Unpublished. Archive of Professor John Beazley containing correspondence with Paul Jacobsthal, Iannou Centre, Oxford.
Christ Church Archive. Unpublished. File on Professor Paul Jacobsthal held at Christ Church, Oxford.
Crawford, S. & Ulmschneider, K. 2017. 'The Bund' and the Oxford Philosophical Society, 1939–45. In S. Crawford, K. Ulmschneider & J. Elsner (eds), *Ark of Civilization: Refugee Scholars and Oxford University, 1930-1945*, 133–50. Oxford, Oxford University Press.
ECAIC. 2016. *European Celtic Art in Context.* Available at: https://ecaic.wordpress.com & http://ecaic.arch.ox.ac.uk (Accessed 28 October 2018).
Gosden, C., Hommel, P. & Nimura, C. 2016. European Celtic art and its eastern connections. *Antiquity Project Gallery* 90(349), https://www.antiquity.ac.uk/projgall/gosden349.
Gosden, C., Hommel, P. & Nimura, C. 2018. Making mounds: Monuments in Eurasian prehistory. In T. Romankiewicz, M. Fernández Götz, G. Lock & O. Büchsenschütz (eds), *Enclosing Space, Opening New Ground: Iron Age studies from Scotland to Mainland Europe*, 141-52. Edinburgh, Edinburgh University Press.

Grenville, A. 2004. Sebastian Flyte, meet Albert Einstein? *Christ Church Matters* 13(Trinity Term), 3.

Griffith Institute. Unpublished. Archive of Professor Paul Jacobsthal at the Griffith Institute, Oxford.

Jacobsthal Archive. Unpublished. Archive of Professor Paul Jacobsthal at the Institute of Archaeology, Oxford.

Jacobsthal, P. 1941. Imagery in Early Celtic Art. The Sir John Rhys Memorial Lecture, British Academy 1941. *Proceedings of the British Academy* 27, 301–20.

Jacobsthal, P. 1944. *Early Celtic Art.* 2 vols. Oxford, Clarendon Press.

Jope/Jacobsthal Archive. Unpublished. Archive of Prof. Martyn Jope at the Institute of Archaeology, Oxford.

Jope, M. 1986. Paul Ferdinand Jacobsthal. In D.E. Evans, J.G. Griffith & E.M. Jope (eds), *Proceedings of the Seventh International Congress of Celtic Studies held at Oxford from 10th to 15th July, 1983*, 15–18. Oxford, Oxbow Books.

Jope, E.M. 2000. *Early Celtic Art in the British Isles.* 2 vols. Oxford, Clarendon Press.

Megaw, J.V.S. & Megaw, M.R. 1998. Cartoons, crocodiles and Celtic art: Images from a Scholar's Notebooks. *Oxford Journal of Archaeology* 17(1), 121–26.

Minns, E.H. 1913. *Scythians and Greeks: A survey of ancient history and archaeology on the north coast of the Euxine from the Danube to the Caucasus.* Cambridge, Cambridge University Press.

OPS Minute Book. Unpublished. Oxford Philological Society Minutes 1927 Book, Balliol College, Oxford.

Pare, C. 2012. Eastern relations of early Celtic art. In C. Pare (ed.), *Kunst und Kommunikation. Zentralisierungsprozesse in Gesellschaften des europäischen Barbarikums im 1. Jahrtausend v. Chr.*, 153–78. RGZM-Tagungen 15. Mainz, Verlag des Römisch-Germanischen Zentralmuseums.

Pottier, E. 1910. L' histoire d'une bête. *Revue de l'art ancienne et modern* 28, 429–36.

Roes, A. 1935. L' histoire d'une bête. *Bulletin de Correspondance Hellénique* 59, 313–28.

Ulmschneider, K. & Crawford, S. 2011. Post-war identity and scholarship: The correspondence of Paul Jacobsthal and Gero von Merhart at the Institute of Archaeology, Oxford. *European Journal of Archaeology* 14, 231–50.

Ulmschneider, K. & Crawford, S. 2014. Introduction: 'Leopold Bloom I' and the Hungarian Sword Style. In C. Gosden, S. Crawford & K. Ulmschneider (eds), *Celtic Art in Europe: Making Connections*, 213–18. Oxford, Oxbow Books.

Ulmschneider, K. & Crawford, S. 2016. The camel that escaped the Nazis: Paul Jacobsthal and a Tang camel at the Ashmolean, Oxford. *Oxoniensia* 81, 87–98.

Ulmschneider, K. & Crawford, S. 2017. The Cheshire Cat: Paul Jacobsthal's journey from Marburg to Oxford. In S. Crawford, K. Ulmschneider & J. Elsner (eds), *Ark of Civilization: Refugee Scholars and Oxford University, 1930-1945*, 161–79. Oxford, Oxford University Press.

Chapter 13

The history of a monster

Paul Jacobsthal

This paper was delivered by Paul Jacobsthal in Oxford on Friday, 3 June 1938.

[1][1] I should like to introduce to you tonight a monster which, up to now, has not met with the interest it deserves and has been ill-treated recently by two French scholars. All of you will have seen some specimens in Romanesque churches, either in this country or abroad. It has two bodies, but only one head (Fig. 13.1). It is a twin beast. There is a variant with one head, but three or four bodies. The animal is very long-lived, its history covers 3,000 years or more, and a distribution pattern would cover the lands from Western Europe to China. Its *akme* lies in the early Middle Age. We are only concerned with its early history.

It would be the ideal form of such a paper to examine first the different species under merely morphological aspect, then to trace their distribution and migrations, and finally to discuss their meaning and 'soul' – if there is any. But the shortness of the given time of 45 minutes excludes this method and compels me to combine morphology and interpretation.

[2] Of these three Cretan gems the left is a fairly exact reproduction of the Mycenean Lion Gate group. The central piece shows the group contracted, two bodies, one head, and the gem on the right gives a picture of a twin-griffin, a variant of a type where two separate griffins appear. The antithetic group is one of the great conceptions of oriental art. In rational European mathematics one plus one are [sic] two, not so in

Fig. 13.1. An example of Jacobsthal's monster from the church of Fontaines d'Ozillac, France (Photo: Courtesy of M. Boisset[2]).

the Orient. Repetition, and especially repetition in the form of antithesis, is here a means of intensification. This has often been neglected and has led to grave errors in interpretation of monuments.

[3] Take this famous seal-cylinder of the early 4th millennium BC. A naive onlooker might see here the representation of a mythical story with two men and two bulls as *dramatis personae*. The truth is: there is one man and one bull; and the correct reading of the cylinder is: 'Isdubar watered the bull – the bull watered Isdubar' – a reduplication which has its parallels in archaic epic language.

After the end of the Cretan period is a gap, we cannot expect to find higher fauna on Geometric pots. It is not before the 7th century in an advanced phase of orientalising style, that our monsters reappear.

[4] On this urn from Arkades in Crete, a work of the first half of the 7th [century], we see a double lion, this time not upright, but recumbent – a relatively rare position.

[5] An ivory plaque from the Argive Heraeum of Protocorinthian style is decorated with [a] seated double sphinx, but her head is that of a Gorgo. She belongs to an interesting species of ephemera. One has to bear in mind that for instance the man-bull (river-god, Minotaurus), the horse-man (Kentauroi, Chiron), the lion-woman (Sphinx), the bird-woman (Siren) etc. represent a relatively narrow selection out of a far larger oriental stock and of virtual possibilities of compound creatures. Corinthian vase painting shows us a good many other combinations, one of them being the Hippalektor still dear to Aeschylus ([The] *Frogs* 937). Only those survived who had managed to secure for themselves a place in a myth, to obtain a mythological personality. The others were doomed to remain in the misty sphere of haunt. One could say that the Argive Gorgo-sphinx is an attempt to contract into one being what a 6th century Laconian vase-picture tells in a group of a central Gorgoneion and two flanking sphinxes.

[6] A normal double sphinx, the ancestor of many of her kind, is to be seen on the famous Protocorinthian jug, we call the Chigi vase, painted about 640 BC.

Most of the Greek archaic twin-animals are double sphinxes, we find them on coins, gems, weapons. Their religious or symbolical meaning and use does not differ from those of their one-bodied counterpart. [7] Other twin monsters than sphinxes are, as already stressed, extremely rare; only Corinthian art is full of them: one of these creatures is the eagle-lion, the pendant to the lion-eagle, to the canonised griffin, the successful creature having the body of a lion and an eagle's beak, the Corinthian ephemeron having been given a bird's body and a lion's head.

It is a fairly wide-spread theory that the archaic monsters, for instance the double lion from Arkades in Crete, has an uninterrupted ancestry of 12–15 generations, leading back to Mycenean times. But in fact, there was no unbroken continuity between the two ages, the break between the Creto-Mycenean civilisation and the rise of Greek civilisation in the 8/7th century was complete. If there is a congruence in forms and motives, as it is the case here, the explanation is that they have come from the Orient twice. Our twin-animals came to the West first at the end of the 2nd millennium, and then again reached Greece in the orientalising period, the 7th century.

The assumption that in the West [there] was no continuity of our animals, but that they died out again and again and had to be imported afresh – like some noble exotic plants or animals which are unable to acclimatise in Europe – is based on general experience, but can be proved by the existence of genuine Oriental material. If this is scanty and scantier than one wished it to be, this is not so much due to the lack of Eastern monuments as to the fact that the main source of Western orientalising art, textiles, haven't come down [to] us. So we have incomparably more Western *apographa* than eastern *archetypi*.

[8] Let us examine these few. The first is a bitumen cup from Susa, dated by Contenau [to] about 3000 BC (3rd Dynasty of Ur[3] – if not other similar recent finds suggest a later date, the time of Hamurabi, 2000 BC). One sees the double ibex, head and neck modelled in the round, the two bodies recumbent in lower relief on the surface of the cup. [9] The second is a seal cylinder of about the same period. There is a bull-man, a forerunner of Minotaurus and Greek river-gods, two hindquarters of a bull, upwards growing together into a human breast with human arms, and then again a bull's head in frontal view. [10] The third is much later, an Achaemenidan gem, now lost and here shown in the poor drawing Lajard had published in his *Culte de Mithra* [Lajard 1867]. Other Persian gems of the same class show the picture of two sphinxes separate.

That is all we have of genuine early Eastern monuments. But we have Western *apographa* enough to make good for the lost *archetypi*.

[11] A Chalcidian amphora of the 3rd quarter of the 6th [century] is adorned with this pleasant group of four deers [sic]; you can amuse yourselves by connecting either this or that body with the one head. Six hundred years older is a Cretan gem with three lying bulls whirling round the one central head. [12] And 700–800 years after the Chalcidian deers the same puzzle has amused the minds of the Romans: on a mosaic from Carthage is a compound group of horses. Again it is clear *a priori* that there was no Western continuous tradition, but that those motives are migrating westwards at different times; and this is well confirmed by their occurrence on later Oriental textiles.

It will be convenient to survey the distribution pattern of the monster in the West before discussing the question of their origins in full.

[13] Archaic Italy is full of them. Suffice it to show you [this] double sphinx on this antefix which will be a work of the 6th century. [14] And a double lion decorating the neck of an Etruscan amphora of the 3rd quarter of the 6th [century], belonging to the class of vases we conventionally call Pontic.

In Greece after the archaic period there is a gap. The attitude of classic art towards monsters of any kind, towards *kompasmata*, is well defined by Euripides in [Aristophanes'] *The Frogs*.[4]

οὐχ ἱππαλεκρυόνας μά Δὶ οὐδέ τραγελάφους, ἄπερ σύ, ἂν τοῖσι παραπετάσμασιν τοῖ Μηδικοῖ γράφουσιν [l. 936–38]

But after less than a generation, the style of the Medika [sic] *parapetasmata* of Oriental textiles came into fashion again, and the monsters together with other Persian motives invade Greece. I choose a few examples of the great wealth of 4th [century] material.

[15] Sepulchral art in Southern Italy is fond of the motive, there are the column heads of Tarentine heroa, and there is a less pleasant Italiote clay arula. [16] On an Attic krater of Kerch style, painted 370–360 [BC] an Arimasp wears a sleeve garment of Oriental kind with an in-woven double sphinx. It is one of those garments to which Hipparchos in the comedy Anasozomenoi (*Athen.* XI 477 f) alludes:

δαπίδιον εν αγαπητόν ποικίλον, Πέρσας έχων και γρύπας εξώλεις τινάς

And we know from *CIA* II, 2, no. 754–759 [CIA 1873] passim that in the treasury of Artemis Brauronia during the same years were Persian garments, *kandyes* which the Athenian vase painters had before their eyes and may have studied. But the most striking and convincing evidence for a Persian origin of the Attic 4th [century] double monsters is the picture of an attic *pelike* of Kerch style, painted in the twenties of the 4th [century]. Two Arimasps on [a] griffin's back fighting a horned double-lion. Now the horned-lion is a Persian species and the spiral stylisation of the muscles is a very Oriental feature. This beast is an exact copy of a Persian tapestry (like Schefold [1934], pl. 5).

[17] Now I should like to discuss briefly a Celtic *apographon* of a Persian prototype, for two reasons: it is of special historical interest and is dear to me, because it gave me the impulse to write the history of this monster. It is a tiny bronze fragment, about one inch long, the back flat, apparently once fixed to a wooden surface; it is broken on both ends, but you will recognise that it is the representation of a lion with one owl-like head and two recumbent bodies like the animal on the 7th [century] vase from Arkades. It was found in a 4th [century BC] chieftain grave at Weisskirchen in Rhineland, about 80 years ago and has never been properly published nor found the interest it deserves. It is one of the monuments which prove a strong influence of Persian Achaemenidan art on the Celts. You will have observed that the Weisskirchen animal has the same spiral muscles as the attic horned double lion; it also reflects such a Persian monster.

[18] Hellenistic material is relatively scanty.[5] The next wave reaches the West in the 1st century AD. Roman decorative art of sacred objects from Augustean to Flavian times offers many examples. Sepulchral altars often use double creatures, mostly and almost regularly sphinxes, as corner decoration. [19] They are also living on terracotta revetments of small sacred buildings of Augustan age. [20] Together with other emblems of religious significance the double sphinx occurs on a crescent shaped silver plaque belonging to the *dona militaria* of a Roman officer, found near the road connecting Colonia Agrippina and Castra Vetera, at a place called Lauersfort; probably of Claudian times.

[21] And finally this column-head, now in the church of S. Pietro in Grado near Pisa which is not, as some scholars even still believe, a Greek 4th [century] original, but an Augustan slightly archaising work; I reproduce with it a marble krater engraved by Piranesi and published by him in *Vasi e Candelabri* with the label 'in my possession'. The absolute identity of *capitell* and vase in every detail can only be explained by the

assumption that the krater – if it existed – was a forgery after the Pisa piece and that the great Piranesi was taken in by a *scultore* or dealer.

After this shortened survey of Greek and Roman material we come back to the central problem.

My list of Italian monsters was incomplete; I had excluded from it two monuments which set riddles difficult to solve. [22] Two unpublished tombstones from Chiusi of a type which has a long and interesting history in Etruria. The date of the works is the first half of the 5th [century BC]. Either puts a double creature at the four corners, one double sphinxes with very long bodies, [23] the other double lions; the joining tails of two neighbouring lions form a spiral pattern and support a palmette, a motive which has good parallels, one being a frieze of sphinxes on the Ficoronian cist, which 200 hundred years later Novios Plautios made in Rome for the Praenestine lady Dindia Macolnia and her daughter.

Apart from the Roman tomb altars this is the first time we see double animals used as decoration of corners. It is hardly necessary today to refute the theory, pointed out by Murray in 1881, that twin animals owe their shape and existence to such function in architecture. It is of course true that there are many such examples in Romanesque architecture and that the double creatures are especially qualified for that purpose. But if one examines our material, it is obvious that, with very few exceptions, all of them are two-dimensional.

Even those Roman [tomb] altars differ in one essential point from the Etruscan *cippi*: on them the corner sphinxes are playing a subordinate role in the decoration and could be missing as well. Whereas here their function is essential for the structure and composition.

[24] The closest analogy is a column base from the 'Pavillion of the 40 columns' erected by Abbas the Great at Isfahan in 1600 AD. The only difference between it and the Etruscan cippus is that, owing to the narrowness of the square, the lions here overlap.[6]

[25] I add another example of corner-double-lions in architecture, the Indian column-head of the Gupta Dynasty of the 5th century AD.

The Persian descendence [sic] of the Indian Gupta capital is not altogether surprising; [26] for there is evidence for earlier eastward migrations of Persian animals and monsters to the Far East. The famous column from Sarnath is one. It was erected in 230 BC to commemorate Gautama Buddha's first public sermon. It is crowned by an inverted bell with tongue pattern and four compound lions. The style of the *kymation* is very near to Persepolis models, but the immediate model will have been Bactrian. And the lions reflect Greek 4th century prototypes which then have passed through Persia. And undoubtedly Chinese double monsters of the Han Period have the same Persian ancestry.

[27] This is a Chinese tombstone of the Han Period, on the grave of Tai and his wife who lived in 114 AD. It is the only case where our *gemini leones* have been abused, so to speak, for a practical purpose. We see Mr. and Mrs. Tai riding on lion's back. Sinologists

consulted were unable to answer my question if this is a form of apotheosis; at any rate the double creature here well symbolises the ties of marriage, outlasting death!

The obvious stemma to explain these and other migrations I shall discuss presently, is this: [Fig. 13.2]. Still one puzzling problem asks for discussion. What is the affiliation of the Chiusi cippi and Persia? The fact itself that Etruscan art has other and more roots than Greek is common knowledge today: Syrian and other arts of Asia had a very strong influence on the Etruscans. The sphinx cippus might give a clue to the way [in] which the Persian motive has come to Etruria. Sphinxes with long bodies are common in Cypriote art; this probably suggests the route: Persia – Cyprus – Chuisi.

[28] There is probably a second case of migration of double-monsters from those regions of Asia to Etruria: the cippus from Settimello near Florence, belonging to the same class of tomb stones, one or two generations older than the Chiusi stones. At the four corners upright lions support like Atlantes the pointed conus. [29] Again we have only one parallel, the top piece of the Easter candelabrum in San Paulo in Rome, of the 13th century AD. No-one will believe that the two works, though 1800 years distant, are independent creations, the distorted attitude of the lion-atlantes is too peculiar a feature. Bernheimer [1931] in his study of Romanesque animal sculpture took the Ducento work for a direct copy of an Etruscan model. That is possible in principle, because before the Cinquecento, when Michelangelo made a drawing of an Etruscan Hades picture of the type of the Tomba dell Orca at Orvieto, Italian artists took an interest in Etruscan sculptures; [30] already in the Ducento Pisano in the cycle of reliefs decorating the fountain at Perugia made a picture of Goliath which is a copy of an Etruscan (Eteokles and Polyneikes) urn. But after our experience with the Chiusi cippi another explanation offers itself: the Settimello cippus copies an Oriental model of the late 6th century and the Easter candelabrum is made after its late Oriental descendant; it would be too far-reaching to prove this in full by an analysis of pedestal groups.

After this digression I should like to sum up.

1) The native country of the monster is Asia. Our knowledge of the arts of Asia, still being imperfect, one [had] better refrain from strict localisation; but it seems that the lion's share falls to Persia.

2) There is a disproportion of preserved Oriental monuments and their Western reflections; that would look different, if we had archaic Oriental textiles.

3) The monster has invaded Europe first at the end of the 2nd millennium BC, and reached Greece; then again in the orientalising period, the 7th and 6th [centuries BC]. After an interval in the 5th [century BC] another time, again in the Persianising century, the fourth. Another strong wave in the Roman age. The flood in [the] Early Middle Age[s] is beyond our scope.

4) The monsters at different times also migrated eastward, to India and China.

5) The most frequent creature is the double-sphinx. Of the incomparatively smaller class of double lions most occur in Italy, only one in Greece.

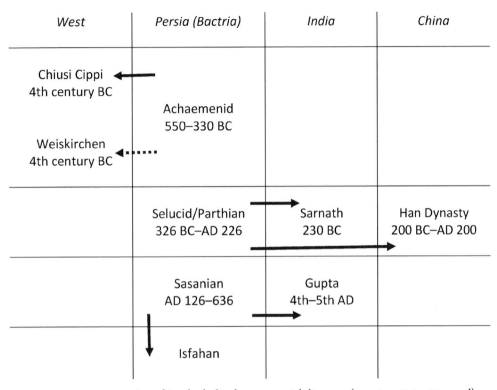

Fig. 13.2. *A reconstruction of Jacobsthal's chrono-spatial diagram (Drawing: Peter Hommel).*

6) The monsters are often set on objects of religious character, on sacred buildings, on sepulchral monuments, or on objects which, as coins [or] gems, ask for symbolical decorations and emblems.

In some cases the monster could be proved to be equivalent to single creatures of their kind.

Their origin is not to be sought in formal conditions as corner-decoration, nor are they, as it has also been said, a naive attempt to depict an animal as completely as possible, seen from front, right and left.

It would even be too formal to take them for a contraction of an antithetic group, although that would do some justice to them. They are a case of the great phenomenon: EIDOS POLYGUION; they are rooting in that layer of religion and forms which has also created other types of monsters, for instance with two heads and one body, and the divine twins, the MOLIONE and AKTORIONE, Herakles had fought and killed, or the three bodied GERYONEUS. EIDOS POLYGUION means intensification of power, accumulation of faculties. On the other hand it cannot be denied that sometimes

other impulses were at work: some of the Corinthian compound beasts are not to be taken too seriously, and the 3 or 4 deers or horses are no more than an amusing puzzle. [31] And the double owl on the Athenian dioboles is a mark of value, though at Sigeion and Miletopolis, however, it occurs on coins of more than one denomination, and is also used on Corinthian coins as a moneyers symbol. [32] A good example of multiplication of types for such a purpose is the triple silphior on Cyrenian coins, the triple half thunderbolt on trihemiobolia of Pisa, the double trident at Troizen, or the double corn ear at Arpi in Apulia.

If we try to give our monster its *topos*, we first have to overcome inveterate prejudices. Of the great book 'The image of Animal' only one chapter has been written, the representation of the 'natural' animal. We are dazzled by the beauty of the dying lioness on the walls of Assurbanipal's palace, of the Greek horses and lions and eagles. We have forgotten that they are but disenchanted portraits, and that there is another great creation:[7] the apocalyptic, magic monster. It has its roots in a world older than the Greek graven image of Gods, shaped after the image of man.[8] There is an everlasting fight between the Olympians and the animal-demon. For centuries the victory of the Gods was complete, the monsters were doomed to live in the innoxious[9] sphere of 'decoration', to become neutralised symbols: Euripides had conquered Aeschylus. But *'usque recurrunt'*. Out of their dens in the Orient they creep forth again, to live in churches, *'Imago Mundi'*, and embodying the world of Sin and Antichrist.

Notes

1 Numbers in square brackets indicate Jacobsthal's placement of slides to illustrate his lecture.
2 This image is from M. Boisset's website, Art *roman modillons chapiteaux et peintures*: https://sites. google.com/site/modillonsetpeinturesromanes/.
3 Information given to Jacobsthal in a letter dated 22 February 1938 (*Jacobsthal Archive*, Box 14, Letter 18).
4 None like you—/no horse-cock monsters or goat-stags, by god,/the sort they paint on Persian tapestries. (Trans. Ian Johnston: http://johnstoniatexts.x10host.com/aristophanes/frogshtml. html).
5 Here Jacobsthal added in a handwritten note: 'Mastyugino silver 3rd', which refers to material from the 3rd century BC Scythian kurgan near Mastyugino, Russia.
6 In an earlier draft, Jacobsthal added the following: 'I have discussed my results with Professor Sarre, the greatest authority on Persian art, and he was especially satisfied that thus the puzzling Isfahan piece is a copy of earlier Persian models'.
7 Jacobsthal here corrects his original draft which saw this as a 'much greater creation'.
8 Exodus 20, 4.
9 Cf 'innocuous'.

References (reconstructed)

Bernheimer, R. 1931. *Romanische Tierplastik und die Ursprünge ihrer Motive*. München, F. Bruckmann.
CIA. 1873. *Corpus Inscriptionum Atticarum*. Berolini, Apud G. Reimerum.
Contenau, G. 1916. *Umma, sous la dynastie d'Ur*. Paris, Librarie Paul Geuthner.

Jacobsthal Archive. Unpublished. Archive of Professor Paul Jacobsthal at the Institute of Archaeology, Oxford.

Jacobsthal, P. 1944. *Early Celtic Art*. 2 vols. Oxford, Clarendon Press.

Lajard, F. 1867. *Introduction a l'étude du culte public et des mystères de Mithra en Orient et en Occident*. Paris, Impremerie Impériale.

Murray, A.S. 1881. Perspective as applied in Early Greek art. *The Journal of Hellenic Studies* 2, 318–23.

Schefold, K. 1934. *Untersuchungen zu den Kertscher Vasen*. Berlin, de Gruyter.

Discussion: Dialogues with Jacobsthal

Tim Champion

The origin of this volume lies partly in a seminar held as part of the European Celtic Art in Context project (ECAIC), which provided a fascinating opportunity, especially for someone like myself whose interest in the Iron Age has not been primarily focused on the art, to see the way in which our interpretation of Iron Age material culture has been transformed in recent years, and in consequence how our understanding of life in the Iron Age has been enhanced. The seminar provoked a multitude of ideas for further reflection, and that is even more true of these final written contributions. There is only space to review some of these issues, so the focus here will be on the concept of Celtic art and some recent developments in research.

One thing that stands out from the contributions to this volume (it is cited in every chapter but one) is the enormous importance of Jacobsthal's *Early Celtic Art* (1944), making him 'the founding father of scholarship on Celtic art of the La Tène period' (Ginoux, Chapter 8, this volume). It was a work of great scholarship by a leading figure in classical archaeology, completed in circumstances of great difficulty and published during the Second World War. It was a foundational text that placed the study of Celtic art on a new basis and reset the agenda for future work, to the extent that Vincent Megaw (1970, 8) could refer to subsequent researchers as 'commentators' on Jacobsthal, as we are reminded by Laurent Olivier (Chapter 6, this volume). To a British archaeologist there is a striking parallel with another project that transformed the study of our Iron Age, the excavation of Little Woodbury in 1938–9 by Gerhard Bersu (1940), which set new standards in the practice of excavation, and transformed our knowledge of Iron Age settlements and economy. Two of the most important texts in the history of Iron Age archaeology, produced by distinguished German archaeologists forced into exile in Britain, whose research, though curtailed by war, was brought to publication in the most difficult circumstances. And yet, however important these works, we can now see, with the benefit of hindsight, that their impact was so great as to almost stultify research for a period. Iron Age settlement archaeology in Britain was obsessed with the idea of Little Woodbury as 'typical' (Evans 1989), while research in Celtic art was constrained as much as stimulated by Jacobsthal's ideas; as Jody Joy argues (Chapter 7, this volume), Jacobsthal's 'shadow ... loomed large' over subsequent decades, playing a major part in the intellectual schism that saw the study of Celtic art divorced from other strands of Iron Age archaeology, asking different questions and speaking a different language.

If European 'prehistoriography is still a dialogue with the ghost of Childe' (Sherratt 1989, 185), then continuing research in Celtic art has also been, and perhaps inevitably still is, a dialogue with Jacobsthal: a dialogue that was initially too respectful of his unparalleled scholarship, but has now come to respect his fundamental contributions, not least in his clear recognition of the importance of eastern contributions to the origins of Celtic art, but also to be able to build on those foundations in order to move the debate on in new directions.

What is Celtic art?

Recent scholarship on the European Iron Age has included much discussion of the concepts of 'Celtic' and 'art', and this is not the place to rehearse or continue such debates. There has, however, been much less discussion of the term 'Celtic art', in respect not so much of the connotations of the two words, but of its use to denote a meaningful category of objects (though see Garrow 2008, 17–19). The prime focus of Celtic art studies has been the decorated metalwork. This is perhaps understandable in a historical context, as it was the rich funerary finds from the Rhineland and the votive deposits from La Tène that first allowed Lindenschmidt (1858–1900), in the earliest fascicules of his *Alterthümer unserer heidnischen Vorzeit*, which began to appear in 1858, to suggest the idea of a stylistically coherent group of material, though, in view of the fine craftsmanship represented, he attributed the objects to the Etruscans. It was the subsequent discovery of the critically important groups from Waldalgesheim (1869) and Klein Aspergle (1879) that confirmed its true pre-Roman date. Such a focus continued to make sense as long as the main source of artefacts for study was the excavation of burials or ritual deposits, but with the steady development of settlement archaeology in the 20th century, other less deliberately selected forms of material were increasingly available for study. The richly ornamented metalwork lent itself to study through the established methods of classical, medieval and renaissance art history, and Jacobsthal's *Early Celtic Art* (1944) represents a good example of the reflexive interplay between an academic tradition and a selected group of material that forms the canon of the discipline, an interaction that enforces and perpetuates disciplinary boundaries.

It is interesting to reflect on the inclusion or exclusion of other categories of material in the debates on Celtic art. It is understandable that the importance of textiles has often been acknowledged, together with a lament for the lack of surviving evidence, leading to their almost total exclusion (Jacobsthal 1944, 11; Megaw 1970, 45 and pl. 7). More recent evidence, however, may be beginning to remedy this, especially finds from salt-rich contexts such as at Hallstatt and Dürrnberg (Grömer 2010; 2013; Grömer *et al.* 2013).

Stone sculptures have been regularly included (though they represent a major counter-argument to the repeated characterisation of Celtic art as portable and aniconic); is this because carved stonework was an accepted part of the classical and western artistic tradition, or the sculptures were thought to have a particular

aristocratic or religious significance? Jacobsthal (1944, 1) starts his review of Celtic art with a discussion of 'the image of man', contrasting the 'clumsy idols' then known to him with 'the refinement of the metalwork with its beautiful and ingenious ornamentation'; there is no explanation for structuring the text in this way, but presumably it was implicitly obvious to begin the analysis of an art style with a consideration of human statuary. Subsequently, statues such as Hirschlanden and Glauberg, the massive carvings from Roquepertuse and Entremont, and even the smaller decorated stones from Ireland such as Turoe and Castlestrange have become familiar images, but why have the rotary querns from Ireland, some decorated with elaborate La Tène art motifs, not appeared more often (Caulfield 1977; Raftery 1984, 244–46)?

Two other categories of material are particularly relevant here, coins and 'utilitarian' items such as pottery and bone tools, which have occupied marginal or liminal positions in the study, ranging from total exclusion to inclusion of a small sample of elaborate or highly decorative items (I doubt if many examples of British Class II potin coinage will ever appear in works on Iron Age art). In the final centuries of the Iron Age, coins were produced in their millions and must have provided the most frequently seen source of visual imagery for most of the population at the time. They were certainly the work of highly skilled metalworkers, including those who made the dies as well as those who struck the coins. On the basis of the materials used, the degree of skill required and the variety of imagery deployed, they surely deserve to be included in any study of Iron Age visual culture, if not art.

The decoration of so-called 'mundane' or 'utilitarian' items has been seriously under-researched. Textiles would have provided us with one obvious source of evidence for the use of pattern, colour and texture, but survival of the evidence is understandably very rare. It is clear, however, that, in certain regions of Europe and in certain times of the Iron Age, some types of another everyday material, pottery, were decorated with varying degrees of elaboration. Some striking regional traditions, such as the stamp-decorated pottery of north-western France (Schwappach 1969) or eastern England (Elsdon 1975), have attracted attention, but we still have very little appreciation of how common such decoration was, what types of pots were decorated, how they related to other contemporary decoration, or what their social impact might have been. Niall Sharples (2008, 209–10) suggested an inverse relationship between the use of elaborately ornamented metalwork and decorated pottery in parts of southern Britain, but this remains to be tested on any larger European scale. Helen Chittock (2014) has explored some of the issues concerned with the decoration of 'everyday' items such as bone combs and their relation to the wider set of visual patterns, but other categories of artefact have been largely ignored. We still have little idea of the regional patterns at a European scale of the application of non-geometric ornament of La Tène type to such 'mundane' items, or the circumstances in which this happened.

Different approaches to the definition of the corpus of Celtic art have been taken by various studies and exhibitions, occasionally with explicit reasons for inclusion or

otherwise. Jacobsthal's focus was on the metalwork, especially personal ornament, horse and vehicle fittings and weaponry, though he included a sample of pottery as the final items in his Catalogue (nos. 402–419), but no coins or other utilitarian items; the small sample of pottery was explained by his inability to visit relevant museums (1944, v). Cyril Fox's discussion of early Celtic art in Britain in his *Pattern and Purpose* (1958) has the same primary focus on the metalwork; he does include more utilitarian items, as well as coins, but they are relegated to a chapter entitled 'Side-lines'. His use of the term 'peasant art' to refer to work in wood, iron and clay, is rooted in the values of the 'high civilisation' of modern Europe, as he acknowledges (Fox 1958, 132), but its relevance to prehistoric Britain is not considered.

Megaw (1970, 8) 'was concerned with presenting the varied range of the arts..., illustrating the more mundane objects, 'folk crafts', pottery, tools and weapons side by side with the great cult statues and the panoply of ornaments in precious metals', but he included only a small sample of stamped or painted pots, and three pages of coins in a collection of over three hundred photographic plates. The structure and approach adopted in Jope's survey of Celtic art in the British Isles follows closely that of Jacobsthal, with a primary emphasis on the metalwork, especially, again, personal ornament, horse and vehicle fittings and weaponry. Other categories and materials are included; there is no explanation for this, or discussion of its significance, but the introductory chapter sets the tone: 'many pieces are small and not impressive, fittings made primarily for use but nevertheless with some decorative intent'; chapter 7 is described as 'descending into work in humbler materials – wood, bone, shale and clay – ... is concluded on a higher tone with the achievements of art as seen on British coinage' (Jope 2000, 2).

The Technologies of Enchantment project adopted an inclusive approach, recognising the concept of 'Celtic art' as a 'slippery and hazy-edged' one (Garrow 2008, 17–19); it incorporated in its database all items that had been categorised as 'Celtic art' in previous catalogues, and including some undecorated items belonging to types that were sometimes decorated. Exclusions were justified on various grounds: coins were omitted because of the existence of the Celtic Coin Index (housed in the Institute of Archaeology at Oxford), while Celtic art on pottery, bone and other materials was excluded 'primarily due to the limited timescale of the project'. The ECAIC project, as explained by Courtney Nimura and colleagues (Chapter 2, this volume), adopted a similar combination of inclusivity and pragmatism. Its primary sources of data were two pre-existing databases, thus perpetuating their biases and idiosyncrasies; again, the emphasis was on comprehensive collection of items of personal ornament and weaponry, and items associated with horses and vehicles, while glass, ceramic, bone and other materials were excluded in order to prevent the dataset becoming unmanageably large.

Jacobsthal's legacy has therefore, for a variety of intellectual and pragmatic reasons, been highly influential in shaping and constraining the canon of objects studied under the heading of 'Celtic art', with the primary emphasis on the repeated study of metalwork, and of personal ornaments and weaponry, and horse and vehicle

equipment. There can be no denying the importance of these objects in many regions and in many periods of the European Iron Age, but they are only part of the story. The many other objects, whether 'side-lined' or marginalised as of 'humbler materials', may well have been seen by a far larger proportion of the Iron Age population and played a significant part in the visual culture of their societies. We surely cannot understand the true significance of the elite metalwork if we cannot place it in the context of a wider range of contemporary imagery. Several factors might suggest that it would now be opportune to widen the range of material to be included in research enquiries: the growing criticism of the concept of art as an appropriate category for the analysis and understanding of Iron Age material culture; the increasing preference for the concept of decoration, with much wider implications; the increased interest in the function of the decorated artefacts, especially their context and effect; and the massively increased volume of archaeological evidence now available in many parts of Europe and further afield.

Another approach to the idea of Celtic art might be to question not its range, but its coherence. Is it appropriate or useful to regard it as a single entity? Perhaps the clearest answer to such a question is this: 'We see not one style, but several; not one history but many. There were links, but also dissimilarities. These Celtic arts – plural – need to be placed into their own histories' (Hunter *et al.* 2015, 31). Or this: 'It is more correct to understand it as a series of 'Celtic arts' than as a single, homogeneous tradition' (Joy 2015a, 51). We might distinguish continental Celtic art of the Early and Middle La Tène periods, reworked in Britain in the final centuries BC, reworked again further north in the changed circumstances of the Roman conquest, with a significant amount of the Celtic art in Britain deposited after AD 40. Rena Maguire (Chapter 10, this volume) suggests a similar picture for Ireland in her study of horse tack, with conscious adoption of archaic motifs at a time of perceived Roman threat. If there is a unity to Celtic art, it is as a corpus of techniques, forms, patterns and motifs which can be serially reworked, with additions, subtractions and modifications at every stage.

If our understanding of the chronology of the art is improving to the point where we can now recognise such diachronic episodes of adoption and reinvention, the scale of modern research projects will increasingly allow us to discern synchronic patterns of regional variation. The Technologies of Enchantment project was able to elucidate a variety of spatial and temporal patterns in the British data (Garrow & Gosden 2012, 68–79). Its successor, the ECAIC project, with over 38,000 records, is already beginning to reveal some patterns, but at the much larger European scale, as described by Nimura and colleagues (Chapter 2, this volume). Variability in the distribution of items such as torcs and brooches, as well as in the depositional contexts of different categories of material, will produce many patterns for further critical investigation.

Researching Celtic art

At the risk of stating the obvious, the minimum requirements for research are a body of material, appropriate methodologies, and research questions generated from the

current state of knowledge and debate in the discipline. For Celtic art, all of these have been transformed in recent years.

The quantity of relevant material has increased enormously, especially in parts of western Europe, through the proliferation of archaeological investigations, many of them in advance of development projects. The quality of recovery and recording has also increased the contextual information available for objects found; Dirk Krausse (Chapter 9, this volume) discusses the significance of some finds from the Heuneburg excavations for our understanding of the origins of Celtic art. As well as formal excavation, finds from other sources have also increased, though recording has been more variable. In Britain, the Portable Antiquities Scheme (PAS) had recorded more than 1.4 million finds by July 2019, of which 54,773 were attributed to the Iron Age, including 45,296 coins. Though not directly reflected in this volume, the PAS has made a significant contribution to Iron Age research, for instance in such areas as brooches (Adams 2014) and fittings for horse-drawn vehicles (Lewis 2015).

Perhaps the most significant progress in methodology has been the ability to construct and analyse increasingly large computerised databases. The Technologies of Enchantment database included 2582 objects; John Talbot's (2017) study of the Icenian coinage of eastern England contained records of over 10,000 individual coins; the ECAIC database eventually had 38,383 records. There are undoubtedly issues associated with the compilation of such databases, as discussed by Nimura and colleagues (Chapter 2, this volume), but it could be argued that the larger the database, the less the impact of any such biases. Archaeology is still learning how to exploit the advantages of very large information sets (*e.g.* Green *et al.* 2017), and it remains to be seen whether the biases of the data collection processes outweigh the value of the suggested interpretations.

Another change not highlighted here is in the field of radiocarbon dating, with advances in the analysis and interpretation of dates, and a greater willingness to apply the method despite the calibration problem of the mid-1st millennium BC (Hamilton *et al.* 2015). Particularly important has been the possibility of estimating not just the absolute date of events, but the duration of activities, and hence the 'tempo of change' (Hamilton *et al.* 2015, 653–55). Thus, in Britain, we now have at least an outline C14 chronology with significant improvements on previous stylistic dating (Garrow *et al.* 2009), and an estimate that the chariot graves of the Garton/Wetwang group in East Yorkshire, with their grave goods including examples of Celtic art, were all deposited within a period perhaps as short as 25 years towards the end of the 3rd century BC; this not only provides a date for the objects themselves, but suggests that their deposition was more of an event or a brief episode than a long cultural practice (Jay *et al.* 2012).

Perhaps the most important development has been the changing questions that have concerned researchers and the methodologies adopted to answer them. The intellectual inspirations for these changes were complex, drawn from contemporary archaeology but also from various branches of anthropology. One landmark event in

this process, as discussed by Joy (Chapter 7, this volume), was the Oxford seminar held as part of the Techniques of Enchantment project in 2006 and published soon afterwards (Garrow *et al.* 2008), with its talk of 'rethinking', 're-integrating' and 'contextualising'; this reviewed changing aims but also strongly reinforced them. The impact of the anthropology of art, especially Alfred Gell's *Art and Agency* (Gell 1998), was already obvious, and together with changing attitudes to the study of material culture in archaeology this laid the foundations for a new approach, less concerned with Jacobsthal's styles and meaning, and more focused on themes such as: making the art, including the processes and the social organisation of production; using the art, with notions of the biographies of objects, or display and visibility, repair and modification, fragmentation and re-assembly; and the deposition of objects, with particular attention to the location and social context of deposition. An interest in colour, as well as form, pattern and line, was being developed (Giles 2008; Hoecherl 2015). Above all, following Gell, there was a concern with art objects as having agency, and with function rather than meaning, and the wider social context in which those functions were performed. 'It is not what objects mean that counts, but what they do', as Chris Gosden says (Chapter 1, this volume).

The focus on function and effect required a new methodology for investigating how the art objects worked, and a significant landmark in this direction was Peter Wells's *How Ancient Europeans Saw the World* (2012), drawing not so much on the anthropology of art as the anthropologies of perception and representation. It was necessary to explore ways of seeing and ways of representing that were fundamentally different from those of the classical world and those of our own modern, western world. A major event in the consolidation of the new approaches was the exhibition of Celtic art (or rather arts) held at the British Museum and National Museums Scotland in 2015–6, and its accompanying volume of essays (Farley & Hunter 2015). With its emphasis on the function rather than the meaning of the art, on art as 'powerful objects', and on the repeated re-invention of Celtic art, it brought these ideas to a much wider audience.

Many of these research themes are reflected, directly or indirectly, in various chapters in this volume. Gosden (Chapter 1, this volume) is concerned primarily with the decorated metalwork, seen as essentially ambiguous, in the context of the social networks, potentially open-ended, through which they operated. Olivier (2014, and Chapter 6, this volume) has explored how Celtic art has reproduced the world, treating the art as an organised system of representation with its own logic, but one that is totally unlike our own.

These new approaches concerned with how Celtic art achieves its effect have still left room for other types of investigation, focusing on particular categories of material or designs. Human imagery has been one issue of major concern since the first page of Jacobsthal's *Early Celtic Art*, and Chittock (Chapter 5, this volume) now provides a new discussion of this material in its wider Eurasian context, but treating it as 'images that *resemble* humans rather than represent them'. Individual motifs can also be usefully reassessed in the light of new ideas. Joy (Chapter 7, this volume)

argues for the importance of analysis at his scale, focusing on how individual motifs can work, while Maguire (Chapter 10, this volume) concentrates on how and why particular motifs could be selected from earlier phases of artistic production and given new meaning in a different social and political context.

Making Celtic art

Studies of the techniques and processes of manufacturing have been a significant development in prehistoric archaeology in recent years, so that it comes as something of a surprise to reflect how little has been done in this field for the study of Celtic art. In other fields of research on Iron Age technology there has been significant progress, for instance in the study of the manufacture and working of iron (Berranger 2014; Dubreucq 2013), some of it specifically using the concept of the *chaîne opératoire* (*e.g.* Fluzin *et al.* 2000; Serneels 1998). There is very little comparable work in respect of the art objects.

The chances of finding significant evidence for the making of Celtic art objects in the form of structures or activity areas may be very small, but it is not impossible, as the remarkable discovery of a goldsmith's workshop at the Heuneburg demonstrates (Krausse, Chapter 9, this volume). Manufacturing debris may be more widespread: spectacular finds such as the pit containing the evidence for the casting of terrets, linch-pins, strap-unions and button-and loop fasteners at Gussage All Saints, England (Foster 1980; Garrow & Gosden 2012, 267–87) are highly informative, even if likely to be the result of unusual events. The objects themselves, however, can also be the source of important information, so it is surprising how few major objects have been the focus for detailed technical study of the processes of manufacture. Though such studies are becoming more common for recent finds, few of the older finds have undergone detailed technical analysis.

Tess Machling and Roland Williamson's previous paper (2018) therefore caused considerable surprise. It not only demonstrated the information that could potentially be gained through detailed technical examination of complex objects using a variety of modern investigative techniques, it also proved that previous ideas about the manufacturing methods of a group of gold torcs were fundamentally wrong. In addition to clarifying the production processes involved, they showed some pathways to potential progress. The ability to recognise individual workers through their toolmarks or distinctive patterns raised the possibility of identifying producers on a more secure basis than that of subjective stylistic comparison, such as with Jope's (1971) attempt to define the Waldalgesheim master, and thus shedding light on the date of manufacture and the social context of production.

As a follow-up, they now demonstrate (Machling & Williamson, Chapter 11, this volume) how the experience of modern craftworkers can provide extraordinary insight into the processes of manufacture of ancient objects. It is not just a question of the technical proficiency required to produce the objects, but the social context

of the smiths that is important. They emphasise that skills were learnt by repeated practice: how, where and from whom did novice smiths learn these skills in the Iron Age? One fascinating insight is the fact that smiths often have favourite tools: did the tools themselves perhaps have histories, associating them with previous workers who had used them, or the objects they had been used to produce?

The degree of skill required to produce at least the most complex objects was clearly considerable, and it seems logical to assume that in any one area at one time there could only have been a few workers with such abilities. The testimony of the modern smiths suggests that they would be familiar with the work of their contemporaries, and perhaps able to identify the products of individual workers. Did the same apply to smiths in the Iron Age? Did individual smiths try to distinguish their own products by some distinctive technical or artistic trait?

The social organisation of highly skilled craft production in the Iron Age is still very much an open question for further exploration. The transmission of skills through demonstration, observation and practice was clearly important, but so too may have been the passing on of physical items such as tools. Also important was the maintenance of the networks that were needed to ensure the supply of metal to be worked as well as other necessary materials such as fuel, clay or wax, and to ensure distribution of the finished product. Transmission through lineages of specialist workers would be one obvious possibility, but other systems would have been possible.

One obvious feature of the fine metalworking traditions of the second half of the 1st millennium BC is the wide geographical distribution of objects produced with distinctive techniques. The interaction of Greek and Scythian traditions is well known. Recent finds of Iron Age goldwork in Britain have been marked by a high proportion of items with significant continental, including classical Mediterranean, characteristics of form and manufacture (Joy 2015b, 153–59), provoking important questions about where the items were made, and how either the items themselves were transported to where they were deposited, or the knowledge to produce them was transferred. In the case of Winchester hoard, for instance, the techniques used in the manufacture of the torcs were of Roman or Hellenistic origin; it is possible that the looped structure of the 'necklace torcs' could have been imitated by a skilled non-Mediterranean smith through careful observation and experiment, but the techniques of filigree and granulation would have required training and practice in a workshop familiar with these processes. The final judgement, that 'the Winchester necklace torcs were probably made by craftspeople trained in a Mediterranean Roman or Hellenistic workshop' (Hill *et al.* 2004, 16), leaves open the identity of the smith and the means of transmission of object or knowledge.

The evidence from the Heuneburg discussed by Krausse (Chapter 9, this volume) is therefore particularly interesting. The discovery of gold ornaments in graves in the Bettelbühl necropolis characterised by filigree ornament typical of Etruscan work therefore raises the same range of questions, but here we have additional information. The identification of toolmarks suggesting that four objects were made by the

same hand, and the presence in the Heuneburg of a goldsmith's workshop with tools identical to those used for objects in the graves, argue strongly for local manufacture, but again leave open the question of the identity of the smith. It is tempting to interpret it as the local smiths being trained in the practice of Etruscan jewellery, but the possibility of an Etruscan specialist working in the Celtic world is also intriguing.

Using Celtic art

The focus on the function and the effect of Celtic art objects raises the obvious question of how they were used in that period of their life histories between the archaeologically visible episodes of manufacture and deposition. This is not a major theme of the contributions to this volume, but several chapters make suggestions of considerable interest, pointing to a wide variety of life histories.

At one end of the spectrum are the stone sculptures, by their nature not easily portable, and presumably designed to be placed permanently in a specific location. The anthropomorphic statues, as discussed by Chittock (Chapter 5, this volume), seem to be associated with the locations of important burials, where the imagery of the warrior would have been visible in the open air to anyone coming there, though who that was and for what purpose may be difficult to discern. Similarly, the sculptures in the southern French sanctuaries such as Roquepertuse would have been permanently visible to anyone there. The contexts of the non-anthropomorphic stones are not well known, but it is reasonable to assume that they were similarly intended to be permanently visible.

As several chapters have stressed, the majority of the objects included in the category of Celtic art comprise the decorated metalwork, primarily personal ornament, weapons and horse and vehicle equipment, 'powerful objects' most commonly associated with 'the body, the battlefield, the chariot and the feast' (Hunter 2015, 82). The fact that much of this material is found in the context of funerary or votive deposits shows that these events could have been powerful and dramatic occasions for the display of the art, but how frequent would other opportunities have been for such display? Feasts and battles were undoubtedly important events in Iron Age lives, but how common were they? What did people do with their highly decorated objects when they were not in such use? It has been suggested, on the basis of use-wear on the handles, that British mirrors, rather than having been hung up for display in the house when not in active use, as previously imagined, may have spent much of their lives covered up (Joy 2010, 43–44, 51). In the case of small, portable items such as these or the majority of decorated personal ornaments or weapons, their impact might have been much greater if they were unwrapped on special occasions rather than being familiar objects.

Similar questions arise in the case of horse and vehicle equipment. Presumably horses would have been stabled or put out to grass when not in use, while chariots may have been sheltered in sheds; but how common were such items, and how

frequently would they have been seen? One speculative estimate suggests that, in the later Iron Age of southern Britain, when chariots were still in use for warfare, one person in fifty may have owned a chariot, implying that most people would have been familiar with such vehicles (Gosden & Hill 2008, 6). On the other hand, where we have evidence of the chariots themselves, in the vehicle burials of the Middle Iron Age in East Yorkshire, some of them show evidence of use and repair, while others include non-matching wheels, a non-functional bridle-bit and fragile 'sham' terrets (Giles 2012, 190–206). Was this because working chariots were rare, and a vehicle had to be assembled from any parts available or newly made? Or was it a deliberate act of re-assembly, the very opposite of fragmentation?

With improvements in our knowledge of Iron Age chronology, it is becoming obvious that some art objects were of a considerable age when deposited. The bronze flagon in the Waldalgesheim burial, discussed by Gosden (Chapter 1, this volume), was around sixty years old when buried, while Joy (Chapter 7, this volume) has discussed the possibility that some of the torcs buried at Snettisham were perhaps as much as two centuries old, or alternatively that older items were available to be copied, providing an accumulated repertoire of imagery for later use. How and where were such objects curated so as to be visible and familiar to later smiths? Maguire's discussion (Chapter 10, this volume) of Irish horse tack, decorated with motifs whose origin goes back several centuries, raises similar questions, with motifs spreading over wide geographical areas and being reworked and reinterpreted over long periods of time, with little surviving evidence for how this transmission of visual imagery may have been achieved.

The wider context of Celtic art

Perhaps the most challenging re-orientation of Celtic art research set out in this volume is the attempt to locate the art in its much wider Eurasian context. Jacobsthal had, of course, emphasised the eastern contributions to the art (1944, and Chapters 12 and 13, this volume), looking to Scythian and Near Eastern origins, but the general trend in European history and archaeology, anchored in the origin myth that traces European civilisation to its Greco-Roman roots, has been to focus on the north–south relationship of the Mediterranean and non-Mediterranean worlds rather than to see it in a Eurasian context. More recently, there has been a revival of academic interest in this wider setting, matched by more popular works such as Frankopan's *Silk Roads* (2015), and Cunliffe's *By Desert, Steppe and Ocean* (2015).

Recent archaeological interest in Eurasian contacts for later European prehistorians has been revived by advances in aDNA. The genetic evidence strongly suggests a significant influx of new population from the Yamnaya Culture of the steppes (Anthony 2007), bringing the Indo-European language family (Anthony 2017; Olsen *et al.* 2019). This influx took place in the early 3rd millennium BC, and there is, at least so far, no evidence for further significant genetic intrusions in subsequent centuries before

the Roman period. The archaeological evidence, however, is suggestive of some form of interaction. The claims for the presence of silk in prehistoric Europe have been challenged (Jørgensen 2015), but other evidence is more certain, if still enigmatic: Piggott's (1983) discussion of the earliest wheeled vehicles traced contacts eastwards to the Caspian sea and possibly further; the Gundestrup cauldron, found in Denmark but made in south-eastern Europe, is decorated with images drawn from a wide variety of sources, some with Celtic affinities, others possibly of Indian origin (Hunter *et al.* 2015a); and the domesticated chicken had certainly reached southern England from its south Asian origin by the 5th century BC (Sykes 2012).

Exotic imports or images may be easy to spot, but they can be difficult to explain, though they certainly require some form of human contact(s) over long distances. Even harder to deal with are broadly synchronous developments taking place over vast distances, such as those towards the middle of the 1st millennium BC described by Peter Wells (Chapter 3, this volume): similarities in funerary treatment, especially large mounds with central chambers, grave goods selected from a coherent set of objects, art styles applied to similar objects, using similar techniques, motifs and textures. O'Sullivan and Hommel (Chapter 4, this volume) explore in detail the widespread distribution of some fantastic animal motifs at this time.

These patterns pose different problems from those associated with the rather smaller scale studies more familiar in much of European prehistory, especially in respect of the appropriate intellectual methodology to analyse such widespread distributions, and the question of a search for an origin. Wells (Chapter 3, this volume) explores the utility of the concept of an interaction sphere, borrowed from North American archaeology, as a useful tool for thinking about these patterns, stressing interaction but without itself offering an explanation. Another, somewhat similar concept, is that of the network, here adopted by Gosden (Chapter 1, this volume) for a smaller scale study in western Europe. Networks have the advantage of focusing on connections, potentially open-ended, rather than trying to isolate bounded culture groups representing bounded social groups, which therefore problematise the question of interactions between them.

Archaeology has a long fascination with the origin of inventions or innovations and their subsequent diffusion or adoption. In some cases, this may be the correct sequence of events, but perhaps we should be prepared to think in terms of areas of shared cultural practice: areas where it is impossible to tell the point of origin, not because our chronology is not good enough, but because there was no single point of origin, and ideas moved so quickly that innovations were effectively contemporaneous.

A multi-sensory archaeology of the Iron Age?

> In seeking to develop an archaeology of perception and the senses ..., we must ensure that the significance of colour and coloured objects be contextually grounded within a world experienced equally through texture, sound and smell (Scarre 2002).

How can we try to place the visual imagery we see in the material items of the archaeological record of the Iron Age in the wider context of contemporary sensory perception of the natural and cultural world, and the artistic and creative forms through which they represented it? Perhaps the nearest we can come at this moment to the real-life world of the Late Iron Age is not through the academic works of professional archaeology, but through the fictional world of Asterix the Gaul. It seems difficult to identify any way in which we can pursue serious research into the olfactory senses in the Iron Age, except possibly through the experimental reconstruction and long-term inhabitation of Iron Age houses and settlements, but there may be more hope for other senses, especially sound.

There may be fields of investigation other than archaeology that can shed relevant light. One such field is the study of Indo-European poetry (Watkins 1995; West 2007) as briefly noted by Nathalie Ginoux (Chapter 8, this volume), which may be able to help us understand the auditory context of Celtic art, primarily vocal, but by extension possibly musical. This research has reconstructed a world of verbal and poetic creativity, dating back to perhaps at least the 3rd millennium BC, revealing a world of poets and patrons, with rich rewards for the invocation of 'imperishable fame' on the patron. Watkins (1995, 14) briefly discusses a widespread metaphorical analogy between the composition of poetry and the physical manufacture of craft products, and West also discusses the idea of poesy as construction, weaving or carpentry (2007, 35–40). These analogies can be seen, for instance, in the Early Irish word *cerd*, meaning 'craft, poetry', as well as 'craftsman, poet', or the Greek poet Pindars's phrase (*Pythian Odes*, 3.113) '*epeon ... tektones*'; the Greek word *tekton* has a primary meaning as 'worker in wood, carpenter, joiner', but by extension comes to mean a craft worker in any material, and then in words. Pindar's phrase can therefore mean 'crafters of words or poems', or even 'wordsmiths'. It seems there was a widespread conceptual alignment of skilled workers in physical materials with those who created in words.

The textual sources for such studies are obviously limited by the adoption of literacy and the accidents of survival, but comparative analysis allows the reconstruction of an archaic tradition of words, formulae, themes and metrical forms. Modern research tends to use the word 'poet' for these artists, but it is clear from classical literary sources and later survivals such as in early medieval Ireland, that music was also important, and the idea of the bard is common, at least in the later phases of this long poetic tradition.

Watkins (1995) focuses on one theme, that of the hero killing the serpent/worm/ dragon. Using a methodology with a striking similarity to that employed by Jacobsthal (Chapter 13, this volume) and O'Sullivan and Hommel (Chapter 4, this volume), Watkins traces this poetic motif through many strands of Indo-European poetry, through several millennia and across vast geographical spaces. His evidence is drawn from surviving traces in the various Indo-European languages, but there does not seem to be any *a priori* reason why such motifs should not have appeared also in other

non-Indo-European languages and cultures in Eurasia. West (2007) provides a more comprehensive analysis of the main themes of the poetry; perhaps the most relevant here are the idea of the king and the hero, the ideal qualities of such figures, including bravery, wealth and generosity, and their material trappings, including swords, horses and chariots.

Evidence for such artistic practices in Iron Age Europe is inevitably hard to find. The limited extent of literacy, and the limited functions for which it was used, mean that the poetic texts have all but disappeared; fragments of the poetic language may survive in inscriptions at Chamalières and Larzac, though transferred to the medium of the curse tablet for deposition and survival (Watkins 1995, 63). Archaeological evidence for music is also rare. Most attention has been paid to the carnyx (Hunter 2011), though other wind instruments certainly existed such as the bronze horns from Loughnashade in Northern Ireland (Jope 2000, 74). Even more enigmatic are string instruments. The remarkable recent find from High Pasture Cave, Isle of Skye, Scotland, of a fragment of worked wood, interpreted as part of a lyre and dated stratigraphically to the second half of the 4th century BC (Highland Historic Environment Record; Hunter 2015, 104) is the oldest physical evidence for such instruments in Europe. A small statue from Paule, France (Ménez 1999), shows a person holding a lyre-like instrument in front of his chest, but this dates to the 2nd or 1st century BC. Representations of lyre-like instruments are known from at least the Late Hallstatt period (Reichenberger 1985). The early history of such instruments in Europe is not well documented, but the find from Scotland suggests that they may have been more common and more widespread than hitherto imagined. We currently have no evidence earlier than the Late Hallstatt representations, and it may be that lyre-like instruments were an innovation of the Early Iron Age, introducing a new world of sound alongside a new visual imagery.

Classical sources are few, but informative. Diodorus Siculus (*Library of History*, 31), following Poseidonios, tells us that the Gauls had lyric poets called bards, who, accompanied by instruments resembling lyres, sang both praise and satire; the poets are regularly placed in a triad of bards, seers and druids. Appian (*Keltike*, 12) tells the story of Bituiitos of the Arverni (though he mistakenly assigns him to the Allobroges), who sent an embassy to the invading Romans in 122 BC: 'a musician was also in the party, who sang in barbarous fashion the praises of Bituitos, and then of the Allobroges, and then of the ambassador himself, celebrating his birth, his bravery and his wealth'.

Perhaps the most revealing passage is the well-known story of Lovernios, father of this Bituitos, told by Athenaeus, again following Poseidonios (*Deipnosophistae*, 4.37). In search of popular support, Lovernios distributed large quantities of wealth to the people and entertained them to a lavish feast. A poet arrived belatedly and sang the praises of Lovernios, lamenting his own tardiness, a performance that elicited further generosity. In return the poet sang again, running beside Lovernios as he rode in his chariot, celebrating how even his chariot-tracks gave gold and benefits to the people. Here we have the association of chiefly status, feasting, conspicuous generosity, the

material culture of high status in the form of the chariot and the horses (and these were surely decorated with some form of Celtic art), and music and singing in the form of praise-poetry. The physical objects with their decoration were an integral part of the performance, but would survive long after it had ended and provide a material reminder of the social relationships it had created or consolidated.

Watkins also makes two other intriguing suggestions, though without much discussion of their significance or supporting evidence. He suggests that the poet was the highest paid artistic specialist in early Indo-European society (Watkins 1995, 70). For archaeologists working within the constraints of their material evidence, that may be a salutary reminder of the social importance of the non-material and intangible elements of a past society's cultural heritage, possibly due in part to the long tradition of composition and performance that lay behind them.

The second suggestion may be related: that, in comparison to linguistic creativity, the visual world of these societies may have been rather underdeveloped until some point in the 1st millennium BC: 'It should be emphasised that in the Early Indo-European world the primary form of artistic expression is precisely verbal. Visual art typically plays a distinctly limited role until relatively late in the tradition' (Watkins 1995, 179). This would certainly warrant more detailed investigation in the archaeological record of the mid-1st millennium BC; if this is borne out by the current evidence, it would suggest that the explosion of non-geometric imagery seen in the period from the 7th to the 5th century through much of Eurasia was a veritable 'shock of the new', not just a new way of seeing the world but a completely new cultural and creative medium for seeing, understanding and reproducing the world and our place in it. How did people react to the first shocking appearance of 'Celtic art' in Early La Tène Europe?

References

Adams, S.A. 2014. The First Brooches in Britain: From manufacture to deposition in the Early and Middle Iron Age. Unpublished PhD thesis, University of Leicester.

Anthony, D.W. 2007. *The Horse, the Wheel, and Language: How Bronze-Age riders from the Eurasian steppes shaped the modern world*. Princeton, NJ, Princeton University Press.

Anthony, D.W. 2017. Archaeology and language: Why archaeologists care about the Indo-European problem. In P.J. Crabtree & P. Bogucki (eds), *European Archaeology as Anthropology: Essays in memory of Bernard Wailes*, 39–69. Philadelphia, PA, University of Pennsylvania Museum of Archaeology and Anthropology.

Berranger, M. 2014. *Le fer, entre matière première et moyen d'échange, en France, du VIIe au Ier siècle av. J.-C.: Approches interdisciplinaires*. Dijon, Editions universitaires de Dijon.

Bersu, G. 1940. Excavations at Little Woodbury, Wiltshire. Part I: The settlement as revealed by excavation. *Proceedings of the Prehistoric Society* 6, 30–111.

Caulfield, S. 1977. The beehive quern in Ireland. *Journal of the Royal Society of Antiquaries of Ireland* 107, 104–38.

Chittock, H. 2014. Arts and crafts in Iron Age Britain: Reconsidering the aesthetic effects of weaving combs. *Oxford Journal of Archaeology* 33(3), 313–26.

Cunliffe, B.W. 2015. *By Steppe, Desert, and Ocean: The birth of Eurasia*. Oxford, Oxford University Press.

Dubreucq, E. 2013. *Métal des premiers Celtes: Productions métalliques sur les habitats des provinces du Hallstatt centre-occidental*. Dijon, Éditions universitaires de Dijon.

Elsdon, S.M. 1975. *Stamp and Roulette Decorated Pottery of the La Tène Period in Eastern England: A study in geometric designs*. Oxford, British Archaeological Reports British Series 10.

Evans, C. 1989. Archaeology and modern times: Bersu's Woodbury, 1938 & 1939. *Antiquity* 63, 436–50.

Farley, J. & Hunter, F. (eds). 2015. *Celts: Art and identity*. London, British Museum Press.

Fluzin, P., Ploquin, A. & Serneels, V. 2000. Archéométrie des déchets de production sidérurgique. Moyens et méthodes d'identification des différents éléments de la chaîne opératoire directe. *Gallia* 57, 101–21.

Foster, J. 1980. *The Iron Age Moulds from Gussage All Saints*. London, British Museum Occasional Paper 12.

Fox, C. 1958. *Pattern and Purpose: A survey of early Celtic art in Britain*. Cardiff, National Museum of Wales.

Frankopan, P. 2015. *Silk Roads: A new history of the world*. London, Bloomsbury.

Garrow, D. 2008. The space and time of Celtic art: interrogating the 'Technologies of Enchantment' database. In Garrow *et al.* 2008, 15–39.

Garrow, D. & Gosden, C. 2012. *Technologies of Enchantment? Exploring Celtic Art, 400 BC to AD 100*. Oxford, Oxford University Press.

Garrow, D., Gosden, C. & Hill, J.D. (eds). 2008. *Rethinking Celtic Art*. Oxford, Oxbow Books.

Garrow, D., Gosden, C., Hill, J.D. & Bronk Ramsey, C. 2009. Dating Celtic art: A major radiocarbon dating programme of Iron Age and early Roman metalwork in Britain. *Archaeological Journal* 166, 79–123.

Gell, A. 1998. *Art and Agency: An anthropological theory*. Oxford, Clarendon Press.

Giles, M. 2008. Seeing red: The aesthetics of martial objects in the British and Irish Iron Age. In Garrow *et al.* 2008, 59–77.

Giles, M. 2012. *A Forged Glamour: Landscape, identity and material culture in the Iron Age*. Oxford, Windgather Press.

Gosden, C. & Hill, J.D. 2008. Introduction: Reintegrating 'Celtic' art. In Garrow *et al.* 2008, 1–14.

Green, C., Gosden, C., Cooper, A., Franconi, T., ten Harkel, L., Kamash, Z. & Lowerre, A. 2017. Understanding the spatial patterning of English archaeology: Modelling mass data, 1500 BC to AD 1086. *Archaeological Journal* 174(1), 244–80.

Grömer, K. 2010. *Prähistorische Textilkunst in Mitteleuropa: Geschichte des Handwerkes und Kleidung vor den Römern*. Vienna, Naturhistorisches Museum.

Grömer, K. 2013. Discovering the people behind the textiles: Iron Age textile producers and their products in Austria. In M. Gleba & J. Pásztókai-Szeőke (eds), *Making Textiles in Roman and Pre-Roman Times: People, place, identities*, 30–59. Oxford, Oxbow Books.

Grömer, K., Kern, A., Reschreiter, H. & Rösel-Mautendorfer, H. (eds). 2013. *Textiles from Hallstatt: Weaving culture in Bronze Age and Iron Age salt mines [Textilien aus Hallstatt: gewebte Kultur aus dem bronze- und eisenzeitlichen Salzbergwerk]*. Archaeolingua 29. Budapest, Archaeolingua Alapítvány.

Hamilton, W.D., Haselgrove, C. & Gosden, C. 2015. The impact of Bayesian chronologies on the British Iron Age. *World Archaeology* 47, 642–60.

Highland Historic Environment Record. *EHG4257 – Excavations – High Pasture Cave site, Isle of Skye: 2010*. Available at: https://her.highland.gov.uk/Event/EHG4257 (Accessed 15 July 2019).

Hill, J.D., Spence, A.J., LaNeice, S. & Worrell, S. 2004. The Winchester hoard: A find of unique Iron Age gold jewellery from southern England. *Antiquaries Journal* 84, 1–22.

Hoecherl, M. 2015. *Controlling Colours: Function and meaning of colour in the British Iron Age*. Oxford: Archaeopress.

Hunter, F. 2011. The carnyx in Iron Age Europe. *Antiquaries Journal* 81, 77–108.

Hunter, F. 2015. Powerful objects: The uses of art in the Iron Age. In Farley & Hunter 2015, 81–105.

Hunter, F., Goldberg, M., Farley, J. & Leins, I. 2015a. Celtic arts in the long term: Continuity, change and connections. In Farley & Hunter 2015, 261–79.

Hunter, F., Goldberg, M., Farley, J. & Leins, I. 2015b. In search of the Celts. In Farley & Hunter 2015, 19–35.

Jacobsthal, P. 1944. *Early Celtic Art.* 2 vols. Oxford, Clarendon Press.

Jay, M., Haselgrove, C., Hamilton, D., Hill, J.D. & Dent, J. 2012. Chariots and context: New radiocarbon dates from Wetwang and the chronology of Iron Age burials and brooches in east Yorkshire. *Oxford Journal of Archaeology* 31(2), 161–89.

Jope, E.M. 1971. The Waldalgesheim master. In J. Boardman, M.A. Brown & T.G.E. Powell (eds), *The European Community in Prehistory: Studies in honour of C.F.C. Hawkes*, 167–80. London, Routledge and Kegan Paul.

Jope, E.M. 2000. *Early Celtic Art in the British Isles.* Oxford, Oxford University Press.

Jørgensen, L.B. 2015. The question of prehistoric silks in Europe. *Antiquity* 87(336), 581–88.

Joy, J. 2010. *Iron Age Mirrors: A biographical approach.* Oxford, BAR British Series 518.

Joy, J. 2015a. Approaching Celtic art. In Farley & Hunter 2015, 37–51.

Joy, J. 2015b. Connections and separation? Narratives of Iron Age art in Britain and its relationship with the Continent. In H. Anderson-Whymark, D. Garrow & F. Sturt (eds), *Continental Connections: Exploring cross-channel relationships from the Mesolithic to the Iron Age*, 145–65. Oxford, Oxbow Books.

Lewis, A.S.G. 2015. Iron Age and Roman-era Vehicle Terrets from Western and Central Britain: An interpretive study. Unpublished PhD thesis, University of Leicester.

Lindenschmidt, L. 1858–1900. *Alterthümer unserer heidnischen Vorzeit.* Mainz, von Zabern.

Machling, T. & Williamson, R. 2018. 'Up Close and Personal': The later Iron Age Torcs from Newark, Nottinghamshire and Netherurd, Peebleshire. *Proceedings of the Prehistoric Society* 84, 387–403.

Megaw, J.V.S. 1970. *Art of the European Iron Age.* Bath, Adams and Dart.

Ménez, Y. 1999. Les sculptures gauloises de Paule (Côtes-d'Armor). *Gallia* 56, 357–414.

Olivier, L. 2014. Les codes de représentation visuelle dans l'Art celtique ancien [Visual representation codes in Early Celtic Art]. In C. Gosden, S. Crawford & K. Ulmschneider (eds), *Celtic Art in Europe: Making connections*, 39–55. Oxford, Oxbow Books.

Olsen, B.A., Olander, T. & Kristiansen, K. (eds) 2019. *Tracing the Indo-Europeans: New evidence from archaeology and historical linguistics.* Oxford, Oxbow Books.

PAS. *Portable Antiquities Scheme database.* Available at: https://finds.org.uk/database (Accessed 01 July 2019).

Piggott, S. 1983. *The Earliest Wheeled Transport: From the Atlantic coast to the Caspian Sea.* London, Thames and Hudson.

Raftery, B. 1984. *La Tène in Ireland.* Marburg, Vorgeschichtliches Seminar Marburg.

Reichenberger, A. 1985. Der Leierspieler im Bild der Hallstattzeit. *Archäologisches Korrespondenzblatt* 15, 325–33.

Scarre, C. 2002. Epilogue: Colour and materiality in prehistoric society. In A. Jones & G. MacGregor (eds), *Colouring the Past: The significance of colour in archaeological research*, 227–42. Oxford, Berg.

Schwappach, F. 1969. Stempelverzierte Keramik von Armorica. In O.-H. Frey (ed.), *Marburger Beiträge zur Archäologie der Kelten: Festschrift für Wolfgang Dehn*, 213–87. Bonn, Habelt.

Serneels, V. 1998. La chaîne opératoire de la sidérurgie ancienne. In M. Feugère & V. Serneels (eds), *Recherches sur l'économie du fer en Méditerranée nord-occidentale*, 7–44. Montagnac, M. Mergoil.

Sharples, N. 2008. Comment I: Contextualising Iron Age art. In Garrow *et al.* 2008, 203–13.

Sherratt, A. 1989. V. Gordon Childe: Archaeology and intellectual history. *Past & Present* 125, 151–86.

Sykes, N. 2012. A social perspective on the introduction of exotic animals: The case of the chicken. *World Archaeology* 44(1), 158–69.

Talbot, J. 2017. *Made for Trade: A new view of Icenian coinage.* Oxford, Oxbow Books.

Watkins, C. 1995. *How to Kill a Dragon: Aspects of Indo-European poetics.* Oxford, Oxford University Press.

Wells, P.S. 2012. *How Ancient Europeans Saw the World: Vision, patterns, and the shaping of the mind in prehistoric times.* Princeton, NJ, Princeton University Press.

West, M.L. 2007. *Indo-European Poetry and Myth.* Oxford, Oxford University Press.